PICASSO
IN THE COLLECTION OF
THE MUSEUM OF MODERN ART

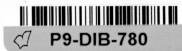

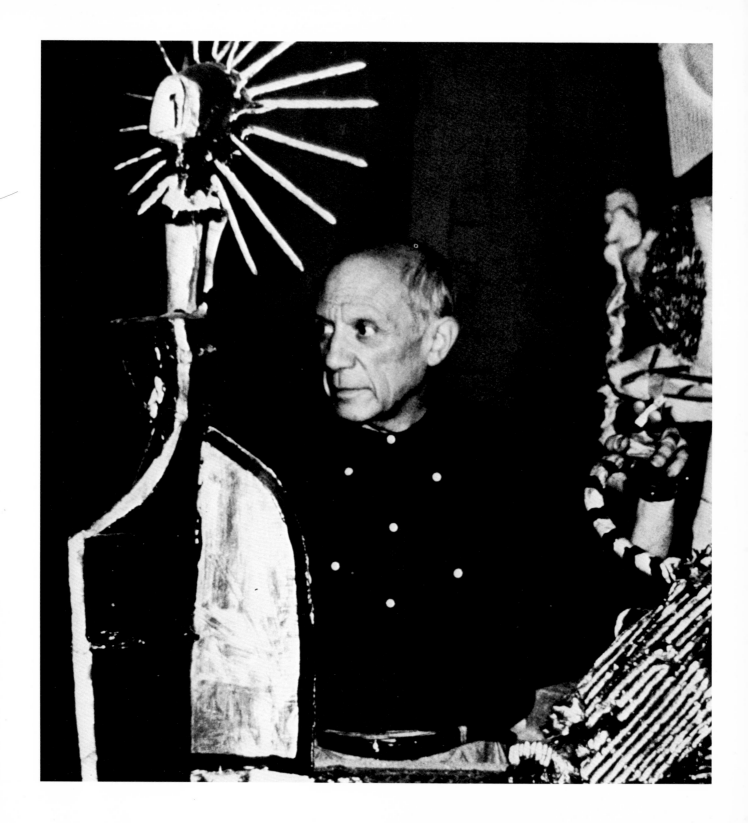

PICASSO

IN THE COLLECTION OF

THE MUSEUM OF MODERN ART

including remainder-interest and promised gifts

WILLIAM RUBIN

with additional texts by Elaine L. Johnson and Riva Castleman

Distributed by New York Graphic Society Ltd., Greenwich, Connecticut

THE MUSEUM OF MODERN ART, NEW YORK

Copyright © 1972 by The Museum of Modern Art

Library of Congress Catalog Card Number 70-164877

Cloth Binding ISBN 0-87070-537-7

Paperbound ISBN 0-87070-538-5

Designed by Carl Laanes

Type set by Boro Typographers, Inc., New York, New York

Printed and bound by Von Hoffmann Press, Inc., St. Louis, Missouri

The Museum of Modern Art

11 West 53 Street, New York, New York 10019

Printed in the United States of America

frontispiece: Picasso with *Goat, Skull and Bottle* (p. 177).

Vallauris, 1954

CONTENTS

LIST OF ILLUSTRATIONS

Page numbers marked with an asterisk indicate works reproduced in color.

Picasso in his Studio at Royan with Jaime Sabartés.
On the easel: *Woman Dressing Her Hair*, 1940 (p. 159)

PREFACE

THIS BOOK, part of a continuing program of publications on aspects of the Museum Collection, is issued in honor of Pablo Picasso's 90th birthday. The paintings and sculptures included in it are either already at the Museum, or fall into the categories of remainder-interest gifts (works that are the property of the institution but remain with the donors for their lifetimes) or promised gifts (works that have been formally committed as future gifts and bequests). The entire group of works, which constitutes by far the most complete and important public collection of Picasso's art, boasts a number of his unique and unrivaled masterpieces, and offers a virtually step-by-step revelation of the development of his Cubism.

The formation of this group of eighty-four paintings and sculptures is the fruit of the efforts of many curators and of the generosity of many trustees and friends of the Museum Collection. But above all, it is a testimony to the connoisseurship, devotion and persuasiveness of Alfred H. Barr, Jr., first Director of the Museum, and later, Director of Museum Collections, until his retirement in 1967. Mr. Barr was often aided by James Thrall Soby, who served the Museum in many capacities including Director of Painting and Sculpture and Chairman of the trustee Committee on the Museum Collections, and by James Johnson Sweeney in the years 1945–46 when he was Director of Painting and Sculpture. René d'Harnoncourt, Director of the Museum from 1949 to 1968, lent special support to projects concerning Picasso's sculpture. Yet if the quality, range and depth of the Museum's Picasso collection is a fitting tribute to Mr. Barr's efforts, the fact that even this large group of works still leaves a number of significant aspects of the artist's explorations unrepresented is an equal tribute to Picasso's astonishing variety.

The lacunae in the Museum's Picasso collection do not exist for want of having tried to fill them. (Indeed, in many cases the specific work that has been sought is one with which Picasso has never wished to part.) But the effort to fill out the collection goes on, and one of this author's greatest pleasures in his four years at the Museum has been the continuing exchange of ideas with Mr. Barr in relation to these possibilities as they arise.

THE FIRST PICASSO TO COME into the Museum Collection was the gouache *Head* of 1909 (p. 59), given by Mrs. Saidie A. May in 1930, the second year of the Museum's existence. Picasso's *Green Still Life* of 1914 (p. 94) came to the Museum in 1934 as a part of the magnificent bequest of Lillie P. Bliss, a Founder of the Museum and its Vice-President at the time of her death in 1931. The next year a third Picasso, *The Studio*, 1927–28 (p. 129), was accessioned; it was the gift of Walter P. Chrysler, Jr., a member of the Museum's newly formed Advisory Committee. The fund provided by that committee made possible the acquisition in 1937 of three more Picassos, *Man with a Hat*, 1912 (p. 78), *Guitar and Fruit*, 1927, and *Seated Woman*, 1926–27. Over the years the latter two were sold, funds from the sale of *Seated Woman* being used in 1964 for the purchase of *Studio with Plaster Head*, 1925 (p. 121).

In 1938 Mrs. Simon Guggenheim established a purchase fund that was continuously replenished until her death in 1969 and that over the years made possible some of the Museum's most important painting and sculpture acquisitions. *Girl before a Mirror*, 1932 (p. 139), had been selected for the Museum by Mr. Barr late in 1937; purchased early the next year, it became the first of the Guggenheim Fund acquisitions. In 1939 *Les Demoiselles d'Avignon*, 1907 (p. 41), was acquired essentially by exchange. Its asking price was largely accounted for by a trade of a minor Degas from the Lillie P. Bliss Bequest (the remainder having been a contribution by two art dealers who preferred to remain anonymous). In that same year, one of Picasso's most important Surrealist drawings, *Two Figures on the Beach*, 1933 (p. 141), was purchased with funds from an anonymous donor.

During the war years three important Cubist pictures were accessioned. In 1944 *Fruit Dish*, 1909 (p. 55), was acquired with funds realized through the sale of works in the Bliss Bequest, and the following year *"Ma Jolie,"* 1911–12 (p. 69), and *Card Player*, 1913–14 (p. 87), were acquired by the same method. At the time of the publication of Mr. Barr's *Picasso: Fifty Years of His Art* in 1946, the Museum owned twelve paintings by Picasso, in addition to one sculpture (*Woman's Head*, 1909, p. 61),

9

one collage (*Man with a Hat*, 1912, p. 78), and one gouache—the Saidie A. May gift that had initiated the Picasso collection.

Toward the end of the decade the pace of Picasso acquisitions accelerated. In 1949, *Three Musicians*, 1921 (p. 113), which had been on extended loan, was finally purchased, followed the next year by *Harlequin*, 1915 (p. 99), and *Seated Bather*, 1930 (p. 133), and in 1951 by *Still Life with Liqueur Bottle*, 1909 (p. 63), and *Sleeping Peasants*, 1919 (p. 109), the last acquired through the Abby Aldrich Rockefeller Fund. In 1952, *Pierrot*, 1918 (p. 102), came to the Museum in the bequest of Sam A. Lewisohn, and *Three Women at the Spring*, 1921 (p. 115), was given to the Collection by Mr. and Mrs. Allan D. Emil, while *Night Fishing at Antibes*, 1939 (p. 157), was acquired through the Guggenheim Fund. In 1955, A. Conger Goodyear gave the monumental collage-painting *Guitar*, 1919 (p. 105). Meanwhile, a number of important Picasso drawings, watercolors and collages had been given to the Collection by Mrs. Stanley Resor, Sam Salz, Mr. and Mrs. Daniel Saidenberg, and Mr. and Mrs. Werner E. Josten.

The next large infusion of Picassos into the Museum Collection took place in 1956 with donations of five works (including *Glass of Absinth*, 1914, p. 95, and *Pregnant Woman*, 1950, p. 173, both gifts of Mrs. Bertram Smith) and purchases of five others (including *Baboon and Young*, 1951, p. 175). In 1958, following the death of Philip L. Goodwin, an architect (with Edward Durrell Stone and, later, Philip Johnson) of the Museum, and Vice-Chairman of the Board, the Collection received a group of works including Picasso's *The Rape*, 1920 (p. 111).

Before the opening in October 1958 of the exhibition *Works of Art: Given and Promised*, the Museum Collection included thirty-seven paintings and sculptures by Picasso. The nine Picassos in *Given and Promised* included *Two Acrobats with a Dog*, 1905 (p. 32), promised gift of Mr. and Mrs. William A. M. Burden; *Boy Leading a Horse*, 1905–06 (p. 35), promised gift of William S. Paley; *Two Nudes*, 1906 (p. 39), promised gift of G. David Thompson; and *Girl with a Mandolin*, 1910 (p. 67) and *Interior with a Girl Drawing*, 1935 (p. 147), both promised gifts of Nelson A. Rockefeller. It also included *Seated Woman*, 1927 (p. 125), a promised gift of Mr. Soby, whose entire collection, comprising forty-eight paintings and ten sculptures (including two other paintings by Picasso), was pledged to the Museum in February 1961.

In the early 1960s, Picasso acquisitions included five works on paper from the John S. Newberry Collection; *Violin and Grapes*, 1912 (p. 77), a bequest of Mrs. David M. Levy; and the *Vase of Flowers*, 1907 (p. 45), a remainder-interest gift of Mr. and Mrs. Ralph F. Colin. Then, in 1967, Sidney Janis, on behalf of his late wife Harriet and himself, gave the Museum his entire private collection of some one hundred works, which included four Picassos, among them the monumental *Painter and Model*, 1928 (p. 131).

Since the retirement of Mr. Barr, two major groups of promised gifts have been added to the Museum's Picassos. The first consists of seven Cubist paintings—the Museum's choice from among those in the estate of Gertrude Stein. This gift was the result of the initiative of Bates Lowry, then Director of the Museum, at whose suggestion a group of trustees and friends—David Rockefeller, Governor Rockefeller, John Hay Whitney, Mr. Paley and Mr. André Meyer—purchased the estate and pledged to bequeath at least one painting each to the Collection. (These commitments were in addition to other important outright and promised gifts, some of them Picassos, which the same donors had already made.)

The second major group of promised gifts, also seven Picassos—including *Woman Combing Her Hair*, 1906 (p. 37), *Woman with Pears*, 1909 (p. 60), and *Girl Reading*, 1934 (p. 144)—came from the Florene May Schoenborn and Samuel A. Marx Collection. During the lifetime of Mr. Marx, the Museum received from him and his wife, Florene, Matisse's great *Moroccans* and González' *Torso*. Following Mr. Marx's death in 1964, the Museum received title, in the form of remainder-interest gifts, to three other major Matisses, and later, in 1967, was promised a Braque, a Bonnard and a Léger. In 1965–66, the Marx-Schoenborn Collection was exhibited under the rubric *The School of Paris*; and in January 1971, William S. Lieberman, Director of Painting and Sculpture, formally announced to the Board that eighteen other works, including the seven Picassos, were to be bequeathed to the Museum by Florene Marx Schoenborn.

The Drawings Collection of the Museum was the recipient of a munificent bequest of 267 drawings from the collection of Joan and Lester A. Avnet following Mr. Avnet's death in 1970. Mr. Avnet's bequest of superb nineteenth- and twentieth-century drawings, including

six works by Picasso, followed a number of generous gifts made during his lifetime.

The most recent additions to the Museum's Picasso collection, all made within the last year, have been *Repose*, 1908 (p. 47), *The Charnel House*, 1944–45 (p. 167), both acquired by exchange, and *Guitar*, 1912, generously donated by the artist—the only metal construction sculpture of the Cubist period with which he has ever parted.

PERHAPS THE ONLY RATIONALE for yet another book on Picasso is that paradoxically little art history or criticism deals with his individual works. There is a virtual library of publications on Picasso; but after discounting the non-books, ceremonial objects and purely documentary (though invaluable) catalogs and photo albums, only the merest fraction of the serious writing that remains touches on individual works of art except in passing. Nevertheless, it was with some trepidation that I undertook this catalog, and not a little of my commitment to see it through stemmed from the encouragement of Alfred Barr. His great book *Picasso: Fifty Years of His Art* remains today, a quarter of a century after its publication, *the* standard general reference on the artist. It was, indeed, Mr. Barr's reminder to me that *Picasso: Fifty Years of His Art* contains little material on many works now in the Museum's Collection that helped convince me of the value of doing this text. He had urged that I write the entire book from tabula rasa, but given Mr. Barr's scholarship and the lapidary quality of his prose, it seemed to me unnecessary, even presumptuous, to deal with works for which texts of substantial length were to be found in *Picasso: Fifty Years of His Art*—as was the case, for example, with *Les Demoiselles d'Avignon*. This text of Mr. Barr's, along with passages on *Le Chef-d'oeuvre inconnu*, *Minotauromachy* and *Dream and Lie of Franco*, have therefore been reprinted here with his permission. In none of these cases has scholarship of the last twenty-five years rendered his texts obsolete. Except for the addition to the notes on *Les Demoiselles d'Avignon* of a brief discussion of publications after 1946 (p. 195), Mr. Barr's texts have been reprinted unchanged, and with his own notes. It is a pleasure in this way to salute a book on which a generation of art historians and critics was raised and nourished.

IN THE FIVE MONTHS during which this book was in preparation, I had the good fortune to spend a number of evenings with Picasso and to go through old and new work in his studio. Picasso dislikes being interrogated about his own work, but he speaks frequently, and very movingly, about art in general—and about the work of other artists. When he does speak of his own painting, it is rarely about individual works. Like most artists, he has no interest in delimiting the poetry of his iconography by explicating it verbally.

Picasso has never submitted to a formal interview on his work by a critic or scholar. Most of the first-hand remarks and information we possess on individual works —altogether comparatively little—has come from the records of casual conversations with a number of his friends, notably Daniel-Henry Kahnweiler, Brassaï, Roland Penrose and Hélène Parmelin. All Picasso quotations regarding individual pictures from whatever source must therefore be understood to involve some paraphrasing inasmuch as 1) the only two statements the artist has ever expressly approved are general in character, and 2) one does not take notes or use any form of recording device while conversing with Picasso. I have permitted myself only one direct quotation from my conversations with him (p. 72), my wife and I having separately determined to remember and write down those few sentences, and having found virtually no difference in our respective recollections.

Despite Picasso's dislike of interrogation, a circumstance arose that made it possible to pose in passing a number of questions regarding the reading of particular pictures: on the occasion of one visit, I had brought Picasso a provisional mock-up of this catalog, which interested him considerably. As he slowly leafed through the plates, musing about the pictures, we chatted, and he good-naturedly answered a number of my queries. Needless to say, these were far fewer than I should have liked to pose—and not necessarily the most important.

IN ADDITION TO MR. BARR, to whom I am indebted for his encouragement, and for permission to reprint certain of his texts, I want to express my gratitude to my co-authors. Elaine L. Johnson, former Associate Curator in charge of Drawings, has contributed texts on a number of the drawings (excepting those I have treated in conjunction with paintings). Riva Castleman, Associate Curator in charge of Prints, has contributed texts on a number of the etchings and lithographs. (While all paintings, sculptures and drawings in the Museum Collection are reproduced, only

a selection of the most important prints could be incorporated.)

All texts by authors other than myself are signed. The notes and the reference photographs for each work appear under the full catalog entry in the back of the book. The page number of that full entry is given at the end of the short caption that accompanies the reproduction of each work.

So many people have been of help to me in the preparation of this catalog that I can hardly hope to do them all justice. Professor Robert Rosenblum, my friend and colleague at the Institute of Fine Arts, New York University, gave the manuscript a careful and concentrated reading, and discussed its particulars with me at length; I owe him a great debt of gratitude for his encouragement, and for the many valuable suggestions and constructive criticisms he made. Betsy Jones, Associate Curator of the Painting and Sculpture Collection, also graciously consented to read the manuscript, and made helpful suggestions. Picasso's friend and biographer Roland Penrose, his long-time friend and dealer Daniel-Henry Kahnweiler and M. Kahnweiler's associate, Maurice Jardot, have all been extremely helpful in answering queries.

Carl Morse, Managing Editor of the Department of Publications, put immense effort into this book and made numerous excellent suggestions that I have incorporated. The same is true of Carolyn Lanchner, Researcher of the Collection. Both of them worked evenings and weekends, under tremendous pressure, to help get out this catalog in the very short period allotted for it. At no time did they lose their cheerfulness or interest in the project—which did much to sustain the author.

As always occurs during the preparation of such a catalog or exhibition, a heavy burden of duties and responsibilities materializes for my Assistant, Sharon Oswald. Her goodwill is matched only by her professionalism and hard work.

Finally, my special thanks go to Carl Laanes, who designed this book quickly and handsomely, despite a number of unusual problems arising from the format chosen; to Jack Doenias, who saw through the printing of the color plates and the general production of the catalog; and to Inga Forslund, who prepared the list of the Museum's Picasso publications.

William Rubin
October 1971

EXHIBITIONS OF PICASSO'S WORK

AT THE MUSEUM OF MODERN ART

THIS LIST INCLUDES all one-man exhibitions of Picasso at The Museum of Modern Art, as well as others in which a significant number of his works were included.

Painting in Paris, January 19 – February 16, 1930. 14 works. Directed by Alfred H. Barr, Jr.

Memorial Exhibition / The Collection of the Late Miss Lizzie P. Bliss / Vice-President of the Museum, May 17 – September 27, 1931. 9 works. Directed by Alfred H. Barr, Jr.

Modern Works of Art: 5th Anniversary Exhibition, November 20, 1934 – January 20, 1935. 10 works. Directed by Alfred H. Barr, Jr.

Cubism and Abstract Art, March 2 – April 19, 1936. 29 works. Directed by Alfred H. Barr, Jr.

Modern Painters and Sculptors as Illustrators, April 27 – September 2, 1936. 8 illustrated books. Directed by Monroe Wheeler.

Fantastic Art, Dada, Surrealism, December 7, 1936 – January 17, 1937. 13 works. Directed by Alfred H. Barr, Jr.

Art in Our Time: 10th Anniversary Exhibition, May 10 – September 30, 1939. 11 works. Painting and Sculpture section directed by Alfred H. Barr, Jr.

Picasso: Forty Years of His Art, November 15, 1939 – January 7, 1940. Directed by Alfred H. Barr, Jr. 294 oils, watercolors, gouaches and drawings, 7 collages, 11 sculptures and constructions, and 49 prints.

Twentieth Century Portraits, December 9, 1942 – January 24, 1943. 9 works. Directed by Monroe Wheeler.

Modern Drawings, February 16 – May 10, 1944. 27 works. Directed by Monroe Wheeler.

Art in Progress: 15th Anniversary Exhibition, May 24 – October 15, 1944. 8 works. Painting and Sculpture section directed by James Thrall Soby.

The Museum Collection of Painting and Sculpture, June 20, 1945 – January 13, 1946. 13 works. Directed by Alfred H. Barr, Jr.

Collage, September 21 – December 5, 1948. 20 works. Directed by Alfred H. Barr, Jr.

Picasso. The Sculptor's Studio, January 24 – March 19, 1950. 40 etchings. Directed by William S. Lieberman.

Masterworks Acquired through the Mrs. Simon Guggenheim Fund, January 29 – March 23, 1952. 5 works. Directed by Alfred H. Barr, Jr.

Picasso: His Graphic Art, February 14 – April 20, 1952. 140 prints and 13 illustrated books. Directed by William S. Lieberman.

Sculpture of the Twentieth Century, April 29 – September 7, 1953. 4 works. Directed by Andrew Carnduff Ritchie.

Paintings from the Museum Collection: xxvth Anniversary Exhibition, October 19, 1954 – February 6, 1955. 21 works. Installed by Alfred H. Barr, Jr. and Dorothy C. Miller.

Picasso 75th Anniversary Exhibition, May 22 – September 8, 1957. 149 oils, watercolors, gouaches and drawings, 11 collages, and 11 sculptures and constructions. Directed by Alfred H. Barr, Jr.

Works of Art: Given or Promised and the *Philip L. Goodwin Collection*, October 8 – November 9, 1958. 10 works. Directed by Alfred H. Barr, Jr.

80th Birthday Exhibition – Picasso – The Museum Collection – Present and Future, May 14 – September 18, 1962. 80 paintings, sculptures, drawings and collages, 97 prints and 5 illustrated books. Directed by Alfred H. Barr, Jr., Dorothy C. Miller and William S. Lieberman.

The School of Paris: Paintings from the Florene May Schoenborn and Samuel A. Marx Collection, November 2, 1965 – January 2, 1966. 14 works. Directed by Monroe Wheeler, installed by Alicia Legg.

The Sculpture of Picasso, October 11, 1967 – January 1, 1968. 202 sculptures and constructions, 32 ceramics, 15 drawings and collages, and 24 prints. Selected by Roland Penrose, installed by René d'Harnoncourt.

Prints by Picasso: A Selection from 60 Years. October 11, 1967 – January 1, 1968. 50 prints. Directed by William S. Lieberman.

The Sidney and Harriet Janis Collection, January 17 – March 4, 1968. 4 works. Installed by Alfred H. Barr, Jr., with Dorothy C. Miller.

Dada, Surrealism and Their Heritage, March 27 – June 9, 1968. 12 works. Directed by William S. Rubin.

Twentieth Century Art from the Nelson Aldrich Rockefeller Collection, May 26 – September 1, 1969. 26 works. Directed by Dorothy C. Miller.

Picasso: Master Printmaker, October 15 – November 29, 1970. 528 prints and 25 books. Directed by Riva Castleman.

Four Americans in Paris: The Collection of Gertrude Stein and Her Family, December 19, 1970 – March 1, 1971. 108 works. Directed by Margaret Potter, installed by William S. Lieberman.

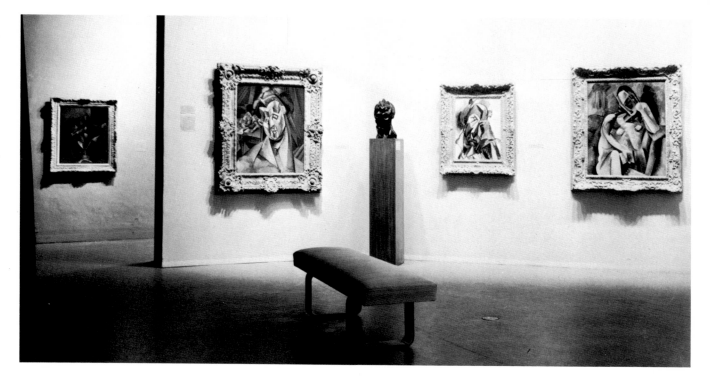

Picasso: Forty Years of His Art, November 15, 1939 – January 7, 1940

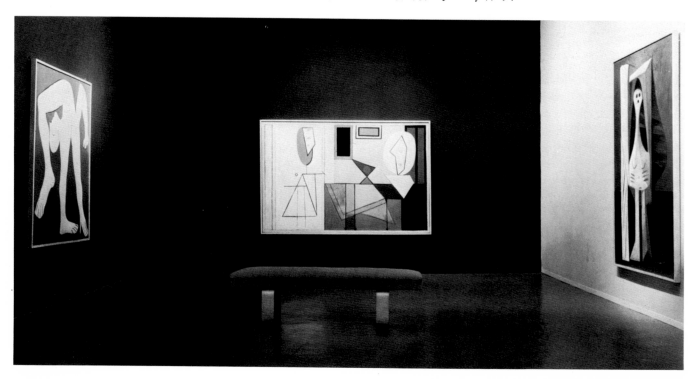

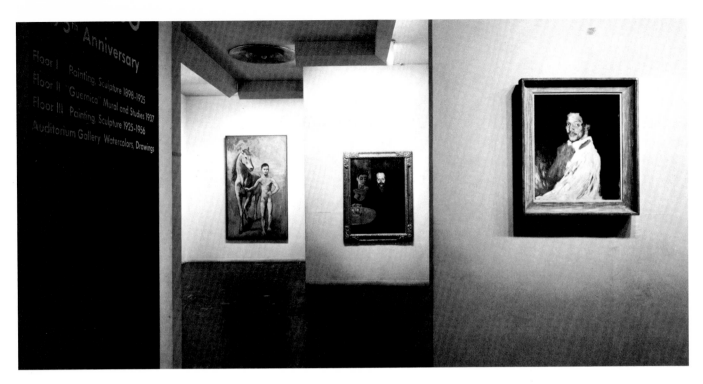

Picasso 75th Anniversary Exhibition, May 22 – September 8, 1957

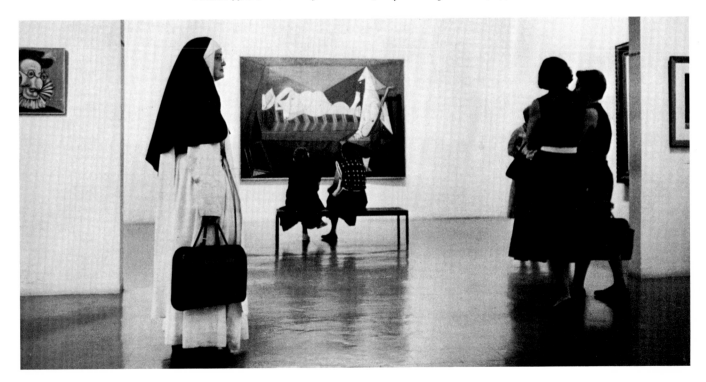

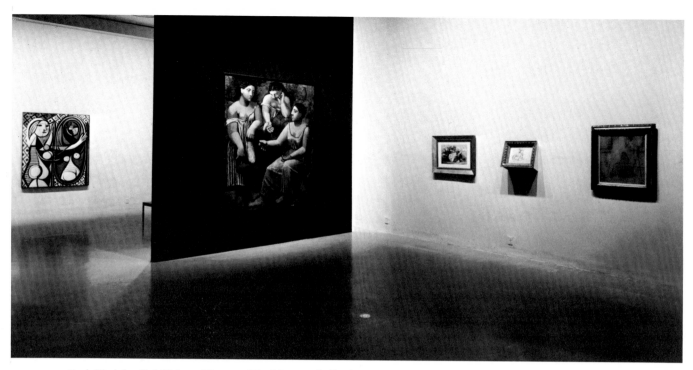

80th Birthday Exhibition – Picasso – The Museum Collection – Present and Future, May 14 – September 18, 1962

The Sculpture of Picasso, October 11, 1967 – January 1, 1968

The Sculpture of Picasso, October 11, 1967 – January 1, 1968
Picasso: Master Printmaker, October 15 – November 29, 1970

Picasso and his wife, Jacqueline

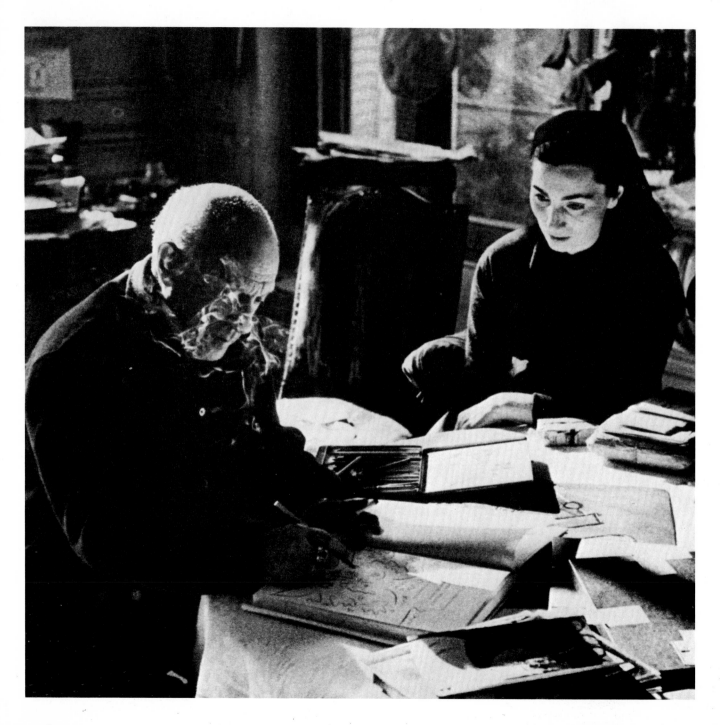

PUBLICATIONS ON PICASSO

ISSUED BY THE MUSEUM OF MODERN ART

MONOGRAPHS

Picasso: Forty Years of His Art. Edited by Alfred H. Barr, Jr. 1939. 207 pp., 214 ills. (1 col.)
 Two statements by the artist and bibliography. Includes catalog of exhibition, Nov. 15, 1939 – Jan. 7, 1940, organized in collaboration with the Art Institute of Chicago.
 Three revised editions published, 1939–41.

Picasso: Fifty Years of His Art. By Alfred H. Barr, Jr. 1946. 314 pp., ills. (7 col.)
 Based on *Picasso: Forty Years of His Art,* with new and greatly amplified text. Statements by the artist; extensive bibliography.
 Second edition, 1955. Also, reprint edition by Arno Press, New York, 1966 (ills. only in black and white).

Symposium on "Guernica." Nov. 25, 1947. 80 leaves.
Typed transcript
 Contents: Opening remarks by Alfred H. Barr, Jr., Chairman; Remarks by José L. Sert, Jerome Seckler, Juan Larrea, Jacques Lipchitz, and Stuart Davis; and general discussion.

Photographs of Picasso. By Gjon Mili and Robert Capa. 1950. [20] pp. (mostly ills.)
 Installation shots by Mili and Capa and statements by Steichen, Mili and Capa from wall labels for the exhibition, Jan. 24 – Mar. 19, 1950.

The Sculptor's Studio: Etchings by Picasso. With an introduction by William S. Lieberman. 1952. 4 pp. plus 24 plates
 A series of etchings from the collection of the Abby Aldrich Rockefeller Print Room of The Museum of Modern Art.

Picasso: 75th Anniversary Exhibition. Edited by Alfred H. Barr, Jr. 1957. 115 pp., ills. (pt. col.)
 Catalog of exhibition, May 22 – Sept. 8, 1957.

Portrait of Picasso. By Roland Penrose. 1957. 96 pp., ills.
 Based on material collected for the exhibition "Picasso himself," organized by Penrose for the Institute of Contemporary Arts of London, 1956, and amended in connection with the exhibition at The Museum of Modern Art, May – Sept. 1957.
 Second revised and enlarged edition, 1971. 128 pp., 330 ills. (6 col.).

The Sculpture of Picasso. By Roland Penrose. 1967. 231 pp., ills.
 Chronology and bibliography. Includes catalog of the exhibition, Oct. 11, 1967 – Jan. 1, 1968.

Gertrude Stein on Picasso. Edited by Edward Burns. 1970. [138] pp., ills. (pt. col.)
 Commentaries on Picasso, taken from the writings and notebooks of Gertrude Stein, and illustrated with photographs and works from the Stein collection.
 Published in cooperation with Liveright, New York.

ARTICLES ON PICASSO

"Picasso 1940–1944." A digest with notes by Alfred H. Barr, Jr.
 In *The Museum of Modern Art Bulletin,* XII, 3, Jan. 1945, pp. 1–9, ills.
Postscripts in XII, 4, Spring 1945, p. 15.

"Picasso at work, August 1944." By John Groth
 In *The Museum of Modern Art Bulletin,* XII, 3, Jan. 1945, pp. 10–11, ills.

"Picasso: his graphic art." By William S. Lieberman
 In *The Museum of Modern Art Bulletin,* XIX, 2, Winter 1952, pp. 1–17, ills.
On the occasion of the exhibition, Feb. 14 – Apr. 20, 1952. Includes checklist of the exhibition.

"Picasso as sculptor." Statements by Julio González
 In *The Museum of Modern Art Bulletin,* XXIII, 1–2, 1955–56, pp. 43–44.

"Works of Art: Given or Promised." By Alfred H. Barr, Jr.
 Commentaries on nine major works by Picasso. In *The Museum of Modern Art Bulletin,* XXVI, 1, Fall 1958, pp. 34–43, 9 ills.
In connection with the exhibition, Oct. 8 – Nov. 9, 1958. Also published in the catalog of the exhibition.

GENERAL BOOKS AND CATALOGS

Painting in Paris from American Collections. Edited by Alfred H. Barr, Jr. 1930. pp. 36–38. 5 ills. of Picasso's work
 Catalog of exhibition, Jan. 19 – Feb. 16, 1930.

Memorial Exhibition. The Collection of the Late Miss Lizzie P. Bliss. 1931. pp. 32–33. 2 ills. of Picasso's work
 Catalog of exhibition, May 17 – Sept. 27, 1931.

International Exhibition of Theatre Art. 1934. pp. 53–54. 2 ills. of Picasso's work
 Includes catalog of exhibition, Jan. 16 – Feb. 26, 1934.

The Lillie P. Bliss Collection. Edited by Alfred H. Barr, Jr. 1934. pp. 56–58, 81–83. 4 ills. of Picasso's work
 Catalog of exhibition, May 14 – Sept. 12, 1934.

Modern Works of Art. Fifth anniversary exhibition. Edited by Alfred H. Barr, Jr. 1934. pp. 32–33. 8 ills. of Picasso's work
 Includes catalog of exhibition, Nov. 20, 1934 – Jan. 20, 1935.

Cubism and Abstract Art. By Alfred H. Barr, Jr. 1936. pp. 29–42, 78–92, 96–111, 219–221. 26 ills. of Picasso's work
 Includes catalog of exhibition, Mar. 2 – Apr. 19, 1936.
Reprint edition by Arno Press, New York, 1966.

Modern Painters and Sculptors As Illustrators. By Monroe Wheeler. 1936. pp. 67–71. 5 ills. of Picasso's work
 Includes catalog of exhibition, Apr. 27 – Sept. 2, 1936.
 Third revised edition, 1946. pp. 65–71. 7 ills. of Picasso's work.

Fantastic Art, Dada, Surrealism. Edited by Alfred H. Barr, Jr. 1936. pp. 216–217 and passim. 9 ills. of Picasso's work
 Includes catalog of exhibition, Dec. 7, 1936 – Jan. 17, 1937.
 Second revised edition, 1937, and third revised edition, 1947, contain essays by Georges Hugnet.

Art in Our Time. An exhibition to celebrate the tenth anniversary of The Museum of Modern Art and the opening of its new building, held at the time of the New York World's Fair. 1939. passim. 11 ills. of Picasso's work
 Catalog of the exhibition, May 10 – Sept. 30, 1939.

Painting and Sculpture in The Museum of Modern Art. Edited by Alfred H. Barr, Jr. 1942. pp. 66–69. 7 ills. of Picasso's work
 Supplement edited by James Johnson Sweeney. 1945. p. 12. 1 ill. of Picasso's work.
 ———— ————. 1948. pp. 57–58, 84–85 and passim. 16 ills. of Picasso's work.
 ———— ————. 1958. pp. 48–49.
 The above catalogs of the Museum's collection are supplemented by publications entitled "Painting and Sculpture Acquisitions," which appeared as Bulletins at various intervals.

20th Century Portraits. By Monroe Wheeler. 1942. pp. 13 and passim. 8 ills. of Picasso's work
 Includes catalog of exhibition, Dec. 9, 1942 – Jan. 24, 1943.

What Is Modern Painting? By Alfred H. Barr, Jr. 1943. pp. 20, 26–29, 36–38. 3 ills. of Picasso's work. (Introductory series to the modern arts. 2)
 Last revised edition (7th), 1959. Also editions in Spanish and Portuguese, 1953.

Modern drawings. Edited by Monroe Wheeler. 1944. p. 13 and passim. 11 ills. of Picasso's work
 Includes catalog of exhibition, Feb. 16 – May 10, 1944.
Second revised edition, 1945.

Art in Progress. A survey prepared for the fifteenth anniversary of The Museum of Modern Art, New York. 1944. pp. 66–69 and passim. 6 ills. of Picasso's work
 Includes catalog of the exhibition May 24 – Oct. 22, 1944.

Sculpture of the Twentieth Century. By Andrew Carnduff Ritchie. 1952. pp. 25–28, 29, 31–32, 231. 13 ills. of Picasso's work
 Published on the occasion of the exhibition 1952–53 at the Philadelphia Museum of Art, the Art Institute of Chicago and The Museum of Modern Art. Also a catalog published. 1952. 47 pp.

Masters of Modern Art. Edited by Alfred H. Barr, Jr. 1954. pp. 67–71, 80–83, 92–93, 97. 14 ills. (6 col.) of Picasso's work
 Second edition, 1955. Also foreign-language editions (French, Spanish, 1955; German, Swedish, 1956).

The James Thrall Soby Collection of Works of Art Pledged or Given to The Museum of Modern Art. 1961. pp. 62–63. 3 ills. (1 col.) of Picasso's work
 Catalog of exhibition at M. Knoedler & Co., Inc., New York, Feb. 1–25, 1961 (extended to Mar. 4). Catalog with notes by James Thrall Soby. Preface by Blanchette H. Rockefeller. "James Thrall Soby and his collection" by Alfred H. Barr, Jr.

The School of Paris. Paintings from the Florene May Schoenborn and Samuel A. Marx Collection. Preface by Alfred H. Barr, Jr. Introduction by James Thrall Soby. Notes by Lucy R. Lippard. 1965. pp. 16–29. 14 ills. (4 col.) of Picasso's work
 Catalog of exhibition, Nov. 2, 1965 – Jan. 2, 1966, in collaboration with the Art Institute of Chicago, City Art Museum of St. Louis, San Francisco Museum of Art, Museo de Arte Moderno, Mexico. All paintings in the collection reproduced.

Dada, Surrealism, and Their Heritage. By William S. Rubin. 1968. pp. 124–127, 240 and passim. 12 ills. of Picasso's work
 Includes catalog of the exhibition, Mar. 27 – June 9, 1968.

Twentieth Century Art from the Nelson Aldrich Rockefeller Collection. 1969. pp. 12–14 and passim. 13 ills. (3 col.) of Picasso's work
 Foreword by Monroe Wheeler. Preface by Nelson A. Rockefeller. "The Nelson Aldrich Rockefeller Collection" by William S. Lieberman, pp. 11–35. Includes catalog of exhibition, May 26 – Sept. 1, 1969.

Four Americans in Paris. The Collection of Gertrude Stein and Her Family. 1970. passim. 39 ills. (6 col.) of Picasso's work
 Partial content: "Matisse, Picasso and Gertrude Stein" by Leon Katz, pp. 51–64. "More adventures" by Leo Stein [recollections of Matisse and Picasso], pp. 96–98. "Portraits: Pablo Picasso" by Gertrude Stein, pp. 101–102.
 Includes catalog of exhibition, Dec. 19, 1970 – Mar. 1, 1971.

(Compiled by Inga Forslund, Associate Librarian)

Picasso with his long-time friend and dealer, Daniel-Henry Kahnweiler.
Mougins, summer 1965

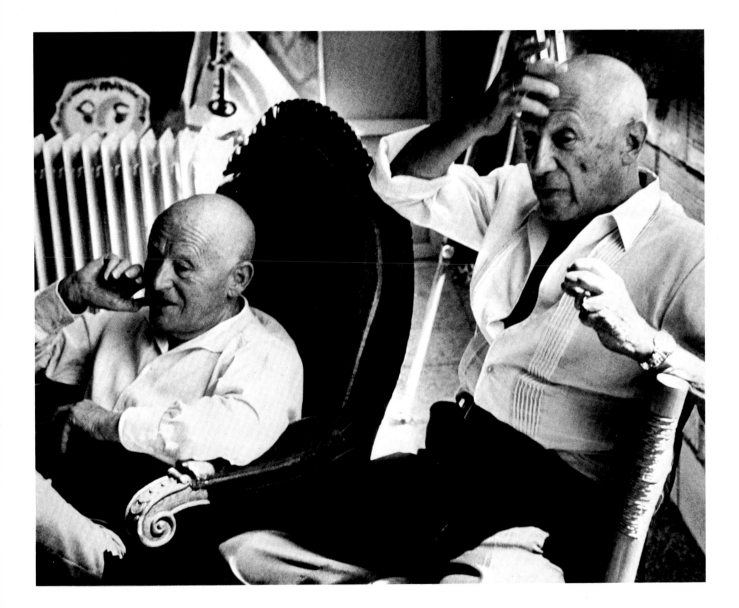

PICASSO
IN THE COLLECTION OF
THE MUSEUM OF MODERN ART

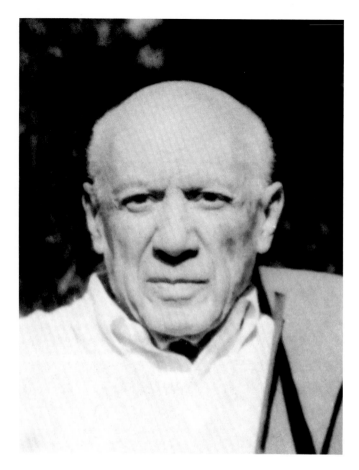

Picasso, April 1971

make it the earliest of these self-portraits. But the artist himself does not recall its having been in that show, and it was most likely painted during or after it.[2]

The picture is remarkable for the bravura of its execution—and Picasso's awareness of his astonishing talents surely contributed to the panache and self-assurance with which he presents himself. His mood may also reflect his satisfaction with external events, for though the Vollard exhibition has often been characterized as a failure—largely on the basis of Vollard's unreliable reminiscences—fifteen pictures were in fact sold even before the opening. In a highly laudatory review in *La Revue Blanche*, Félicien Fagus spoke of the "brilliant virility" of the pictures but warned that Picasso's "impetuous spontaneity" might "lead him into facile virtuosity." Indeed, it is hard to believe that these words were not ringing in Picasso's ears when, not long afterward, he adapted the consciously awkward contouring and facture of the early "Blue Period" pictures.

In *Self-Portrait: Yo Picasso* (p. 189:1), probably the picture exhibited at Vollard's, since it was the only other self-portrait painted in the spring of 1901, we see the artist at work. Here, nothing intervenes between us and the unrelenting immediacy of his presence. This directness is enhanced by the absolute frontality of the pose but depends even more on Picasso's penetrating gaze. His eyes were—and remain—his most remarkable physical attribute. Fernande Olivier, his companion from late 1904 until spring 1912, wrote of them as "dark, deep, piercing, strange, and almost staring."

Picasso has said that in 1901 Van Gogh exerted a greater influence on him than did any other artist. The Dutch painter's spirit may be manifest in the unguarded directness of *Self-Portrait*; but that influence is more readily apparent in the motor vigor of Picasso's brushwork—though he has substituted an angular, discontinuous contouring for Van Gogh's curvilinear patterning. Picasso's brushwork is particularly noteworthy in the rectilinear strokes of blue that determine the hairline of the forehead and the contour of the shock of hair that falls toward his right ear. A similar decisiveness is evident in the contouring of the neckline. These "sticks" of color are found in some paintings of the summer and fall of 1901, but they disappear with the development of the more tightly painted fabric of the Blue Period, to reemerge—transformed into a more systematic component of style—in such works of 1907 as the *Vase of Flowers* (page 45).

SELF-PORTRAIT. *Paris, late spring or summer 1901. Oil on cardboard, 20¼ x 12½ inches. (Full Catalog entry and Notes, p. 189)*

Although Picasso drew his own image not infrequently during his teens, the first painted self-portraits he seems to have completed date from 1901, probably just after the twenty-year-old artist arrived in May for his second sojourn in Paris.[1] This picture has sometimes been identified as the one in the catalog list for Picasso's exhibition at the Vollard Galleries in June of that year, which would

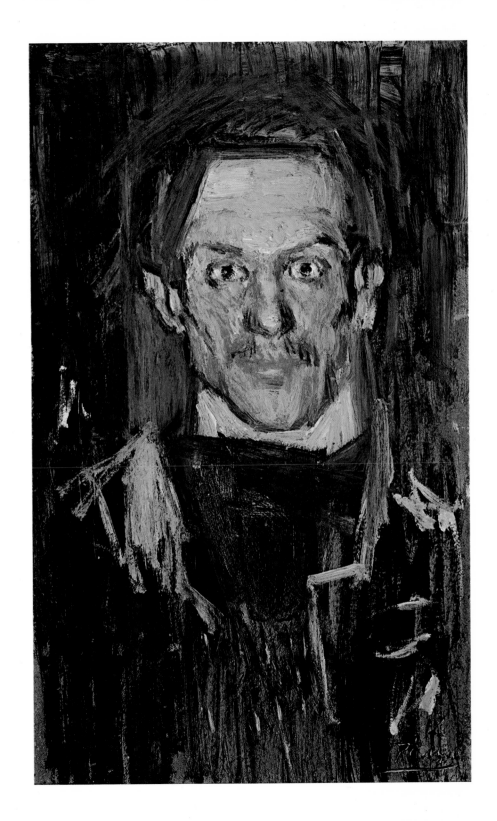

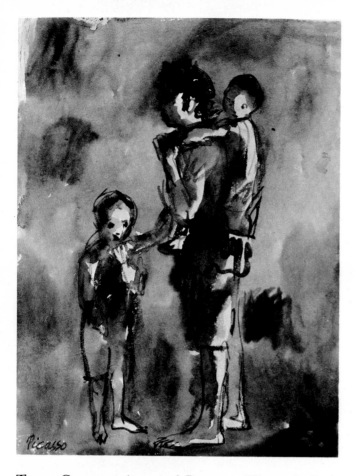

THREE CHILDREN (*verso of* BROODING WOMAN). *Paris, 1903–04. Watercolor, 14½ x 10⅝ inches. (C&N, p. 190)*

BROODING WOMAN. *Paris, 1904. Watercolor, 10⅝ x 14½ inches. (C&N, p. 190)*

Blue dominated Picasso's palette and hence the mood of his subjects from the end of 1901 until late 1904. His friend Jaime Sabartés recalled that "a mound of white in the center [of the palette] constituted the base of a kind of cement composed mainly of blue. The other colors formed its border."

The use of a single hue to create a mood, a hue that floods the picture and usurps the local colors of objects, was essentially a Symbolist device. Thus it relates Picasso's work in these years to late nineteenth-century art more than to contemporary explorations of color such as in the work of the painters then gathering around Matisse, who were soon to be known as Fauves.

Whistler and later, near the turn of the century, Monet had painted blue pictures which, like their other monochrome works, evoke an ambience of isolation, emptiness and reverie. These images approximated the moods of the Symbolist poets, particularly of Verlaine (one of Picasso's favorites), who in *L'Art poétique* called for an art of nuance rather than color. A number of Cézanne's later pictures, which were also painted in gradations of blue, have affinities with Symbolist painting and even more closely anticipate Picasso, insofar as some were portraits and figure pictures while the Whistlers and Monets were largely uninhabited landscapes.

Except for the appropriation of the basic Symbolist device, however, the "Blue Period" paintings have little in common with late nineteenth-century prototypes, for Picasso associated the mood-color in a very literal way with a particular cast of characters: lonely, suffering, poverty-stricken outcasts from society (a subject matter favored by his Barcelona friend, Isidre Nonell, whose studio Picasso had borrowed for a while just before 1900). Beyond the humanitarian sentiments they imply, these subjects have been considered symbols of Picasso's penurious situation at the time; his sales had fallen sharply after the Vollard exhibition, and mere survival had become difficult. But the narrowing to these themes perhaps represented as much an effort to define himself in terms of a characteristic subject matter as it did a commentary on the artist's place—or rather lack of place—in society. To be personal, one had to be sincere; and in Picasso's immediate circle, as Sabartés said, "sincerity. . . could not be found apart from sorrow." Despite noble intentions,

however, it often happened, especially in Picasso's imagined compositions—as opposed to the portraits of his friends, which are firmer and more direct—that such sentiments spilled over into sentimentality.

Brooding Woman teeters on the edge of this distinction. The long face is unsubtle, and the arms and shoulder are manneristically attenuated to make a parallelogram around the head. The facial type—forehead and nose forming an almost unbroken line and lips pinched tight—appears early in 1902 and had already become familiar in Picasso's art. The shadow of the eye is handled so as virtually to make the figure appear blind, which reinforces the mood of dejection.

The obviousness in the presentation of the subject is compensated for in *Brooding Woman* by a delicacy and fluency in the facture that is uncommon in the Blue Period. This arises in part from the watercolor medium, which Picasso uses here most imaginatively (as in the blotting that divides the highlight of the cheek and the shadow of the jowl). Watercolor also produced an image that is free of the almost enameled surfaces and overemphatic contouring of many Blue Period oils; the blotting and staining on the right are so painterly as to be unreadable, though there are some hints of a figure—perhaps a café waiter or waitress.

Brooding Woman represents a stylistic extreme in Picasso's early explorations in mediums other than oil. The year 1904 was devoted largely to such studies; in that year, he executed only seven oil paintings as opposed to some twenty the year before.

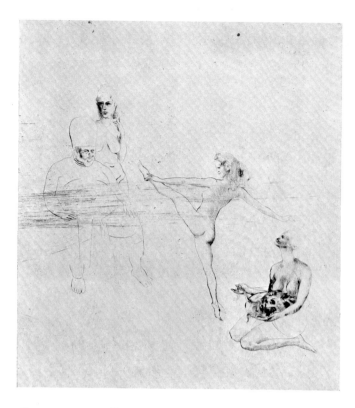

SALOME. *1905. Drypoint, 15⅞ x 13¾ inches. (C&N, p. 190)*

Two continuing themes, couples in cafés and the haunting solitude of the blind, are brought to ultimate refinement in the etching *The Frugal Repast*. In developing the first theme—couples seated at café tables—Picasso combined two poses used in other compositions: one in which the man is internalized, deep in his own thought, while the woman stares at the viewer—depicted in the paintings *The Two Saltimbanques* of 1901 (p. 190:4) and *The Couple in the Café* of 1903;[1] and the other in which one of the pair casually rests a sensitive, elongated hand on the companion's shoulder—as in *The Couple (Les Misérables)* of 1904[2] and in the lost painting *Pierrette's Wedding*[3] of the same year. The second theme, the portrayal of blindness, particularly the blind man as seen in profile, evolved from the softly delineated head in *The Blind Man's Meal* of 1903 (p. 190:5) into the increasingly defined and emaciated face in *The Frugal Repast*—and later into the even more withdrawn portrait of the acrobat in *The Acrobat and the Young Harlequin* of 1905.[4]

Whereas *The Two Saltimbanques* of 1901 reveals a lack of experience, *The Frugal Repast* is a mature work in which the visual contact made by the female with the viewer emphasizes the blindness of her companion. The artist, whose "eyes were magnificent,"[5] was aware of his gift, which accentuated for him the plight of the sightless and made them the vessels of his own sense of disorientation as he struggled to establish himself in Paris. A mannerism of the late "Blue Period" works, the nearly absolute frontality of both bodies, shoulders hunched in the shivering cold of poverty, also introduces an element of Spanish character into the composition. With their heads slightly inclined to one side or in brave profile, the two figures take the ritual stance of the bullfighter who faces the bull with his entire body, turning his head in dignified, courageous respect as the bull passes. It is this Spanish attitude that seems to transform this otherwise piteous situation into one of self-reliance and determination.

Until he moved into the Bateau Lavoir in April 1904 Picasso had made only one attempt at printmaking. In Barcelona in 1899, under the direction of his friend Ricardo Canals, he had made one etching depicting a bullfighter.[6] In 1904 Canals was also in Paris, and it is quite possible that he brought to Picasso the zinc plate, already used by another artist for a landscape, upon which *The*

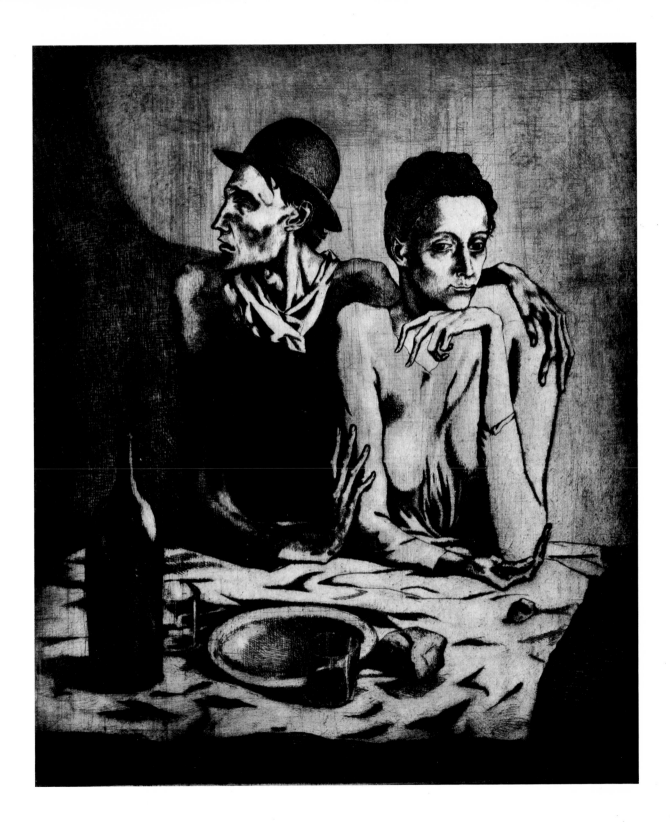

Frugal Repast was etched. It is more likely, however, that the plate for *The Frugal Repast* and those for fourteen other prints of 1905, some of which were done in time for an exhibition that opened in February 1905,[7] were from the shop of Eugène Delâtre, who printed the small editions of these prints for Clovis Sagot and Père Soulier.

The facility with which Picasso approaches new materials has always been cause for astonishment. Although only his second print, *The Frugal Repast* was a completely successful essay into the type of etching practiced in Paris at the turn of the century. While Delâtre was a specialist in color printing and could have taught Picasso the then popular color techniques, only one experimental proof in blue was taken of this major, late work of the Blue Period. Picasso did not involve himself in the complicated processes of color printing until the late 1930s.

The large edition of *The Frugal Repast* was printed from the steel-faced plate and published by Ambroise Vollard in 1913 together with thirteen prints of 1905 under the title *Les Saltimbanques*. Of the 1905 prints, the most ambitious is *Salome*. The figure of the portly *saltimbanque* seen in two other prints of the series and in the painting *Family of Saltimbanques* (p. 191:7) represents Herod, while Herodias, seated behind him, is the so-called "Woman of Majorca" seated in the right foreground of the same painting. Salome herself is an adolescent acrobat who may well have been the model for *Girl with a Basket of Flowers*.[8] *(Riva Castleman)*

MEDITATION. *Paris, late 1904. Watercolor and pen, 13⅜ x 10⅛ inches. (C&N, p. 191)*

Toward the end of 1904, the gloom of the preceding years began to dissipate, and the transition to the "Rose Period" was signaled by a pair of lyrical flower pictures and by a variation on a theme that would recur frequently in Picasso's later art: the sleeper watched.

One of the earliest appearances of this motif, *Sleeping Nude* (p. 191:6)—probably executed several months before *Meditation*—suffers from the fitful bathos of the Blue Period. There, the emaciated male onlooker seems bowed down by the awareness of his inability to know or possess the sleeping woman. He is psychologically turned in upon himself, and his isolation is intensified by his location within a dark mass that is utterly circumscribed and apart from the lighter area of the nude—the "gloom of the mind and the light of the body."[1] That to which the voyeuristic anti-hero of the *Sleeping Nude* can only aspire has obviously been experienced by the watcher in *Meditation*, whom we recognize immediately as Picasso himself. Picasso's thoughts are not turned inward to his own feelings; rather he contemplates the mystery of his new love. Though dressed in blue, he inhabits a world now warmed with red and yellow.

The sleeping woman of *Meditation*, who seems almost to emanate a light of her own, is Fernande Olivier.[2] She met Picasso in the latter part of 1904, became his mistress some months afterward and played a crucial role in the change of mood that led to the Rose Period in the first months of 1905. In her memoirs Fernande tells us that during her first years with Picasso he did all his painting late at night so as not to be interrupted. The nonmanneristic mode in which the artist limned her and himself points to direct experience rather than to imagination as the starting point for this image. One may speculate that the *Sleeping Nude* was executed hard upon his first encounter with Fernande—the nude being Picasso's projection of desire, and the bathetic male an exaggerated personification of his feelings of deprivation. *Meditation*, then, would celebrate the consummation of this first major love relationship of the painter's life.

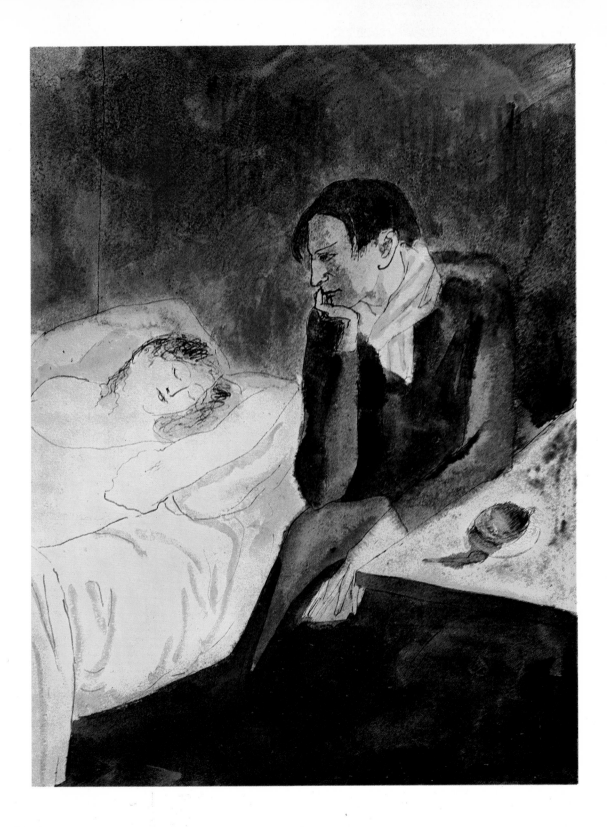

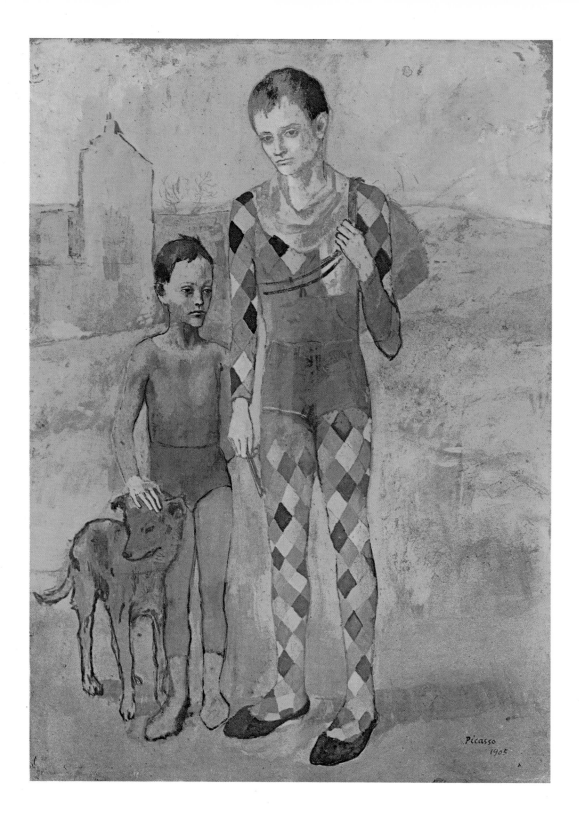

TWO ACROBATS WITH A DOG. *Paris, early 1905. Gouache on cardboard, 41½ x 29½ inches. (C&N, pp. 191–92)*

The "Rose Period" paintings of 1905 are less permeated with rose than those of the previous years had been with blue. Gray and pastel hues (including blue itself) play a significant role. And while the rose tonality generally intimates a happier state of mind, the figures in some transitional paintings done early in the year retain a melancholy characteristic of the Blue Period.

The charm of *Two Acrobats with a Dog* lies in the tenderness and fragility of its subjects—qualities reinforced by the delicate drawing and pale, elusive colors as, for instance, the umber tinted with rose of the ground. The declamatory and expressionist contouring of 1902–04 —when, as Apollinaire wrote, "pity made [Picasso] more violent"—has here given way to a relaxed and limpid line. The discontinuous outlines of the dog in particular mark a break with the summary silhouettes of the Blue Period.

The dog was probably modeled on a stray that Picasso adopted around this time. He has always loved animals and keeps them about. They play an especially important role in the imagery of the Rose Period, where dogs, monkeys, horses, crows and a goat are all cast as virtual members of the *saltimbanques'* families. *Family with a Crow* may well represent a transposition into the prevailing iconography of 1905 of the crow tamed by Margot, the daughter of the proprietor of the Montmartre café *Le Lapin Agile*, whom Picasso portrayed a year earlier fondling her pet.

Whereas Picasso's harlequins of 1901 evoke the commedia dell'arte—a world removed from the artist's immediate experience—those of the Rose Period largely resemble workaday circus performers in costume, and reflect the fact that in 1905 the artist spent far more time at the Cirque Médrano than in museums. Nevertheless, Picasso's return to the harlequin theme after a lapse of three years may well have been "sanctioned" by Cézanne, whose *Mardi Gras* he probably saw at the Salon d'Automne of 1904.

The two young acrobats in this picture are caught in a wistful moment—perhaps their band must move on to yet another town. "But who are . . . these wanderers . . . even a little more fleeting than we ourselves," wrote Rilke of the *Family of Saltimbanques* (p. 191:7), in which they reappear.[1] As wandering entertainers living in a community of their compeers on the margins of bour-

FAMILY WITH A CROW. *Paris, 1904–05. Crayon, pen and ink, 12⅞ x 9½ inches. (C&N, p. 193)*

geois society, the *saltimbanques* of the Rose Period are metaphors for the artist's own situation. But Picasso also painted the *saltimbanques* in the rehearsal or performance of their act, and this allusion to art-making inspired paintings of particular sureness and authority.[2]

Two Acrobats with a Dog must have been executed by mid-April 1905, as it is reproduced in *La Plume* of May 15. It represents a fusion of motifs summarily sketched out in the *Young Acrobat and Child* (p. 191:8) and *Boy with a Dog* (p. 191:9). The two boys reappear frequently in works of 1905, notably in the *Death of Harlequin*[3] and in the *Family of Saltimbanques*, in which the simpler and more sculptural treatment of their faces reflects the progress of Picasso's modeling toward the masklike visages of later 1906.

BOY LEADING A HORSE. *Paris, 1905–06. Oil on canvas, 86½ x 51¼ inches. (C&N, pp. 192–93)*

Late in 1905, Picasso began some studies of figures and horses, which at first reflected the ambience of the circus. Soon, however, the varied motifs combined in the artist's imagination to form an image that evoked a more remote world, pastoral and antique in spirit. The large work Picasso had in mind, *The Watering Place*, was never realized, though a gouache study for it exists (p. 192:10).[1] The monumental and superbly assured *Boy Leading a Horse* is a full-scale rendering of one of its central groups.

The classical, more sculptural turn that Picasso's art took late in 1905 was probably influenced by Cézanne, thirty-one of whose paintings had been exhibited in the Salon d'Automne of 1904 and ten more at that of 1905. The monumentality of the boy, whose determined stride possesses the earth, the elimination of anecdote, and the multiaccented, overlapping contouring all speak of the master of Aix.[2]

But Picasso had also been looking at Greek art in the Louvre, and under this influence he showed himself increasingly responsive to the kind of revelatory gesture that is the genius of classical sculpture. In the *Study for Boy Leading a Horse* in the Baltimore Museum of Art (p. 192:11), the youth directs the animal by placing his hand on its neck; but in later studies and in the final painting Picasso chose a gesture whose sheer authority—there are no reins—seems to compel the horse to follow. This "laureate gesture," as it has been called, draws attention by analogy to the power of the artist's hand.[3] Sculptures of idealized, striding male nudes were given as prizes to the winners of the ancient Olympics; that Picasso intended to allude to such laureates can be shown by tracing this very model back through *Girl on Horseback, and Boy* (p. 192:12) to *Boy with a Pipe* (p. 193:13), where his head is wreathed in flowers.

Picasso's interest in classicism at this time was probably stimulated by the views of Jean Moréas, a leader in the neoclassical literary movement that developed out of, but finally reacted against, Symbolism. Moréas was a regular, along with Apollinaire and Salmon, at the soirées that Picasso attended Tuesday evenings at the Closerie des Lilas. The painter's search for an antique image—as distinguished from his contemporary restatement of ancient themes such as the sleeper watched—may also have been stimulated by the painting of Puvis de Chavannes,[4] whose work was featured along with that of Cézanne in the Salon d'Automne of 1904. But in *Boy Leading a Horse* we see that Picasso's classical vision is imbued with a natural *areté* unvitiated by the nostalgia of Puvis' "rose-water Hellenism."[5]

In *Boy Leading a Horse* Picasso makes no concession to charm. The shift of emphasis from the sentimental to the plastic is heralded by a mutation of the Rose tonality into one of terra cotta and gray, which accords well with the sculpturelike character of the boy and horse. The pair is isolated in a kind of nonenvironment, which has been purged not only of anecdotal detail but of all cues to perspective space. The rear leg of the horse dissolves into the back plane of the picture, and the background is brought up close to the surface by the magnificent scumbling on the upper regions of the canvas.

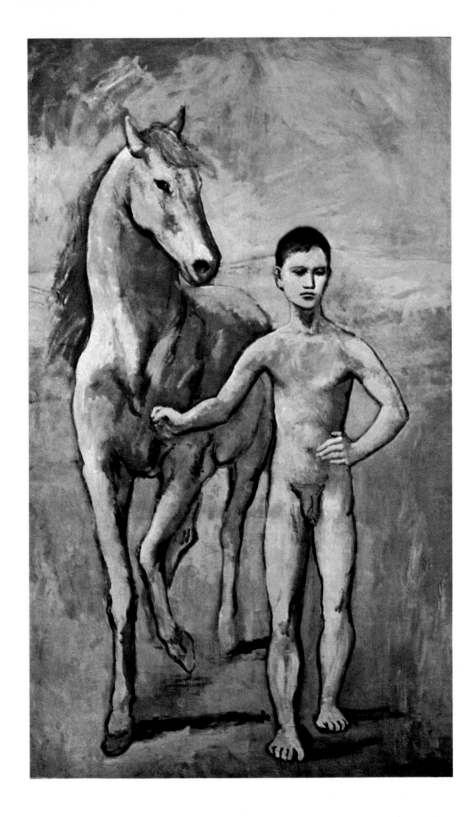

THE FLOWER GIRL. *Gosol, summer; or Paris, fall 1906. Pen and ink, 24⅛ x 19 inches. (C&N, p. 194)*

This drawing is a refined and stylized version of part of an earlier sketch (p. 194:15), probably executed in Gosol in the Spanish Pyrenees,[1] which depicted a girl accompanying a blind flower vendor. The physiognomy of the child, her long face and thin nose, are characteristic of the peasant types of that area. Picasso, who often worked from memory at this time, has stated, however, that the first sketch was not drawn from life.[2] The flower girl was later incorporated into the painting *Peasants and Oxen*, Paris, 1906 (p. 194:16). That canvas with its angular contours, broken planes, and distorted proportions reflects the style of El Greco, in which Picasso had taken a renewed interest during his Spanish sojourn and the months that followed.[3] *(Elaine L. Johnson)*

WOMAN COMBING HER HAIR. *Paris, late summer or fall 1906. Oil on canvas, 49⅜ x 35¾ inches. (C&N, pp. 194–95)*

From late spring 1906 until the cessation of work on *Les Demoiselles d'Avignon* about a year later, Picasso's style underwent a remarkable and increasingly rapid transformation. Like many pictures of the year in question, *Woman Combing Her Hair*, painted in Paris after his return from Gosol, combines elements marking different stages in his stylistic evolution. In certain Gosol works these stylistic disparities are visually wrenching, but here they are adjusted in a hierarchical arrangement that makes them easier for the eye to assimilate. The head, its planes relatively purged of visual incident, is the most abstract aspect of the figure, and the most sculptural; its style and facial type reflect Picasso's experience of ancient Iberian sculpture (p. 194:17,18),[1] which helped endow this painted image with more real sculptural plasticity than is to be found in the bronze of 1905–06 (p. 194:19) on which it was based. The torso is less stylized; its monumental but still fleshy contours are more softly, more intimately modeled, the blue-gray underpainting showing through its terra-cotta surface. Finally, the body dissolves into sketchily indicated drapery, comparable in painterly élan to the scumbled passages of *Boy Leading a Horse*. Thus, read from bottom to top, the picture recapitulates successive phases of Picasso's various manners during the first half of 1906.

The pose—a variant of one not uncommon in late nineteenth-century art—is handled so as to give the figure a feeling of maximum compression. And the stability of the configuration is enhanced by the virtual alignment of the upper arm and forearm with the frame, despite the fact that the pose itself would seem to suggest a more Mannerist turning of the body, as in the sketches (pp. 194:20, 195:21). The recollection of Archaic Greek *kouroi* in the striding posture notwithstanding, *Boy Leading a Horse* had been Classical in style and spirit. The treatment of the head in *Woman Combing Her Hair*, however, suggests that Picasso's interests were now reaching back to the pre-Classical.[2]

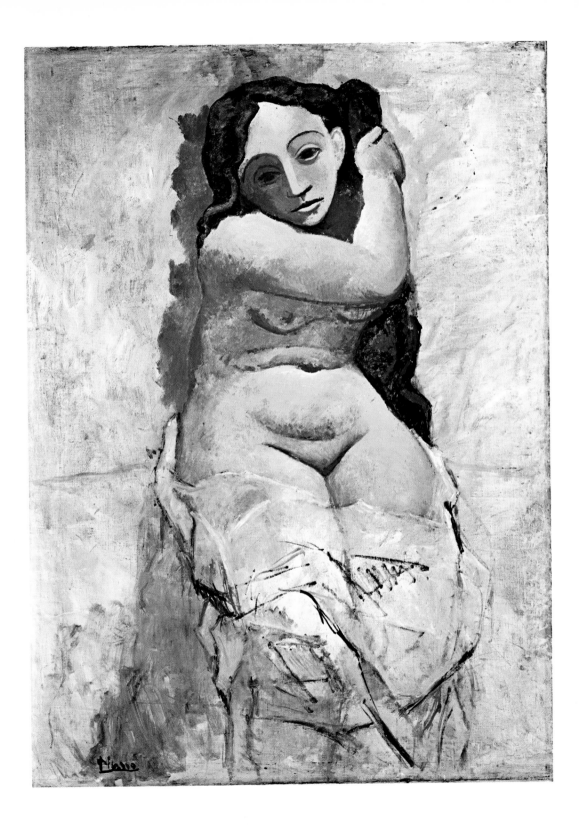

TWO NUDES. *Paris, fall 1906. Charcoal, 24⅜ x 18½ inches. (C&N, p. 195)*

TWO NUDES. *Paris, late fall 1906. Oil on canvas, 59⅝ x 36⅝ inches. (C&N, p. 195)*

Such vestiges of classical beauty and lyrical warmth as survived in *Woman Combing Her Hair* vanish entirely in these massive nudes. The stylization of the heads—especially the heavy-lidded, almost lozenge-shaped eye—and the squat proportions of the figures reflect the continued influence of Iberian sculpture. Indeed, the picture has been called "the culmination of the 'Iberian' phase."[1] But these bulbous, awkward and semihieratic nudes also

have a kinship with Cézanne, as we see him in such pictures as *Five Bathers* (p. 195:22), a type of composition that would continue to influence Picasso right into the earlier stages of *Les Demoiselles d'Avignon*.

As in Cézanne, the shading that models Picasso's nudes is not consistent with any outside source of light and thus seems a property of the monumental forms themselves. Such patterning of light and dark becomes increasingly autonomous—that is, independent of even the motif itself—as Picasso moves into and through Cubism.

Two Nudes is sculpturesque in a very specific and modern way, for despite the figures' insistent plasticity, they are modeled not in the round but in relief, and diminish to virtual flatness in a few passages. Notice, for example, that there is no shadow at the edge of the women's abdomens to bend the plane back into space. From now on, Picasso will tend to work increasingly within a shallow space—as closed off here in the back by drapery—in which the relief modeling suggests forms bulging toward the space of the spectator rather than retreating into a perspective space behind the picture plane.

As compared to its formulation in the study for *Two Nudes*, the figure on the right of the painting is in substantially the same posture save for the head (now turned in *profil perdu*) and the right leg, which has been set farther back so as to provide a more architecturally stable support for her massive trunk. In order to assure this support, Picasso has flattened the nude's feet and omitted the front contour of her lower right leg where it joins the foot—the latter decision demonstrating a now more radical willingness to sacrifice verisimilitude in favor of pictorial structure. The posture of the figure on the left of the study has been more obviously altered in the painting. Her right arm has been raised to enhance the almost mirror-image symmetry of the picture, and her left hand now parts a curtain—anticipating the motif of the nude on the extreme left of *Les Demoiselles*.

While *Two Nudes* is not "primitive" in the sense that the word might be applied to many paintings of 1907 and 1908, there is a simplicity and numbing rawness in the facture—particularly in the rough hatching on the arms and the scrubby brushwork of the background. Picasso first painted the figures in pink flesh tones (still visible in the feet and lower legs) but largely overpainted them with deeper terra cottas and red-browns that he no doubt found more consonant with the gravity—both physical and metaphoric—of his subjects.

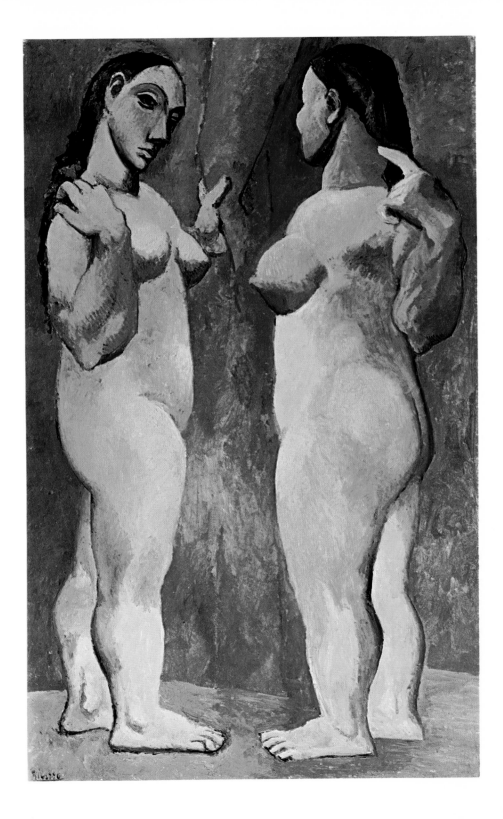

LES DEMOISELLES D'AVIGNON. *Paris, 1907. Oil on canvas, 8 feet by 7 feet 8 inches. (C&N, pp. 195–97)*

The resolution and culmination of Picasso's labors of 1906 is concentrated in one extraordinary picture, *Les Demoiselles d'Avignon*, which was painted for the most part in the spring of 1907 after months of development and revision. Zervos reproduces no less than 17 composition sketches for this canvas.[1] Of the three studies reproduced on page 196 the earliest suggests that the composition of *Les Demoiselles* was inspired by Cézanne's late bather pictures in which the figures and background are fused in a kind of relief without much indication either of deep space in the scene or of weight in the forms.[2] As the painting developed it is also possible that memories of El Greco's compact figure compositions and the angular highlights of his draperies, rocks and clouds may have confirmed the suggestions drawn from Cézanne.[3]

Each of the five figures in the final composition was the subject of considerable study, beginning in several cases in 1906 and continuing in "postscripts" long after the painting was finished. Although their bodies are fairly similar in style the heads of the two right-hand figures differ so much from the others that they will be considered separately.

What happened to Picasso's figure style in the months between the *Two Nudes* of late 1906 (p. 39) and the painting of *Les Demoiselles* may be summarized by comparing the left-hand figures in the two canvases—figures which are quite clearly related in pose and gesture.[4]

Obviously the painter has lost interest in the squat forms, the sculpturesque modeling and the naturalistic curves of the earlier nude. The later figure is drawn mostly with straight lines which form angular overlapping planes and there is scarcely any modeling so that the figure seems flat, almost weightless. The faces of the two figures differ less than their bodies. The mask-like character of the earlier face (p. 39) is carried further in the "demoiselle's" head and the eye is drawn in full view although the face is in profile.

This primitive or archaic convention seems more startling when applied to the noses of the central two figures of *Les Demoiselles* which are drawn in profile upon frontal faces, a device which later became a commonplace of cubism. The faces of the central two "demoiselles" may be compared with that of the transitional *Self-Portrait* (p. 197:27) in which the stylized features of

Iberian sculpture are not yet so exaggerated.

The right half or, more precisely, two-fifths of *Les Demoiselles d'Avignon* differs in character from the rest of the picture. The light browns, pinks and terra-cottas at the left are related to the colors of late 1906, the so-called Rose Period. But, toward the right, grey and then blue predominate with accents of green and orange. The planes too are smaller and sharper and much more active.

The most radical difference between the left and right sides of the painting lies in the heads of the two figures at the right. The upper head is no longer flat but foreshortened, with a flat-ridged nose, a sharp chin, a small oval mouth and deleted ears, all characteristic of certain African Negro masks of the French Congo[5] more than of Iberian sculptures. In the face below the tentative three-dimensional foreshortening of the upper and doubtless earlier head gives way to a flattened mask in which eyes, nose, mouth and ear are distorted or even dislocated. The hand and arm which support this lower head are even more violently distorted. Like their forms, the coloring and hatched shading of these two faces seem inspired in a general way by the masks of the Congo or Ivory Coast, more than by any other source.

Traditionally *Les Demoiselles d'Avignon* was indeed supposed to have been influenced by African Negro sculpture but Picasso has since denied this, affirming that although he was much interested in Iberian sculpture he had no knowledge of Negro art while he was at work on *Les Demoiselles*.[6] Only later in 1907, he states, did he discover Negro sculpture.

Quite recently however Picasso has assured us that the two right-hand figures of *Les Demoiselles* were completed some time after the rest of the composition.[7] It seems possible therefore that Picasso's memory is incomplete and that he may well have painted or repainted the astonishing heads of these figures *after* his discovery of African sculpture, just as only a year before, stimulated by Iberian sculpture, he had repainted the head of Gertrude Stein's portrait months after he had completed the rest of the picture.[8]

Whatever may have been their inspiration, these two heads for sheer expressionist violence and barbaric intensity surpass the most vehement inventions of the *fauves*. Indeed the shocking strangeness of the lower mask anticipates the "surrealist" faces in Picasso's paintings of twenty or thirty years later.

Yet in spite of the interest of these heads and the fame

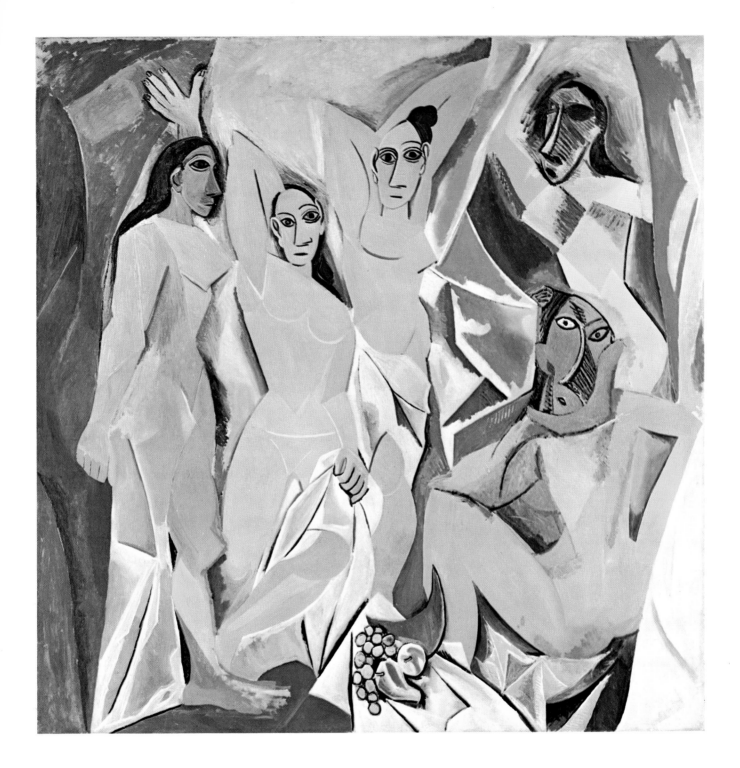

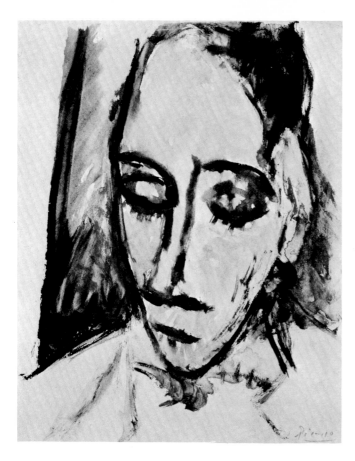

HEAD. *Paris, late 1906. Watercolor, 8⅞ x 6⅞ inches. (C&N, p. 198)*

figures, still life or drapery, into a semi-abstract all-over design of tilting shifting planes compressed into a shallow space is already cubism; cubism in a rudimentary stage, it is true, but closer to the developed early cubism of 1909 than are most of the intervening "Negro" works. *Les Demoiselles* is a transitional picture, a laboratory, or, better, a battlefield of trial and experiment; but it is also a work of formidable, dynamic power unsurpassed in European art of its time. Together with Matisse's *Joie de Vivre*[10] of the same year it marks the beginning of a new period in the history of modern art.

To judge from his work it was at Gosol in the summer of 1906 that Picasso first began to plan a large composition of nudes,[11] but none of these early attempts so closely anticipate *Les Demoiselles d'Avignon* as do certain bather groups of Cézanne which in drawing as well as arrangement inspired the earliest composition studies (p. 196:24, for example).

Picasso explained, in 1939, that the central figure of the early study is a sailor seated and surrounded by nude women, food and flowers. Entering this gay company from the left is a man with a skull in his hand. Picasso originally conceived the picture as a kind of *memento mori* allegory or charade though probably with no very fervid moral intent. Only the three figures at the right and the melons were retained in the final version.

Though its relation to actuality is remote this study recalls the origin of the painting's rather romantically troubador title, *"Les Demoiselles d'Avignon,"* which was invented years later by a friend of Picasso's in ironic reference to a cabaret or *maison publique* on the Carrer d'Avinyó (Avignon Street) in Barcelona.[12]

In a later study (p. 196:25) the sailor has given place to another nude. The figures are shorter in proportion, the format wider.

In the latest, perhaps final, study (p. 196:26) with only five instead of seven figures, the man entering at the left in the earlier studies has been changed into a female figure pulling back the curtain. In the painting itself this figure loses her squat proportions in harmony with other figures and the taller narrower format of the big canvas. All implications of a moralistic contrast between virtue (the man with the skull) and vice (the man surrounded by food and women) have been eliminated in favor of a purely formal figure composition, which as it develops becomes more and more dehumanized and abstract. *(Reprinted by permission of Alfred H. Barr, Jr.)*[13]

of the vividly painted fruit in the foreground, *Les Demoiselles d'Avignon* is more important as a whole than for its remarkable details. Although it was only once publicly exhibited in Europe, and was very rarely reproduced, the picture was seen by other artists in Picasso's studio[9] where its early date, originality, size and power gave it a legendary reputation which persisted after it had passed into the collection of Jacques Doucet about 1920.

Les Demoiselles d'Avignon may be called the first cubist picture, for the breaking up of natural forms, whether

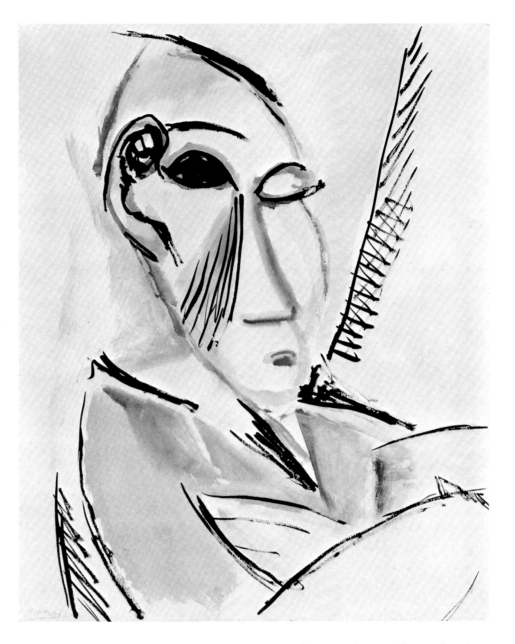

HEAD OF A MAN. *Paris, spring 1907. Watercolor, 23¾ x 18½ inches. (C&N, p. 198)*

Although the studies for *Les Demoiselles d'Avignon* are traditionally dated 1907, it is certain that the earliest—probably including *Head* (opposite)—date from the winter of 1906. By the time the *Head of a Man* was executed,[1] Picasso's conception of *Les Demoiselles* had considerably advanced; in his now firmer and more linear drawing, long striations were introduced to indicate shading—in the shadow of the nose, for instance, which has been displaced over the figure's right cheek. When this special form of hatching was later adapted to the two right-hand figures of *Les Demoiselles*—possibly with the scarification marks of African art in mind—the striations were brushed more assertively and the color became violent.

43

VASE OF FLOWERS. *Paris, fall 1907. Oil on canvas, 36¼ x 28¾ inches. (C&N, p. 199)*

The brilliant *Vase of Flowers*, probably painted soon after the right-hand figures of *Les Demoiselles*,[1] extends their vigorous linear hatchings into a system that governs the entire picture. But in keeping with the decorative motif, the colors (though still saturated) become less dissonant, and the striations (though still rectilinear) more contained. The directness of the facture is echoed in the simple, almost centralized composition: the vase is situated so that its lip is at the apex of the triangle formed by the table's orthogonals; the fireplace and fern at the left are balanced at the right by the masonry of a large chimney from which hang some of the artist's long-stemmed, gambier pipes.[2] The centrality is also enhanced by the presence in the bouquet of flowers of remote, tertiary hues that appear nowhere else in the composition. Along with green and blue, the stylized blossoms are realized in lavender, rose, pink, purple and fuschia, all of which contrast with the bluntness of the near-primary yellow and blue and the Indian red of the remainder of the picture.

Although Picasso had drawn with short, sticklike strokes of color as early as in the *Self-Portrait* of 1901, their reappearance in 1907 suggests study of the ribbed patterns of copper-covered guardian figures from the Bakota, Gabon[3] (p. 198:30), and possibly also of the veining of leaves, as reflected in certain of the drawings Picasso executed about that time[4] (p. 198:31). Striated hatching is a visual convention, a group of linear signs on a flat surface signifying the shading of forms in relief. Its advantage for the modern painter is that unlike graduated modeling, it does not necessarily lead to an illusion of volume; as used in *Vase of Flowers*, the "sticks" of color flatten the schematic forms so that they can be better assimilated to the two-dimensional surface of the support. This is the aim, too, of the marked tilting of the tabletop toward the picture plane—a practice explored by Cézanne.

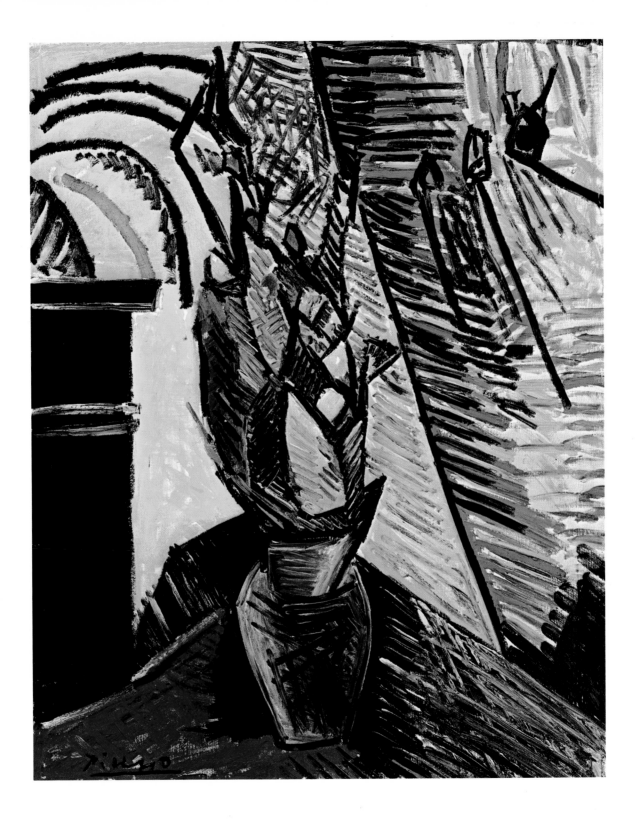

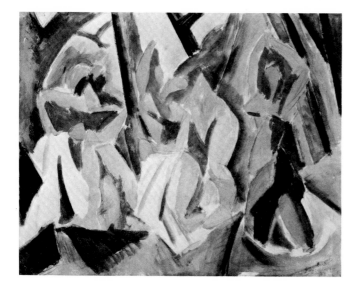

BATHERS IN A FOREST. *1908. Watercolor and pencil on paper over canvas, 18¾ x 23⅛ inches. (C&N, p. 199)*

REPOSE. *Paris, spring or early summer 1908. Oil on canvas, 32 x 25¾ inches. (C&N, p. 200)*

During the winter of 1907 and throughout 1908 Picasso's art ceased to follow the clear line of development that characterized it in the years leading to *Les Demoiselles.* That picture had left so many unanswered questions and

posited so many new possibilities that Picasso naturally returned to it as a point of departure—though never literally—for some time after abandoning it. To the extent that it is possible to generalize in regard to his style during the complicated year that followed *Les Demoiselles, Repose* marks a stage roughly midway between the "African" postscripts of the great painting and the re-emergence of Cézanne's influence in the work of the late summer and early autumn of 1908.

Repose is a reworking of the upper half of the motif of a large canvas titled *Seated Woman* (p. 200:35) which was executed in the first months of 1908. In the latter canvas the nude is seated on what appears to be the edge of a bed; she has dozed off with her head resting on her right hand and her right elbow propped on her lap. The picture's vigorous shading is contained within heavy black contour lines and realized with the striations that go back to the right-hand figures of *Les Demoiselles,* except that contrasting, saturated color has given way to monochromy.

Why did Picasso return to the *Seated Woman* and make a new version of its upper half? Perhaps he was dissatisfied with the head and bust of the figure, which, to be sure, are less successfully defined than the rest. In any event, he effected a number of subtle changes in his second version. In *Repose* the tilt of the head is less acute, and it is turned slightly more into a three-quarter view, away from the picture plane. The black contouring has been simplified and made less vehement; it no longer tends to isolate so strongly the planes of the arms and chest. Moreover, the coalescence of the planes is fostered by the substitution of thinly brushed shading for the impasto striations of the earlier picture. That shading is, in turn, allowed to model planes in relief.

The influence of the primitive abides in *Repose*—but it is more assimilated, more generalized and, hence, less manifest than in the paintings of late 1907. The barbaric energy of those earlier figures has been contained—transmuted from an active into a passive state—and their violent contours have given way to a linear network that adumbrates the scaffoldings of Analytic Cubism. The manner in which Picasso has framed this figure, bringing her monumental form close up to the picture plane where she fills the space of the canvas almost to crowding, endows her with a sense of immense if dormant power, virtually Michelangelesque in scale (one thinks of the personification of *Night* in the Medici Chapel).

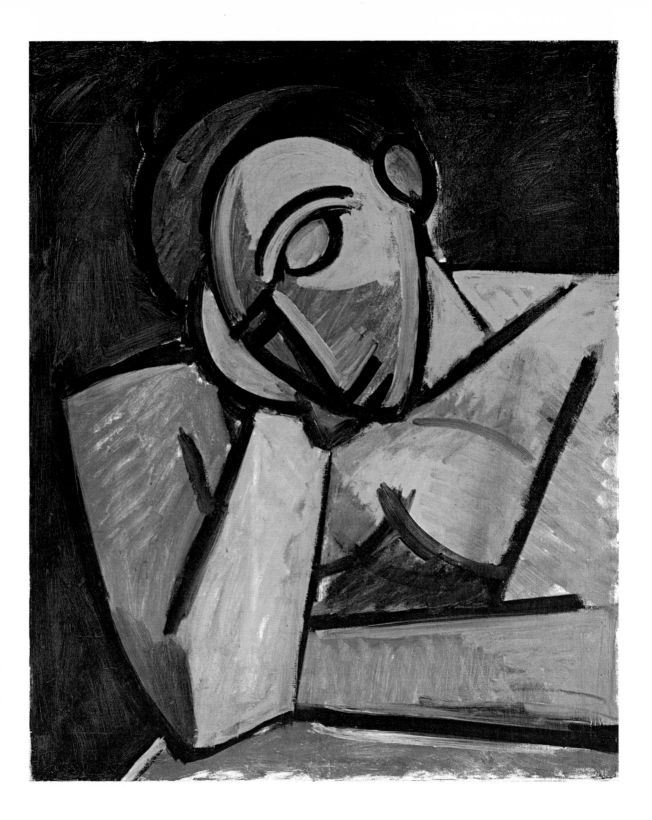

FRUIT AND GLASS. *Paris, summer 1908. Tempera on wood panel, 10⅝ x 8⅜ inches. (C&N, p. 200)*

Given the fluctuations of Picasso's style in 1908, this superb little still life is difficult to place securely. Zervos (II, part 1, 123) assigned it to the last months of the year, hence after the paintings executed at La Rue des Bois, a village not far from Paris where Picasso stayed for a number of weeks beginning late in August. Picasso is not sure, but believes it was executed before his departure. The probable accuracy of his recollection is supported by the modeling of the fruit, which is similar in style to that of *Pears and Apples* (p. 200:36), a painting that Zervos himself placed in the summer months. In the landscapes of La Rue des Bois, Picasso was to explore the Cézannian technique of *passage* (see below, p. 50). The appreciation of Cézanne in *Fruit and Glass* is of a different order, focusing not on *passage*—the silhouettes here are unbroken—but on relief modeling, sophisticated analogies between forms, and finely tuned adjustments in their placement.

The prestige of Cézanne had never been higher than in the year following his large memorial retrospective of October 1907. At the time of that exhibition, the *Mercure de France* had published Cézanne's letters to Emile Bernard, one of which contained his admonition to "treat nature in terms of the cylinder, the sphere, the cone, all placed in perspective, so that each side of an object or plane is directed toward a central point." This famous passage was later to be considered by many, including certain minor Cubist painters, as both a sanction for Cubism and a program for its style—which they took to be essentially an extension of Cézanne's work.

But Cubism, despite its immense debt to Cézanne, is far from being simply a further development of his art. On the contrary, it represented in some fundamental ways a rejection of his methods—as, for instance, in the primacy it gave the conceptual over the perceptual. Moreover, no one who looks carefully at Cézanne's painting can believe that his instructions in the letter to Bernard have any connection with his own work. Illusions of integral three-dimensional forms such as cylinders, spheres or cones are no more to be found in his paintings —so utterly devoid of modeling in the round and closed contouring—than is the classical perspective he mentions.[1]

Fortunately, Picasso looked to Cézanne's paintings rather than his letters (which in any case contain many observations directly at odds with the unfortunate prescription he gave Bernard). He must have recognized that Cézanne's genius lay in his resolution of the disparity between the Old Master picture, its forms modeled in the round within a context of deep perspective space, and the type of "flat" modern picture which Manet had initiated (and which Gauguin, Matisse, Mondrian and others were to advance in different ways). Cézanne's was a middle-ground solution that maintained the emphatic planarity of the modern picture while reinstating the illusion of sculptural relief, which the Impressionists had dissolved. This he achieved by modeling, in effect, only the fronts of objects, thus turning the picture into a simulacrum of a bas-relief; his objects never appear to have backs, nor do they create the illusion of space behind them. It was in terms of such an accommodation of modeled forms to the two-dimensional surface, and their disposition in sequential groupings, that Cézanne seems to have interested Picasso in *Fruit and Glass*; his influence is specifically felt in the high viewpoint and the common contour of the goblet and pear.

Nevertheless, *Fruit and Glass* looks very little like a Cézanne. Absent are Cézanne's subtle inflections of color, natural light and overlapping, polyphonic contours. Rather, Picasso's still life seems to temper the sophistication of Cézanne with the simplicity of Henri Rousseau. Around the time of this picture Picasso had come upon one of the latter's paintings in the second-hand shop of Père Soulier, and his purchase of it was later celebrated at a banquet for Rousseau in Picasso's studio. While Rousseau returned Picasso's admiration for his work (he characterized Picasso as the greatest artist of the day "in the Egyptian style"), he considered Cézanne inferior to such salon heroes as Bouguereau, whose painting he judged, like his own, to be "in the modern style." Of Cézanne's pictures he said: "I could finish them."

LANDSCAPE. *La Rue des Bois, fall 1908. Oil on canvas, 39⅝ x 32 inches. (C&N, pp. 200–201)*

Like most pictures executed at La Rue des Bois,[1] *Landscape* is free of African influences. And while the simplified houses and trees may owe something to Rousseau, Picasso's reduction to these quintessential notations also followed naturally from his conceptual approach to painting ("I paint objects as I think them, not as I see them").

On the other hand, close study shows *Landscape* to be a less compartmentalized composition than those that preceded or followed the stay at La Rue des Bois. And the way the discreteness of the planes of objects is modified in favor of interpenetration—at least in certain passages—reflects Picasso's continuing interest in Cézanne. This interest was probably more focused now on the latter's landscapes than on his Bathers, and it may also be symptomatic that for the first time in over two years, Picasso was once again painting from nature—at least in part.

Painting from a mental image unencumbered by the actualities and details of the visual field had allowed Picasso more readily to synthesize his compositions between 1906 and 1908, and to push them toward fantasy and abstraction. It is not by accident that his interest in Cézanne during those years focused primarily on the Bathers, for those were the most conceptual and synthetic pictures in the older painter's oeuvre. While Cézanne made much of painting before the motif, his Bathers were conceived from imagination, memory, photographs and art (mostly his own earlier drawings and paintings); they were distinguished by their more schematic, sequential compositions, their generally less colorful and often monochromatic palette, and their more radical reductions or deformations of the human figure. If Cézanne's art was usually poised between the conflicting requirements of fidelity to nature and of two-dimensional pictorial structure, then the Bathers were those of his pictures in which the balance weighed most heavily on the side of autonomous esthetic construction.

However, the stylistic trait common to all Cézanne's mature painting is *passage*, and it is to *passage* that Picasso—who had used it in a rough and rudimentary way in the blue drapery of *Les Demoiselles*—began to address himself at La Rue des Bois. Cézanne's contours were rarely closed; there was usually some point at which the planes of an object bled into or elided with one another and with those of objects contiguous on the flat surface—though these neighboring forms might represent objects at very different levels of depth in the visual field. This technique not only subordinated the integrity of individual forms to the fabric of the composition as a whole, but enabled and invited the eye to *pass* uninterruptedly from plane to plane through the whole space of the picture. In *Landscape*, the way the right branch of the central tree dissolves, or melds, into the plane of the earth near the horizon line is an elementary example of *passage*. The following summer at Horta de San Juan, Picasso would multiply instances of such elision in what were his first fully developed Cubist pictures (p. 57).

Landscape shows Picasso's exploration of other Cézannian techniques. With the high viewpoint tilting the forms closer to the picture plane, he was at pains to multiply nexuses where the contours of planes moving at different angles, and on different levels of depth, might touch on the surface of the canvas—as in the corner of the roof. There, the passage of a branch of the tree over the point at which four other planes meet is marked by a change to a darker value.

Cézanne's color originated in perception, and was part of his heritage from Impressionism. (Thus, the conceptual character of the Bathers may explain their limited color.) Generally he modeled or, as frequently was the case, modulated his planes through changes of hue as well as value. In focusing on the structural aspects of Cézanne, Picasso eliminated color, preferring to reduce the problem of modeling to the more conceptual terms of light and dark. Indeed, since 1901 Picasso had worked mostly in manners that approached monochromy, and when he juxtaposed bright colors, as in *Les Demoiselles* or the *Vase of Flowers*, he never modulated them (though he might roughly shade them by overpainting a wet, local color with black). At La Rue des Bois, however, Picasso began increasingly to modulate the individual planes, though still within a monochromatic context—one in which the greens of the landscape displaced the browns of the previous months' painting. These greens, which recall to some extent the coloring of Rousseau's landscapes, were no doubt suggested by the rich foliage of the countryside near Paris. Picasso actually preferred the drier, sparer landscape of Provence and Spain; while painting years later in the Ile-de-France, he would complain of "green indigestion."

BUST OF A MAN. *Paris, fall 1908. Oil on canvas, 36¼ x 28⅞ inches. (C&N, p. 201)*

Picasso always tended to innovate radically while on summer sojourns outside Paris where he was free of the influences and opinions of his milieu and able to concentrate more uninterruptedly on his art. The stay in Gosol in 1906 saw the establishment of the Iberian style. And while there is no firm record of Picasso's having left Paris in the summer of 1907, the one indication that he did leave briefly[1] suggests that he repainted the radically different right-hand figures of *Les Demoiselles* just after returning (in a repetition of the pattern set when he repainted the face of Gertrude Stein's portrait upon his return from Gosol). The vacation at La Rue des Bois in 1908 witnessed a new kind of Cézannism, and in the summer of the following year at Horta de San Juan, Picasso fully confirmed his Cubist style.

The concentration Picasso maintained in his work during these holidays rarely lasted much beyond his homecoming to Paris. Not surprisingly, when he returned from La Rue des Bois in autumn 1908, his work seems to have undergone a détente. With the isolation he and Fernande had enjoyed there now gone, and the countryside replaced by the city, the Cézannian impulse diminished temporarily, and the African and Iberian influences embodied here in *Bust of a Man* reasserted themselves—this time in autumnal deep oranges and rusts. The highly stylized head revives the almost lozenge-shaped Iberian eyes, but in a manner equally reminiscent of certain African masks; this eye form is then repeated as the mouth, all three shapes being rimmed in bright orange. Such interchangeability of shorthand physiognomic symbols, characteristic of African art rather than Iberian sculpture, would recur later in the schematic heads of 1913 and, in quite another spirit, in the Surrealist-oriented paintings of the later twenties and thirties.

Picasso found African art *"raisonnable,"* by which he meant that despite its distortions of reality it had a rationality and logic of its own. And though the degree of its conceptual basis (as opposed to its basis in observation) has often been exaggerated,[2] it is certainly with this abstract aspect of African art that Picasso felt his deepest affinity. Still, the qualities that give *Bust of a Man* its unique character are those that most distinguish it from primitive art. Whereas the latter's symmetry and stasis speak of the operation of timeless and impersonal laws, the tilted axis of Picasso's head, combined with the asymmetry of its silhouette, bring to the face a sense of strain and disturbance that is of the moment. In this context the analogizing of the mouth and eyes does not lead to the generalized anonymity of African art, but rather endows the visage with a haunted, almost expressionist cast.

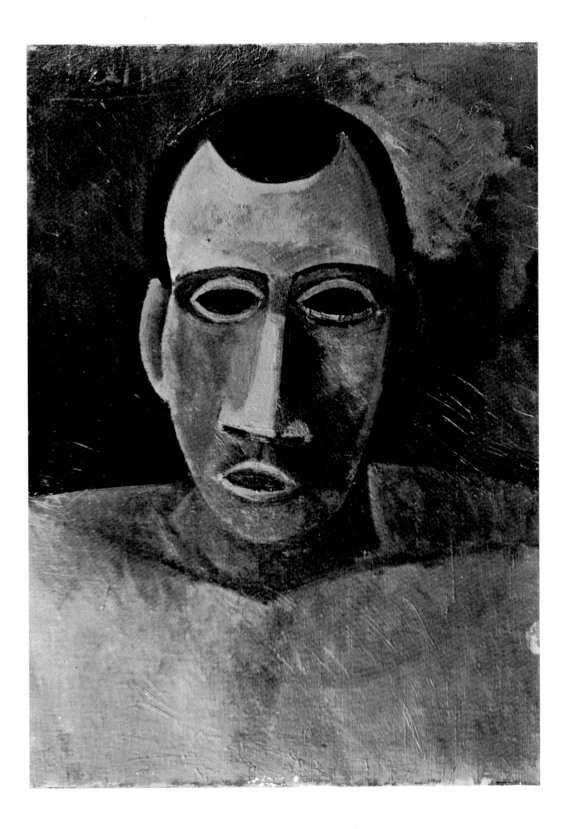

SHEET OF STUDIES. *Late 1908. Brush, pen and ink, 12⅝ x 19½ inches. (C&N, p. 201)*

FRUIT DISH. *Paris, early spring 1909. Oil on canvas, 29¼ x 24 inches. (C&N, p. 201)*

Although at least one sketch for the motif of *Fruit Dish* goes back to late 1908 (p. 201:37), the painting itself was probably executed toward the spring of 1909,[1] a few months after the related *Vase, Gourd and Fruit on a Table* (p. 201:38), which Leo Stein lent to the Armory Show in 1913. (The latter picture's silvery green tonality, its less firm contouring, and less bold sculptural relief link it to the style of the La Rue des Bois *Landscape* of autumn, which was also in the Stein collection.) In *Fruit Dish*, Picasso treats the crumpled tablecloth in a Cézannian manner, and adopts an even higher horizon line than in *Vase, Gourd and Fruit on a Table*; but the picture's most noteworthy feature is the deployment of individual —hence contradictory—perspectives for different objects. One sees more of the stem and side of the fruit bowl than is consistent with the high viewpoint established by the

tabletop; and by the same token the gourd is represented as if at eye level.[2]

The fruit bowl itself, with its undulating floral rim, does not appear in any other painting, although the simpler and more familiar bowl in *Fruit Bowl, Fruits and Glass* (Zervos II, part 1, 124), a picture of the same period, may be its original model. Picasso has confirmed that the art nouveau goblet juxtaposed with the compotier in the *Sheet of Studies* is the source of the undulating rim with which he redesigned his ordinary compotier in the form in which it appears on the right of the sheet and in the painting.[3] The *Sheet of Studies* probably dates from late 1908, as it might logically be placed earlier than the fully developed, dated crayon drawing of the motif (p. 201:37).

Between the time of the preliminary sketch on the right of the *Sheet of Studies* and that of the crayon drawing, the motif acquired a tablecloth which obscures, in a Cézannian manner, the transition from the vertical plane to that of the horizontal tabletop. The studies show the table from the long side, but the painting depicts the still life from the left-hand short side of the table, which swings the tablecloth around to the right of the composition. This is the view Picasso seems to have begun exploring on the lower left of the *Sheet of Studies*.

54

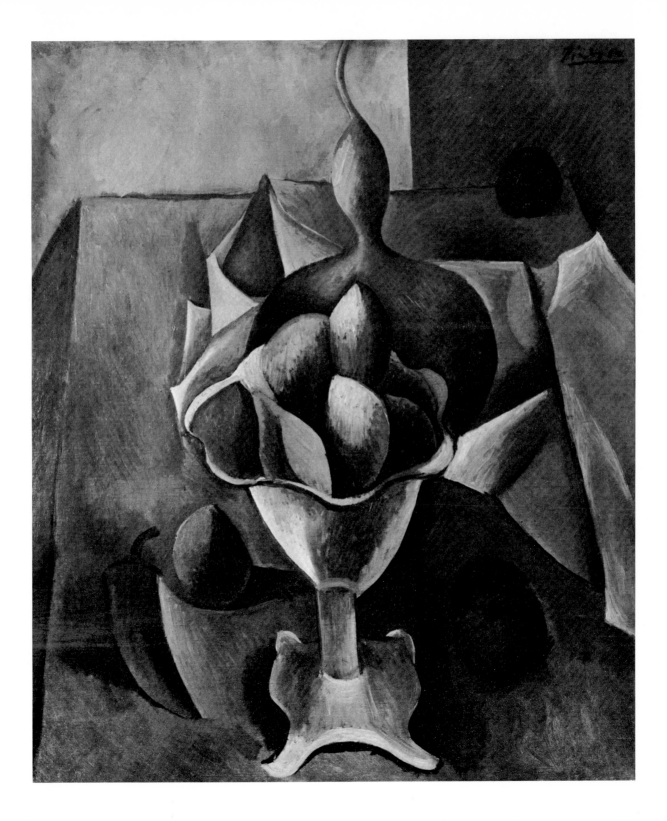

THE RESERVOIR, HORTA. *Horta de San Juan, summer 1909. Oil on canvas, 23¾ x 19¾ inches. (C&N, p. 202)*

The summer of 1909, which Picasso spent with Fernande in Horta de San Juan (then known familiarly as Horta de Ebro), was the most crucial and productive vacation of his career. There, in the pellucid Mediterranean light of his native Spain, he distilled from the materials he had been exploring during the previous two years his first fully defined statement of Analytic Cubism. The stucco houses of the Spanish hill town especially appealed to Picasso (who, in addition to making an unusual number of sketches of them, took some photographs which he mailed to Gertrude and Leo Stein, p. 202:39). Their geometrical forms provided the simple motifs that Picasso used in his earliest paintings at Horta to clarify his structural ideas (much as Braque had used somewhat comparable architectural motifs a year earlier for those pictures that gave Cubism its name).[1] Picasso's photograph shows that the houses of Horta were then somewhat widely spaced, and indeed they so appear in another painting of the town (p. 202:40). The remarkable pyramidal configuration of interlocking houses in *The Reservoir* results partly from the perspective chosen by Picasso (looking diagonally across and upward from the so-called reservoir in the lower left of the photo, he told the author), but obviously derives much more from invention than nature.

The Reservoir is a paradigm of early, sculptural Analytical Cubism (even as its pyramidal configuration of verticals and horizontals anticipates the characteristic scaffolding of the more abstract, painterly Cubism of 1911–12). The word "sculptural" in this context does not refer, however, to illusions of forms modeled in the round, as the misnomer Cubism would imply. Rather, it suggests the kind of relief modeling—here, ocher for the lights, gray for the shadows—through which the structure of the composition moves stepwise downward and outward toward the spectator from a back plane that effectively closes the space. Even the "reservoir" itself—it was actually a masonry *abreuvoir*—fails to interrupt or punch a visual hole in this monumental fabric. Except for some accents of green that relieve the parchedness of the scene (occasioned, the artist recalls, by a scum that covered part of the water's surface[2]), the reflected patterns in the *abreuvoir* are continuous in character and texture with the planar forms around them.

In order that the eye might pass in a smooth but controlled way through the picture, Picasso effected numerous refinements in the painting as over and against its sketch (p. 202:41). For instance, he has aligned the sunny side of the "tower" so that its width is exactly that of the roof of the second highest building, into which it passes as if the neighboring ocher and gray were different planes of the same structure; he has adjusted the line that divides the light and shadow of the tower to continue downward through three other buildings, almost to the middle of the picture; and he has continued the left contour of the building that frames the composition in the right foreground from the bottom of the canvas to the top of the silhouette of the town.

The technique of *passage*, grasped in *The Reservoir* with a conceptual clarity that distinguishes it from its intuitive Cézannian origins, is omnipresent. In the case of the house in the middle, for example, the shaded wall elides with a diagonal plane diving downward to the left of the door; the sunlit wall spills into the plane below in a comparable manner; and the ocher plane of its gabled roof is continuous with that of the upper wall of the house to its left, while on the right the roof plane bleeds into that of the wall behind it.

These elisions provoke ambiguities as to the angles of the planes, which counterpoint the ambiguity produced by the "reverse perspective," most noticeable in the gabled roof (in front, and just to the right, of the shady side of the tower) whose orthogonals converge toward rather than away from the spectator. This effect is clearly a conscious addition to the painting, for in the drawing—and presumably in actual fact—the gable in question was disposed laterally. Such inside-out perspective is a logical coefficient of a style that gives the illusion of sculptural relief from a flat plane toward the spectator—as opposed to traditional illusionism in which objects move back from the picture plane to a vanishing point at infinity.

Picasso realized that for complete control of the surface he could not afford to isolate his sculptural mass against an unarticulated sky, but would have to ease it into that back plane by assimilating the sky to the patterning of the picture as a whole. The practice of extending the articulation and color of the landscape into the sky was familiar to Picasso from Cézanne's late versions of Mt. Ste.-Victoire. The very first landscape Picasso executed at Horta (p. 202:42) is a view of a mountain that rises above the houses in the center of the composition;

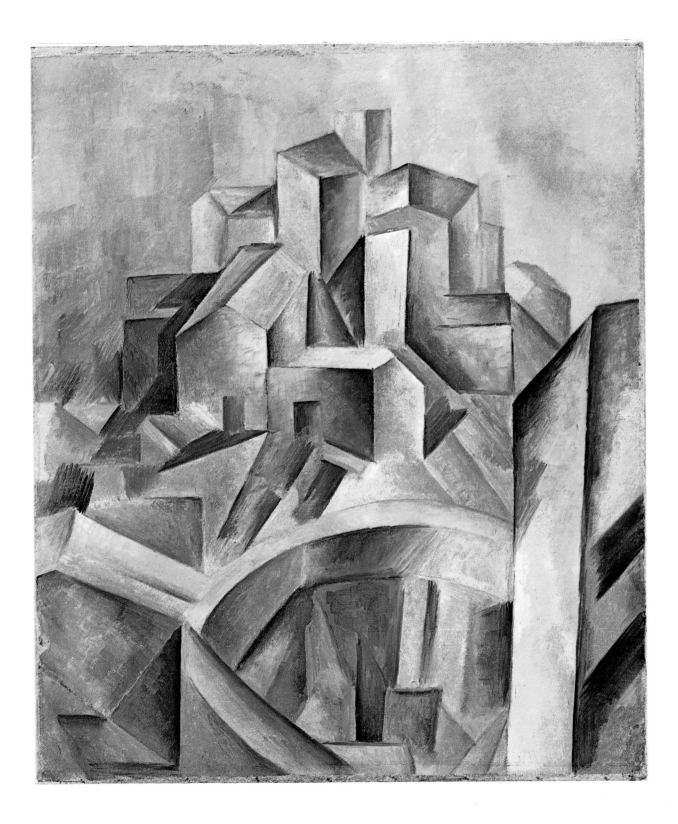

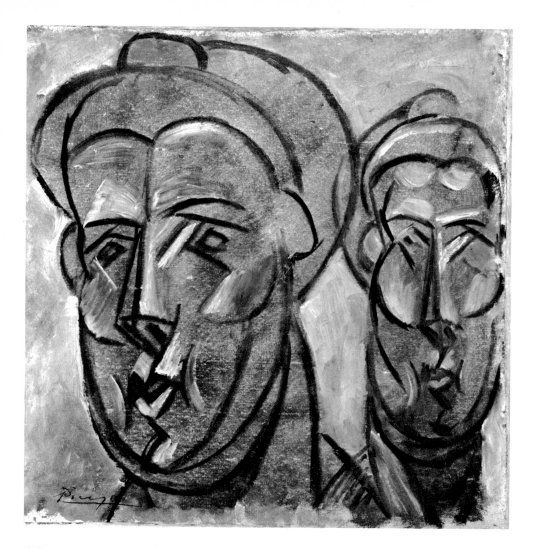

delicate value changes in the sky echo this pyramidal shape in a Cézannian way, suggesting distant mountains. In *The Reservoir* the problem was more difficult since the sky had to respond to an architectural patterning of verticals and horizontals. Nevertheless, close scrutiny of the sky on the left shows that through delicate value shifts in the blue-gray, Picasso has tentatively carried the geometrical patterning toward the top of the picture. Concomitantly, he has so brushed the houses in the middle left that they dissolve into one another and finally into the sky in a painterly manner. These are the first intimations of that dissolution or "fading" near the margins that would become fundamental to the esthetic of high Analytic Cubism.

TWO HEADS. *Horta de San Juan, summer 1909. Oil on canvas, 13¾ x 13¼ inches. (C&N, p. 203)*

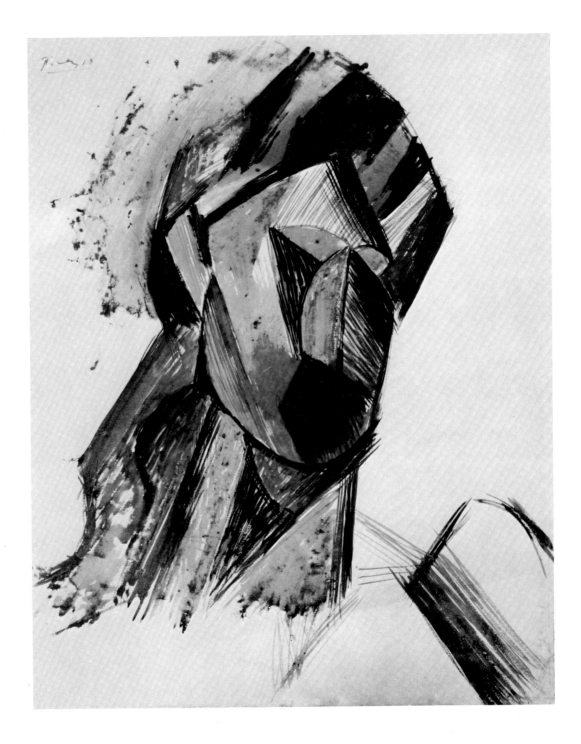

HEAD. *Spring 1909. Gouache, 24 x 18 inches. (C&N, p. 202)*

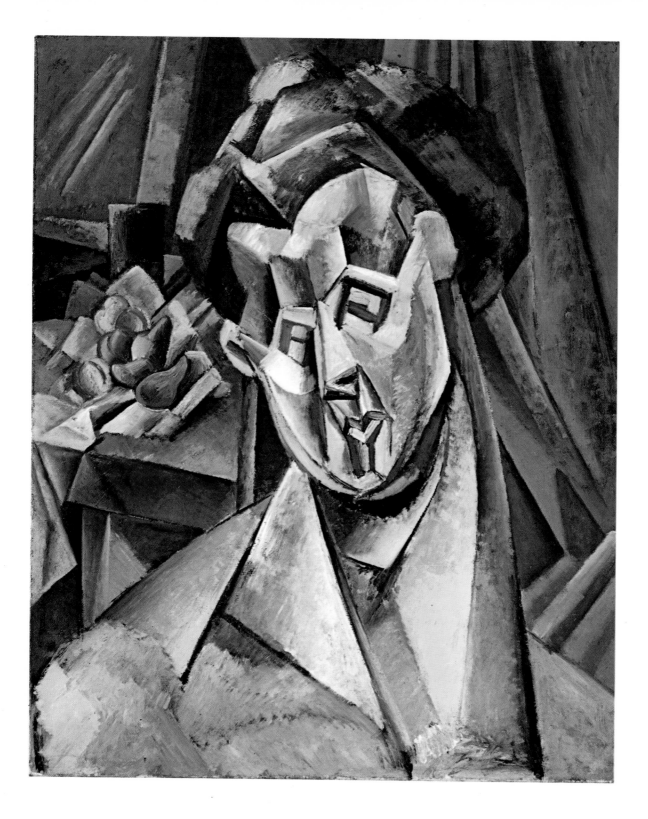

WOMAN WITH PEARS. *Horta de San Juan, summer 1909.*
Oil on canvas, 36¼ x 28⅞ inches. (C&N, p. 203)

Woman with Pears, the finest of many busts of Fernande
executed at Horta, shows Picasso's Cubism at a more ad-
vanced stage than *The Reservoir*: the shading is more
graduated, the elisions are less abrupt, and in passages
such as the head, the surface has been divided or "ana-
lyzed" into smaller and more complexly related planar
units. Although the fruit retains its round forms, the
contours of the figure and drapery have become largely
angular—Fernande's eyes in particular having been radi-
cally geometricized. The still life to the left behind the
figure is drawn toward the picture plane by the affinities
of its drapery pattern with the faceting of Fernande's
face, and by the manner in which the orthogonal of the
table's right side is locked between her ear and shoulder,
where it reads vertically.

To forestall any tendency to read the sculptural aspects
of the figure in the round, and simultaneously to possess
more of it than would be consistent with a single point
of view, Picasso has pulled the shoulders, the ears and the
back of the neck around toward the picture plane. The
shaded dark ocher and gray vertical plane that descends
below Fernande's left ear, and which represents a part of
her neck that would not normally be visible, has been
swung into a position where it mediates in value and
form between her predominantly ocher bust and the
green and gray drapery to the right, while the ocher
triangles of the side of her neck provide a firm architec-
tural support for her monumental head.

WOMAN'S HEAD. *Paris, fall 1909. Bronze, 16¼ inches*
high. (C&N, p. 203)

The bronze *Woman's Head* is also Fernande, and was
modeled in Paris sometime after Picasso's return from
Horta. It is conceived less with a feeling for modeling
from an a priori sculptural mass than as if it derived from
the bas-relief surface of one of the paintings' having been
rotated through 360 degrees. The Cubist stylization to
which it has been submitted does not obscure the work's
direct continuity with nineteenth-century sculpture.

"This is Rodin's art 'of the hollow and the lump,' with
the lumps sharpened between the increased hollows."[1] It
does not constitute a break with the past comparable to
that represented by the Cubist painting which inspired it.
Picasso no doubt realized that Analytic Cubism, even be-
fore its modeling dissolved into painterly effects, was
essentially a pictorial rather than a sculptural art—which
may explain why this line of investigation all but ends
with *Woman's Head*.[2] Only around 1912 would Picasso
return to sculpture, but then it was in the form of open-
work, planar constructions.

61

STILL LIFE WITH LIQUEUR BOTTLE. *Horta de San Juan, late summer 1909. Oil on canvas, 32⅛ x 25¾ inches. (C&N, p. 204)*

Still Life with Liqueur Bottle is the only still life known to date from Picasso's stay at Horta, which lasted—with intervals—from May until September, and it was one of the last paintings he executed there.[1] It shows how much Picasso's art had developed in the several months following the painting of *The Reservoir*. Here the surface is diced into small facet planes whose staccato elisions define a shallow space closed by the drapery behind. The effect is prismatic—recalling the faceting of certain late Cézannes—and the composition moves down and outward to its greatest relief at the lower center.

So abstract is Picasso's "analysis" of the motif that the reading of *Still Life with Liqueur Bottle* is not easy. For some years it was known erroneously as *Still Life with Siphon*, and was subsequently mislabeled *Still Life with Tube of Paint*.[2] To clarify it for the author, Picasso sketched some of its motifs (p. 204:46).[3] The object in the center turns out to be a large ceramic *botijo* in the form of a cock. (Another such *botijo* is held by a woman at the fountain in print No. 81 of the *Suite 347*, p. 204:48.) Wine was poured into the ceramic through the tail of the cock and was drunk from a spout in its head. The handle at the top was, in fact, round—as shown in Picasso's sketch; but it was rendered as an angular form to coalesce better with the diced planes of the painting. To the right of the *botijo* are the gray planes of a newspaper to which Picasso subscribed; it is still folded for mailing and has an address wrapper around the middle. Sandwiched between the *botijo* and the newspaper is a glass containing a straw, while below and to the left of the *botijo* are two decorative liqueur bottles, the multifaceted surface of the larger being distinctive to the Spanish anisette, Anis del Mono.

Green, which had been merely an accent among the earth colors of *The Reservoir* (though it played a more important role in *Woman with Pears*), is here the dominant tone, sometimes warmed with ocher but more often cooled with a metallic gray that emphasizes the inorganic aspects of the motif. The dull orange neck of the faience *botijo* is an unusual color accent in the work of this period, for though Picasso had tried a number of times to build passages of even stronger color into Analytic Cubist pictures, he almost always ended by painting them out. Color juxtaposition, as opposed to monochromy, involved systems at odds with the chiaroscuro modeling basic to Analytic Cubism. Only small and unsaturated accents of brighter colors could be absorbed into its shaded browns, greens, tans and grays. Substantial use of color did not occur until 1912–13 with the transformation of Cubism from an art of sculptural relief into one of flat, unmodeled planes.

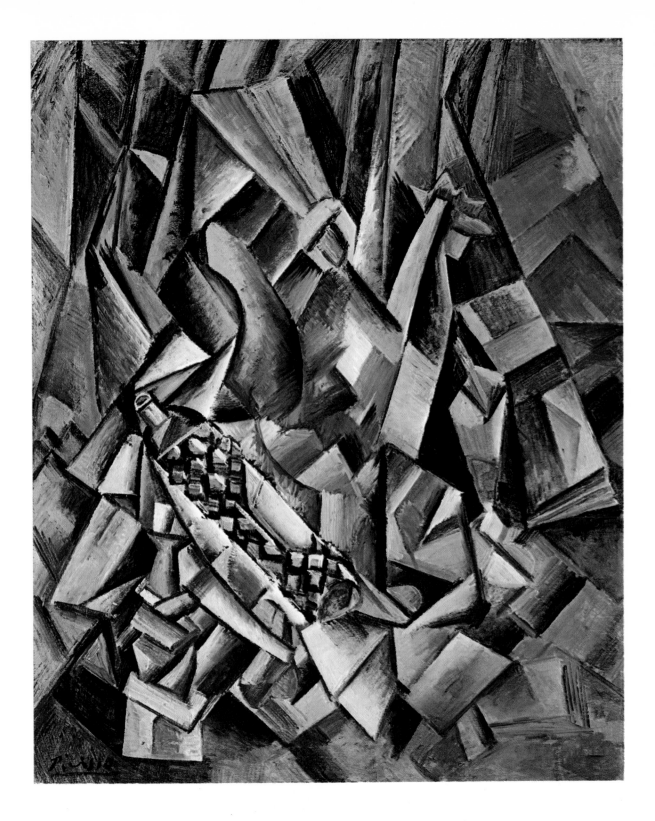

CASKET, CUP AND APPLE. *Late 1909. Ink wash, 9½ x 12⅜ inches. (C&N, p. 204)*

WOMAN IN A CHAIR. *Paris, late 1909. Oil on canvas, 28¾ x 23⅜ inches. (C&N, p. 204)*

As often happened after his return from a "vacation" of concentrated work, the fall of 1909 saw an easing up in Picasso's efforts. Mostly he experimented with different aspects of his discoveries at Horta. *Woman in a Chair*, painted late in the year, is less stylistically assured or consistent than the Horta pictures. The faceting of the face is so geometric that the features almost disappear; the passage is not, however, fully resolved, and its high level of abstraction does not harmonize with the realism of the scroll-back chair. Nevertheless, this difficult picture has its rewards. The strained pose of the figure—her arm bent over her head in a manner recalling *Les Demoiselles* and other works of 1907—the crowding of the composition toward the bottom right of the field, and the very inconsistencies in its raw handling suggest that the disturbing, expressionistic content previously carried by African influences in Picasso's art is here finding a place of its own within the hitherto classical language of Analytic Cubism.

GIRL WITH A MANDOLIN. *Paris, early 1910. Oil on canvas, 39½ x 29 inches. (C&N, p. 205)*

Picasso ceased work on this superb painting when Fanny Tellier, the professional model who sat for it, became impatient with the numerous sittings it required and quit. "But who knows," the artist is reported to have said, "it may be just as well I left it as it is."[1]

Except for parts of the mandolin and the sitter's right breast, the sculptural effects in *Girl with a Mandolin* are of a more finely graduated and lower relief than in the Horta pictures. There is, to be sure, an ambiguous suggestion of deeper space behind the figure's right arm, but that arm itself has little real cylindrical projection, and the stacked picture frames that close off the background—echoing the verticals and horizontals of the support—are pressed up toward the picture plane, reinforcing the shallowness of the space.

Concomitant with this lessening of convexity, the sculptural hardness of the surface has been tempered, especially near the margins of the picture. The planes tend to dissolve into touches of pigment whose painterly finesse is matched by the sophistication of their elusive coloring: a gray warmed with ocher and faintly cooled with blue. This soft brushwork also introduces a degree of transparency into the planes, a transparency which along with the painterliness that engenders it marks the picture as a transitional work, pointing the way to high Analytic Cubism.

Girl with a Mandolin is also known as "Portrait of Fanny Tellier"[2]; but it is not a portrait in the same sense as others painted in 1910. Compare it, for example, with the *Portrait of Wilhelm Uhde* (p. 205:49), which dates from shortly afterward. Despite the greater fragmentation and dislocation of its planes, Uhde's face is invested by the artist with a remarkable sense of personality, and even considerable verisimilitude—according to those who knew him—through just a few key decisions. The high upper lip above the tiny mouth, the heavy brows and asymmetrical eyes are choices that remind us of Picasso's powers as a caricaturist. Fanny Tellier's face has no such endowments; on the contrary, it is reduced to a simple rectilinear schema in which the mouth is not indicated and the nose is in doubt.

The continuation of the scalloped line of Miss Tellier's hairdo confirms the plane adjoining the head to the right as the shaded (left) side of her face, thus indicating schematically a three-quarter rather than profile view. But that plane, which we would expect to be obliquely situated in space, has been swung around toward the picture surface. This is characteristic of Picasso throughout *Girl with a Mandolin*, where shapes that have been modified into largely straight-edge forms are moved toward parallelism with both the picture plane and the picture frame. To the extent this happens, the configuration announces the implied rectilinear grid that was to become firmly established in the Cadaqués pictures the following summer, and that would subsequently provide the infrastructure for Analytic Cubist painting.

Girl with a Mandolin is one of the earliest examples of Picasso's interest in the motif of the half-length figure playing a musical instrument; its immediate stimulus may have been a Corot (p. 205:50) exhibited in the Salon d'Automne of 1909, some months prior to Picasso's having begun the picture.[3] The increasing abstraction of Cubism in the years following made possible the multiplication of analogies between figures and instruments, and finally their fusion in whimsical and even hallucinative ways. Indeed, the musical instrument would shortly become a focus of Cubist iconography. Given its contrasts of curved and rectilinear shapes, solids and voids, lines and planes, the stringed instrument is "almost a dictionary of the Cubist language of 1910–12."[4]

Picasso's direct observation of the motif is still evident in *Girl with a Mandolin*, which retains a semiorganic morphology in aspects of both the figure and the instrument. One need only compare it to the treatment of a similar motif in the later *"Ma Jolie"* (p. 69)—painted without direct reference to a model—to see how far these vestiges of the recognizable world of human beings and objects were to dissolve into largely self-referential compositions.

STILL LIFE: LE TORERO. *Céret, summer 1911. Oil on canvas, 18¼ x 15⅛ inches. (C&N, p. 205)*

"MA JOLIE" (WOMAN WITH A ZITHER OR GUITAR). *Paris, winter 1911–12. Oil on canvas, 39⅜ x 25¾ inches. (C&N, pp. 205–206)*

These two pictures and *The Architect's Table* (p. 73) date from the period spanning summer 1910 and spring 1912, during which Picasso and Braque, with whom he was then working closely, developed the mode we may call high Analytic Cubism. Such paintings are difficult to read, for while they are articulated with planes, lines, shading, space and other vestiges of the language of illusionistic representation, these constituents have been largely abstracted from their former descriptive functions. Thus disengaged, they are reordered to the expressive purposes of the pictorial configurations as autonomous entities.

This impalpable, virtually abstract illusionism is a function of Cubism's metamorphosis from a sculptural into a painterly art. Sculptural relief of measurable intervals has here given way to flat, shaded planes—often more transparent than opaque—which hover in an indeterminate, atmospheric space shimmering with squarish, almost neo-impressionist brushstrokes.[1] That this seems finally a shallow rather than a deep space may be because we know it to be the painterly detritus of earlier Cubism's solid relief.

The light in early Cubist paintings did not function in accordance with physical laws; yet it continued to allude to the external world. By contrast, the light in these high Analytic Cubist pictures is an internal one, seeming almost to emanate from objects that have been pried apart. Accordingly, the term "analytic" must here be understood more than ever in a poetic rather than scientific sense, for this mysterious inner light is ultimately a metaphor for human consciousness. The Rembrandtesque way in which the spectral forms emerge and submerge within the brownish monochromy and the searching, meditative spirit of the compositions contribute to making these paintings among the most profoundly metaphysical in the Western tradition.

The degree of abstraction in these images is about as great as it will be in Picasso's work, which is to say that while the pictures approach nonfiguration, they maintain some ties, however tenuous or elliptical, with external reality. Even without the advantage of its subtitle —*Woman with a Zither or Guitar*[2]—we would probably identify the suggestions of a figure in *"Ma Jolie."* The sitter's head, though devoid of physiognomic detail, can be made out at the top center of the composition; her left arm is bent at the elbow—perhaps resting on the arm of a chair whose passementerie tassels are visible just below—and her hand probably holds the bottom of a guitar whose vertical strings are visible in the center. Together with the wine glass at the left and the treble clef and musical staff at the bottom of the picture, all this suggests an ambience of informal music-making. In *Still Life: Le Torero,* too, we can make out suggestions of real objects: a liqueur bottle in the upper center; the masthead of *Le Torero,* a popular bullfight periodical, and a pipe just below it; and a folding fan to the right—a combination that alludes to the comforts of the aficionado if not to the corrida itself.

How similar are the configurations of these two pic-

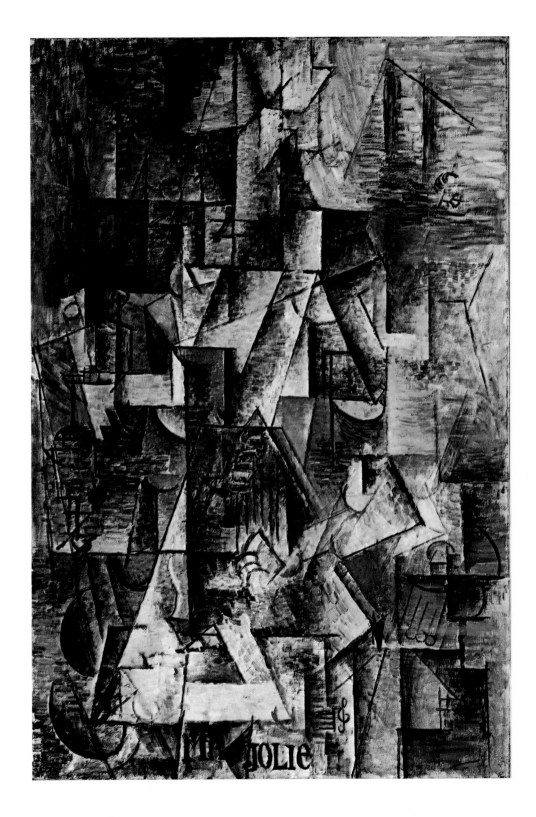

tures despite their very different motifs. The forms of both build pyramidally toward the top of the picture within the framework of an implied grid along whose verticals and horizontals most contours align themselves. Diagonals are less frequent and curves rare; both are locked into the pattern of verticals and horizontals that gives the scaffolding its stability and equilibrium. The planes are almost all frontal. Gone are the indications of cylindricality, of the turning surfaces still evident as late as in *Girl with a Mandolin.* Indeed, throughout high Analytic Cubism, all motifs, whatever their nature, end as pictorial architecture.

In *"Ma Jolie,"* the area of planar overlapping narrows toward the top, maintaining the symmetry of the composition. In *Le Torero,* a comparable triangulation of the scaffolding takes place to the left of the picture's central axis and is balanced by the placement of the fan. In both cases, the greater frequency of planes toward the center of the composition, as well as the slight increase in their opacity, alludes schematically to the convexity that had been actually illusioned in earlier Cubism. Thus the passage from dense to less dense areas represents—or better, reenacts—the passage from figure to ground. In the upper sides and corners of *"Ma Jolie,"* the elongated, more liquid accents of the brush suggest the insubstantial character of the space behind the figure, which is contrasted with the more firmly faceted, more opaque planes in the center.

Partly to draw attention by contrast to its luminous space, and thus reconfirm this highly abstract art as one of illusion, Picasso followed Braque in placing large trompe-l'oeil printed or stenciled letters on the surfaces of many pictures of this period.[3] Such frontal letters are sometimes nandled so as to appear as silhouettes *on top* of the picture plane, neither moving in the space of the picture nor subject to its light, both of which are felt to be behind them. "They stop the eye at the literal plane . . . the imitation printing spells out the real paint surface and thereby pries it away from the illusion of depth."[4]

"Cubism," as Picasso observed, "is an art dealing primarily with forms." But its subjects, he added, "must be a source of interest."[5] Lettering plays a crucial role in communicating these, and its often witty references to external reality relieve the pictures' formal asceticism. The words *"Ma Jolie,"* for example, are from the refrain line of a popular song of 1911,[6] but they were also a pet name of Picasso's new companion Marcelle Humbert

("Eva"), about whom he wrote to his dealer Kahnweiler that he loved her very much and would write it on his pictures.[7] Placed at the bottom center of the picture like a mock title,[8] these easily legible words form a whimsical contrast with the nearly indecipherable image of the "pretty one" to whom they appear to refer.[9]

STUDY FOR A CONSTRUCTION. *1912. Pen and ink, 6¾ x 4⅞ inches. (C&N, p. 206)*

CUBIST STUDY. *1912. Brush and ink, 7¼ x 5¼ inches. (C&N, p. 206)*

THE ARCHITECT'S TABLE. *Paris, spring 1912. Oil on canvas, oval, 28⅝ x 23½ inches. (C&N, p. 206)*

The tenuous links that Picasso's art maintained with the external world while on the threshold of total abstraction in pictures such as *"Ma Jolie"* were reinforced early in 1912 in *The Architect's Table*. Let us inventory some of its motifs. Traversing the picture from the upper left is part of the carpenter's square that led Kahnweiler to name it *The Architect's Table*[1]; the "architect" is, of course, Picasso—and the remainder of the iconography is more familiar. Below the square is a liqueur glass paired with a bottle of Vieux Marc. To their left is the slightly truncated inscription "Ma Jolie," above some lines of the musical staff; both are superimposed upon an album of music that has been folded open. Lying on this album is a pipe, and below it, toward the bottom of the painting, emerges the horizontal edge of a table with a tassel-fringed runner. (The scroll form just above is the terminal of the arm of a chair.) Lying obliquely on the table, at the lower right, is a calling card on which Picasso has written "Mis [sic] Gertrude Stein" in script letters—a reference to a visit by Miss Stein which found Picasso absent.[2] Toward the top right of the oval field, below the fragment of a picture frame, is the scroll and peg of a stringed instrument; like the transparent linear mechanisms at the upper center and left—whose identities and whose locations in space remain ambiguous—this fragmentary instrument resembles the fantastic, often anthropomorphic constructions that Picasso began to image around this time (p. 71, *left*). The rope tieback of a curtain at the upper left does not look out of place amid this weird machinery.

Speaking of the transformations of motifs in this picture Picasso observed that he possibly could not have surely identified the point of departure in reality for all its shapes even at the time it was painted—and certainly cannot now. "All its forms can't be rationalized," he told the author. "At the time, everyone talked about how much reality there was in Cubism. But they didn't really understand. It's not a reality you can take in your hand. It's more like a perfume—in front of you, behind you, to the sides. The scent is everywhere, but you don't quite know where it comes from."[3]

The oval form of *The Architect's Table* facilitated a centralized composition whose "fading" or dissolution at the edge would be equal on all sides of the composition, thus overcoming what Braque referred to as "the problem" of the corners.[4] The oval also contributed to the development of a compositional web that could be set floating in a weightless way (rather than being anchored to the bottom of the frame). That configuration, which was carried somewhat further by Braque than by Picasso, was the last major innovation of Analytic Cubist painting.

GUITAR. *Paris, early 1912. Sheet metal and wire, 30½ x 13⅞ x 7⅝ inches. (C&N, pp. 207–208)*

In the Cubism of 1909, the "skins" of objects were never penetrated, however much they were abstracted or re-ordered; *Woman's Head* (p. 61), the sculptural counter-part of those paintings, was still in the tradition of the monolith, which had obtained since ancient times. High Analytic Cubism, on the other hand, provided a model for an illusionistic art of seemingly transparent as well as opaque planes superimposed so as to suggest that the eye could see into and through objects. The type of open-work construction-sculpture that Picasso initiated with *Guitar* (executed toward the beginning of 1912, or per-haps at the end of the previous year[1]) built on this "see-through" arrangement, but necessarily in terms of larger, opaque planes (of a type that would increasingly char-acterize his paintings in 1912).

In inventing this three-dimensional counterpart for the uncurved planes and frontal arrangements of Cubist paintings of 1911–12, Picasso so radically altered the nature and direction of sculpture that he provided a point of departure for a veritable second history of the medium.[2] Sculpture, which had remained from before the time of the Egyptians and Greeks up to that of Brancusi and Arp essentially an art of carved and modeled solids, became predominantly one of hollow constructions made from planes and lines. Moreover, the configurations of these sculptures at once demanded and made possible the use of new materials and techniques.

The pictorial origin of Picasso's constructions is con-firmed by the fact that *Guitar*, and most of the sculptures that succeeded it in the years 1912–16, were not con-ceived in the round, but as reliefs, which permitted the recapitulation of the paintings' planar overlappings in an actual shallow space. Musical instruments were preferred motifs precisely because, viewed frontally, they are struc-tured in a high Cubist manner, their major planes flat and parallel to one another. Like the objects in the paint-ings, the body of the sheet-metal guitar is cut open and its components dislocated so as to provide simultaneous views of its different levels. As a result, however, of the metal's opacity, the transparencies illusioned in the paint-ings could only be implied. Later, in his linear sculptures (p. 223:100), Picasso achieved transparency by indicat-ing planes through their edges alone—as line drawings made with wires or rods—thus allowing the viewer at once to locate the plane and to see through it. Con-structivist sculptors solved the problem in another way through the use of translucent and transparent materials.

Guitar shows Picasso well along the road to that "re-habilitation" of objects which characterized the paint-ings of 1912. Most of its planes are readily identified with parts of the instrument. The back of the guitar's body is partially visible to the left. The neck of the instrument is represented only by its rear plane, a vertical half cyl-inder, as if the flat front plane of the fingerboard (im-plied by the wire strings) had become transparent.

The front of the guitar's body is radically cut away, leaving only a cylinder that represents the hole in the sounding board. This is the most remarkable formal con-stituent of the work. Viewed from an angle, the "hole" is paradoxically the only positive and integral form in the central void of the composition; viewed frontally, only the rim of the cylinder is visible, so it functions like a line drawing of a circle. Kahnweiler has compared this "hole" to the cylindrical eyes of Wobé masks (p. 208:54), in which the geometricized features project forward from a back plane.[3] Picasso owned such a mask, and while its direct influence as postulated by Kahnweiler is dis-putable, it probably confirmed the artist in some aspects of his new sculptural conception.

Unlike many constructions of 1913 onward, *Guitar* in no way involved the collaging of diverse materials. On the contrary, in pioneering the use of sheet metal Picasso maintained a classical unity in the medium. Moreover, the artist is firm in his recollection that this and other of his earliest construction-sculptures preceded his first collage, *Still Life with Chair Caning*.[4] This confirms the need to discard the traditional view that sees construc-tion-sculpture as representing a three-dimensional exten-sion of collage (rather than a sculptural mutation of painting).

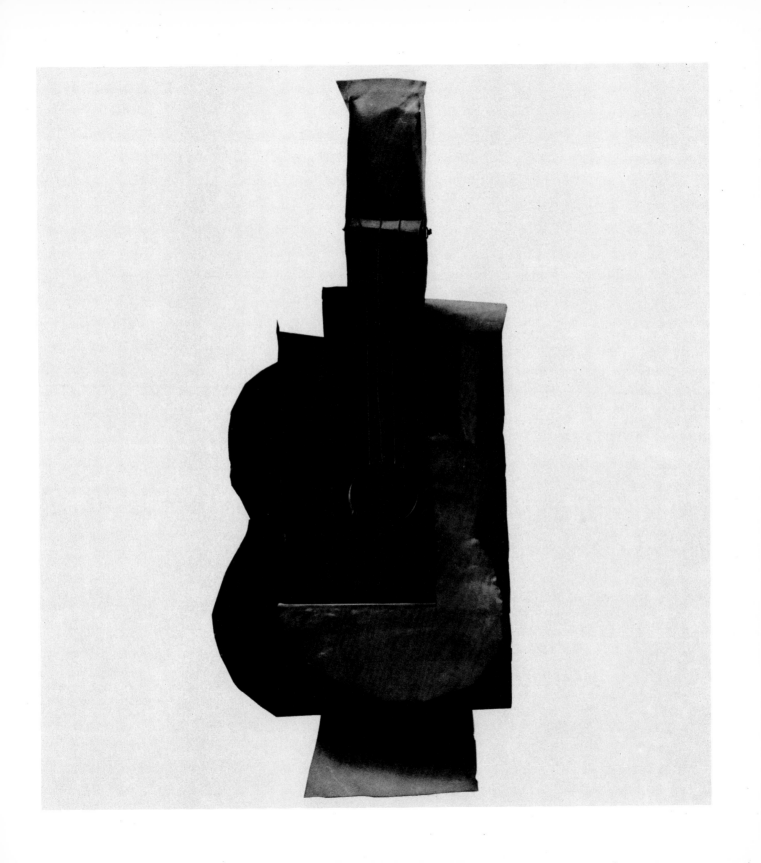

VIOLIN AND GRAPES. *Sorgues, summer or early fall 1912. Oil on canvas, 20 x 24 inches. (C&N, p. 209)*

During the course of 1912, Analytic Cubism gradually evolved toward the mode that would subsequently be called Synthetic Cubism. In the latter style, which has also been called "the Cubism of reconstitution,"[1] the many fragments into which the motifs had earlier been "analyzed" were resynthesized as larger, more legible shapes, and the textures and colors of the represented objects began to play a role. Constructions such as *Guitar* signaled Picasso's concern with the reintegration of the *forms* of objects; the reconstitution of their particular *surfaces* he accomplished in part with the kind of trompe-l'oeil technique used for the wood graining of the instrument in *Violin and Grapes*. Braque, who had been trained as a *peintre-décorateur*, showed Picasso how to imitate a wood surface by using a comb in combination with the brush. Collage represented, among other things, an even more convenient and more directly tactile method for achieving comparable effects. Thus, it is not surprising that Braque's first *papier collé* should have been composed around commercial wallpaper printed with imitation wood paneling (p. 209:55).

Violin and Grapes is a transitional picture. The forms of the instrument's body are mostly flat, relatively colorful, and realized in trompe l'oeil; the forms behind it imply more space, and their monochromy recalls the shaded planes of the previous years' work. Even in the latter passages, however, the earlier, flickering brushstrokes have given way to longer, summary markings that imply harder, more opaque surfaces; these background planes are pressed up toward the picture surface so as to abolish much of the recessional space inherited from Analytic Cubism. The grapes, on the other hand, are modeled so sculpturally that they seem to project beyond the picture plane, like an element collaged in relief.

The orange-reds and tans of the violin and the green of the grapes are still a far cry from the bright coloring that would characterize subsequent Cubism, but they go beyond anything in the work of 1909–11. And the fact that they are local colors—situated thus between the monochromy of Analytic Cubism and the decorative, often fantastical coloring of Synthetic Cubism—testifies to Picasso's concern for the integrity of objects during the crucial transitional year of 1912.

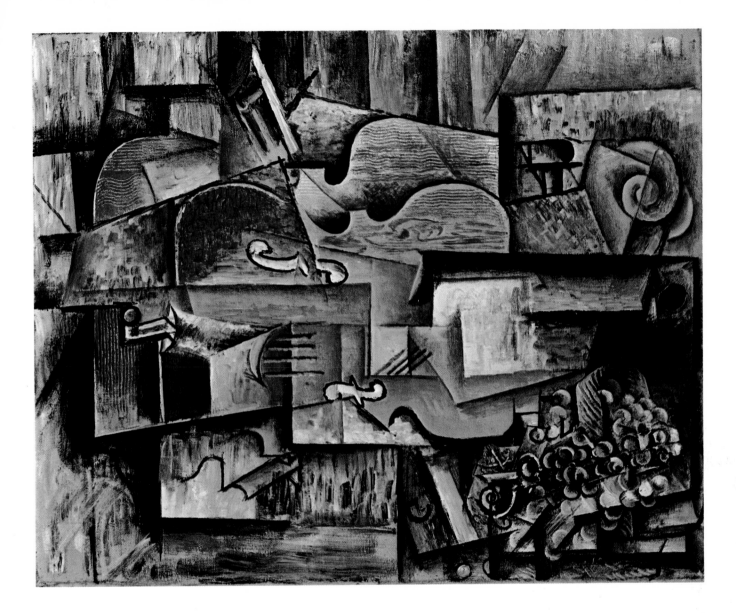

MAN WITH A HAT. *Paris, December 1912. Charcoal, ink, pasted paper, 24½ x 18⅜ inches. (C&N, p. 209)*

In the course of the eight months or so he worked in the boulevard Raspail beginning in autumn 1912, Picasso focused an extraordinary amount of his energy on *papiers collés*. Never again would this or any other form of collage interest him as much. *Man with a Hat* and *Head* (p. 80) are of the type of *papier collé* most common during that year—a severe drawing often in charcoal, in which newsprint and painted paper are employed sparingly to clarify the spatial position of key planes. Picasso did not work simultaneously with his charcoal and scissors. The composition was usually drawn in first, then the collage elements were cut as required for particular planes; the charcoal lines covered when these elements were glued down were redrawn on top.[1]

By boldly individuating certain planes and endowing them with a distinctive material existence, collage helped Picasso and Braque toward a solution to the problem they posed for themselves in 1912: how to represent three-dimensional objects on a flat surface without illusion. High Analytic Cubism, paradoxically, had retained the language of illusionism—its space and graduated shading—even as it disengaged that language from representation. Collage facilitated a new form of Cubist representation based on allusion rather than illusion.

In *Man with a Hat*, the eyes are indicated by black dots, the nose and mouth by a diagonal terminating in an arc, and the outer contour of the head by a pattern that echoes the ear and resembles the body of a guitar. (The equation of ears with the stringed instruments to which they listen is even more fully defined on the right side of *Head*, where Picasso punningly let the ear also stand for the sound hole of a guitar.[2]) The three planes of the face in *Man with a Hat*—newsprint, blue and black—are set, unmodeled, in the picture plane. However, they are *understood* to be in different positions in space, even though they are not *seen* to be so. The newsprint represents the side of the face catching the light; the blue center face is in shadow, with the black ink shaping its outer edge.

To the viewer who troubles to read the text of the newsprint a witticism is revealed: the text that covers part of the man's upper chest deals with the treatment of tuberculosis, while in the columns opposite his nose and mouth, *fosses nasales* and *dents* are mentioned.[3] Al-though this piece of humor may have been unintentional, the fact that Picasso troubled to cut these particular passages from different pages of *Le Journal* suggests otherwise. The article, "A propos de la Déclaration obligatoire de la Tuberculose," is from page 3 of the issue of December 3, 1912; the other passage, which includes segments of "Le Bonbon dentifrice," about a breath sweetener, is from page 5 of the same issue.[4] December 3, 1912, is thus the *terminus post quem* for the completion of the work; since Picasso generally did not keep the daily papers about for extended periods, it is more than likely that this *papier collé* was executed before the end of the year.

HEAD. *Spring 1913. Collage, pen and ink, pencil and watercolor, 17 x 11⅜ inches. (C&N, p. 210)*

The drawings that form the armatures for collages such as *Head* and *Man with a Hat* almost resemble working plans for three-dimensional constructions. In *Head,* the parallel forms at the left and right, the dotted line, and the general precision with which Picasso mapped out the whole arrangement suggest that the paper could be cut along certain contours and folded out into a construction-sculpture. Much later, Picasso would do precisely that; his *Chair,* 1961 (p. 210:57), was cut from a single sheet of metal on the basis of a line drawing on wrapping paper that served as a template. Showing the latter to a

critic who had difficulty making out the subject, Picasso observed that it was a chair. "That is an explanation of Cubism," he continued. "Imagine a chair passed under the rollers of a press—it would look about like that."[1]

For the newsprint panel of *Head,* Picasso exceptionally used a very old newspaper, to the best of his recollection because of the brown color it had turned.[2] Its text describes the coronation of Czar Alexander III, as witnessed by a reporter for *Le Figaro.* Clippings from this front page of May 28, 1883, have been identified in three other *papiers collés* by Picasso; and a study of them in relation to *Guitar* (p. 83) and certain other collages has clarified the date of *Head*—formerly assigned to the winter of 1912–13—as spring 1913.[3]

GLASS, GUITAR AND BOTTLE. *Spring 1913. Oil, pasted paper, gesso and pencil on canvas, 25¾ x 21⅛ inches. (C&N, p. 210)*

Although its colors were originally somewhat more varied (much of the olive-green has faded to dun), *Glass, Guitar and Bottle* was always more monochromatic than most paintings of the six months that preceded it. Otherwise, it is well advanced into the Synthetic Cubist style, and especially reflects the latter's debt to *papier collé,* which it simulates at almost every turn. Only by exceedingly close scrutiny can one identify its few bits of true collage from their various trompe-l'oeil counterparts, such as the imitation marbleized paper. What the viewer without a magnifying glass would certainly identify as pieces of heavy paper and cardboard are, in fact, gesso panels that Picasso built up by masking the adjacent areas. The fretwork of the guitar, which resembles a mortar of sand and pigment, has been achieved by impasto alone, and its strings, which give the illusion of twine glued to the surface, are carefully painted in trompe l'oeil. Only the newsprint planes that carry the block letters are actually pasted on; but even here Picasso keeps us guessing about illusion and reality, for although the larger letters are part of the original newsprint, the word [R]ENNES—while on real newspaper—has been stenciled on it by Picasso.[1]

Although the lettering in *Glass, Guitar and Bottle* is primarily of formal interest, it serves poetically to link the still-life objects directly to the world of the café and to the artist's home. The word [R]ENNES probably refers to the rue de Rennes, which joins the boulevard

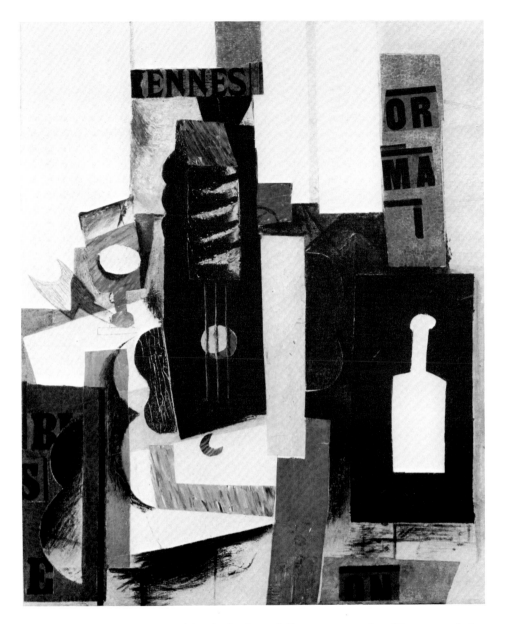

Raspail where Picasso had been living since the fall of 1912 to the place Saint-Germain-des-Prés whose cafés were much frequented by the artist at the time[2]; it is also possible that the partial suppression of the initial letter of "Rennes" was effected so that the remaining fragment —ENNES—could be alternately taken for part of the label of Hennessy brandy[3]—a reading entirely consistent with the imagery of the picture as a whole. Moreover, the lower left quadrant of the picture may contain a combined plastic and literary pun: the silhouette of the guitar, which is repeated twice in the lower left, is juxtaposed with the word BIS, which means "continuation," "repetition" or "encore." And just as that silhouetting represents a dislocation of the guitar's body, so the third letter of "bis" is shifted downward toward the left corner. As it is likely that Picasso had just rented the studio at 5 bis rue Schoelcher,[4] the word might well have been in his mind.

GUITAR. *Paris, spring 1913. Charcoal, wax crayon, ink and pasted paper, 26⅛ x 19½ inches. (C&N, p. 211)*

This is one of the most majestic and sumptuous of Picasso's *papiers collés*—and with its whites and ochers (and their black shadows) set in crystalline clarity against a transparent blue ground, it is one of his most "Mediterranean" as well. The artist had already stylized fragmentary front and back planes of the instrument as contrasting curvilinear and rectilinear shapes in the construction-sculpture *Guitar* (p. 75). Here the front of the guitar is represented integrally as a sinuous female form in which white paper represents the light, and flowery wallpaper the shaded parts of the instrument. The rear of the guitar is stylized into a more masculine, straight-edged, ocher shape, its shadow also represented by the ornate wallpaper. The box pattern on the ivory and gold paper that stands for the neck of the guitar serves to recall the instrument's fretwork, to which the parallel lines of charcoal and white crayon just to its right also allude; the shaded underside of the neck is displaced to the side and represented in black ink.

The curvilinear guitar body—which in *Head* and *Man with a Hat* Picasso had analogized to both the human face and ear—is here associated with the female torso, the newsprint sound hole assuming the role of navel. And since, by extension of the metaphor, the rectilinearity of the rear plane of the guitar suggests a masculine torso, the motif as a whole may be seen as expressing the union of male and female anatomies. In confirming the anatomical analogy to this author, Picasso noted with a mischievous smile that his attention had been drawn some time ago to the advertisement, prominent on the front page of the Barcelona *El Diluvio* collaged below, for Doctor Casasa, a specialist in venereal diseases. As to whether this played a role in his choice of the particular page of newsprint, the artist suggested that if it had influenced him at all, it would probably have been subconsciously. It is interesting to speculate that the advertisement for an oculist, Doctor Dolcet, at the bottom of the page might have been a whimsical prescription for the viewer who had trouble seeing what this collage was about.

The problem is knowing just how far such interpretations may be carried.[1] Picasso himself considers that when the work leaves his hand, its imagery is what its interpreters make of it. He is aware that his very reluctance to discuss iconography encourages speculation. And while in another context he observed with regard to interpretation that *"rien n'est exclus,"* he was more bemused than persuaded by the interpretation which suggests that the white and the wallpaper halves of the female guitar-torso in this work are meant to show the body respectively as "nude" and "encased in a tight-fitting lace undergarment."[2] More in the spirit of Picasso's humor is the same authors' contention that in cutting the masthead of *El Diluvio* in a way that isolated the letters "Diluv," Picasso had transformed its meaning into a tongue-in-cheek, "Esperanto" hint as to the great French museum in which such *papiers collés*—then not even considered art beyond a small group of amateurs—would eventually find their place.[3]

Few clues as to the position of the guitar are given. It is probable that it was sitting upright in a chair like a person,[4] though the motif in the lower right corner that suggests this placement is admittedly very summarily indicated; what looks like a pipes of Pan is actually three fringed tassels hanging from the braided arm of a chair.[5] The braided motif—which can also serve to indicate the molding on a wall or the edge of a table or table runner (or a picture frame)—is frequently found in relatively realistic form in Picasso's Cubist pictures (p. 101), both with and without the passementerie tassels. The latter appear as an abstract schema very like the one here at the bottom right in *"Ma Jolie"* (p. 69) and in the upper center of *The Architect's Table* (p. 73), as well as, in more realistic form, at the right in *Man with a Guitar* (p. 85).

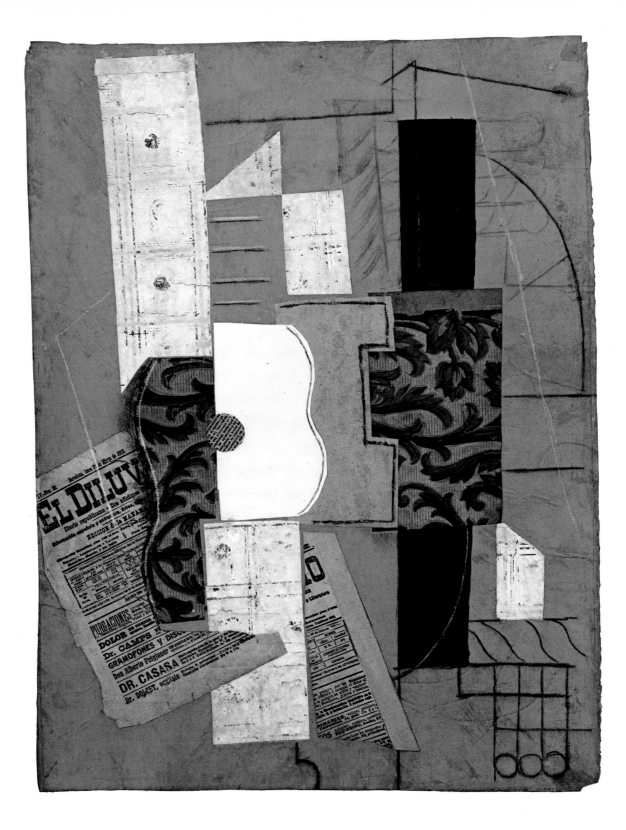

MAN WITH A GUITAR. *Céret, summer 1913. Oil and encaustic on canvas, 51¼ x 35 inches. (C&N, p. 211)*

The terms "analytic" and "synthetic," commonly employed to characterize, respectively, the Cubism of 1909–12 and that of 1913 onward, tend to suggest a radical change in style when in fact Cubism had never ceased its gradual evolution. Indeed, many Synthetic Cubist works of 1913–14 are closer as regards configuration, scale and character to their Analytic predecessors than to such subsequent Synthetic Cubist pictures as *Harlequin* (p. 99) and *Three Musicians* (p. 113). Keeping these caveats in mind, however, the conventional nomenclature can still be of value in defining Cubism's development.

The term "synthetic" has been used in two quite different ways. First, it may describe Picasso's and Braque's "synthesis" of the fragmented facet-planes and atomized motifs of Analytic Cubism into large, flat and more readable shapes; this use of the word relates it to the Synthetism of the late nineteenth century. Second, and more frequently, it has been used to indicate an invented and semiautonomous—hence "synthetic"—vocabulary of forms. In this case, the artist is understood to have arrived at the configuration not by abstraction ("analysis") of the motif, but by constructing his figures and objects directly from preexisting signs and forms.

Man with a Guitar is a Synthetic Cubist picture largely in the latter sense. The configuration—a bold conceit of adjacent rectangles—seems more imposed upon the motif than derived from it. Little more than the head of the figure and the pink still life with the bottle of Bass at the right are exempt from the imperatives of its grid. More typical are the black sleeve and gray right hand of the guitar player at the bottom center of the picture, which testify to the manner in which the image was required to conform to the dominant patterning. (The parallel white arcs in the upper torso of the sitter are also something of an exception in their curvilinearity, but they are no more derived from the motif than are the rectangles; and their graduated, semitransparent shading makes their visual assimilation difficult. In conjunction with the three shaded vertical rectangles with which they are paired, these arcs presumably express the convexity of the upper torso of the sitter.)

Despite its predominantly rectangular patterning, *Man with a Guitar* enjoys a considerable range of vocabulary, as exemplified in the juxtaposition of the symbolic geometry of the upper torso and the realistic drawing of the braided tassel. Another aspect of this range is the "double image"[1] by which the contours of the head and hat of the figure read also as those of a guitar—a kind of pictorial counterpart of the double entendres found in the lettering of the paintings and collages of 1911–14

The unexpected aspect of this picture's variety, however, is its coloring. Nothing in Picasso's Cubist painting prior to 1913 prepares us for its great slabs of sonorous reds, greens and ochers (some of them enhanced in their density through the use of encaustic). Nor are these carried over from collage, though the flatness of the *papiers collés* helped bring such coloring about.[2] This is not to say, however, that Picasso was suddenly reborn a colorist. Despite the rich play of color in *Man with a Guitar*—as witnessed by the subtle calibration of its five shades of red—the colors are darkened with shading and embedded within a light-dark matrix (as is always finally the case in Picasso's draftsmanly art) so that it is their rightness as values rather than as hues that makes the picture work.

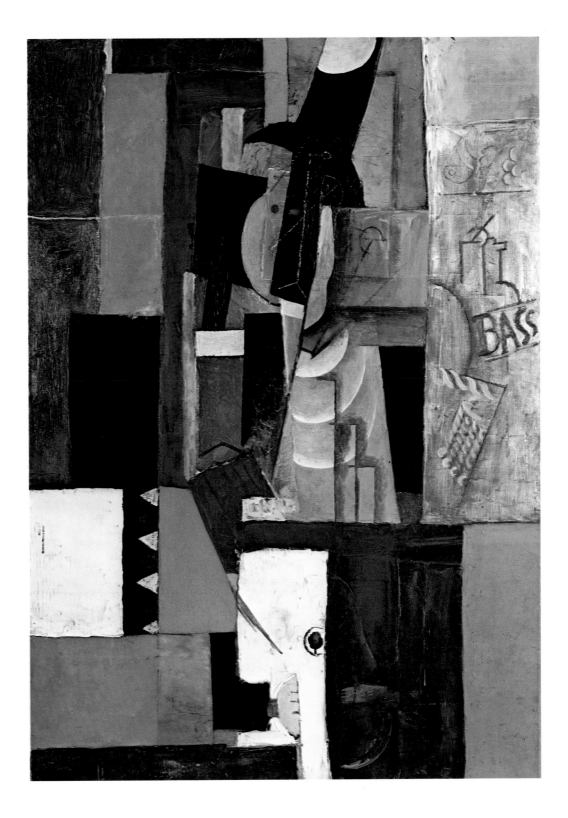

CARD PLAYER. *Paris, winter 1913–14. Oil on canvas, 42½ x 35¼ inches. (C&N, p. 211)*

Synthetic Cubism is commonly considered less abstract than its Analytic predecessor, but this is true only in a limited sense. The generally greater legibility of its images certainly makes it more representational; but its *schematic* mode of representation is more inherently abstract than the *illusionistic* mode that had prevailed in Analytic Cubism. Even where the forms in pictures in the latter style are most broken up and difficult to read, they are defined by a kind of drawing and shading and set within an atmospheric space derived ultimately from the language of pictorial illusionism inherited from the past. By contrast, Synthetic Cubism is characterized by a nonillusionist flatness, which it helped establish as central to the twentieth-century esthetic, and which is in no way undermined by representation per se.

Card Player exemplifies the greater legibility of Synthetic Cubism as against that of the Cubism of 1911–12. The mustachioed player is seated at a wooden table, his legs visible between those of the chair at the bottom of the picture. In his left hand he holds a playing card face up—three are face down on the table—and in his right, a pipe. On the table are a glass, a bottle behind it, and a newspaper. The newspaper masthead is truncated so as to facilitate a triple entendre, its letters serving to identify the name of the newspaper *(Le Journal)*, the objective nature of the action (JOU from *jouer*, "to play"), and the subjective nature of the experience (JOI, from *joie*, "joy"). Although the action is indicated in both pictorial and literary ways, the picture is not a narrative one, as are traditional depictions of card playing. Its centrality, frontality, flatness and motionlessness are almost Byzantine, and remind us of the persistently iconic character of high Cubist imagery.

The influences of *papier collé* are more directly evident in *Card Player* than in *Man with a Guitar*. The simulated wood graining of the table, the Greek key motif of the wainscoting, the playing cards, the fragment of *Le Journal* and the shapes of the composition in general and of the player's head in particular might each be considered, in effect, a trompe l'oeil of collage. Even the pointillist stippling that represents the shaded side of the player's neck was probably suggested by newsprint or sandpaper, although such stippling is used as a decorative convention for shading in a more freely

dosed manner elsewhere in the picture. As with the somewhat irregular edges and rough facture of *Man with a Guitar*, the collagelike effects here remind us that *papier collé* had provided Picasso with a built-in guarantee against the finessed execution that characterized the work of 1910–11. At its apogee, high Analytic Cubism enjoyed a refinement in the nuancing of values and a fluency in brushwork comparable to that in the work of the great seventeenth-century masters. As Picasso is both capable of great virtuoso painting and suspicious of it, his development is often characterized by an exploitation of this gift followed by an abrupt reaction against it. In that connection, collage played a role analogous to that of the awkward contouring of the early Blue Period and the "primitivism" of late 1906–1907; it at once delivered Picasso from the temptations of pigment and instituted a kind of drawing that would long survive collage as such, one in which the scissored, manufactured and torn edge replaced the suavely hand-drawn one. Collage also focused attention on the two-dimensionality of the picture as an esthetic object by endowing the surface with a more emphatic materiality.

The coloring of *Card Player* is more typical of Picasso's work in 1913 than that of *Man with a Guitar* insofar as the light-dark scaffolding that organizes the picture (passing from white to black through ocher, gray and blue) is more obviously dominant. The saturated red of the left arm and the green of the wainscoting are isolated, bright accents that "season" the picture and are easily absorbed into its prevailing light-dark structure.

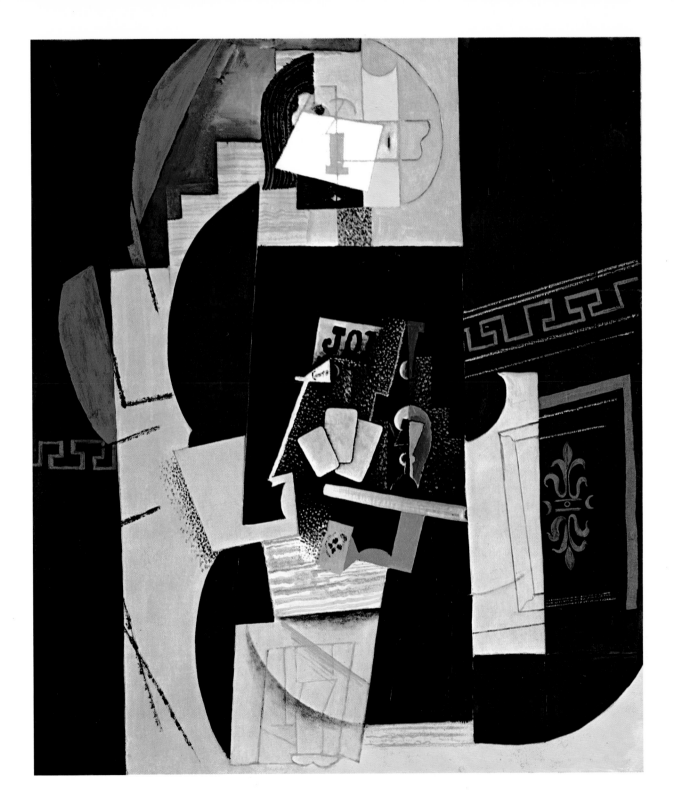

STUDENT WITH A PIPE. *Paris, winter 1913–14. Oil, charcoal, pasted paper and sand on canvas, 28¾ x 23⅛ inches. (C&N, p. 212)*

Student with a Pipe is one of two bust-length versions of a student wearing the traditional *faluche*, or beret, executed in the winter of 1913–14. Whereas *Student with a Newspaper* (p. 212:58) is entirely painted and drawn, though partly in simulated *papier collé*, the *faluche* and pipe in this picture are pasted paper. This particular use of *papier collé* to represent discrete objects is different from the functions we have seen it fulfill earlier. In *Man with a Hat* (p. 78) and *Head* (p. 80), pasted paper was used to define only selected planes of an object; in *Guitar* (p. 83), a page of newsprint was used descriptively (as well as plastically) to identify the newspaper as such within the iconography of the still life. In *Student with a Pipe*, Picasso provides a paper surrogate for the object. He cut the paper in the form of a *faluche*, colored it dark reddish-brown (it has since faded), and painted on the details of the headband and the clip, which identifies the student's *Faculté*. Then he creased and crumpled the paper so as to suggest the irregular surface of the *faluche*, and proceeded to attach it in such a way that it forms a kind of low relief.

The features of the student are quite easy to read. In what was probably the study for this picture (p. 212:59), Picasso had already narrowed the central plane of the head toward the top, thus indicating its slight tilt backward. The student's round "cheeks," executed partly in pasted paper in the study, are here contoured in charcoal, their relief indicated by the slight shadow they cast on the adjoining planes. The large, blue-gray rectangular form on the left stands for the shadow of the head as a whole.

The student's ears have been turned outward forty-five degrees so that they lie flat in the picture plane, their parallel lines echoed by the four wavy lines that describe the hair. As a shorthand symbol, the black dot that indicates the orifice of the student's left ear mediates between the smaller black dots of his nostrils and the little round circles that stand for his eyes; the top view of the pipe bowl (superimposed on its profile) combines both circle and dot.

The circular eyes and the long flat nose—the latter stippled so as to remind us of the sandy texture of the surface—are typical of Picasso's heads of 1913–14 and

represent, as Kahnweiler pointed out,[1] a translation of the schematic features of the Wobé masks (p. 208:54) into a whimsical and personal sign language. The X by which Picasso indicates both the bottom of the nose and the ridge that descends toward the upper lip shows that he can more than equal the economy of the African artists.[2]

WOMAN WITH A MANDOLIN. *Paris, spring 1914. Oil, sand and charcoal on canvas, 45½ x 18¾ inches. (C&N, p. 212)*

Many forms in *Woman with a Mandolin*—among them the parallel wavy lines, red pointillist plane, blue-gray shadow and profile ear—relate closely to those of *Student with a Pipe*. However, their more disjointed syntax suggests that it was executed some months later, probably in the spring of 1914. And the almost hallucinatory way in which the anatomies of the sitter and the mandolin are confounded anticipates the "surreal" spirit of the drawings Picasso was to make still later, during his 1914 summer holiday at Avignon.

The reading of *Woman with a Mandolin* is comparatively difficult. The facial features are represented twice, once against a blue plane shaped like a musical instrument, then, just below, in charcoal, which has been partly erased, leaving a spectral "afterimage." Here the wavy hairlines serve as a bridge to the radically displaced arms. The brown sleeve of the sitter's left arm—puffed at the shoulder and tight around the forearm—makes a shape analogous to that of the mandolin; the sleeve of the right arm—from which a finlike hand emerges—goes one step further and itself forms one contour of the mandolin.

The unusually narrow format of *Woman with a Mandolin* draws special attention to the structural role of the framing edge in Synthetic Cubism. The composition is locked into and supported by the frame in a way that suggests its teetering scaffolding might collapse without it. The structures of high Analytic Cubist pictures were, by comparison, self-sufficient. While they echoed and re-echoed the stabilizing verticals and horizontals of the frame, they usually floated at a short distance from it—both laterally and recessionally—on all but the bottom edge (and even there in some paintings of 1911–12, especially in the work of Braque).

As illusionist space was squeezed out of Picasso's and Braque's pictures in 1912, the forms moved increasingly up into the picture plane, where they were no longer spatially "behind" the edges of the field. This development brought those edges—the first lines of any composition—more into play as direct components of the linear scaffolding. With these serving as a part of the scaffolding rather than a frame around it, much more instability could be tolerated in the center of the composition. In *Woman with a Mandolin*, for example, not only do curvilinear forms predominate, but even the straight lines (with one minor exception) are tilted away from the axes of the field.

It is interesting in this regard to compare *Woman with a Mandolin* to a related composition, *Man with a Guitar* (Fig. 212:60), abandoned in an unfinished state around the time *Woman with a Mandolin* was completed, but certainly begun before it—perhaps as early as in the summer of 1912 to judge by the traces of atmospheric, neo-impressionist brushwork in the upper corners. In *Man with a Guitar* the curvilinear forms are far fewer and are subordinated to the straight edges, many of which parallel the frame, which is at some distance from the scaffolding. It is clear that in opting for the less autonomously balanced, more meandering configuration of *Woman with a Mandolin*, Picasso saw the necessity of removing the spaces on the sides of the earlier image, thus allowing the framing edge to move in and give its support. Picasso's awareness of the special importance of the frame in *Woman with a Mandolin* may be reflected in a pictorial witticism whereby every form in the picture is flat except the rendering of a piece of picture-frame molding, which descends from the upper left of the composition.

The inscriptions on Picasso's Cubist paintings and collages testify to his fascination with the language of typography. According to Gertrude Stein, he learned the Russian alphabet from his friend the painter Serge Férat (*né* Jastrebzoff, whom Picasso and Apollinaire called G. Apostrophe), and began "putting it in some of his pictures."[1] As *Woman with a Mandolin* belonged to Miss Stein, she must have had this picture in mind, all the more so since it is, in fact, the only Picasso with Russian lettering. However, the presence here of the fragmentary phrase бол концерт, transliterated as Bol(shoi) Concert or the equivalent of the French "Grand Concert," may have had a different immediate inspiration than Miss Stein suggests. Kahnweiler recounts that a number of Picasso's paintings which had been sent to Russia for exhibition were returned carefully wrapped in Russian posters. "Picasso saw them," he continues, "and found the Russian characters so attractive that he carried them off and used them in his still lifes."[2]

Pipe, Glass, Bottle of Rum. *Paris, March 1914. Pasted paper, pencil, gesso on cardboard, 15¾ x 20¾ inches. (C&N, p. 212)*

While most of Picasso's *papiers collés* are playful and improvisational, *Pipe, Glass, Bottle of Rum* is close to the sober spirit of Braque. Its studied elegance is epitomized by the precise, somewhat self-conscious signature, similar in its regular script letters to the "printing" on Picasso's formal calling card, as imaged elsewhere (p. 212:61). The objects are contoured and shaded with particular subtlety, their shapes almost wholly independent of the silhouettes of the two large, brown pasted papers on which they are partly inscribed. The table on which the still life is situated is extravagantly tilted, but except for the displacement of the molding of its edge to the middle of the composition, it is realized in a much less abstract manner than other parts of the work. The black accented with brown of the pipe and the black lettering on the pasted newsprint that labels the rum bottle establish the dark end of a value scale that is carefully graduated through the middle tones (the large pieces of *papier collé*) to the gessoed, white ground of the field (which has been treated in some areas as simulated collage).

MAN IN A MELON HAT. *1914. Pencil, 13 x 10 inches.*
(C&N, p. 213)

The process by which Picasso abstracted his motifs from the visible world is illuminated by a large group of drawings of 1914, in which men seated at a table or leaning on a chair or a balustrade are depicted in styles ranging in varying degrees from naturalism to Cubism (p. 213:62, 63).[1]

Man in a Melon Hat represents a midway point in that spectrum. The figure is basically naturalistic. The use of several Cubist devices, however, invests it with additional qualities of tension, rhythmic unity and spatial control. The rectilinear crease of the sleeve is one such device; another is the recurring circular form that courses through the knee, clenched fist, shoulder, hair, brim, crown, hand, and elbow. The flattened hat and tilted tabletop engender surface unity and a feeling of compression. The displacement of the left eye, in an otherwise conventional face, intensifies the image's power.

The naturalistic compositions in this series foreshadow the neoclassic figure drawings that were to become an important complement to Picasso's Cubist style from 1915 onward. *(Elaine L. Johnson)*

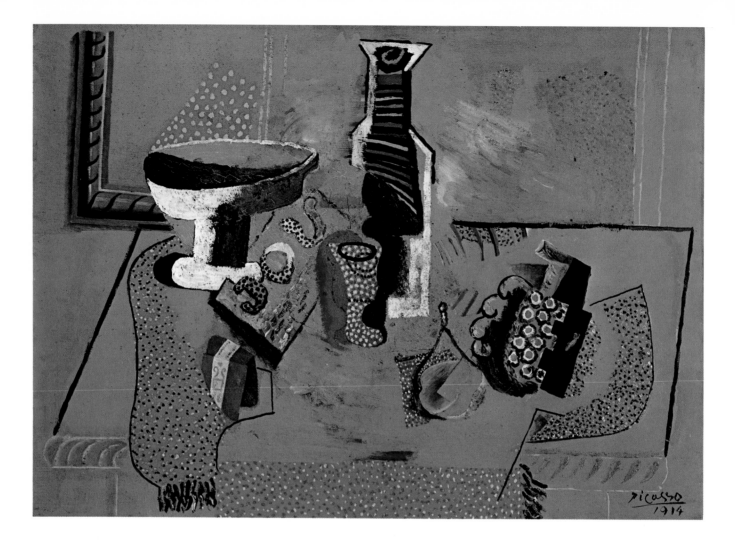

GREEN STILL LIFE. *Avignon, summer 1914. Oil on canvas, 23½ x 31¼ inches. (C&N, p. 213)*

Even in Picasso's most richly colored paintings of 1913, such as *Man with a Guitar* (p. 85), the hues tended to be dark in value, in keeping with the severe and rigorous spirit his Cubism preserved as it evolved into its Synthetic phase. However, the bright colors and uncomplicated stylizations of *Green Still Life*, executed at Avignon during the summer of 1914, announce a gay and more frankly decorative aspect of the style, the ornamental elegance of which has suggested the name "Rococo Cubism."[1] The sometimes obscure sign language of the two previous years is here temporarily suspended; the reading of the fruit dish, newspaper (with a segment of the masthead of *Le Journal*), cigarette package, glass, bottle, pear, grapes

and fragment of a picture frame requires little effort.

The omnipresent green of this picture establishes a lyrical mood and provides a continuous foil against which the staccato accents of other hues are played off. Pointillist stippling, which Picasso had been using sparingly for over a year to differentiate a plane or indicate a bit of shadow, is employed more generously here, its dots given special brightness by the use of commercial enamels. The striations of green, violet, yellow, orange and dark blue on the bottle are the stylistic counterpart of the dots—a lyrical transmutation of a shading device that goes back to the *Vase of Flowers* (p. 45). Along with the red dots and the red "shadow" of the glass, these striations focus attention on the center of the composition through their high contrast with the brilliant complementary green of the background.

GLASS OF ABSINTH. *Paris, 1914. Painted bronze with silver sugar strainer, 8½ x 6½ inches. (C&N, p. 213)*

Glass of Absinth is the only sculpture in the round executed by Picasso between 1910 and 1926. Its decorative pointillism makes it look of a piece with the *Green Still Life,* except that in the painting the artist dealt almost entirely with the surfaces of objects. In this little sculpture—cast in bronze from a wax model—Picasso returned to the possibilities of transparency that had concerned him in the sheet-metal *Guitar* (p. 75). Unlike the lateral, relieflike structure of musical instruments, the real absinth glass was, of course, conical and transparent—which probably prompted Picasso to attempt to fuse these two qualities in this unique experiment.

The stem and bottom of the glass are shown integrally. Above the stem, however, the glass's contours are opened to reveal its "interior."[1] The strange shapes that result were perhaps originally suggested by the levels of absinth in it, or by the planes of light passing through it. But these are less in the spirit of the objective abstraction that animated the sheet-metal *Guitar* than they are akin to the structural double entendres and fantastic mutations common to the painted works of 1913–14. Not surprisingly, therefore, the glass takes on an anthropomorphic character; for one critic, it brought to mind the "top-heavy slanting hats and the tight-fitting lace chokers of the ladies of those times."[2]

Picasso offset the weighty appearance of the bronze casts by painting them pointillistically, each with differ-

ent planar articulation and coloring with the exception of one that was covered with brown sand. This pointillism also enhanced the effect of transparency in the planes. The flatness and ornamental perforation of the real sugar strainer[3] must have especially appealed to the artist, and its juxtaposition with the painted bronze sugar cube is a three-dimensional recapitulation of the mixing of levels of reality in collage.

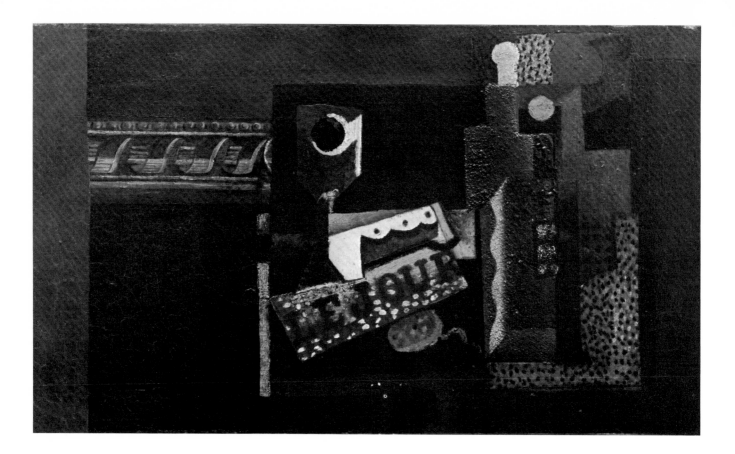

GLASS, NEWSPAPER AND BOTTLE. *Paris, fall 1914. Oil and sand on canvas, 14¼ x 24⅛ inches. (C&N, p. 214)*

This still life and those on pages 97 and 101—dating from 1914, 1915 and 1916 respectively—have much in common. All are constructed primarily with straight lines, which give way here and there to scalloped edges, braided moldings or small circles. All the backgrounds and most of the objects are dark in value—with deep reds, browns and grays predominating. Only where the forms cluster and overlap does Picasso relieve the prevailing somberness with brightly-colored pointillist planes. These stippled passages are counterpointed in *Glass, Newspaper and Bottle* and *Guitar over Fireplace* by planes heavily textured with sand. Indeed, in the latter picture it is a relieflike ridge of sand—rather than the passage from a deep blue to a still darker one—that determines the left-hand contour of the guitar.[1]

GUITAR OVER FIREPLACE. *Paris, 1915. Oil, sand and paper on canvas, 51¼ x 38¼ inches. (C&N, p. 214)*

96

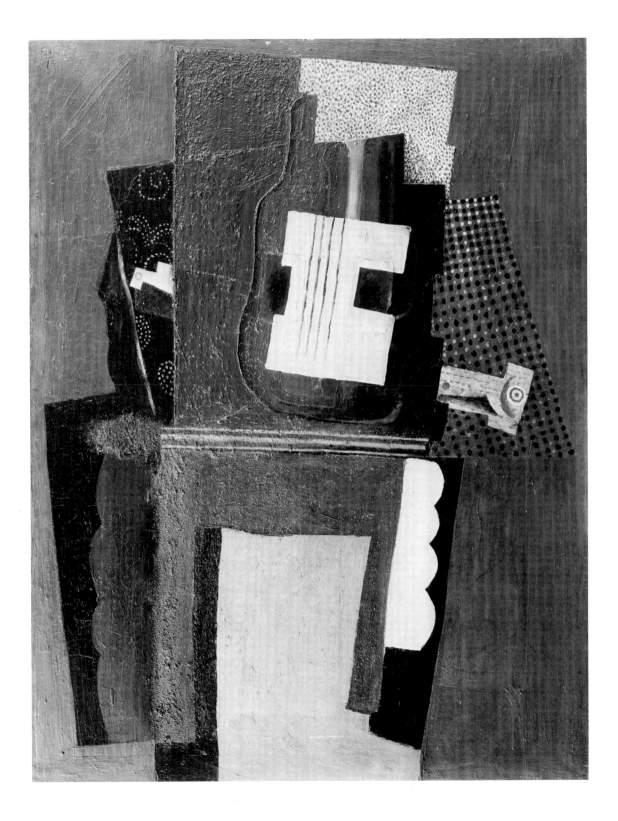

HARLEQUIN. *Paris, late 1915. Oil on canvas, 72¼ x 41⅜ inches. (C&N, pp. 214–15)*

At the end of 1915, when Picasso painted this monumental, disquieting *Harlequin,* his beloved Eva lay dying in a hospital on the outskirts of Paris. In a letter of December 9 to Gertrude Stein, the artist spoke of his anxiety over Eva's illness and described himself as having little heart for work—or even time for it, as he spent much of the day commuting to the hospital by *Métro.* "Nevertheless," he concluded, "I have done a painting of a harlequin which in the opinion of myself and several others is the best thing I have done."[1] This remark, quite uncharacteristic of Picasso, is an indication of the importance he attached to *Harlequin,* a painting which indeed marks the redirection of Synthetic Cubism on the specifically personal path that would culminate six years later in *Three Musicians* (p. 113).

In addition to personal tragedy there was the war. As a Spanish citizen, Picasso was not directly involved with World War I—nor was he profoundly affected by it. But Paris had become an anxious, gloomy city, and among Picasso's friends, Braque, Derain, Léger and Apollinaire had left for duty at the front, Cocteau was in the ambulance corps, and Kahnweiler, a German national, was forced to close his gallery. That Picasso should have chosen to paint a commedia-dell'arte figure at a time of deep personal and general social distress might seem merely a confirmation of the customary hermeticism of his imagery. But a hostile spirit that may well reflect the tenor of the times has slipped into this *Harlequin.* The decorative character of the red, green and tan costume is neutralized by the rigid rectilinearity of the configuration and the somber blacks of the background and figure, which permit chillingly stark contrasts of black and white. In this setting, Harlequin's toothy smile seems almost sinister.

The planes of *Harlequin* are flat, unshaded and broadly brushed in a manner appropriate to the scale of the work. There is, however, a purely schematic and quite whimsical contradiction of this flatness in the parody of perspective by which the diamond shapes of Harlequin's costume increase in size from right to left, a suggestion of bulging reinforced by the curve of his belt. Carried into the lower part of Harlequin's figure, this distortion of what we know to be a regular diamond pattern seems to make his legs buckle under him.[2]

The stylization of the light and shaded areas of figures as contrasting flat planes, already an established convention by the end of 1912, is freely elaborated in *Harlequin* in such a manner that the motley, the blue, the black and the brown-and-white planes all represent the figure, although they are on different levels in space and are tilted on different lateral axes. The angular white side of the head is drolly united with the round black one by their common mouth. Harlequin's white right arm—the fingers indicated by tiny black lines—leans on a piece of furniture; his left hand—articulated by white dots—holds a rectangular white plane, the freely brushed surface of which gives it an unfinished look.

Even study of the many drawings and watercolors that relate to *Harlequin* (p. 214:64–66) does not reveal what, if anything, Picasso might have originally intended for this "unfinished" area. It may have been a sheet of music, as suggested by *Pianist* (p. 215:67); or a guitar, as in *Harlequin Playing a Guitar* (p. 215:68)[3]; or perhaps a painting-within-a-painting. (Although the unpainted buff area of the rectangular plane vaguely suggests a profile, the latter reading is unlikely, and is supported by nothing in the sketches or watercolors.) Whatever Picasso's iconographic intentions here, the decision to leave the plane in its brushy, uneven state set up a pleasing dialogue between it and the flat, relatively even execution of the other parts of the picture, while introducing a note of abandon into the facture that sorts well with the breadth and boldness of the conception as a whole.

The pitching of Harlequin's figure simultaneously on four different lateral axes suggests the motion of the dance—specifically, the stiff, angular, mechanical-toy choreography in works like *Coppelia.* This reading is reinforced by the relation of the simultaneity of axes (and, indeed, by the multiplication of planes denoting the figure itself) to the images of dancing couples (p. 214:66) that date from approximately the time of *Harlequin.*[4] If these studies antedate the painting, they suggest that the configuration of *Harlequin* was arrived at by fusing two figures; at the very minimum, they confirm that Picasso thought of the multiple axiality in terms of a kind of *jaquemart*'s dance.

Harlequin's size, scale and general character represent a departure from earlier Cubism. Prior Synthetic Cubism (1913–14) had retained much of Analytic Cubism's scale and configuration. And to the extent that it involved a decorative transmutation of earlier conventions — e.g.,

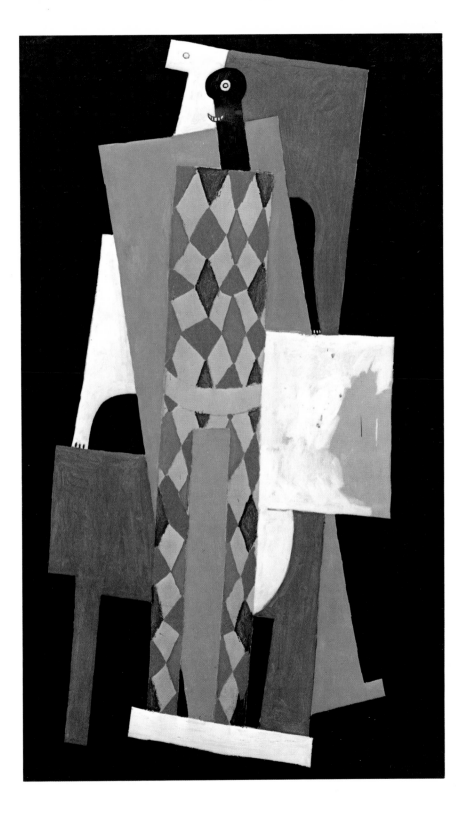

sprays of highly colored pointillist dots for the flickering facet-planes of the monochrome works—it could be considered the other side of the coin of the Analytic style. *Harlequin* breaks with such common denominators and reflects Picasso's realization that the suppression of recessional space in the years 1912–14 had facilitated—indeed, made expedient—a lateral expansion of the picture space, which naturally entailed a more monumental scale than either he or Braque had heretofore explored. The large, simple, flat planes of *Harlequin* are Picasso's entirely personal contribution to the language of Synthetic Cubism, and they pointed in a direction which Braque did not choose to follow when he returned from military service.

STILL LIFE: "JOB." *Paris, 1916. Oil and sand on canvas, 17 x 13¾ inches. (C&N, p. 215)*

Still Life: "Job" takes its name from a brand of cigarette papers whose label—with its curious, lozenge-shaped O—Picasso meticulously copied. The picture is notable for the marked contrast between the abstract, flat and rectilinear planes of the upper left and such trompe-l'oeil details as the high-relief, brown wood molding at the middle right. The braided rope and tassels of Picasso's table covering, which are so fragmentary and difficult to read in many earlier Cubist appearances, are here quite legible. The focus of the composition is the bright red ground of the bottle label. The bottle itself—in stippled reds, tans and blacks—already halves the intensity of this red ground, and the eye then passes through muted greens, blues and violets to the grays and browns of the outer edges.

Picasso often referred to his intimate friends—even sent them whole messages—in a kind of cryptic language full of puns, double entendres and neologisms. Proper names were studiously avoided.[1] In this regard it has been suggested that "Job" was the code name of Max Jacob,[2] whose godfather Picasso had become at the poet's baptism a year before this still life was painted. The name "Job" has a biblical connotation appropriate to Jacob's personality (and to the penury in which he and Picasso lived when they shared a room in the boulevard Voltaire in 1902–1903); its three letters not only constitute a contraction of Jacob's name but "Job" was also the brand name of the cigarette papers the poet used.[3]

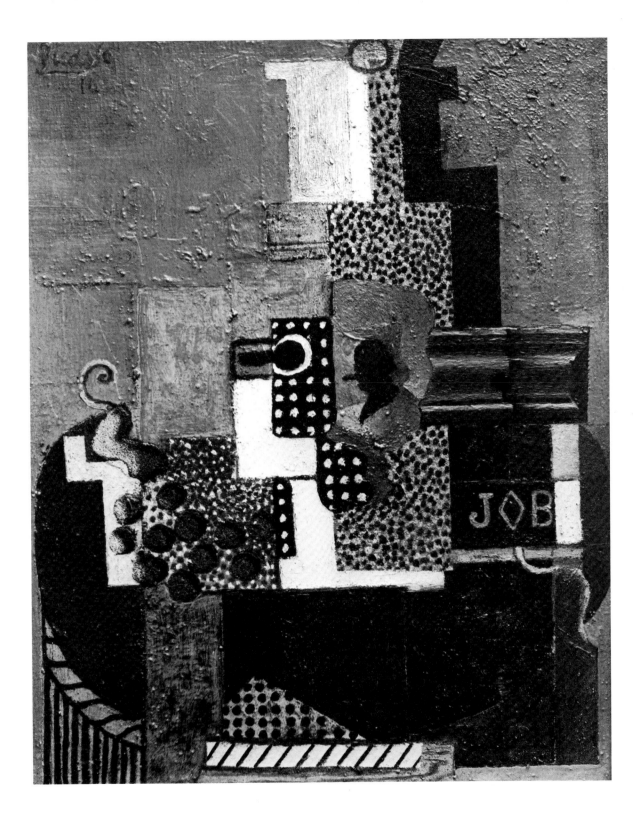

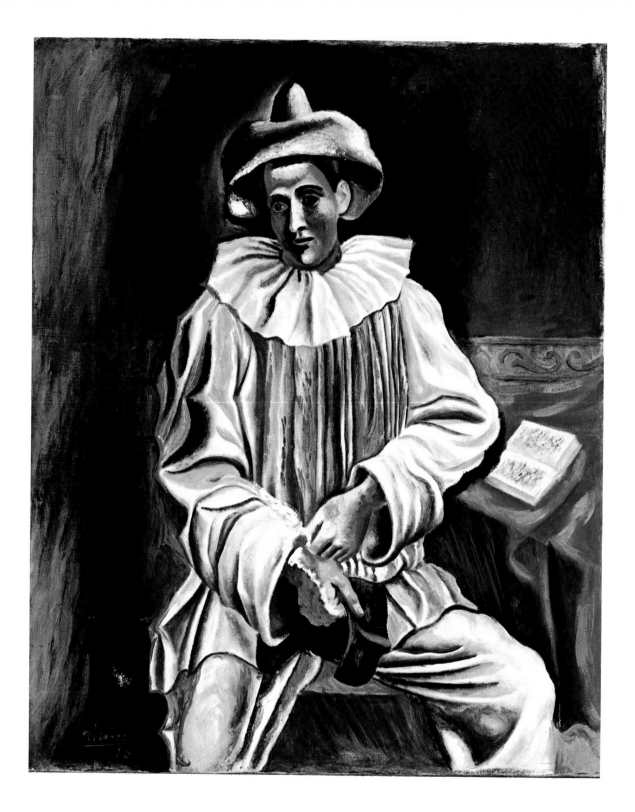

PIERROT. *Paris, 1918. Oil on canvas, 36½ x 28¾ inches.* (*C&N, p. 216*)

Picasso had worked in a variety of styles up to the out-break of World War I—almost entirely successively, how-ever. This sequential development was now to change, for the realistic imagery to which he turned in 1915 in no way signaled an end to his use of abstraction. Picasso's simultaneous exploration of many styles from that point on constituted an artistic practice previously unexampled in the history of art.

As his battery of styles diversified through the 1920s and 1930s, Picasso retained the capacity to summon up any one of them—although he usually borrowed frag-mentarily from them rather than resurrecting them inte-grally. While a single style tended always to dominate at any given moment, Picasso could and did work in more than one manner in a single week—or day. The artist has observed that different subjects may require different stylistic means.[1] But the situation is not that simple since Picasso's preferred and rather conventional subjects—the single figure and the still life—were repeated in many different styles. On the contrary, it might be argued that style itself somewhat usurped the prerogatives of subject matter in communicating content. Thus, where an earlier artist would have chosen a battle scene or revel to express violence or sensual delight, Picasso might paint the same still life in an angular, expressionist fashion with hot, clashing colors, or alternatively, in an arabesqued manner with a rich, decorative palette.

Even within the realism with which Picasso explored the theme of Pierrot in different images of 1918 there is a considerable esthetic and expressive range. The line draw-ing here, for example, has a classic purity, which relates it to many of Picasso's "Ingresque" sketches of the war years. The delicacy and fragility of the line are at one with the airiness and ephemerality of the figure, who seems to exist in a poetic world remote from our own. The slight tilt of Pierrot's head and the inclination of his eyes establish a mood of reverie and nostalgia largely absent from the oil painting.

In the oil *Pierrot*, as in an elaborately modeled pencil study for it (p. 216:70), the sculptural style endows the figure with a more immediate physical presence. Here he is less the evanescent personage of the Italian Comedy than the professional dancer costumed as Pierrot. He has removed the mask that characterizes him when active in

PIERROT. *1918. Silverpoint, 14³⁄₁₆ x 10¹⁄₁₆ inches. (C&N, p. 216)*

his role (p. 216:71), and the passivity of the moment is symbolized by the book opened on the table. In both drawings, Pierrot is pensive and self-absorbed; in the painting he appears peculiarly blank and abstracted. Nor is his facial expression enlivened by the green shadow under the left eye—part of a system of sour complementary greens and reds Picasso used with curious indecisiveness to model parts of the costume, and then moderated to establish a larger contrast between the tablecloth and background. The artist seems to have been much more at home in the drawings of Pierrot than in the painting, in which the handling of the color and the patterning of the drapery on Pierrot's right arm—a scalloping almost autonomous in its shapes—introduce a note of abstraction out of harmony with the realism of the conception as a whole.

Picasso had not painted theatrical performers since 1905, when they were drawn primarily from the circus world. His collaboration with the Russian Ballet, beginning in 1917 (he was to marry Olga Koklova, one of its leading ballerinas, the following year), was the inspiration of a large number of Harlequins and Pierrots. Seen primarily as *saltimbanques* in his earlier work, they are now given the particular costumes and attributes that characterize them in the commedia dell'arte.

GUITAR. *Paris, early 1919. Oil, charcoal and pinned paper on canvas, 85 x 31 inches. (C&N, p. 216)*

This is a work of immense figural as well as formal economy. The heraldic and monumental four-colored diamond against which the paper guitar is pinned has always been read as a purely abstract, decorative motif. But it may be considered the ultimate graphic abbreviation for Harlequin—an interpretation consistent with the relative proportions and dispositions of the guitar and prismatic "figure," and reinforced by the presence, at the appropriate juncture, of the words "urinary tract" (*voie urinaire*) which appear on the band of newsprint.[1] The trompe-l'oeil frame with which Picasso surrounded the picture may also have been inspired by his desire to thwart a consideration of the image as primarily a décor.

The diamond-shaped figure, the black background from which it emerges (cf. *Harlequin*, p. 99), and the frame are executed in oil on canvas. The sheet of paper on which the guitar is drawn is attached to the canvas by real pins, which are visible only at close range. We are asked rather to imagine that this sheet is tacked at the top center by a nail, which is in actuality a paper cutout shaded in trompe l'oeil, bent out at a slight angle to "cast" a simulated shadow and pinned to the canvas in the same manner as the guitar. Braque and, soon afterward, Picasso had introduced trompe-l'oeil illusions of nails and their shadows in their high Analytic Cubist pictures. Critics have usually associated this practice with the artists' desire simply to reinvest the image with "reality," a motivation that subsequently led them to introduce lettering and then collage. But the trompe-l'oeil nails had another, more subtle purpose—that of distinguishing by contrast the special nature of Analytic Cubist space. Painted in a conventionally illusionist manner, they predicated a second, "naturalistic" spatial layer above the unconventional, ambiguous, abstract (but ultimately also illusionist) space of the remainder of the picture. In *Guitar*, the nail serves a comparable exegetical purpose within the framework of Synthetic Cubism. Since it is not a real nail, it belongs to the world of representation. Yet as a piece of paper pinned *on top* of the canvas and bent outward from it, it forces a distinction between the lateral space of the picture plane and the "relief" space in front of it.

The guitar itself is represented by a combination of three strings crossing a sound hole and a black shadow whose right contour determines the curvilinear front of the instrument and whose left defines its rectilinear back plane. The indented or "notched" pattern of the latter is echoed by the right-hand contour of the pinned paper and by the corners of the painted frame.

Guitar was dated 1916–17 in Zervos' catalogue raisonné, but the strip of newspaper pinned to the bottom of the guitar to represent its shadow is dated February 11, 1919.[2]

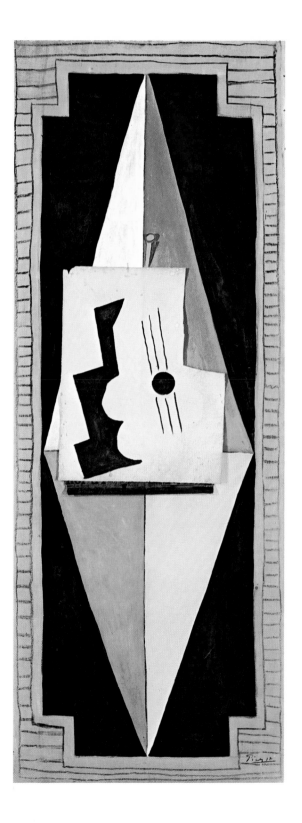

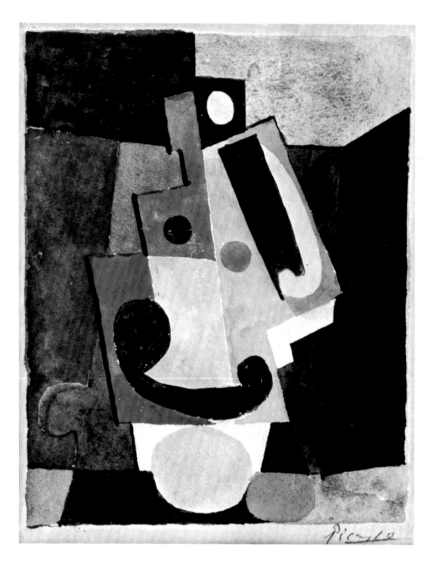

SEATED WOMAN. *Biarritz, 1918. Gouache, 5½ x 4½ inches. (C&N, p. 216)*

The seated figure—particularly the seated woman—has been a central theme in the work of Picasso since his student days in Spain. The artist has re-created the subject in a wide range of styles as exemplified by the two works on this page, both executed during the same year. The design of the small gouache is typical of many of Picasso's Synthetic Cubist works after 1915, in which the composition is articulated along two diagonal axes and planes seem to be laid lightly upon one another in shallow space.[1] Here various areas of the composition are inte-grated in part by the repetition of stylized motifs. In some cases, the symbolic meaning of these forms is sometimes suggested by their shape, in others, by their position or their symbolic role in Picasso's other work. Often, of course, the meaning is ambiguous or unassignable. In addition to their formal uses, the circles in this composition have a wide range of metaphorical implications—a face on dark hair or the aperture of a mask; a heart or breasts, fists or chair knobs; feet or footstools (both of the latter were explicitly drawn in previous versions of this theme). The principal colors of this work are browns, yellows, blues and oranges, relieved by olive-green and tan and accented by one red spot. *(Elaine L. Johnson)*

RICCIOTTO CANUDO. *Montrouge, 1918. Pencil, 14 x 10⅜ inches. (C&N, p. 217)*

Although an expert draftsman in the traditional sense, Picasso had rarely drawn "realistic" portraits between 1906 and 1914. This one represents a type of composition he rendered frequently in the years immediately following that period of extraordinary innovation. Many of its qualities—the sitter's pose, the gesture of his left hand, and most important, the use of fine line to delineate all forms and surface incidents—recall the work of Ingres.

Canudo (1879–1923), an Italian, had been part of Picasso's circle in Paris since 1902. He was a novelist, music and film critic, and co-founder of the Cubist-oriented publication *Montjoie!* During the war, which disbanded the Cubist group, he was a member of the Garibaldi Corps and was later in the Zouaves. *(Elaine L. Johnson)*

TWO DANCERS. *London, summer 1919. Pencil, 12¼ x 9½ inches. (C&N, p. 217)*

SLEEPING PEASANTS. *Paris, 1919. Tempera, 12¼ x 19¼ inches. (C&N, p. 217)*

Sleeping Peasants reflects an aspect of Picasso's study of Ingres quite different from that which we see in many of his classical line drawings. Here, in the foreshortened head and upper torso of the woman's figure there are mannered effects reminiscent of the French painter's late style, as exemplified by his *Bain turc*.[1] But the effect of Picasso's drawing is more monumental, and in that respect this small gouache anticipates his more colossal "Roman" or "Pompeiian" figures of the early twenties (pp. 115, 117).

Comparison of the finished picture with its preparatory drawing (p. 217:72) provides a lesson in the functioning of a master composer. In the background, a house has been added, whose rectilinear flat planes act as a foil for the sculptural and organic forms of the peasants. A number of changes have made the painting's composition more compact, interlocking its two figures in a more mutually sustaining manner. The young man's right elbow has been extended so that it abuts the right knee of the girl, while his left leg has been placed in front of his right one and swung over to support her head. The girl's right calf and both of the boy's arms have been rendered abnormally broad. In combination with their sculptural modeling, these colossal members endow the figures with epic weight and solidity.

This bulk makes them seem very much of the earth they work, tying them closely to the cycle of nature, to which they are also bound by the sunlight that permeates the scene. The heat of the sun and the exaggeration of the figures' mass also intensify the sense of exhaustion in their sleep. It is as if the feeling of great weight in their tired bodies had found its counterpart in their shapes. We imagine their prior lovemaking—implied by the disposition of their bodies—to have been primal in nature, more procreative than erotic. (That Picasso's own associations were of this order is suggested by his use of the face of this same peasant girl, similarly foreshortened, in a *maternité* drawn at about this time, p. 217:73.)

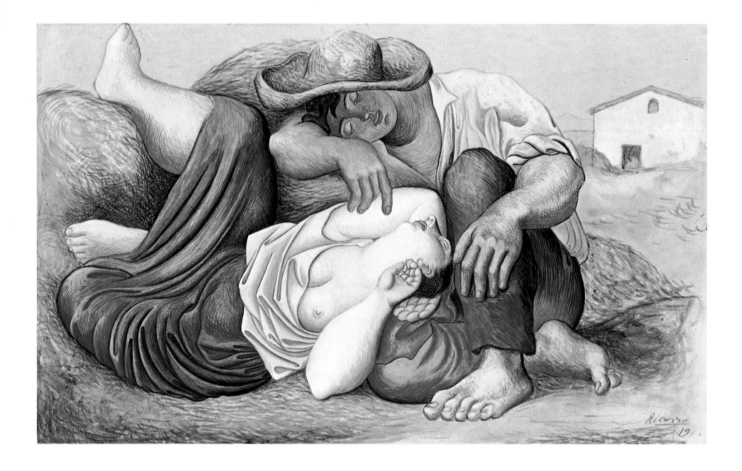

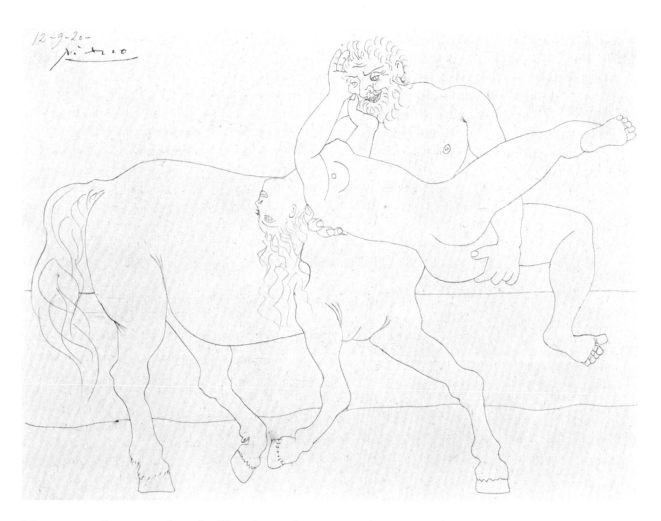

NESSUS AND DEJANIRA. *Juan-les-Pins, September 1920.*
Pencil, 8¼ x 10¼ inches. (C&N, p. 217)

In September 1920, while vacationing at Juan-les-Pins on the Mediterranean, Picasso executed five drawings and a watercolor based on the theme of the centaur Nessus' attempted rape of Hercules' bride Dejanira while ferrying her across the river Evenus. On the Riviera years later he observed: "It is strange, in Paris I never draw fauns, centaurs or mythical heroes . . . they always seem to live in these parts."[1] Picasso read and illustrated classical stories frequently during the twenties and thirties (this one is recounted in Ovid's *Metamorphoses*, which he would illustrate in 1931), but he generally used mythology as a point of departure for personal glosses and private fantasies. In the watercolor version of this theme

(p. 217:74), for example, Nessus is restrained by a satyr who is entirely the artist's invention. As graphic projections of man's primitive energy and potential violence the classical combinations of man and beast such as the centaur and Minotaur especially interested Picasso; they also pleased him, as he loved to draw animals.

In the first version of this subject, dated September 11 (p. 217:75), the drawing is rapidly executed and nervously contoured; Nessus' lip-smacking leer is almost caricatural. In the Museum's more restrained drawing, executed the following day, the line is smoother and more continuous, hence more "classical" in appearance. Although the postures of the protagonists are substantially the same in the two versions, Picasso has here introduced refinements such as the foreshortening of Dejanira's right foot and the alignment of her chin with Nessus' back.

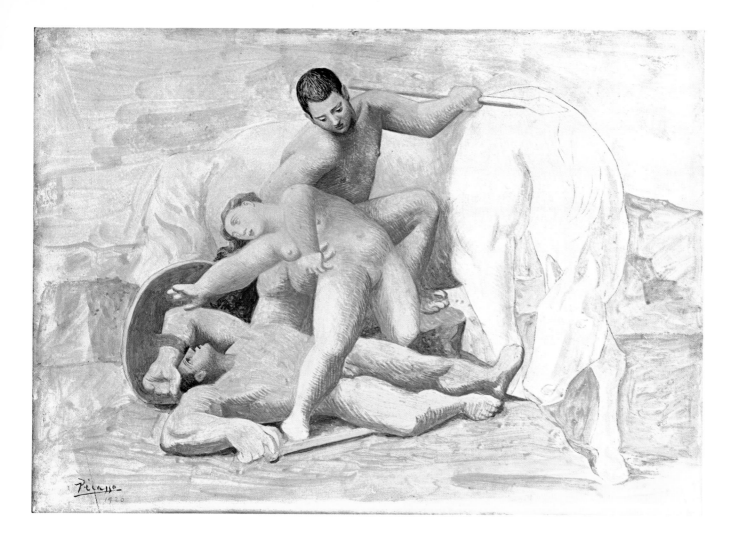

THE RAPE. 1920. *Tempera on wood, 9⅜ x 12⅞ inches.* (*C&N, p. 218*)

We do not know if this picture was intended to illustrate a particular ancient story such as the Rape of the Sabines, but its monumental, triangular figure group unquestionably evokes antique sculpture. The dead warrior in particular harks back to the figures in the angles of ancient Greek pediments, even as he anticipates the soldier of *Guernica*. The proportions of the figures are not classical, yet it is precisely their exaggerated bulk which, like their terra-cotta color, makes them seem more like sculptures than living figures. The setting and background constitute a somewhat dematerialized foil that projects the plastically modeled figure group forward, the chalky white of the horse and the pale brown and blue of the earth and sky enhancing its terra-cotta tones by contrast.

The nature of Picasso's line cast Nessus' rape of Dejanira as a lively, psychologically animated, narrative episode. In *The Rape*, the figures' simplified, almost "archaic" contours, insistent sculptural bulk and reserved expressions make them seem stolid and almost inanimate by comparison—as if frozen in the enactment of a timeless mythological event.

THREE MUSICIANS. *Fontainebleau, summer 1921. Oil on canvas, 6 feet 7 inches x 7 feet 3¾ inches. (C&N, pp. 218–19)*

In the garage of the villa he rented at Fontainebleau for the summer of 1921 Picasso painted three very large canvases: this and another version of *Three Musicians* (p. 218:76), and their neoclassical counterpart, *Three Women at the Spring* (p. 115). The exceptional size and classical ternary form of these compositions and the solemn, almost hieratic demeanor of their figures suggest that Picasso intended these pictures not only as summations of his contrasting Synthetic Cubist and classical realist styles, but also as personal challenges to the monumental art of the past.

Three Musicians plays a role in Picasso's oeuvre different from that of its colossal predecessor of fourteen years earlier, *Les Demoiselles d'Avignon*. In the course of its execution, *Les Demoiselles* had evolved from a summation of earlier work to departure toward the new—an exploration left unfinished, and resolved only in succeeding paintings. *Three Musicians*, on the other hand, represented a magisterial recapitulation of the artist's powers, rather like a "masterpiece" in the old guild sense. Picasso made no studies for either version of *Three Musicians*; the whole history of Cubism, particularly that of the five preceding years, had prepared him for them.[1]

Although there are no studies for *Three Musicians*, certain of Picasso's Synthetic Cubist pictures of 1920 anticipate its pairing of Harlequin and Pierrot in frontal poses. In some of these, the two hold musical instruments (p. 219:79); in others, they are seated at a table (p. 219: 80). Both motifs are combined in *Three Musicians*, where Pierrot plays a recorder (or clarinet) and Harlequin a guitar, and both are seated at a table on the brown top of which are a pipe, a package of tobacco and a pouch.[2] (These small objects and, even more, the mini-hands of the figures establish the monumental scale of the composition through their contrast with the large panels of color.) The barefooted monk, or domino, on the right—the addition of whom made *Three Musicians* Picasso's first three-figure Synthetic Cubist composition—sings from a score held in his hands.[3] The monk is totally unanticipated in prior work save for a charcoal sketch (p. 219:81) dating from shortly before the painting and showing him in a very different pose.

The three maskers are realized in flat planes whose angularity recalls the *papier collé* origin of the Synthetic Cubist morphology. Their zigzag contours, in combination with sudden transitions of value and hue, suggest the sputtering cacophony of their serenade. The colored shapes are less jigsawed in a single plane than laminated on top of one another, although the order of their layering is not wholly consistent. (The blue, for example, is in front of Pierrot's white costume above the table but behind it under the table.) Shapes overlap increasingly toward the center of the composition in a progression that recapitulates in Synthetic Cubist terms the graduated opacities from background to foreground planes in the Cubism of 1910–11. Thus, despite the similar magnitude of the three figures, there is a clear staging in the sizes of the picture's constituent shapes from the framing edge to the center of the composition.

The centrality resulting from this progression is paralleled in the quantification and location of the color. Browns govern the margins of the picture absolutely and are present throughout. Black and white, next in the order of quantity, begin only at some distance from the right and left edges of the field respectively and cut across each other. (Thus, while the monk is largely black and Pierrot primarily white, the blacks are echoed in the latter's arm, mask, pipe and pouch, while the former's sheet of music is white.) Blue panels, few in number, comprise slightly less surface area than the black or white and are concentrated closer to the center of the composition. Finally, the only bright hues—the yellow and orange of Harlequin's costume and guitar—are centered near the vertical axis of the composition (and are less dispersed than any other tones from the horizontal axis as well). Such a compositional hierarchy, in combination with the iconic frontality and frozen postures of the figures, might seem more appropriate to a Byzantine *Maestà* than a group of maskers from the commedia dell'arte; but it is precisely this structuring that informs the monumentality of *Three Musicians* and endows it with a mysterious, otherworldly air.

As there is neither modeling in the paper-thin figures nor atmospheric shading in the space around them, the picture is devoid of any illusionism that might compromise its flatness. There is, however, a purely schematic indication of space—a boxlike "room" in which the figures are understood to be standing. Its perspective orthogonals are determined by the edges of the variously lit brown planes that represent the floor, side walls and ceiling. The

system is not consistent, however, for the horizon line is higher on the left than on the right.

That this space is finally a kind of stage space recalls the theatrical antecedents of *Three Musicians*. The frequent appearance of commedia-dell'arte figures in Picasso's work of the years just previous to this picture stemmed from his collaborations, beginning in 1917, with the Russian Ballet. Of these, the most important for *Three Musicians* was the ballet *Pulcinella*—its choreography based directly on commedia-dell'arte types—which Diaghilev produced the year prior to Picasso's summer at Fontainebleau. The score was a reworking by Stra-

vinsky of music by Pergolesi, and its fusion of "antique" and modern is echoed by the hieratic mode within the Cubist orchestration of Picasso's composition.[4]

The viewer's conceptual reconstruction of the subject from the ideographs that identify its parts is readily accomplished, except perhaps in the case of the much-segmented dog under the table, who is easily overlooked. This interpolation from Picasso's domestic life is also the central motif of an important picture titled *Dog and Cock* (p. 219:82), painted in Paris either just before or just after the summer at Fontainebleau. While in the latter picture the dog strains, mouth watering, toward the cock on the table, in *Three Musicians* it lies quietly, as if charmed by the sounds of the nocturnal music.

The dog in *Three Musicians* is a whimsical motif plastically as well as iconographically. To form its gestalt we must first distinguish the particular brown tone of its head from the four other browns that adjoin it. Then this shape must be assembled with the segmented forelegs (to the left of the leg of the red-brown table), the body and rear leg (framed by Pierrot's white trousers) and the drolly isolated tail (projecting between the Harlequin's legs). The dark-on-dark treatment of the dog is reminiscent of Manet's handling of the cat in *Olympia*, where in order to distinguish the animal we must make fine discriminations at the dark end of the value scale. In the Manet, as here, the composition combines the nuancing of close values with a bold, posterlike contrast of light and dark that is made all the more dramatic by the suppression of the middle tones.

THREE WOMEN AT THE SPRING. *Fontainebleau, summer 1921. Oil on canvas, 6 feet 8¼ inches x 7 feet 3¾ inches. (C&N, p. 220)*

This capital example of Picasso's neoclassicism is as comfortable a configuration as that of *Three Musicians* is taut. Although its rhythms turn gracefully around the superb play of hands in the center, its pictorial pleasures reside less in the lateral adjustment of the composition than in its compelling illusion of sculptural relief. Picasso's isolation of this quality through bold and simplified modeling—at the cost of complex lateral articulation and rich pictorial detail—suggests a limited kinship with the "primitive" early Cubism of 1908, as well as with certain post-Gosol works such as *Woman Combing Her Hair* (p. 37) and *Two Nudes* (p. 39). As in all such works the sculptural effects are finally, however, those of relief—as opposed to modeling in the round—as is seen in Picasso's dissolution of the solids of the three women into the patterning of the composition as a whole.

The classicism of *Three Women at the Spring* may be more one of motif and mood than of esthetic structure, though the pneumatic volumes of the women do recall—at a considerable remove—certain monumental paintings the artist saw on a visit to Pompeii in 1917. Picasso's figures do not have the ideal features or proportions of classical Greek art. Nor does their superhuman size have any kinship with the protean figures of Michelangelo—which seem to achieve their magnitude through an exteriorization of passion and energy. Michelangelo's Sibyls are muscle and sinew; Picasso's women are terra cotta and marble.[1] It is precisely their architectural character—the folds of drapery are like the fluting of marble columns—that endows the picture with its conviction of order and stability.

The theme of women at a spring or fountain was possibly suggested by the very name of the town (Fontainebleau) in which Picasso and his family were spending the summer.[2] There are at least nine drawings and paintings of this subject (p. 220:83, 84) that precede the Museum's *Three Women at the Spring*, as well as seven sketches for the hands and heads alone. In addition, there are three allegorical drawings (of which the Museum possesses one, p. 116) and a painting that proceed from the same general inspiration.

Many of the preparatory studies for *Three Women at the Spring* show the central woman standing in front of the stone fountain. But only by hiding her lower torso could Picasso clear the center space for the play of hands. As the sketches progress, both the woman on the right (whose hands hold her crossed legs in earlier versions) and the woman on the left are inclined increasingly toward the center of the field. The marvelous charcoal sketches for the former's two hands (p. 220:85, 86), one holding the jug, the other on her lap, have an even greater plasticity than the rendering in the painting.

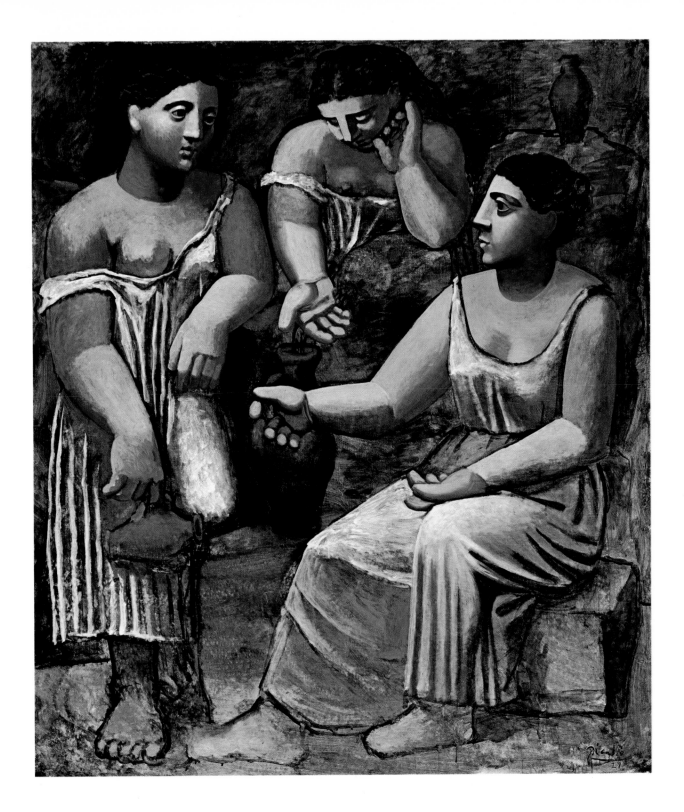

LA SOURCE. *Fontainebleau, July 1921. Pencil, 19 x 25¼ inches. (C&N, p. 220)*

In his previous classical period, Picasso had not used themes from antiquity; but in his neoclassical works after 1920, the subjects of Greek mythology occurred frequently in his art, as seen here in *La Source*.[1] Picasso spent the summer of 1921 in Fontainebleau, and this composition probably found its basic inspiration in a painting in the royal château there.[2] The "Nymph of Fontainebleau" (p. 220:87), a fresco honoring the Goddess of the Hunt, depicts an elegant nude with drapery, seated amid tall grasses; a jug from which water pours; and a dog. Picasso transforms the goddess into a woman of peasant sturdiness, and the aristocratic hound into a boxy, square-nosed, water-lapping beast, whose formal modifications were possibly suggested by the dogs of the nearby Fountain of Diana (p. 220:88). *(Elaine L. Johnson)*

NUDE SEATED ON A ROCK. *1921. Oil on wood, 6¼ x 4⅜ inches. (C&N, p. 221)*

Of all the "colossal" or "Pompeiian" nudes Picasso created, *Nude Seated on a Rock* is perhaps the smallest in actual size, being no larger than a postcard. The illusion of monumentality the figure engenders is especially intriguing in view of the fact that it is placed in a generalized environment with no other elements of known size by which to gauge its scale. This emphatic sense of largeness is achieved through the alteration of one dimension of the nude's proportions (compared to her torso, each limb is double the girth—but not the height—of the norm), as well as by the dramatic modeling of the flesh. The introspective attitude of the woman is atypical of the works Picasso created in this particular style, most of which are impersonal in feeling. *(Elaine L. Johnson)*

THE SIGH. *Paris, 1923. Oil and charcoal on canvas, 23¾ x 19¾ inches. (C&N, p. 221)*

Around 1923 Picasso began to create figure compositions such as *The Sigh* which, in comparison to the colossal nudes, were more sentimental in feeling and delicate in execution. "Picasso was living in considerable splendor and elegance on the rue la Boétie in Paris. Perhaps the new luxuriousness of his life, plus his interest in ballet, accounts in part for the gentle sweetness and almost romantic mood of *The Sigh*, its deliberate and courageous dandyism in an era when most artists were afraid of sentiment and fashion.

"*The Sigh* is among other things a remarkable *tour de force*. The figure, the chair and the cane seem to have been drawn with headlong certainty, without visible corrections of any kind; the patches of thin color are restrained and deft.

"The picture probably horrified the more harsh and dogmatic of the artist's former Bohemian colleagues. But then, as he once remarked, 'Do these people think I paint only for them?' "[1] *(Elaine L. Johnson)*

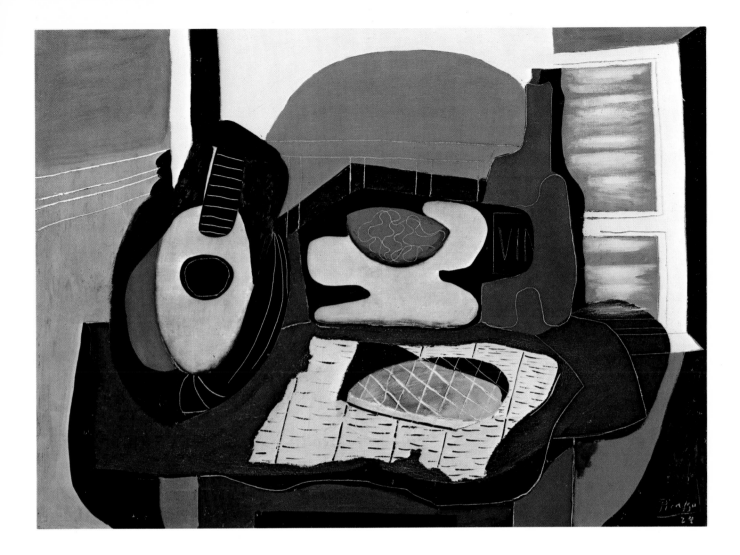

STILL LIFE WITH A CAKE. *May 1924. Oil on canvas, 38½ x 51½ inches. (C&N, p. 221)*

While the scaffolding of this composition is still mainly rectilinear (e.g., the wall molding, balcony railing, window and table legs) its multiplication of curves presages a major direction in the Cubism of the following years. *Still Life with a Cake* shares its airy, relaxed configuration and its meandering, intentionally awkward drawing with a group of other still lifes of 1924 in which, as here, Picasso first laid down flat, softly contoured areas of quiet color for the principal objects and then drew additional contours by scoring the pigment with the wooden end of the brush to reveal the lighter underpainting. This practice created a characteristic line, generally fluid—almost automatic—and largely uninflected except where the wooden tip has caught in the weave of the canvas (as in the bottom contour of the tablecloth).

STUDIO WITH PLASTER HEAD. *Juan-les-Pins, summer 1925. Oil on canvas, 38⅜ x 51⅝ inches. (C&N, pp. 221–22)*

This is one of Picasso's most powerfully condensed and intricately interwoven compositions. The packing of the surface, even where seemingly purely decorative—as in the heraldic fleurs-de-lis of the wallpaper—reinforces the urgency and emotional pressure of the picture, whose disturbing organic implications are intensified in turn by the unusual viscosity and fleshiness of the dryly brushed pigment. Despite the almost "all-over" patterning, the picture never seems too crowded because Picasso has maintained a carefully articulated and characteristically Cubist hierarchy in the design and coloring: the still-life objects are progressively multiplied and projected forward toward the center of the field; such saturated colors as the red of the tablecloth are also centered, leaving the less articulated margins of the picture to the comparatively recessive pale yellow, pale blue and olive-green.

Studio with Plaster Head is at a dividing line of Picasso's career. Its underpinning remains Cubist, but aspects of its facture and color and, above all, its imagery point to the surreal and expressionist dimensions his art would increasingly assume over the following two decades. The mixture of the organic and inorganic in its iconography is not, in itself, unusual. It is rather the blurring of these distinctions, prompted less by the novelty of some of the motifs than by their provocative juxtapositions, which engenders the picture's special poetry. Picasso's quasi-surreal displacement of objects from their conventional environments denatures them, and thereby releases their potential for new and unexpected connotations when set down, as here, in an "alien" context.

What are we to make, for example, of the lone yellow and orange apple in the center? It has been virtually isolated from other references to the conventional fruit bowl iconography. Even the sprig of leaves seems rather more identified with the plaster fragments of classical sculpture—perhaps as an allusion to the laurel wreath, but certainly as an organic foil for the inanimate limbs. In this context of dismembered anatomies, the shape and scale of the apple suggest a breast (an anticipation of the apple-breasts in the pictures of the 1930s, p. 139); isolated against the scenery of the toy theater made by Picasso for his son Paul, it stands enigmatically ten feet tall in the piazza of a street scene that recalls the set for *Pulcinella* (p. 221:89).[1] The toy theater's scale, which promotes a

confusion of its scenery with a vista through a window, epitomizes the constantly modulating realities of this picture's imagery.

Picasso's characteristic forms of neoclassicism, as exemplified by such works as *Nessus and Dejanira*, *The Rape* and *Three Women at the Spring*, disappeared from his painting (though not his drawing) in 1924. *Studio with Plaster Head* was conceived the following summer at Juan-les-Pins. If, as had happened before, this Mediterranean ambience induced in Picasso a dream of the classical, that dream had become a troubled one. The classical head, for instance (one of the earliest appearances of the "double head," here actually a triple one), has been partially brought alive to give the deeply disquieting effect of an individual still half-immured in plaster.

The basic pattern of the double head—usually the presence of a clearly defined profile within the full face, as in the traditional "man-in-the-moon" image—originated in the Synthetic Cubist flattening and stylization of the light and shaded planes of the head.[2] Except in very rare instances, however, integral profiles within the full face are not defined as such prior to 1925 (p. 221:90, 91).[3] Only when Picasso distinguished the different views by investing them with contrasting expressive and psychological content was the double head proper born. In *Studio with Plaster Head*, the white and ocher profile of the "philosopher" is as frank and open as his frontal eye. However, the blue right-face that joins the profile to form a three-quarter view is literally and figuratively more opaque; the disappearance of the beard and mustache are but outward signs of the altered ego. The enigma of the "philosopher" is further heightened by his mysterious shadow, which when read in conjunction with the frontal eye, completes the full front view of the head. Not at all the silhouette we would expect the head on the table to cast, this dark blue shape implies the presence of still another persona.

Picasso's neoclassicism never had an academic air. Nor did it exhibit a nostalgia for classical fragments. This, one of their first appearances,[4] has less to do with neoclassicism than with Surrealism and Expressionism. For while they may be read conventionally as simple classical fragments, the strangely human severed arm and leg really constitute forecasts of the destruction and cruelty that would be more overtly manifested in the iconoclastic motifs of Picasso's work over the ensuing decades. The truncated arm holding a fragment of a spear (that may

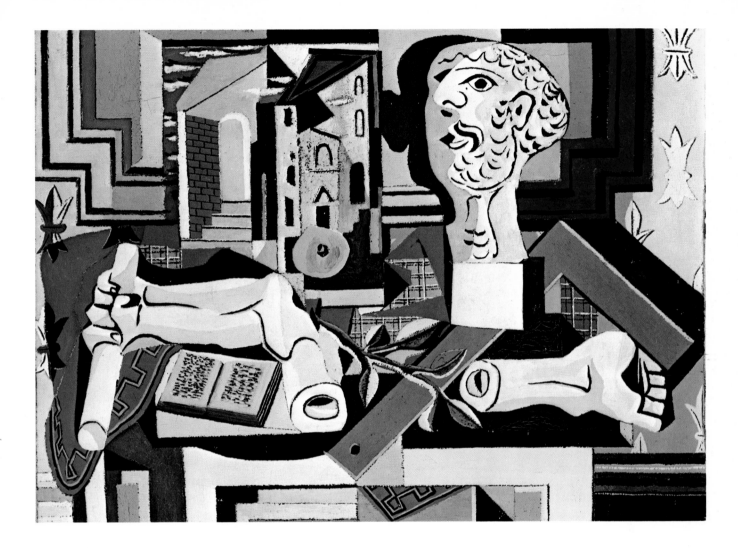

also be read as a scroll) foreshadows the segmented limb of the dead soldier in *Guernica* (p. 237:151), and the plaster head, though less patently, anticipates that soldier's severed head. Picasso's awareness of the potential for expression of aggressive emotions within the convention of the sculptured head isolated on a stand is reflected in his later image of a bull's head impaled on a rod and set upon a socle like a sculptured portrait (p. 153). This later picture exemplifies what has been called the "still life of cruelty,"[5] whose origins are to be found in *Studio with Plaster Head* and in *Still Life with Ram's Head* (p. 221:92), also of the summer of 1925.

All this is not to say that classicism as such as an unimportant aspect of the iconography of *Studio with Plaster Head*. The open book is an uncommon allusion to literature in Picasso's still lifes, and its juxtaposition with the classical sculpture suggests that it relates to the ancient texts which the painter read and illustrated in the twenties and thirties. But as would subsequently be the case with certain Surrealist artists, Picasso became primarily responsive to that which was menacing and violent beneath the apparently orderly structure and smooth veneer of the classical world image.

Such "inverted" classicism had been the poetic pre-

occupation of the protosurrealist painter Giorgio de Chirico, whose spirit hovers about *Studio with Plaster Head*. The Italian's early work was currently being celebrated by André Breton, who had launched the Surrealist movement the year before, and with whom Picasso had increasing contacts.[6] De Chirico's metaphysical still lifes had represented the first fully realized translations into painting of the Symbolist poets' technique of enigmatically juxtaposing apparently unrelated objects in a single image (p. 222:93). His truncated classical marbles, sometimes either indistinguishable from (p. 222:94), or paired with (p. 222:95), fragments of human anatomy, provoke a malaise not unrelated to that of *Studio with Plaster Head*, and his boxlike pictures-within-pictures (p. 222:96) anticipate the compositional functions of Picasso's toy stage. And while Picasso's carpenter's square had already appeared years earlier in his Analytic Cubist *Architect's Table* (p. 73), its presence in *Studio with Plaster Head* rather suggests the enigmatic contexts in which de Chirico used such objects.[7] In *The Architect's Table* the carpenter's square appeared as a studio property —an everyday object kept about to check the alignment of stretchers. In the context of *Studio with Plaster Head*, it might be a hint about the man portrayed in the sculpture, or a symbol of the master builder who wrought the miniature city of the toy stage. Its implication of man-made geometrical order is contrasted with the suggestions of organic nature in the sprig of leaves and apple, while its rectilinear contours counterpoint the irregular forms of the plaster anatomy, particularly the arm at the left, in apposition to which it functions in the composition.

FOUR DANCERS. *Monte Carlo, spring 1925. Pen and ink, 13⅞ x 10 inches. (C&N, p. 222)*

Closely identified with the ballet from 1917 through about 1925, Picasso created costumes, decor and curtains for several productions presented by Sergei Diaghilev's Russian Ballet. He traveled occasionally with the troupe and in 1918 married a ballerina, Olga Koklova. His association with dancers was undoubtedly responsible for his renewed interest in the human figure, which had rarely appeared in realistic terms in his work since the beginning of the Cubist epoch. *Four Dancers* was executed during Picasso's visit to Monte Carlo during the ballet season of 1925, when he was rarely without a sketchbook while attending rehearsals.

Before Picasso, few important artists of the Western European avant-garde had worked for the ballet. His collaboration was at first reluctant and evoked criticism from fellow artists, who considered the genre a reactionary form. Such objections were quelled, however, by the creation of *Parade*, a ballet on which Picasso collaborated with the writer Jean Cocteau, the composer Eric Satie, and the choreographer Léonide Massine. Unprecedented in their originality and modernity, the costumes which he designed contributed to the shock with which the production was received. Among them was a ten-foot-high Cubist construction, a horn-blowing skyscraper wearing cowboy chaps, representing the "New York manager." Inside it, a dancer moved to novel music that included a cacophony of sirens and a dynamo.

Picasso's other important works for the ballet of that time included *Le Tricorne* (1919), *Pulcinella* (1920), *Cuadro Flamenco* (1921), *Mercure* (1924), and *Le Train Bleu* (1924).[1] Since that era, when his personal acquaintance drew him naturally to the world of the dance, Picasso's work with theatrical productions has been sporadic.

Whereas Picasso's designs for costumes and decor were often relatively abstract in form, his drawings of dancers in action were basically classical. In *Four Dancers* the proportions are relatively conventional, except for the small head of the male dancer and his elongated leg. A sense of the quickness and lightness of the figure is enhanced by means of broken outlines, which cause the eye to leap from point to point, and by the omission of modeling and shadow. *(Elaine L. Johnson)*

SEATED WOMAN. *December 1926. Oil on canvas, 8¾ x 5 inches. (C&N, p. 222)*

SEATED WOMAN. *Paris, 1927. Oil on wood, 51⅛ x 38¼ inches. (C&N, p. 223)*

Picasso explored the potential of the "double head" from 1925 to 1927 in a series of Seated Women of which the picture on the right is at once the most beautiful and most unsettling. The patterns of curvilinear Cubism, exploited for their purely decorative rhythms in such works as the monumental *L'Atelier de la Modiste* of 1926 (p. 223:98), are here put in the service of psychological expression to create "an ideogram of neurosis, threat and domination."[1] The arabesques that define the figure also enclose and inhibit her, producing a sense of isolation and repression heightened by both the painted interior frame and the manner in which the rectilinear wall molding presses in upon her silhouette. In the coloring, whose partial transparency is suggested by the changes that take place where shapes overlap, the heretofore largely decorative harmonies of curvilinear Cubism have soured into uneasy dissonances (orange-red against pink, rose and deeper red) that prepare us for the terror-filled face.

The front face of the woman disappears into shadow. We see only her anxious inner profile which, like the visible crescent of the moon, implies the contours of the more remote darkened area. The terror in the face is expressed by her shrunken right eye—a tiny point as compared to the circle of the left one that stares at us from the shadows—and by her recessive mouth and chin, a particularly expressive form of the profile within the double head to which Picasso would return in the reflected image within *Girl Before a Mirror* (p. 139).

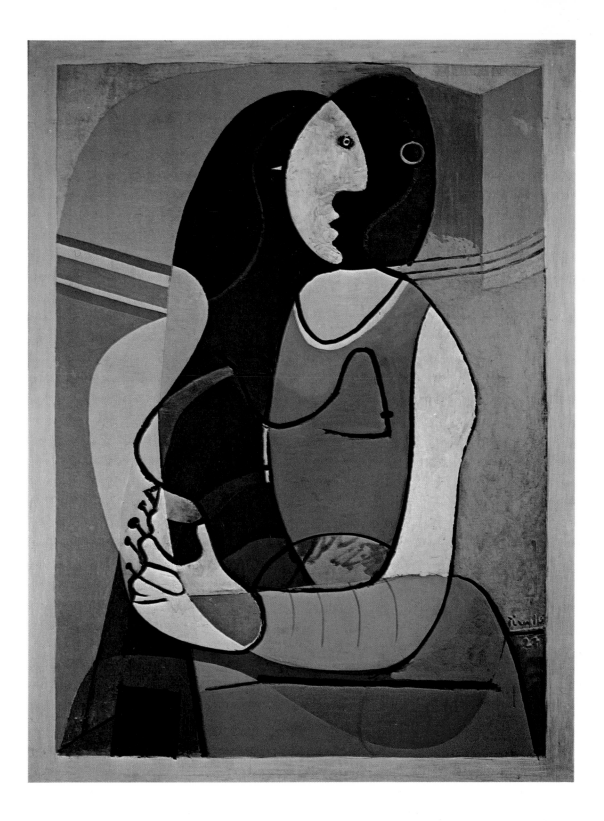

PAGE O FROM LE CHEF-D'OEUVRE INCONNU BY HONORÉ DE
BALZAC. *Wood engraving by Aubert after a drawing by
Picasso, 1926; published 1931; 13 x 10 inches (page size).
(C&N, p. 223)*

PAINTER WITH MODEL KNITTING FROM LE CHEF-D'OEUVRE
INCONNU BY HONORÉ DE BALZAC. *Paris, 1927; published
1931. Etching, 7⁹⁄₁₆ x 10⅞ inches. (C&N, p. 223)*

During 1926 Picasso filled a sketch book with ink draw-
ings unlike any he had made before. They are con-
stellations of dots connected by lines or, better, lines
with dots where the lines cross or end. A few vaguely
suggest figures or musical instruments, others seem ab-
stract. Some are small and simple, arranged three or four
to a sheet; some like the one opposite grew and spread
over the page. All seem done absentmindedly or auto-
matically as if they were doodles.

Later, sixteen of the pages were reproduced by wood-
cut as a "kind of introduction" to a special edition of
Balzac's *Le Chef-d'oeuvre inconnu*, published in 1931 by
Vollard. In this volume, one of the most remarkable illus-
trated books of our time, Vollard printed woodcuts of
many other Picasso drawings both cubist and classic.

Picasso also made a dozen etchings especially for *Le
Chef-d'oeuvre inconnu*. The one above comes nearest
illustrating Balzac's story of the mad old painter who
spent ten years upon the picture of a woman, little by
little covering it over with scrawlings and daubings until
what seemed to him a masterpiece was to others mean-
ingless.

Curiously, Balzac's tale begins in the year 1612 before
a house on the rue des Grands Augustins, the very street
where Picasso was to take a 17th century *hôtel* for a
studio in 1938. *(Reprinted by permission of Alfred H.
Barr, Jr.)*[1]

THE STUDIO. *Paris, 1927–28. Oil on canvas, 59 x 91 inches.* (*C&N, p. 223*)

Although the iconography of Cubist still life sometimes reflected the ambience of the atelier, Picasso seldom painted his studio as such before 1918, and even the images of his working area executed in 1918–21 are little more than records of his surroundings.[1] Only in the mid-twenties did the motif come into its own, when the theme implicit in the methods and facture of Cubism—the process of painting—was associated explicitly by Picasso with the image of the painter at work. In a print for Balzac's *Le Chef-d'oeuvre inconnu* (p. 127) probably etched shortly before *The Studio* was begun, the artist and model were imaged realistically while the picture on the easel was abstract. In this monumental treatment of the theme —which, as an allegory of the relationship of the artist to reality, recalls Velásquez' *Las Meninas*[2]—both the painter and the still life he contemplates are abstract, and the canvas is blank.

The artist is very sparingly imaged. His legs are indicated by two parallel vertical lines; two shorter parallel horizontal lines signify his arms. The back view of his body is almost an isosceles triangle, the right edge of which is common to an inverted right triangle that denotes his body's side view. The roundness of the artist's head is summarized by a gray oval into which a shape recalling the angularity of the salient features intrudes; a third eye, which displaces his mouth, may suggest his visual perspicacity.[3] The imaging of the palette, which is indicated solely by its thumb hole, epitomizes the economy of the whole.[4]

The artist, whose right hand holds a brush, is about to draw the still life at the right, which consists of a fruit bowl and a plaster head on a table partially covered with a red tablecloth. The elements of roundness and angularity in the plaster head are abridged into straight-edged and oval shapes as in the head of the artist. And although its eyes are again vertically arranged, there are only two of them.

Although Cubism had been from the start an art of straight-edged planes that tended to echo the architecture of the frame, the extremes of rectilinearity and economy to which Picasso carried this large picture are less an extension of earlier formulations than a direct counterstatement to the curvilinear Cubism of the two preceding years as we see it in such pictures as *L'Atelier de la Mo-*

diste (p. 223:98) and *Seated Woman* (p. 125). At the same time, *The Studio* is also the two-dimensional counterpart of the pioneering rod and wire sculptures (p. 223: 100) that Picasso completed in the same year. Linear parallelism, and emphasis upon simple straight-edged polygons set off by an occasional circle or oval also characterize these sculptures; they represent the final stage in Picasso's search for sculptural transparency, achieved by delineating only the edges of planes so that the spectator, in effect, looks through them. A not unrelated transparency in *The Studio* makes the green apple visible inside the bowl and allows us to see the yellow canvas through the body of the artist. Other planes such as the darkly shaded section of the red tablecloth suggest the characteristic Synthetic Cubist "folding out" into the picture plane of forms oblique to it in actual space.

Whatever schematic clues Picasso gives for the spatial relationships of the objects in *The Studio*, he totally eschews perspective cues and modeling so as not to qualify the insistent flatness of the composition; lines that would elsewhere in his imagery have converged as orthogonals are here made parallel. The flatness of the space is further assured by the continuity of the linear network through forms which we know to be located on different planes in space. Thus, the diagonal which separates the red tablecloth from the gray tabletop continues through both planes of the fruit bowl to touch the corner of the mirror (or picture frame) on the rear wall.

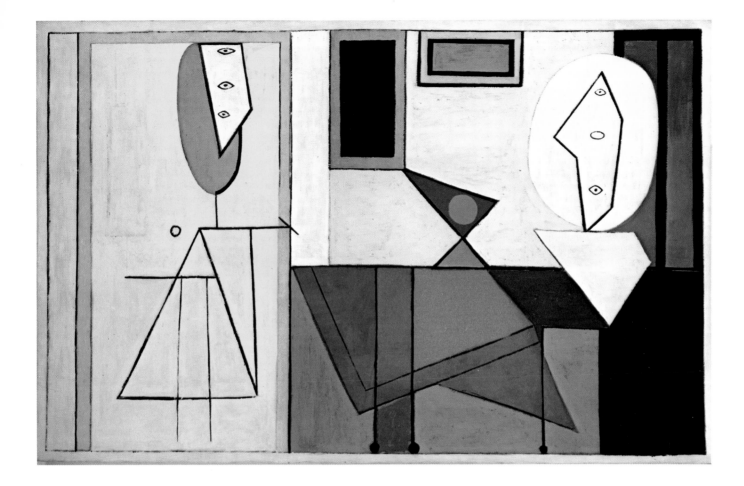

PAINTER AND MODEL. *Paris, 1928. Oil on canvas, 51⅛ x 64¼ inches. (C&N, p. 224)*

The spare rectilinear geometry of *The Studio* gives way in this elaboration of the same subject to a morphological variety that includes the organic (the painter's brown palette) and the decorative (the floral pattern of his rust-colored chair).

The artist is seated at the right on a chair, the passementerie cords of whose arm form a series of black parallel lines at the bottom of the canvas. His head bears a close resemblance to a painted metal sculpture (p. 224:101) of the fall of 1928.[1] In both works an inverted triangle is cut from the top center of the oval of the head, the apex of this negative triangle being also that of the triangle of the nose just below. In both also the oval is divided vertically to represent the light and shaded halves of the face, the light side in *Painter and Model* being turned logically toward the blue window. The features and limbs of the painter have been considerably displaced. His eyes, superimposed on his nose, are one above the other. As in a sketch for the sculpture (p. 224:102)—though not in the sculpture itself—his mouth is represented as a vertical vaginal slit with small hairs on either side. This secondary sexual double entendre is intensified by the rigidly phallic character of the painter's arm, which projects from a point as close to his waist as to his neck, and is in keeping with the general context of the hallucinatory sexuality in Picasso's work of the late twenties. The same type of mouth, in combination with the triangular nose and vertical eyes, appears in a female figure (p. 224:103) executed around the same time as *Painter and Model*.

The interchange or substitution of sexual parts within a single figure, or between male and female, is not uncommon in dreams, as Freud observed, and was already being explored by Surrealist painters, though generally in a more literal and self-conscious way. The nature of Picasso's abstract sign language facilitated such displacements,[2] and it may be that he was encouraged in this by the equation of facial features with sexual members in the art of Oceania, of which the shields, in particular, have been associated with the patterning of the heads of *Painter and Model*.[3]

The model, shown in profile at the left, is usually considered to be an integral female figure. However, the molding that traverses her at shoulder height suggests that the artist in the picture may be working from a female portrait bust propped on a stand.[4] This female face possesses the third eye—aligned vertically with the other two—that had characterized the painter in *The Studio*. As the artist studies this abstract head, the profile he draws on the canvas is realistic—a whimsical reversal of the familiar situation as we see it in the etching for *Le Chef-d'oeuvre inconnu* (p. 127). The conceit that the placid classical profile within the artist's picture disguises quite another personality was elaborated a year later in a picture where the expressionistic profile of a demonic woman is set within the serene outlines of the classical head in a picture on the wall behind her (p. 224:104).[5]

The artist's canvas is aligned vertically with the window behind it so that the white divider of the latter is prolonged as a vertical black panel into the grisaille picture-within-a-picture, and the left edge of the window frame is extended as the left edge of the stretcher. These continuities permit the artist's canvas, which is posed obliquely to the picture plane, to be locked into the flat surface design. Given the marked abstraction of this picture, Picasso's indication of the tacks on the side of the artist's stretcher—a motif of vertical dots echoed on the axis of the painter's upper torso where they suggest rivets—strikes a jocose note. The picture-within-a-picture includes, in addition to the model's profile, a schematic representation of an apple, probably the green one visible on the table to the left of his canvas. As a circle with a dot in the center it also lends itself to being read as a displaced breast. This breast-fruit symbol, together with the organic shape of the palette, emerge—in the context of the female profile—as early intimations of Picasso's vocabulary for translating the unconscious reverie of the body, which we see fully developed in *Girl before a Mirror* (p. 139).

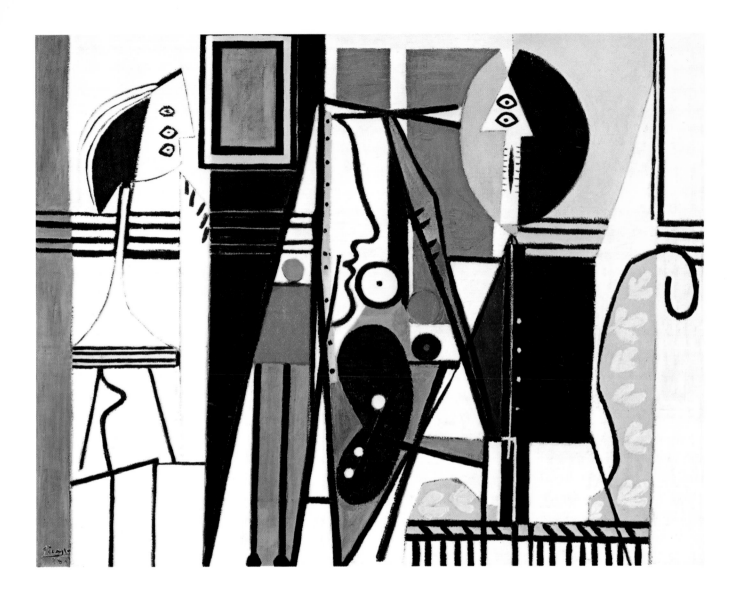

BATHER AND CABIN. *Dinard, August 1928. Oil on canvas, 8½ x 6¼ inches. (C&N, p. 224)*

At Cannes in the summer of 1927 Picasso had begun to explore biomorphism in a series of drawings of ectoplasmic female bathers (p. 225:105) that were highly sculptural in their shading and that not surprisingly culminated in the bronze (p. 225:106) executed the following winter in Paris. Picasso's responsiveness to the newly emerged Surrealist avant-garde is reflected in his adoption of this form-language, which had allowed the painters of the movement to metamorphose the body into an image of hallucinatory sexual intensity.[1] Biomorphism had already been exploited in flat patterns by Miró in painting during the three years previous, but he had not yet translated such shapes into sculpture. Picasso's forms, however, are closer in their sculptural quality (though not in their morphological particulars) to those of Tanguy, whose

earliest paintings he certainly knew, at least through reproductions in the review *La révolution surréaliste.*

By the summer of 1928 when, at Dinard, Picasso painted *Bather and Cabin*, the metamorphic, single-celled bathers of the previous year had given way to others whose monumental forms resemble great weathered dolmens assembled in Stonehengelike grandeur (p. 225:107). Although *Bather and Cabin* is of this latter series, its anecdotal character and the small size of the bather relative to the cabin make it, rather, an intimate work. The theme common to most of the Cannes drawings is revived as the female bather places her key in the cabin door. Preoccupation with insertions of keys is a Freudian commonplace, and its association with the theme of sexuality is rendered specific in this picture by the presence of a man whose silhouette is visible in the cabin opposite. The sexuality is heightened by the fact that the female bather's striped bathing suit—standing autonomously like a totem to the right of her figure—leaves her breasts and vulva uncovered as, towel in hand, she looks back apprehensively at the man while struggling to insert her key. "I like keys very much," Picasso is reported to have said much later. "It's true that keys have often haunted me. In the series of bather pictures there is always a door which the bathers try to open with a huge key."[2]

SEATED BATHER. *Early 1930. Oil on canvas, 64¼ x 51 inches. (C&N, p. 225)*

In *Seated Bather* we are confronted by a hollowed-out creature whose hard, bonelike forms are at the opposite end of the spectrum from the early Cannes Bathers; they were all rubbery flesh, she is all skeletal armor. While she sits in a comfortable pose against a deceptively placid sea and sky, the potential violence that Picasso finds in her (and increasingly in all his female figures—probably a reflection of the difficulties that had surfaced in his marriage to Olga) is epitomized by her mantislike head, which combines the themes of sexuality and aggression. The praying mantis, who devours her mate in the course of the sexual act, had been a favorite Surrealist symbol; as a number of Surrealist painters and poets collected mantises, they could hardly have escaped Picasso's notice. The menacing nature of the bather is intensified by her beady eyes and daggerlike nose, but above all by her viselike vertical mouth, Picasso's personal version of a favorite Surrealist motif, the *vagina dentata.*

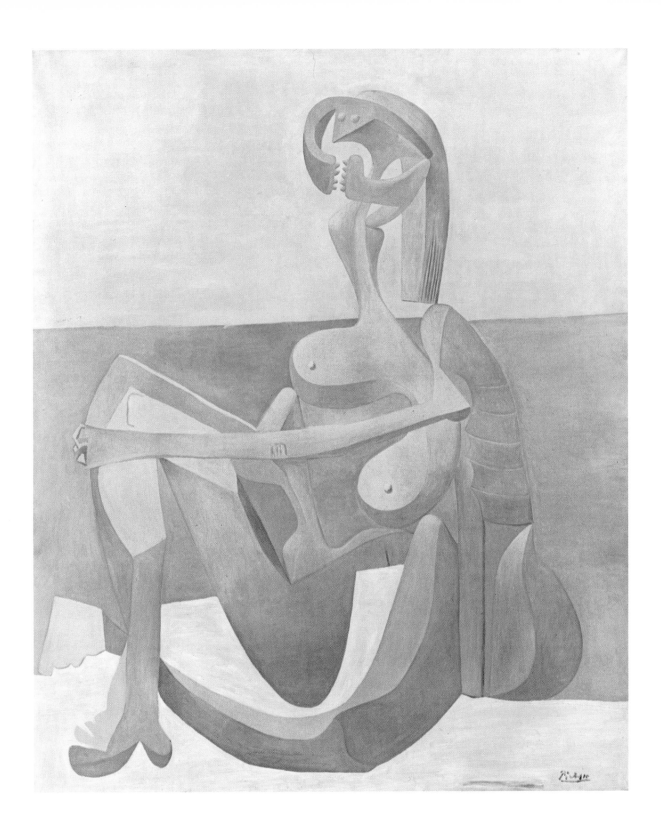

WOMAN BY THE SEA. *April 1929. Oil on canvas, 51⅛ x 38⅛ inches. (C&N, p. 225)*

The female bather in *Woman by the Sea*, a monument of cast-cement orotundity, stands with her arms over her head, like a granite nightmare of a Matisse odalisque. The tiny head and broad buttocks recall the Cannes Bathers, but the manner in which the droll conical breasts sit upon the shelf of the chest and echo the architecture of the legs belongs to the more monumental spirit of the Dinard series. The hard, erect, and pointed shapes of the breasts have obvious phallic connotations and, indeed, from their very beginnings in 1927 Picasso's Bathers, like the primordial self-sustaining amoeboid creatures they were, tended to arrogate to themselves the appurtenances of both sexes. It is perhaps Picasso's ability "to incorporate into a single form the elements of both male and female sexuality, and yet to leave each image so unequivocally itself that both separates Picasso's vision from that of the Surrealists and yet enables him to achieve some of their aims so powerfully and independently."[1]

PITCHER AND BOWL OF FRUIT. *February 1931. Oil on canvas, 51½ x 64 inches. (C&N, p. 225)*

The increasing hostility and violence in Picasso's imagery of the later 1920s, which reached its apogee in such works of 1930 as *Seated Bather*, disappeared temporarily from his art early in 1931 when he embarked on a series of colorful still lifes whose cheerfulness might reflect the artist's first contacts with Marie-Thérèse Walter.[1] It is almost as if Picasso wished to reaffirm a certain aspect of his spirit and his art in this virtuoso exercise in decorative painting—his closest approximation ever to the purely French side of the *Ecole de Paris*.

The sculpturesque effects common in Picasso's work of the three previous years give way here to flat patterning rendered all the more two-dimensional by the wide black contours that resemble the leading of stained-glass windows. Even within these black dividers, the planes of round forms such as those of the pitcher and apples are denied any illusion of convexity by the traceries of near-straight, colored lines that crisscross them. The color is laid on in a luxuriant impasto, with the light and shaded passages of objects stylized into panels of neighboring colors (the yellow and orange of the pitcher) or contrasting values of the same color (the light and dark greens of the tablecloth).

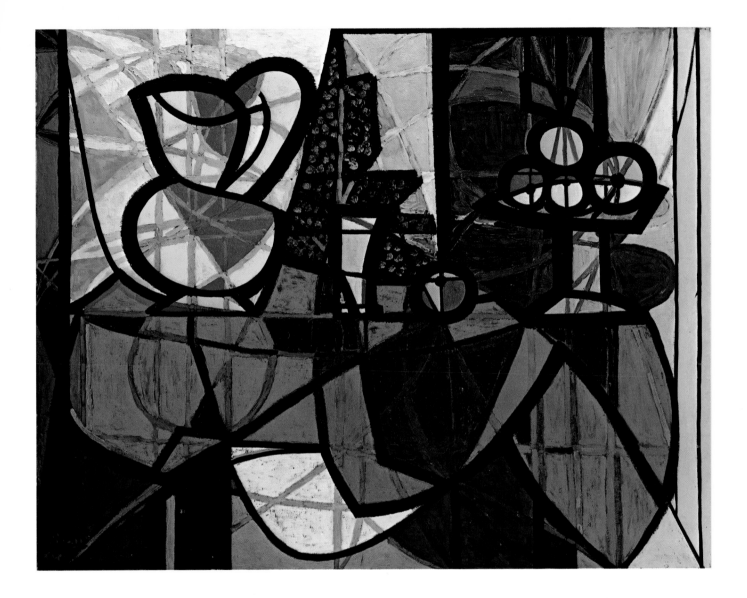

THE SERENADE. *Paris, October 1932. Brush, pen and ink, 10¼ x 13⅛ inches. (C&N, p. 225)*

The sleeping woman was a principal theme in Picasso's work of the early 1930s. Frequently she was portrayed in the company of a man (or a Minotaur or faun) who watched over her. This motif had long been favored by the artist and appears as early as 1904 (p. 31).

In *The Serenade*, the undulating contours of the extravagantly distorted sleeping woman—possibly Marie-Thérèse Walter—recall the thick outlines and leaf forms of the artist's paintings of the period. The salient three-dimensionality of the figure relates to Picasso's sculptural concerns at that time. The flute-player, simpler in form, is associated with an interest in classical antiquity that was important in the artist's painting in the early 1920s and recurred in the prints of the late 1920s and early 1930s.

The drawing, which has an agitated quality not usually associated with idyllic scenes, was executed with a spirited technique, some of whose characteristics are strongly suggestive of Surrealist automatism, but which also have antecedents in Picasso's earlier work. Ink blots are used to express such elements as flowing hair or to represent negative space between the bodies. Spontaneously drawn spirals are used both to suggest atmospheric turbulence and to indicate volume and shadow.[1] *(Elaine L. Johnson)*

THE ARTIST AND HIS MODEL. *Cannes, July 1933. Gouache, pen and ink, 15⅞ x 20 inches. (C&N, p. 226)*

During 1933, Picasso created numerous drawings and prints related to the theme of the artist and his model (p. 143). The sketch shown here was among them. It exemplifies a compositional device used with great effectiveness by Picasso intermittently throughout his career: the contrasting of an unmodeled linear image with one that is rich in detail and tone. Here, a foreshortened female nude—head resting on arms, knees bent—reclines in a blinding white light. A male nude—his powerful body emphasized by heavy outlines and textures—seems to emerge from behind a shadowy curtain to watch over her. The figures are united by the man's hand and by a wedge of dark wash.

Twenty years later, Picasso drew another sequence related to this theme.[1] In it, the model remains young and seductive; the artist has become old and cheerfully resigned in the face of temptation. *(Elaine L. Johnson)*

GIRL BEFORE A MIRROR. *March 1932. Oil on canvas, 64 x 51¼ inches. (C&N, pp. 226–27)*

This modern re-creation of the traditional Vanity image is as fascinating in its multilevel poetic allusions as it is coruscating in its color and design. The balance and reciprocity of the expressive and the decorative here set a standard for all Picasso's subsequent painting—indeed, for twentieth-century art as a whole.

Such equilibrium had not especially characterized Picasso's art in the years just previous. Erotic and psychological expression in the Bathers of the late twenties (pp. 133, 134) had been achieved at some cost in pictorial richness and complexity. Pure decorative virtuosity, on the other hand, had almost become an end in itself in pictures such as *Pitcher and Bowl of Fruit* of 1931 (p. 135). Picasso's resolution of these divergent tendencies in *Girl before a Mirror* did not proceed wholly from the processes of painting. In all probability, its catalyst was his love for the luxuriantly sensual Marie-Thérèse Walter, the inspiration for *Girl before a Mirror*, whose image had first appeared in paintings of the previous year.[1] None of Picasso's earlier relationships had provoked such sustained lyric power, such a sense of psychological awareness and erotic completeness—nor such a flood of images.

In *Girl before a Mirror*, Picasso proceeds from "his intense feeling for the girl, whom he endowed with a corresponding vitality. He paints the body contemplated, loved and self-contemplating. The vision of another's body becomes an intensely rousing and mysterious process."[2] To be sure, it may have been less the particular psychology of the passive Marie-Thérèse that served Picasso than her suitability as a vessel for primal feelings; indeed, that she did not have a salient personality (such as that possessed by Dora Maar who was to replace her in Picasso's affections four years later) may have facilitated the artist's transformation of her into a quasi-mythical being. Picasso has a remarkable ability to empathically displace the egos of his models, male or female. This young girl's act of self-contemplation may well have been banal. If so, the very commonplaceness of the experience contributed to the universality of the insight which Picasso's genius has distilled from it.

The head of the Girl, recognizable despite its stylization as that of Marie-Thérèse, is a variant of the "double head," which Picasso had been exploring since 1925 (pp. 121, 125). In this formulation, the profile usually receives the light, while a darker, shadowed area completes the full face. Here both sections have about the same light value, but because of the intense saturation of its enamels, roughly brushed over its heavily built-up impastoes, the yellow and orange-red front face dominates the smoothly painted lavender profile. "This is an inversion of the expected relation of the overt and the hidden. The exposed profile is cool and pale and what is hidden and imagined, the unseen face, is an intense yellow, like the sun. . . ."[3]

By likening the front face to the sun and the cool profile to "a moon crescent,"[4] the head may be conceived as balancing in a single astral metaphor the Girl's "overt innocence"[5]—her lavender profile is surrounded by a halo of white—and "the more covert frontal view of a rouged cheek and lipsticked mouth."[6] The double head thus becomes by metaphoric extension the two faces of Eve, or that of "a contemporary Mary who is also Isis, Aphrodite. . . ."[7] But it is also a formal microcosm of the picture in its juxtaposition of warm and cool hues and its contrast of richly impastoed with thinly painted flat surfaces, all contained within a circular shape that is the leitmotif of the composition.

The vertical division of the double head is continued down through the Girl's body, where the dichotomy of overt and covert and of public and private is transposed into a contrast of the clothed and the nude. The angular black contour of the Girl's back and the horizontal black banding it encloses recall the striped bathing suits of Picasso's Bathers of the late twenties (p. 132, p. 227:113) and constitute a shorthand image of the body in costume. By contrast, the lavender surface of her curving belly and upper thigh, in repeating the color of her profile and arms, connotes bare skin. The circular "womb" inside the tumescent belly—as in an X ray—associates the sexuality of the image with procreation. Its recapitulation of the shape of the head on virtually the same axis intimates the Girl's consciousness of the biological aspects of her femininity, an awareness explored in her reflected image.

It is very possible that the vertical division of the Girl's body was prompted by memories of an unusual Vanity (p. 227:114) that Picasso almost certainly saw in the collection of his friend the poet Ramón Gómez de la Serna.[8] In this image, the woman who looks in the mirror—where, as is traditional, she is reflected as a death's head—is herself divided vertically from the head down so that while her right side is naturalistic, her left is bare bones. In the Picasso, however, the vertical division of the body distin-

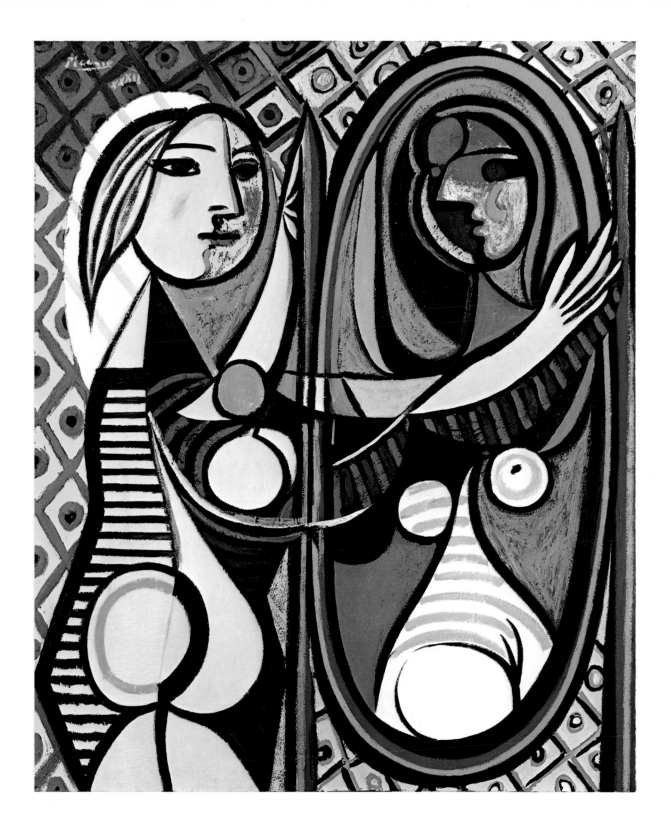

guishes primarily between the clothed and the nude; and the sexual and procreative allusions together with the robustness of the picture's handling communicate a vitality totally at odds with the gloomy implications of the Vanity.

As we move to the right from the image of the Girl toward her reflection in the mirror, we pass from a world of shapes which, though abstract and stylized, are clearly referential, to one in which the forms are rather more symbolic in character. The green circle, which close inspection of the surface shows to have been painted over the arm as a late addition, is a token of biological superfluity, a kind of apple-breast that re-echoes the circular motifs of the composition. The sense of the Girl as a sexual cornucopia is given a different dimension by the arm, which may itself be read "in conjunction with the testicular pair of breasts" directly below it as "an ithyphallic form whose sprouting fingers in turn metamorphose it into an image of generation, a kind of Aaron's rod."[9] Combinations of both male and female sexual features in a single figure were rather explicit in certain of Picasso's paintings of the twenties (pp. 131, 134). But the veiled sexual duality of *Girl before a Mirror* is subtler, and is further enriched by its apposition to the theme of psychic revelation, embodied in the reflected image.

The image in the mirror has also been likened to an X ray,[10] but as an internal image, it is unique, since it reflects the psychology as well as the physiology of the Girl. The anatomical clues are never literal. Above the womblike bulge at the bottom of the mirror, for example, the black stripes of the Girl's tinted green costume are reflected as green arcs, which allude to the ribcage. No interest is shown, however, in making these anatomically convincing, and they are carried up into the breasts as a purely decorative device, crisscrossing one and circling the other.

The symbolic shaping and coloring are most evident in the upper region of the mirror image—more mysterious and exotic than its lower part—where Picasso is concerned with pictorial counterparts for the mind rather than for the body. The reflection of the Girl's head discloses, comparatively speaking, a less secure persona—as if by looking into this swiveling mirror, a type of looking glass known significantly as a psyche,[11] the Girl had penetrated into her unconscious. The recessive chin, which is here substituted for the firm one we see in the Girl's lavender profile, strikes a note of anxiety. This falling away

of the face is counterbalanced by a swelling forehead, in which the unsettling dark green oval (a kind of symbolic "frontal lobe"), the tiny red disk below it and the mass of red to its right are at the heart of the mystery—the awesome nexus of the picture's iconographic network. The setting of these purely emblematic forms within the Girl's dark lavender and purple head infers an "otherness," a psychic distance intensified by the way the face is shrouded within veils of lavender, blue, black, purple and green. The multiplication of secondary and tertiary hues in this area—as opposed to the dominance of primaries and secondaries elsewhere—enhances its remoteness. Indeed, the entire mirror image seems more amorphous, more fluid in its shapes than the morphology of the remainder of the picture, as if the other self that the Girl perceives in her reflection were constantly transposing itself.

Girl before a Mirror is the pictorial and iconographic culmination of a series of works that begins one year earlier with *Still Life on a Table* (p. 227:112). The latter picture is informed by an insistent anthropomorphism, as if the components of the human body had been redistributed and transformed into fruit and objects. The undulating lines of the floor and wall behind the still life establish a condition of movement, a pneumatic expansion and contraction, in which the biomorphic pitcher, fruit dish, fruit and table legs—all of which vaguely allude to human organs—seem to have germinated and flourished. Two green apples in the center, juxtaposed with a golden pitcher whose silhouette is like that of a long-haired, buxom girl, call to mind breast forms of a type that appear in *Girl before a Mirror*. In like regard, the striated tablecloth resembles the Girl's striped costume and the diapered rug anticipates the lozenge patterning of the wallpaper behind her. The black tracery enclosing saturated colors, which had provided the "stained glass" effect in *Pitcher and Bowl of Fruit* (p. 135), was adapted to a more organic form language in *Still Life on a Table* in a manner that prepared the way for its more subtle and selective application in *Girl before a Mirror*.

Two other paintings important in the genesis of *Girl before a Mirror* were completed shortly before it.[12] Both inspired by Marie-Thérèse, *Nude on a Black Couch* (p. 226:110) and *The Mirror* (p. 226:111) show a young girl asleep. In the former the leaves of a large plant seem almost to sprout from her body in a simple metaphor of fertility. In the latter, a swiveling mirror reflects shapes

that might logically be the shoulder and arm of the sleeping girl, or perhaps her buttocks, but are sufficiently ambiguous to provoke less literal associations—to the world of the organic and embryonic. In addition, the wallpaper in *The Mirror* introduces the pattern of a lozenge with a circle in its middle, which forms the background of *Girl before a Mirror*. In *The Mirror* the entire pattern is consistent in its coloring; in *Girl before a Mirror*, where it is painted with particular sumptuousness, the pattern changes hue from part to part, thus serving as a more flexible foil for the shifting formal and poetic contexts of the imagery.

Two Figures on the Beach. *Cannes, July 1933. Pen and ink, 15¾ x 20 inches. (C&N, p. 228)*

Picasso was never an official member of the Surrealist group. A basic difference separated his art from theirs. Whereas Surrealist theory required that an artist be inspired by motives or images from the unconscious mind, Picasso obtained his basic stimulus from the visible world. He exhibited frequently with the Surrealist artists, however, and was a friend of several of the poets of the group. Their insights may have provided the spiritual background for the greater distortion and emotional expres-

sion that characterized much of Picasso's work after 1925. In a few works, including *Two Figures on the Beach*, Picasso adapted the iconographic types and illusionist devices of Surrealists such as Ernst and Dali. This drawing is from a group Picasso executed in Cannes in 1933. Although one writer has reported that these drawings are the only works the artist considers "directly surrealist in conception,"[1] they nonetheless exhibit that conscious control characteristic of Picasso the master draftsman.

In this composition, two strange entities present themselves to each other in front of a conventional seascape. Each is composed of elements representative of several levels of reality: the practical (chair, door, shutter), the symbolic (sculpture, fork, glove), the fantastic (padded growths). The images of self they offer one to the other are guileful facades in view of their complex—sometimes disintegrating, even monstrous—reality. *(Elaine L. Johnson)*

MODEL AND SURREALIST FIGURE. *May 4, 1933. Etching, 10⁹/₁₆ x 7⅝ inches. (C&N, p. 228)*

Picasso's interest in classical life and mythology was heightened by his commission in 1930 to illustrate Ovid's *Metamorphoses* and paralleled his burgeoning preoccupation with his own sculpture. Before completing the plates for Ovid in 1931, Picasso bought a château at Boisgeloup. There, finally, he had the space and seclusion that allowed him to devote some of his energies to sculpture. His next spurt of printmaking activity, in 1933, closely followed this unleashing of creative activity and the simultaneous inspiration resulting from his alliance with the young Marie-Thérèse Walter.

Although Louis Fort, his printer, had installed an etching press at Boisgeloup, Picasso made few prints there. In March 1933 in Paris he embarked on a series of etchings, one hundred of which were later to fulfill an obligation to the publisher and art dealer Ambroise Vollard.[1] Not surprisingly, classic motifs and studio life were the prevailing inspirations for the first prints. Later, after his contributions to the Surrealist-oriented publication *Minotaure*, Picasso recreated this mythological being as his surrogate in compositions both of revelry and utmost seriousness.

The earliest forty prints, devoted to the sculptor in his studio, are serene, filled with light, sweet desire, and generally reflect the artist's own relaxed mood. The sculptured pieces in the first prints are those of Boisgeloup: large moon-heads of Marie-Thérèse. As variations were made on the theme, colossal Roman heads, classical groups and abstracted torsos appear. By far the most extravagant variation is the Surrealist construction shown in the etching reproduced. Here the classically simple nude model, garlands around her neck and waist, wonderingly touches an assembly of manufactured and human forms, a concoction of nineteenth-century furniture, embroidered fleurs-de-lis and objects that allude to diverse sexual possibilities.

The Vollard Suite, as it came to be called, was Picasso's first prolonged experience with printmaking in which he had complete freedom of choice of subject and execution. The dozens of plates became a refined sketchbook in which the artist gave rein to his fertile imagination and consummate draftsmanship, yet generally restricting himself to classical images and limiting the representations of his current stylistic tendencies to works of art observed by persons within the compositions. The juxtaposition of somewhat abstract sculptural forms and recognizably human spectators emphasizes a type of reality Picasso continually explores. While the sculpture could well have been part of his own space and time (either in his own transformations or in relics from the past) the artist and model who gaze upon these works are metaphors in a timeless vacuum. The drawings and prints done by Picasso during the periods of his greatest personal content are usually sensual, often witty, and almost consistently dwell on this double view of reality. *(Riva Castleman)*

GIRL READING. *Spring 1934. Oil on canvas, 64 x 51½ inches. (C&N, p. 228)*

Each day from March 27 through March 30, 1934, Picasso completed an oil painting of Marie-Thérèse and a companion reading together from a book before them (p. 228:115).[1] Despite the intimacy implied by the proximity of their faces and the intertwining of their arms, the act of reading seems to have propelled the girls into private worlds—as is suggested by their lowered eyelids and the tilt of their heads. A month or two later that same spring, Picasso took up the motif of the open book as a point of departure for the depiction of purely solitary reverie in *Girl Reading*, a profoundly poetic picture that isolates Marie-Thérèse from her companion.

Here, she is seated at a table, her left hand holding the book before her, her right supporting her inclined head. The unexpectedly large size of her head, its predominantly chalky coloring and bulbous form—the line of the forehead running characteristically without a break into that of the nose—suggest a kinship to the monumental plaster busts of Marie-Thérèse executed at Boisgeloup during the three years previous (p. 228:116). In the painting, the largely whitish area shaded with light-blue and lavender that comprises her head and hands conveys a certain stability and repose. But the melting, organic shapes and warm, sensuous coloring of such objects as the lamp—and the juxtaposition beneath the table of the phallic chair-arm with her breasts—hint at a more passionate, perhaps sexual content for Marie-Thérèse's fantasies, which we may imagine to have been catalyzed by the book.

The wreath of flowers about Marie-Thérèse's head is consistent with the references to physical blossoming that Picasso habitually associated with her person. But it is also one of the artist's customary indications of the classical. Indeed, in many of the drawings and prints of the time this handsome girl is imaged as a *kórē* in quasi-mythological contexts evoking classical Greece (which frequently include the bearded proxy of Picasso himself). Possibly Marie-Thérèse is here to be imagined as reading an ancient text—Aristophanes' *Lysistrata*, for example, which Picasso was in fact engaged in illustrating at this time. The placement of the picture frame, which surrounds her head like a nimbus, is an inventive device that suggests the formation of images in her mind. Her text illuminated by a lamp that strangely metamorphoses, as

MYRRHINA AND KINESIAS FROM LYSISTRATA BY ARISTOPHANES. *1934. Etching, 8⅝ x 6 inches. (C&N, p. 229)*

if to suggest changing levels of reality, she may drowsily imagine herself transported into the ancient world, perhaps (as Picasso imaged her at that time, p. 228:117) offering her breasts to a Greek warrior, or being ravished by a lubricious Athenian as in the etching from *Lysistrata* illustrated here.

INTERIOR WITH A GIRL DRAWING. *Paris, February 1935. Oil on canvas, 51⅛ inches x 6 feet 4⅝ inches. (C&N, pp. 229–230)*

In a development of motifs that had occupied him the previous spring—aspects of which reach back to *Girl before a Mirror* and its immediate predecessors—Picasso spent much of the month of February 1935 sketching and painting variations on a composition of two girls, one of them drawing on a pad before a large mirror that rests on the floor, the other dozing with her head on a table.

Components of this new conception first appear in a series of drawings dated February 5 (p. 229:118) in which the girl drawing is represented as a quasi-surreal biomorphic pod with limblike extrusions, although the image she sees of herself in the mirror is realistic.[1] In somewhat later sketches (pp. 229:119, 120) the girl herself is represented more realistically and is moved from a chair in the middle of the composition to the floor on the right, while a second female figure, the sleeper, is introduced in the center. The arabesqued forms of the latter recapitulate aspects of the earlier biomorphic pod, but they also recall the contouring of certain Moroccan Matisses—an affinity reinforced in *Interior with a Girl Drawing* itself by the contrast of the rich lavender of this figure's costume with the saturated orange of her slippers and with the forest- and olive-greens of her hair and foot.

The opulent organic shapes of this dozing girl, which recall images of Marie-Thérèse, establish an aura of somnolence and reverie that carries over into the girl who draws. In the penumbra of the room, whose window is largely covered by a sheet tacked across it, the latter's eyelids droop. Although she sits before the mirror (which, unlike that of the earliest sketches, seems to reflect a fragment of another picture frame and painting), we feel that she is less likely to draw her own image or that of the objects about her than to exteriorize her thoughts and fantasies—perhaps as in the automatic drawing of the Surrealists, who sometimes imagined their pictures *les yeux fermés*. Indeed, about this time Picasso himself is said to have made a series of drawings, executed in darkened rooms or with his eyes closed.[2]

Sometime during the week that followed the earliest sketches of the motif on February 5, Picasso painted on his canvas a first version of *Interior with a Girl Drawing*, which was soon afterward photographed by Zervos (p. 229:122). But by the twelfth of the month that image had been entirely painted over to form the work we now see; this was itself announced by a preparatory drawing (p. 230:123) that must therefore date from the second week of the month.[3]

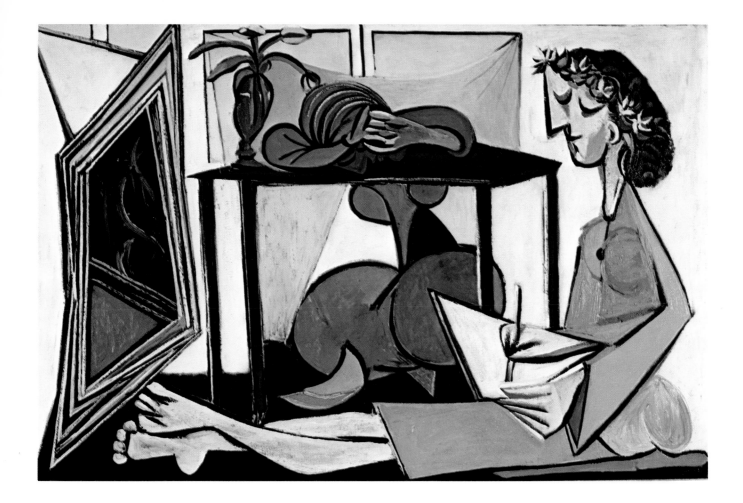

MINOTAUROMACHY. 1935. *Etching and scraper, 19½ x 27⁷⁄₁₆ inches. (C&N, pp. 230–231)*

Whatever reasons may have caused Picasso to stop painting early in 1935—and they seem to have been personal and circumstantial—his creative energies for some twenty months thereafter were to find expression in graphic art and poetry, though the results were meager by comparison with any previous period of similar length.

Picasso's most remarkable composition of 1935—and possibly the most important of all his prints—is the *Minotauromachy*. This large etching is so rich in Picasso's personal symbolism and so involved with the iconography of his previous and subsequent work that it requires some analysis, however brief. The bison-headed Minotaur advances from the right, his huge right arm stretched out toward the candle held high by a little girl who stands confronting the monster fearlessly, flowers in her other hand. Between the two staggers a horse with intestines hanging from a rent in his belly. A female matador collapses across the horse's back, her breasts bared, her *espada* held so that the hilt seems to touch the left hand of the Minotaur while the point lies toward the horse's head and the flower girl. At the left a bearded man in a loin cloth climbs a ladder to safety, looking over his shoulder at the monster. In a window behind and above two girls watch two doves walk on the sill. The sea with a distant sail fills the right half of the background.

The flower girl appears several times in Picasso's earlier work—in 1903 and 1905 (p. 231:126, 127); in the large Grecoesque Composition of 1906 (p. 194:16), and its studies (p. 36; p. 194:15)—but never before in such a crucial role. The ladder, usually on the left-hand side of the composition, occurs in the 1905 paintings and etchings of acrobats; is climbed by a monkey in the curtain for *Parade* (p. 231:128); by a man with a hammer in, significantly, the *Crucifixion* of 1930 (p. 231:129); by an amorous youth in a gouache of 1933 (p. 231:130); by a shrieking woman in a *Study for the Guernica* (p. 231:131).

One of the earliest of the bull ring series of the previous years shows a female matador falling from a horse which is borne, like Europa, on the back of the bull, though her sword has been plunged, ineffectually, into he bull's neck (p. 231:132). The agonized, disembowed horse bares his teeth in many of these same bullts, and in 1937, after dying in *The Dream and Lie of*

Franco (p. 151), revives to become the central figure of *Guernica* (p. 237:151).

Minotaur himself appears as a decorative running figure in 1928 (p. 231:133) but takes on his true character in 1933 when Picasso designed the cover for the first issue of the magazine *Minotaure*, and made numerous etchings and drawings in which the monster holds a dagger like a sceptre (p. 231:134) or makes love (p. 231:135). In a drawing of April 1935 he struts with hairy nakedness across the bull ring toward a frightened horse (p. 231:136).

As a kind of private allegory the *Minotauromachy* tempts the interpreter. But explanation, whether poetic or pseudo-psychoanalytic, would necessarily be subjective. It is clear that the ancient and dreadful myth of the Minotaur which originated, together with the bull ring, on the island of Crete, has here been woven into Picasso's own experience of the modern Spanish *toromachia*. To this he has added certain motives associated with his theatre pictures and his *Crucifixion*.

Apparently the scene is a moral melodramatic charade of the soul, though probably of so highly intuitive a character that Picasso himself could not or would not explain it in words. Of three extraordinary allegories it is the first: it was followed, in 1937, by a nightmare comic strip and a great mural painting. *(Reprinted by permission of Alfred H. Barr, Jr.)*[1]

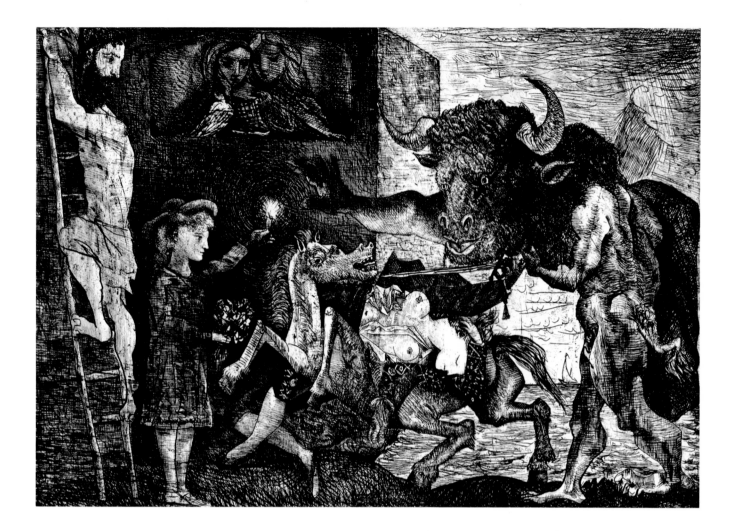

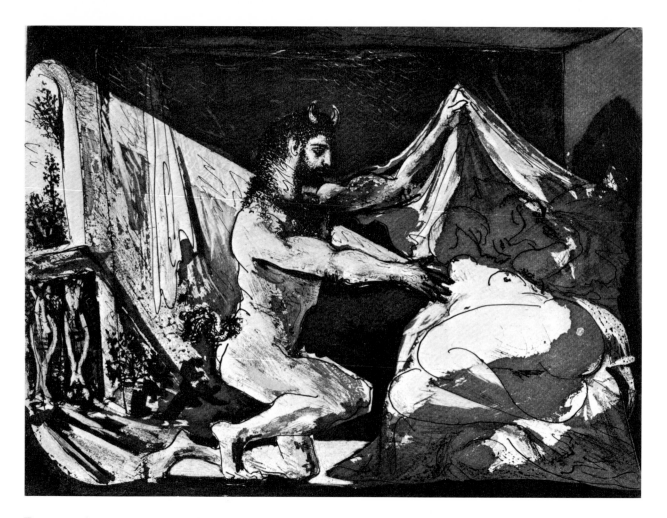

FAUN AND SLEEPING WOMAN. *June 12, 1936. Etching and aquatint, 12⁷⁄₁₆ x 16⁷⁄₁₆ inches.* (C&N, p. 230)

In June 1936 Picasso completed one of his most dramatically expressive prints and one of the last of the one hundred etchings he owed Ambroise Vollard. At this time Picasso was introduced to the technique of sugar-lift aquatint by the gifted intaglio printer Roger Lacourière. Using this medium, the artist was able to create subtle tonalities with the use of a brush. In this composition he skillfully obtains grays of such variety that a theatrically illuminated scene emerges. The triangular planes of light and dark have been considered forerunners of the structure of overlapping triangles in the painting *Guernica*.[1]

Returning again to the theme of the sleeper observed, Picasso introduces a new character, an ardent faun about to awaken a sleeping nymph. Unlike the playful flute-playing beings who entertained young maidens in earlier prints, the composite goat-man here is a serious demigod. Instead of being lustful, the faun is reverently upon his knee, one hand raised in the act of unveiling the object of his quest. The quality of momentarily suspended action recalls early Italian Renaissance annunciations, wherein the revelation is further heightened by a beam of light falling on the Virgin who stands in a loggia or gallery. The nymph, lying asleep, light pouring in upon her through an arched opening, unknowingly participates in a pagan version of one of the most mystical moments in Christian mythology. In his graphic work of the 1930s, Picasso casually introduced symbols and mythological characters that, in evoking ancient rites, extended the limited narrative of his compositions. *(Riva Castleman)*

DREAM AND LIE OF FRANCO II. *January 8–9, 1937, and June 7, 1937. Etching and aquatint, 12⅜ x 16⁹⁄₁₆ inches. (C&N, p. 230)*

Early in January 1937 Picasso etched *The Dream and Lie of Franco* and wrote the accompanying poem. There are two plates, each divided into nine rectangular scenes like traditional woodcut stories or contemporary American comic strips, which Picasso admires. In fourteen scenes Picasso expresses his hatred and contempt for El Caudillo. Again the bull, the disemboweled horse appear in a story which is not as lucid as a comic strip but clear enough for dreams and lies. Franco himself is transformed into a flaccid scarecrow figure with a head like a soft hairy sweet potato—or, to borrow Picasso's phrases, "an evil-omened polyp . . . his mouth full of the chinch-bug jelly of his words . . . placed upon the ice-cream cone of codfish fried in the scabs of his lead-ox heart. . . ."[1]

The first five scenes reading from right to left continue the story of the nine scenes of the first plate. Franco has just driven his lance through the winged horse which expires at his feet (scene 10—upper right-hand corner). The dying horse gives place to a prostrate woman (scene 11) and then to a white horse whose neck rests upon the chest of a bearded man (scene 12). In a close-up (scene 13) Franco is confronted by a bull. In the final scene (central picture) Franco having been turned to a centaur-like beast with a horse's body is ripped open by the bull and dies.[2] The four remaining scenes, added later, are closely related to *Guernica* which Picasso undertook May 1st and finished in June. *(Reprinted by permission of Alfred H. Barr, Jr.)*[3]

fandango de lechuzas escabeche de espadas de pulpos de mal agüero
estropajo de pelos de coronillas de pié en medio de la sartén en
pelotas — puesto sobre el escurucho del sorbete de bacalao
frito en la sarna de su corazón de cabestro — la boca llena de
la jalea de chinches de sus palabras — cascabeles del plato
de caracoles trenzando tripas — menique en erección ni uva
ni breva — comedia del arte de mal tejer y teñir nubes
— productos de belleza del carro de la basura — rapto de las meninas
en lágrimas y en lagrimones — al hombro el ataúd relleno de chorizos
y de bocas — la rabia retorciendo el dibujo de la sombra que le azota las
dientes clavados en la arena y el caballo abierto de par en par
al sol que lo lee a las moscas que hilvanan a los nudos de la

Picasso's contacts with Surrealism led him to write a number of automatic, stream of consciousness poems, which Sabartés helped prepare for publication. Like his other poetry, the text for *Dream and Lie of Franco* distinguishes itself from the works of the Surrealists to the extent that the raw material of its imagery is not the oneiric or marvelous, but finds its point of departure in immediate, concrete reality.

THE DREAM AND LIE OF FRANCO

fandango of shivering owls souse of swords of evil-omened polyps scouring brush of hairs from priests' tonsures standing naked in the middle of the frying-pan—placed upon the ice cream cone of codfish fried in the scabs of his lead-ox heart—his mouth full of the chinch-bug jelly of his words—sleigh-bells of the plate of snails braiding guts—little finger in erection neither grape nor fig—commedia dell'arte of poor weaving and dyeing of clouds—beauty creams from the garbage wagon—rape of maids in tears and in snivels—on his shoulder the shroud stuffed with sausages and mouths—rage distorting the outline of the shadow which flogs his teeth driven in the sand and the horse open wide to the sun which reads it to the flies that stitch to the knots of the net full of anchovies the skyrocket of lilies—torch of lice where the dog is knot of rats and hiding-place of the palace of old rags—the banners which fry in the pan writhe in the black of the ink-sauce shed in the drops of blood which shoot him—the street rises to the clouds tied by its feet to the sea of wax which rots its entrails and the veil which covers it sings and dances wild with pain—the flight of fishing rods and the alhigui alhigui of the first-class burial of the moving van—the broken wings rolling upon the spider's web of dry bread and clear water of the paella of sugar and velvet which the lash paints upon his cheeks—the light covers its eyes before the mirror which apes it and the nougat bar of the flames bites its lips at the wound—cries of children cries of women cries of birds cries of flowers cries of timbers and of stones cries of bricks cries of furniture of beds of chairs of curtains of pots of cats and of papers cries of odors which claw at one another cries of smoke pricking the shoulder of the cries which stew in the cauldron and of the rain of birds which inundates the sea which gnaws the bone and breaks its teeth biting the cotton wool which the sun mops up from the plate which the purse and the pocket hide in the print which the foot leaves in the rock.

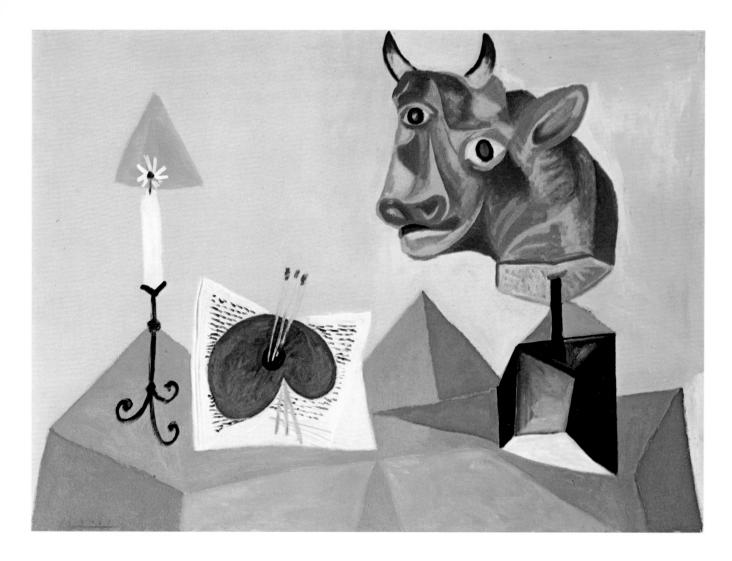

STILL LIFE WITH RED BULL'S HEAD. *Paris, November 1938. Oil on canvas, 38⅛ x 51 inches. (C&N, p. 230)*

Picasso's bulls are symbols not only of mindless power and energy but also of creative force. Here the animal is a figure of considerable pathos; the violence of the decapitation that permits its conversion into a sculptured bust is intensified by the suggestion (through the color) of its having been flayed alive.[1] It seems agonized by its confrontation with the candle, whose light, in Picasso's art, frequently betokens the power of reason (as in *Minotauromachy*, p. 149). *Still Life with Red Bull's Head* may be read as an allegory of the artist, in which the introduc-

tion of the palette and book between the bull's head and candle suggests that the artistic process is a confrontation of the unconscious, quasi-physical creative urge and the rational order with which it must be informed.

For all the violence of the beautifully executed bull's head, Picasso is careful never to let its color become literal. Indeed, its saturated reds and oranges assimilate readily to an antinaturalistic color scheme that is otherwise largely decorative. By the same token, the pointed, spiky forms around it—which echo the tips of the horns— lose their aggressiveness in becoming absorbed in a design motif that culminates in the triangular "halo" of the candle.

THE NECKLACE. *September 1938. Pen and ink, 26¾ x 17⅝ inches. (C&N, p. 232).*

Picasso often juxtaposes images representing different levels of reality in a single work. Here two nudes, disparately portrayed—one a caricature of naturalism, the other an invention of imagination—confront each other. The paradox of their meeting is compounded by the addition of a small image of equivocal meaning held in the bird-claw hands of the long-haired nude at the left. Perhaps she proudly holds a picture of herself; or, more likely—judging from Picasso's interest in the theme of the mirror—a transmuted reflection of the animal-nosed, rivet-breasted figure who is holding up the barbed necklace.

In 1938 Picasso painted and drew numerous figure pieces characterized not only by an intense psychological vitality but by an unusual linear syntax in which faceted forms, volumes, patterns, shadows and perspectives were suggested by stripes, webs, square-within-square motifs and radiating lines. In drawings such as *The Necklace*, in which all structural and decorative elements have been rendered without the aid of intermediate tonalities, the linear pattern of the surface is particularly complex.

Various sources have been suggested for the syntactical devices used in compositions of this type. Figures "which seem to be made of basketry or chair caning" may reflect an interest in the proto-Surreal compositions of the sixteenth-century Italian mannerist Arcimboldo.[1] "The dislocated figure pieces of 1938 are patterned with curious spider-web arabesques, suggestive of a mixed Andalusian-Moorish descent; indeed they often give an impression of an unresolved struggle between Arab calligraphy and Mediterranean anthropomorphism."[2] (Elaine L. Johnson)

RECLINING NUDE. *Mougins, September 1938. Pen, ink and gouache, 17 x 26¼ inches. (C&N, p. 232)*

Picasso's portrayal of the human figure has frequently been influenced by his regard for the styles of other artists and cultures. The elongated shapes of El Greco, the compact volumes of Iberian sculpture, and the refined renderings of Ingres have all nourished his art. The spirit of tradition is present in this drawing, too. Rarely, however, has it been parodied with such relish.

Here Picasso has used a vocabulary of abstract forms to represent parts of the anatomy, then orchestrated them into an alignment characteristic of a voluptuous harem nude. The effect is not sensuous, however, for the face combines human and canine features (see p. 162), and eyes stare from beneath tufts of bristly hair. Languor, too, is belied, for around the bulbous shapes of the throat and torso energy seems to spiral outward through blade-like limbs. The convention of opulent roundness is also betrayed, for space is punctured continually by sharp angles and edges.

The technique by which the drawing was executed adds to the incisiveness of its expression. The paper is brilliant white. The basic design was first established in a brushed gray wash, then redrawn with pen and black ink. The resulting line seems engraved into the surface. Broad sweeps of amorphous tone suggest atmosphere and counterbalance the tension of the formal structure.

The reclining nude did not play an important role in the iconography of Picasso's paintings until the 1930s and the 1940s, when it was developed more fully. The theme was, however, seen in his drawings from the time of his youth.

Reclining Nude was composed two days after *The Necklace* (opposite) and shares many of its characteristics. *(Elaine L. Johnson)*

NIGHT FISHING AT ANTIBES. *Antibes, August 1939. Oil on canvas, 6 feet 9 inches x 11 feet 4 inches. (C&N, pp. 232–33)*

In the summer of 1939, while temporarily occupying a bourgeois furnished apartment in Antibes which Man Ray had just vacated,[1] Picasso removed the pictures, furniture, and bric-a-brac from one of the rooms and entirely covered three of its decoratively papered walls with canvas from a very large roll. On one of these—without the aid of preparatory sketches—he executed *Night Fishing at Antibes*, which was finished toward the end of August (and sometime later trimmed to its definitive size—an unusual procedure for Picasso); the canvases on the other walls remained untouched.[2]

Picasso found the motif for *Night Fishing* in the course of his evening strolls along the quais with his then mistress Dora Maar. She is shown in the painting standing on a jetty, grasping the handlebar of a bicycle with her left hand and licking a double ice-cream cone.[3] Her companion in the scene, the painter Jacqueline Lamba,[4] wears an olive-green skirt and a green kerchief over her head. Among the rocks near the sea wall two men in a boat attempt to catch fish attracted to the surface by a powerful acetylene decoy lamp (delineated in orange and black on a yellow ground near the top center of the painting)[5]; a number of large moths and other insects, also attracted by the light, flutter around them. One fisherman, wearing a striped jersey and blue trousers rolled up near the knee, is about to spear a sole in the shallow water near the jetty; his companion, whose fishing line is tied to a toe of his right foot,[6] peers into the water, perhaps at the fish that has just swum by. On the partially submerged rocks in the lower left corner of the painting rests a crab whose soulful eyes seem to focus on the viewer. Above these rocks, in the distance, rise the towers and battlements of Grimaldi Castle (now a Picasso museum).

This largest of Picasso's paintings of the decade following *Guernica* is characteristic of much of the artist's work of the 1930s, insofar as it accommodates expressionist and biomorphic forms within a compositional armature derived from Cubism. Here, the latter is particularly loosely structured—certainly as compared to the scaffoldings of the last wholly Cubist works of the early twenties—permitting the individual forms considerable autonomy, and facilitating the illusion of their metamorphic expansion and contraction.

As was his tendency in many large compositions of his earlier years, Picasso adopted a centralized, broadly tripartite arrangement in *Night Fishing*. Although the middle area is recessed, it dominates the composition by dint of its lighter values and its marked contrast of warm and cool (the yellow and orange of the lamp against the gray and unsaturated blue of the more prominent of the two fishermen); it is also the region of greatest structural stability as a result of the scaffolding of verticals and horizontals formed by the fisherman's leg, arms and spear. The upper torso and head of the fisherman who peers into the water epitomizes the "internal" or "felt" image of the body[7]; the feeling of distention in his limbs and face as he strains to see into the water is translated by Picasso into an elongated chest and neck that are almost as equine as human, and a face that quite literally swells toward the water. The brown rocks at the left and the sea wall at the right, its reflected green light passing into the gray of the shadow, form the arms of a semicircle that swings around the arc-shaped boat, bringing the sides of the composition close up to the picture plane.

It has been suggested that the disposition of certain forms and accents within this centralized arrangement reflects Picasso's experience of a seventeenth-century Dutch *Bathers* in the Louvre.[8] That picture (p. 232:139), sometimes attributed to Nicolas Maes, shows a group of young boys swimming in the nude from a boat situated in the pictorial field in a manner very similar to the one in *Night Fishing*. The extended arm of the boy about to dive from the far side of the boat suggests that of Picasso's fisherman; it almost reaches the vertical oar, which might be considered the counterpart of the fisherman's four-tined spear. Other possible affinities between the pictures include the position of the whimsical child in the water on the lower left, who looks out at the viewer like Picasso's crab; the precarious posture of the boy with his back toward us in the center—half in, half out of the boat—whose imbalance recalls that of Picasso's crouching angler; the relation of the promontory on the right to Picasso's jetty, and that of the sails of the turning windmill to the wheel spokes of Dora Maar's bicycle. It is unlikely that Picasso was thinking of the Dutch picture as he composed *Night Fishing*. But it is not inconsistent with his artistic processes that a visual experience of spearfishing—either a momentary conjunction of forms or the very nature of the scene itself—should resuscitate if only subliminally the image of one of the multitudinous

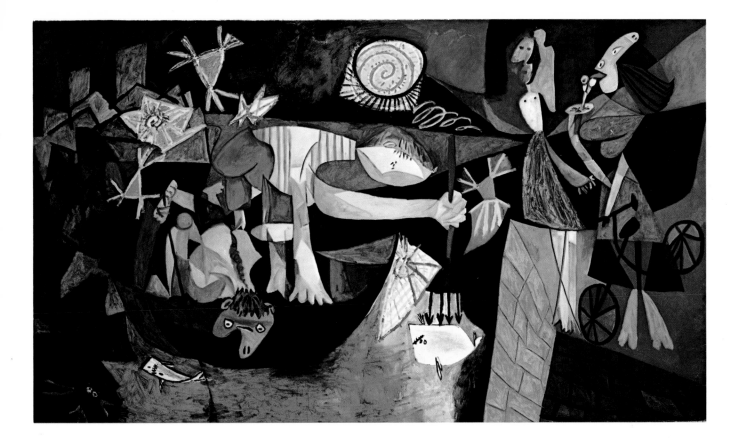

paintings his mind had "photographed" through the years, and that he should adapt the configuration of that work for his own purposes.

The ambience of *Night Fishing* is fundamentally one of physical pleasure, of play. Although fishing may be a livelihood for the men in the picture, we, the viewers—like the girls on the jetty—experience it as a sport; the bicycle, too, has its recreational allusions, and the double ice-cream cone attests to the pleasures of a stroll in the port. This festive mood is sustained by a certain whimsey in the figuration—especially in the contouring of the bicycle, moths, fish and crab, to say nothing of the double cone—and by the panache and bravado of the execution. Indeed, spearfishing "shares with the act of painting, for Picasso, the successful and suspenseful verve of marks-manship and balance, total absorption and intense involvement...."[9]

As the scene is nocturnal, Picasso not surprisingly used a greater range and variety of dark hues—notably purple—than elsewhere in his work. This somewhat exotic coloring enhances the possibility of dalliance implicit in the confrontation of the two couples, for whom the lantern might serve as a surrogate moon and the flickering moths as stars. However, interpretations of this picture as a vast metaphor for sexual activity (in which the spear becomes "a violent sex symbol"[10] and the bicycle "suggests the motion of...sexual intercourse"[11]) or as a political allegory ("a prophetic vision of the impending years of darkness"[12] in which the central motif becomes "the murder of fishes")[13] are certainly the fruit of over-reading.

WOMAN DRESSING HER HAIR. *Royan, June 1940. Oil on canvas, 51¼ x 38¼ inches. (C&N, pp. 234–35)*

This awesome image derives its extraordinary plastic intensity from a series of polar contrasts. The extreme of sculptural relief in the nude's anatomy—shapes "like petrified fruit . . . both swollen and hard"[1]—is opposed to the unbroken flatness of the walls, whose deep green and purple serve, in turn, as foils for the virtual colorlessness of the modeled areas. The tensions are maximal within the nude herself. Her conflict, her divergent impulses are expressed in a head whose features literally turn left and right—and even up and down—at the same time. The gesture of reaching back to arrange a coiffure, which years earlier had inspired some of Picasso's most lyrical pictures, has here occasioned an image of immense strain and discomfort, communicated through the systematic displacement of the nude's tumescent forms. Thus, her left arm projects directly from the left side of her rib cage and her left breast from the right side of her rib cage; her right breast is located under her arm while her buttocks have been swung around almost under that breast.

The purpose of these transpositions is to suggest psychic conflict through somatic dislocation. To express the fullest possible range of such tensions the artist makes aspects of the figure's front, back and sides simultaneously visible. Picasso had hinted tentatively at this fuller visual possession of his subject in such 1909 pictures as *Woman with Pears* (p. 60), where the sides of the sitter's neck and shoulders were pulled around into the picture plane. But nothing in his Cubist work—certainly not the infrequent instances where he conflated different *discrete* perspectives of objects (a formulation given undue importance by Cubism's early popularizers)—foretells the *continuous* revolving of the figure into the picture plane which we see here.[2]

The hardness of flesh and bone in *Woman Dressing Her Hair*, and the disquieting shapes of the near-monochrome anatomy, recall the monumental Bathers of 1929–30 (pp. 133, 134). But potentially violent as were those figures, they were nevertheless posed in a serene and stable manner against backgrounds of infinite space and light. Here the nude is contorted and unbalanced, and her windowless cell is claustrophobic. This oppressiveness is intensified by our unusual proximity to the figure, carefully enforced by Picasso through the foreshortening of her left leg and foot (the underside of which cannot but be inches from the picture plane and, hence, from the viewer).

Woman Dressing Her Hair was painted in Royan in mid-June 1940,[3] by which time the town had been overrun by the invading Germans. The sense of oppression and constraint Picasso must have felt in the face of the curfew, the restrictions on travel and, above all, the presence of the alien occupying army doubtless played a role in motivating it. But this anguished image of a human being unable to cope transcends its immediate context to become a universal image of dilemma.[4] Although the animalistic elements in the figuration—the hooflike hands and snoutlike nose—have led to an interpretation of the protagonist as a "ruthless" being,[5] she seems rather more brutalized than brute, a person whose predicament has reduced her to a less than human state.

The genesis of the nude's head is to be found in a series of portrait sketches inspired by Dora Maar that probably date from the early spring of 1940 (p. 234:141).[6] Although the head is ovoid in these, the mouth has been swung abnormally to the left—as in the painting—which makes the nose appear to be in contrapposto. A sketch dated March 14 (p. 234:140) has numerous affinities with the painting in regard to the posture of the body, particularly the position of the arms, breasts and buttocks. Finally, in a series of sketches dating from June 3 to June 8, Picasso began to elaborate the rib cage and the position of the legs (pp. 234, 235:143–148). A deeply-felt portrait of Dora Maar in oil on paper (p. 235:150) is very close as regards the head to *Woman Dressing Her Hair*; except for the coiffure, the only significant difference is the presence in the portrait of eyebrows, whose handling makes the image resemble Dora Maar more and invests it with a melancholy not present in the larger picture. The intimacy of this more particularized private statement, dated June 16 and thus executed concurrently with *Woman Dressing Her Hair*, descants the bolder and more uncompromising qualities of the larger, public image.

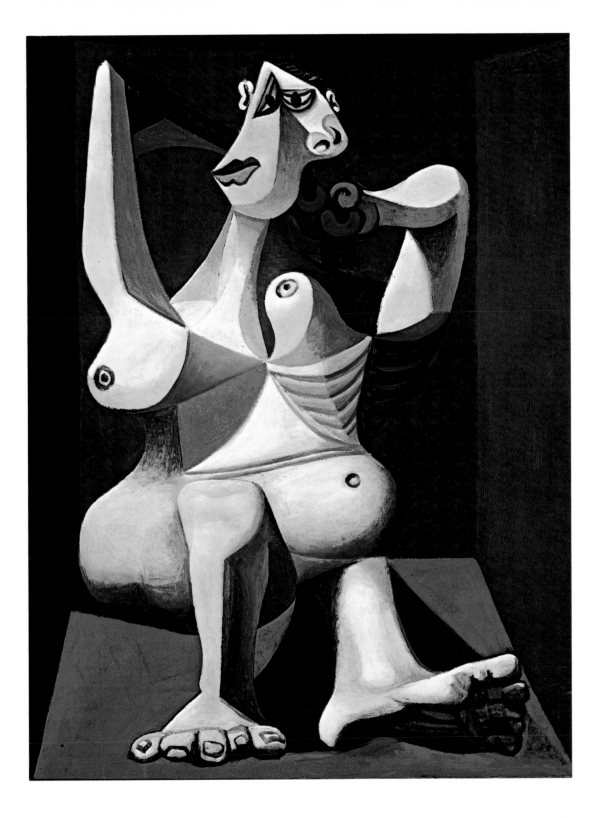

MARTIN FABIANI. *Paris, July 1943. Pencil, 20 x 13 inches.*
(C&N, p. 236)

Throughout his career, Picasso has reserved realistic por-
traiture almost exclusively for persons with whom he has
had close associations in his personal and professional life.
Among art dealers whom he had earlier used as subjects
were Daniel-Henry Kahnweiler and Ambroise Vollard.
Upon the death of the latter in an automobile accident
in 1942, Martin Fabiani took over some of his projects,
including the responsibility for the publication of Picas-
so's *Eaux-Fortes originales pour des textes de Buffon
(Histoire naturelle)*, for which the artist had made plates
in 1936; it appeared in 1942. This portrait of Fabiani, exe-
cuted the following year, is basically conventional in
form and achieves expressiveness by such subtleties as
the finely modeled flesh, the contrast between the size
and focus of the eyes, and the slight raising and shifting
of the crown. The pinched, sharp nose, which ends in
slight tension lines at the bridge and accentuates the elon-
gations of the head, contributes to the muted psychologi-
cal intensity of the image. *(Elaine L. Johnson)*

THE STRIPED BODICE. *September 1943. Oil on canvas, 39⅜
x 32⅛ inches. (C&N, p. 236)*

Here the flesh of the young girl's face has been imaged
as a material hard as stone in three smoothly cut and
polished facets. Even her beret, hair and costume share
this slablike hardness, which is reinforced by the angular-
ity imposed on the breasts and shoulders, and by the
brash contrast of the electric red stripes and complemen-
tary green ground of the costume.

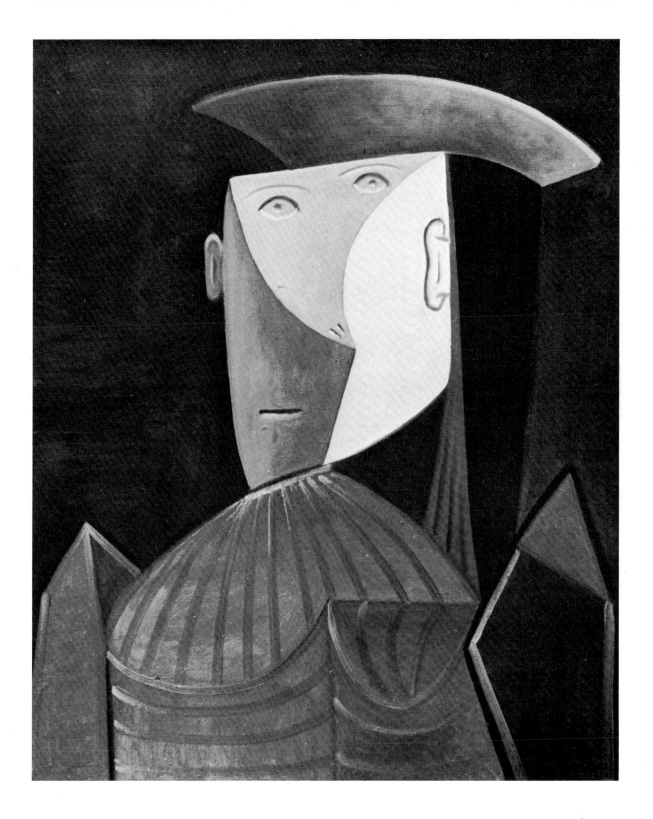

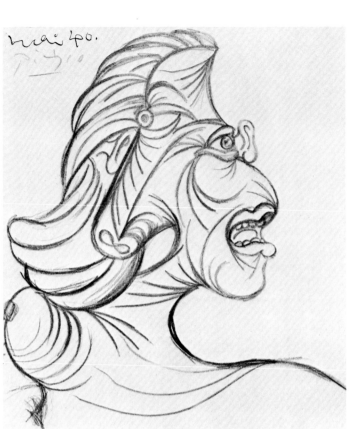

HEAD OF A WOMAN. *July 1941. Pen and ink on brown-gray paper, 10⅝ x 8¼ inches. (C&N, p. 236)*

FEMALE HEAD. *May 1940. Pencil, 8⅞ x 7⅜ inches. (C&N, p. 236)*

Many of the drawings and paintings Picasso executed during the early months of World War II in Royan near Bordeaux were characterized by a sculptural volume that contrasts with the flatness and angularity of the works of the immediately preceding years. This new tendency may have resulted from the impracticability of undertaking works of sculpture in his temporary quarters in Royan.[1] *Female Head*, which dates from this period, has antecedents in the anguished women Picasso drew as studies and postscripts for *Guernica*.

In this composition the intensity of the image is heightened by the short, strong curvilinear rhythms with which it is drawn. The basic form of a woman's head and bust are radically altered by dislocation and elision—such as is seen in the illogical extension of the ears and the metamorphosis of a shoulder into an upturned breast—as well as by the introduction of a subhuman iconographical motif. The latter is evident in the omission of a human nose in favor of the proboscis that emerges from the side of the woman's head and shares with it eyes and forehead contours.

Picasso has habitually kept a number of domestic animals around him, and the animal-snout motif, which appears in many of the artist's portraits in the late 1930s and early 1940s, may have been inspired by Kasbek, his pet Afghan hound.[2] (See also p. 155.) (*Elaine L. Johnson*)

WOMAN WASHING HER FEET. *Paris, July 1944. Wash, brush and ink, 20 x 13¼ inches. (C&N, p. 236)*

The powerful and unsettling *Woman Washing Her Feet* exploits aspects of three styles. The basic form of the composition, which recalls the positions of the bending dancers and bathing women of Degas, is realistic. The unifying devices of the design, such as the line that continues from arm to leg and the geometric space between the arms, derive from Cubism. The extended form of the back and the placement of the head between widely spaced breasts recall the expressionist distortions and dislocations that had dominated Picasso's work in the late 1930s. The artist had drawn earlier several other studies of the same theme in which the neck and back contours were explicitly articulated.[1] The summary forms of this drawing are, perhaps, abstracted from them. *(Elaine L. Johnson)*

HEAD OF A BOY. *Paris, August 1944. Brush and ink wash, 19¾ x 11¼ inches. (C&N, p. 236)*

Head of a Boy continues a tradition of portrayals of idealized youth, begun by Picasso some forty years before in works such as *Boy Leading a Horse* (p. 35). In this draw-ing a sense of sculptural solidity is achieved, remarkably, through overlaid patches of freely brushed tone. The model, whose fully developed head overbalances his immature body, was also used by Picasso in some early studies for the monumental sculpture of 1944, *Man with a Lamb*.[1] (*Elaine L. Johnson*)

PAUL VERLAINE. *Paris, June 1945. Wash, pen and ink,*
11⅝ x 8¼ inches. (C&N, p. 236)

Throughout his career, Picasso sought the stimulus and
friendship of poets, often in preference to painters.
Among the friends he portrayed were Max Jacob, Guil-
laume Apollinaire and Paul Eluard. Although he could
never have met Verlaine, the poet was a favorite of Picas-
so's during his early years in Paris, when the Symbolist's
works shared his bookshelf with books by eighteenth-
century philosophers and stories about Sherlock Holmes,
Nick Carter, and Buffalo Bill.[1] *(Elaine L. Johnson)*

THE CHARNEL HOUSE. *1944–45. Oil on canvas, 78⅝ x 98½ inches. (C&N, pp. 236–41)*

Picasso usually relies on personal experience and the given of his immediate environment as the point of departure for his art. The pressures of external circumstances tend to be communicated indirectly—in terms of style and mood—the subjects remaining nominally familiar, even conventional.[1] "I have not painted the war," Picasso was quoted as saying in autumn 1944, "because I am not the kind of painter who goes out like a photographer for something to depict."[2]

However, in the months following that remark, precisely under the impact of photographs of concentration-camp abominations, Picasso began his awesome *Charnel House.* It represented only the second time that the urgency of collective social distress had drawn him from the more familiar, personal paths of his art.[3] One of his largest and most searingly intense pictures, *The Charnel House* transcends the pure horror in the photographs, converting reportage into tragedy.[4] Its grisaille harmonies distantly echo the black and white of newspaper images but, more crucially, establish the proper key for a requiem.

Like *Guernica, The Charnel House* is a Massacre of the Innocents—an evocation of horror and anguish amplified by the spirit of genius. It marks the final act in the drama of which *Guernica*—with which it has affinities of style as well as iconographic cross-references—may be said to illustrate the beginning. Both works submit their vocabulary of contorted and truncated Expressionistic shapes to a compositional armature derived from Cubism. *The Charnel House,* in particular, derives its visual tautness from the acute contention between these antagonistic modes. Its forms twist, turn, bulge and buckle but finally adjust themselves to what is almost an inner frame of whitish priming and to the rectilinear accents that echo this device in the interior of the composition. This ultimately endows the picture—for all its turbulence—with a kind of classical Cubist "set," absorbing the screaming violence of the morphology into the silent and immutable architecture of the frame.

The Charnel House depicts a pile of dead bodies on the floor of a room that also contains a table with a pitcher and casserole on it. From the tangled bodies the forms of a man, a woman, and a child can be disengaged. Flamelike patterns rising toward the upper right corner of the composition allude to death by fire. The man, whose head hangs as if his elongated neck were broken, is stretched almost horizontally across the picture space. His feet emerge from the mass of limbs at the left of the picture field; his rib cage has been rotated clockwise in relation to his chest and navel; and his wrists have been tied behind him, keeping his arms suspended in a kind of enforced rigor mortis. The woman is stretched in the opposite direction, her feet emerging in the lower right corner of the canvas. Both of the man's eyes are open; one of hers is closed while the other—displaced to her chin—is open and seemingly alive. Blood pours from a gash above her breast into one and then the other hand of the child, who lies obliquely to the picture plane, his body foreshortened. Although the child's eyes are closed, his right arm and open hand, raised as if to stanch his mother's wound, suggest that he might still be living.

The lifeless man is reminiscent of the dead soldier of *Guernica* as that figure was laid out in the mural's first stage (p. 237:152), i.e., with his feet in the lower left of the canvas. Indeed, the raised arm of the dead man in *The Charnel House* also recalls that of the dead soldier; his clenched left fist echoes the soldier's Loyalist salute; and the open fingers of his right hand recapitulate the petal pattern of the "sunflower" radiance that haloed the soldier's fistful of grain in *Guernica*'s second stage (p. 237:153). But the raised hand of the dead man of *The Charnel House* is empty, and his arm is not self-supporting like the *Guernica* soldier's phallic limb, which symbolized rebirth; it remains aloft only through its fastening to the other arm.

This latter motif is directly related to the bound legs of the lamb in the many studies for the *Man with the Lamb,* which Picasso executed during 1942–43 (p. 238:154, 155). The pathos expressed by this motif is reinforced by the manner in which the lamb's head is turned in contrapposto to its bound legs, and by the elongation of its neck—both of which characteristics also appear in the figure of the man in *The Charnel House.* That the artist had associated such a binding of limbs with the killing of innocents was already evident in 1938 when he drew a similarly bound animal (resembling a goat) at the moment of its sacrifice (p. 238:156). There, a frenzied "priestess" holds its body with her left hand while the dagger in her right is plunged through the neck of the animal, its blood pouring into a basin below. However, the idea of innocent sacrifice is only one of several implications of this animal

when it reappears as a lamb in *Man with a Lamb*. While its anguish in that work may suggest a prescience of death, the animal may be considered as much a lost sheep rounded up by the Good Shepherd as a sacrificial lamb.

Among Picasso's many drawings of the bound lamb are some (p. 239:157) in which its head resembles that of the horse in *Guernica*. Indeed, the horse's neck and head in the finished mural (p. 237:151) acquire expressiveness from the same kind of stretching and turning. By these indirect but characteristically Picassoid associations, the man of *The Charnel House* becomes linked to the suffering equine innocent of *Guernica*. As with the lamb, the symbolism of the *Guernica* horse is potentially both pagan and Christian, for he is at once the innocent but often slaughtered member of the corrida and, by virtue of the spear thrust into his side, also the crucified Christ.[5] Moreover, the horse in some studies for *Guernica*, which show him stretched out horizontally across the field (p. 239:158), bears a family resemblance to the man in *The Charnel House*.

The association of the man in *The Charnel House* to the bound lamb, and to the soldier and horse of *Guernica*, may be said to endow the work with secondary symbolic dimensions. But unlike *Guernica*, which is openly symbolic, these are never made explicit, and remain subordinate to the more directly given realism of the work. That realism is rooted in the commonplace associations of the imagery of *The Charnel House*, which revolve around the immediate aspects of Picasso's daily life and work. The presence of a family group, for example, relates to the many intimate images central in his painting during the two years prior to *The Charnel House*—especially those of children, including his own daughter Maïa.[6] Nor are we surprised that the face of the man in *The Charnel House* should bear a strange resemblance to Picasso's own, while that of the woman has its antecedents in pictures inspired by Dora Maar.

This immediate and personal dimension of the iconography of *The Charnel House* is most obvious in the still life in its upper left, whose pitcher and casserole are virtually identical in design with those in *Pitcher, Candle and Casserole* (p. 239:159), painted in February 1945 while work was under way on the larger canvas. *Pitcher, Candle and Casserole* is one of numerous still lifes that recall the darkest days of the occupation—the lack of electricity and the meager meals cooked in Picasso's studio on the rue des Grands Augustins. In transposing it into *The Charnel House*, Picasso suppressed the candle, probably lest it be read as a symbol of optimism. Other still lifes painted while *The Charnel House* was being elaborated significantly include a series in which Picasso juxtaposed a pitcher, some leeks and a skull (p. 239:160). Here, the equation of "still" life with death implied in *The Charnel House* is rendered explicit in a manner well expressed by the French term *nature morte*. Taken together, these references to Picasso's intimate world give a sense of the iconography of *The Charnel House* that might be expressed as: I am this man; these are the woman and child I have loved and painted here during the last few years; these are our pitcher and casserole; it is incredible that we human beings should be as dead as these objects—reduced to the state of things.[7]

Picasso began *The Charnel House* in the last months of 1944 and worked on it over a period of at least a year and perhaps much longer.[8] In the earliest state in which it was photographed (by Zervos) in February 1945, it already contained numerous pentimenti (p. 240:165). Some of these erasures, such as the flamelike form in the upper right, would be reinstated. Not destined to appear in the final version was a cock, whose indistinct form may be made out in the upper left quadrant.[9] The cock appears frequently in Picasso's post-*Guernica* art, particularly in the winter just preceding *The Charnel House* (p. 239:162). Its contexts vary, but it usually conveys an air of triumph, and it was perhaps as a symbol of resurrection that Picasso first envisioned it in *The Charnel House*. But just as he eliminated the soldier's phallic arm, his fistful of grain and its solar halo from *Guernica*, so he eventually deemed the cock inconsistent with the finality of the tragedy depicted here.

The second progressive photograph of *The Charnel House* (p. 240:166), made in April 1945, shows changes that are primarily local. The head of the man, which in the earlier state had been a near oval with an interior profile, has now been given its definitive form, the expressionist twisting of the nose and mouth nevertheless echoing the earlier "double head." The child's head and limbs have been radically altered into very nearly their present contouring, and the right foot of the mother has also found its final position. Erasures at the left of the painting show that sometime after the first photograph was made in February Picasso had enlarged the cock and depicted him crowing, but again decided to eliminate him—this time for good.

In the third progressive photograph, of May 1945 (p. 241:167), the pole to which the man's wrists had been tied at the outset has been suppressed, the flamelike forms reinstated and the table with its still life introduced. The details of the man's feet have been filled in, and Picasso seems to have worked a great deal over the region of the woman's upper torso and the child's legs without making, finally, more than marginal changes.

Up to this point Picasso had worked exclusively in charcoal. In all probability it was sometime in July that he began to heighten certain of the lines with black paint and to fill in the planes with unshaded black and gray. The photographer Brassaï saw *The Charnel House* during or just after these changes. He reports Picasso as saying: "I'm treading lightly. I don't want to spoil the first freshness of my work.... If it were possible, I would leave it as it is, while I began over and carried it to a more advanced state on another canvas. Then I would do the same thing with that one. There would never be a 'finished' canvas, but just different states of a single painting. ... To finish, to execute—don't those words have a double meaning? To terminate, to finish but also to kill, to give the *coup de grâce?*"[10] Only one change was made in the conception: the introduction of the woman's second hand, which seems to be reaching for her child's right foot. We see all these alterations and additions in Zervos' last photograph, regrettably undated but certainly made after mid-July 1945 (p. 241:168). He published it in 1963, long after the work had left Picasso's studio, and identified it as "the present [hence, necessarily, the final] state" of the picture.

Zervos was wrong, however, in thinking that his last photograph represented the definitive state of *The Charnel House*. He was apparently unaware that Picasso had made a number of small additions at some point during the many years that he continued to keep the picture in the studio (see note 8). These primarily involved filling in some previously white areas (i.e., primed canvas sometimes shaded with erased charcoal) with a light blue-gray. In certain sections (the child's left face and right eye, the mother's breasts, the father's upper chest) these additions followed extant contours; in others (the mother's belly, the father's right hand) previous contours were modified and new ones added. The addition of the blue-gray panels added a fourth value—between the gray and white in intensity—to the light-dark arrangement of the picture, making smoother the visual assimilation of its often abruptly contoured shapes; the blueness also gave a mortal chill to the tonality, distinguishing it from the somewhat warmer gray of *Guernica* without fundamentally changing its funereal noncolor scheme.[11]

Like *Girl with a Mandolin* (p. 67), *The Charnel House* is nominally unfinished in the sense that it was abandoned short of Picasso's having carried all its parts to the standard of finish prevailing in his work at the time. (*Les Demoiselles d'Avignon* is unfinished in yet another sense, since certain contradictions of style were left unresolved.) However, we may presume that since Picasso kept *The Charnel House* about him for some time and then signed and released it, he felt that the work was, in its own interior terms, as good and as complete as he could make it. Indeed, the incompleteness at the top of the picture adds to its poetry by giving the still life a different level of reality; its spectral quality makes it like a fugitive thought, a passing association to the main subject of the work. The unpainted areas also enhance the picture's composition by making it more open and unexpected, sidestepping a patness that might have resulted from filling out the patterning (as, indeed, was the case with *L'Atelier de la Modiste*, p. 223:98, up until that time Picasso's only other very large grisaille picture aside from *Guernica*). It is no doubt true, as has been observed with acuity, that *The Charnel House* "was finished and brought off by being left unfinished."[12]

As they could easily have been removed, there is no doubt that Picasso wanted us to see the many charcoal traces of the pentimenti which haunt *The Charnel House* like ghosts, thus allowing us to recapitulate, in a sense, the integration of the image. Picasso's manifest and titanic struggle to *realize* the work pictorially becomes a metaphor for the difficulty of realizing emotionally and intellectually the enormity of the event depicted.

DAVID AND BATHSHEBA. *Paris, March 30, 1947. Lithograph, 25⅝ x 19¼ inches. (C&N, p. 242)*

DAVID AND BATHSHEBA. *Paris, March 30, 1947. Lithograph, 25⅞ x 19¼ inches. (C&N, p. 242)*

In 1935 Picasso told Christian Zervos that "a picture is a sum of destructions" and that "it would be very interesting to preserve . . . the metamorphoses of a picture."[1] The four states shown here of Picasso's lithographic variations on Lucas Cranach the Elder's *David and Bathsheba* (p. 242:170) offer some insight into the artist's manner of composing. In lithography there are infinite possibilities for making changes, dependent mainly on the time, skill and energy of the artist and printer. As the only way the artist can see what he has changed is to have the stone or plate proofed, the resulting prints often form simultaneously a set of preliminary drawings toward the final realization of the composition as well as a series of related and completed works. Because Picasso sees the process in terms of metamorphosis, each state becomes autonomous.

Picasso became deeply involved in lithography only after World War II. At the atelier of Fernand Mourlot he discovered the intricate pleasures of creating prints with the materials and techniques of lithography: transfer paper, crayon, tusche, washes, scraping, transferring images from plate to stone, etc. Never interested in adapting his drawing to the medium (he rarely attempted to "mirror write" the dates he invariably includes in his compositions), he prefers to adapt the medium to himself.

He began to work on *David and Bathsheba* on March 30, 1947.[2] By the end of that day the composition had gone through six states, three of which are shown here. Cranach's composition shows David and his men as a sort of frieze at the top of a wall overlooking Bathsheba's garden while the adultress sits somewhat enclosed in a foliaged bay formed by the receding wall. Picasso puts her

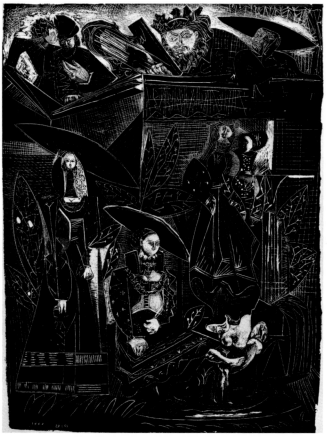

DAVID AND BATHSHEBA. *Paris, March 30, 1947. Lithograph, 25½ x 19¼ inches. (C&N, p. 242)*

DAVID AND BATHSHEBA. *May 29, 1949. Lithograph, 25¹¹/₁₆ x 18¹⁵/₁₆ inches. (C&N, p. 242)*

directly below the forward jutting corner of the wall, and emphasizes the figure of David by increasing his size. According to the Biblical tale, it was at the moment of seeing Bathsheba at her bath that David's goodness and good fortune began to wane. As Picasso proceeds with his adaptation of Cranach's composition, David becomes less a seriously regal personage than a lascivious voyeur, and the agitation of the impending romance permeates the entire composition.

Each state directs the eye to a different aspect of the artist's graphic agility. After the first two states, in which the balance of the composition and the essential outlines of the figures were established, Picasso blackened the plate and redrew the picture with a uniformly thin line. From this very rigid point Picasso, in the subsequent states, scraped away at the black faces and inserted more

and more linear detail. The earliest states are almost literal drawings after Cranach, while some of the final states, although divested of most of the exact references to Cranach, closely echo the rhythm of light that enlivens the sixteenth-century composition.

Picasso's use of the compositions of other artists is faithful to his philosophy that "we must pick out what is good for us where we can find it—except from our own works."[3] Paintings have been directly inspired by works by El Greco, Velásquez, Poussin and Delacroix, among others, but in his prints Picasso has turned almost exclusively to the Cranachs.[4] His first work based on a Cranach painting was a drawing after *Venus and Cupid as a Honey Thief*[5] done in August 1942. He began the *David and Bathsheba* series in March 1947, returning to work further on it in March 1948 and March 1949. During the lat-

MIRROR AND CHERRIES. *June 1947. Oil on canvas, 23⅞ x 19⅝ inches. (C&N, p. 243)*

PREGNANT WOMAN. *Vallauris, 1950. Bronze, first version, 41¼ inches high. (C&N, p. 243)*

The *Pregnant Woman*, descendant of a long line of fertility goddesses that goes back to the Venus of Willendorf, may have had very specific totemic connotations for Picasso. He had already had two children by Françoise Gilot; according to her, he wished to have a third, and the sculpture represented "a form of wish fulfillment on Picasso's part."[1] The metaphor of the woman as vessel is literally incorporated into the work, since the bronze was cast from a model in which the forms of the belly and breasts were those of large ceramic jars partially imbedded in plaster that had been used to fill out the other parts of the anatomy.

Picasso tinkered with the model of this work after the edition was cast, adding nipples to the breasts and changing other details. A second edition of bronzes (p. 243: 171) was made from this revised version in 1959.

ter period he also produced a color lithograph after Cranach the Elder's portrait of *Princess Sibylle von Cleve as a Bride*[6] and several versions of *Venus and Cupid*.[7] Picasso's best-known work after Cranach, this time the Younger, is the linoleum-cut portrait done in 1958 after the *Female Portrait* of 1564.[8]

Picasso seems to have been interested in the costumes, decorative motifs and particularly the meticulous stylization of Cranach's work. He may also have been attracted by the awkward spatial resolution in the *David and Bathsheba* picture, in which the sixteenth-century artist had some difficulty making Bathsheba appear properly enclosed in her garden. Picasso further embellishes on the quantity of detail and in the end establishes through this superficial embroidery a flattening of the last vestiges of Cranach's perspective. *(Riva Castleman)*

SHE-GOAT. *Vallauris, 1950. Bronze, after found objects, 46⅜ x 56⅜ x 27¾ inches. (C&N, p. 243)*

In his sculptures of the forties and early fifties Picasso eschewed the openwork, planar and linear esthetic of Cubist construction in favor of effects of mass. But this did not signal his return to simple modeling. The collage technique common to many of the earlier constructions is at the origin of most of these later works insofar as the models from which they are cast were built up additively with diverse objects and materials. The back of the *She-Goat*, for example, is cast from a palm leaf, her udder is formed from two earthenware jugs, the patterns of the rib cage are the impression of a wicker hamper and the shoulders are shaped by bits of scrap iron. These and other elements of the composite were joined by plaster, which filled out the piece to provide its silhouette and unifying surface texture (p. 243:172). Before choosing the incorporated objects, however, Picasso had already established much of the sculpture's general character and contouring in drawings (p. 243:173).

In spite of the debt to Cubist collage in the procedures for making such sculptures, the composite structures they constitute prior to being cast in bronze are less related to Cubism than to the kind of Surrealist hybrids Picasso drew and painted in the early thirties (pp. 141, 143). Indeed, the rapid assembling of a sculpture from the forms of integral, "Readymade" objects might be considered a variant of Surrealist automatism (Max Ernst, for instance, used this technique in making the models for his bronzes). When the plaster-and-object sculptures are cast, the bronze unifies the sculpture while tending to obscure the real objects. But if these linger primarily as echoes, the loss of surreal cross-references is compensated for by a greater formal coherence.

The concupiscence traditionally associated with goats

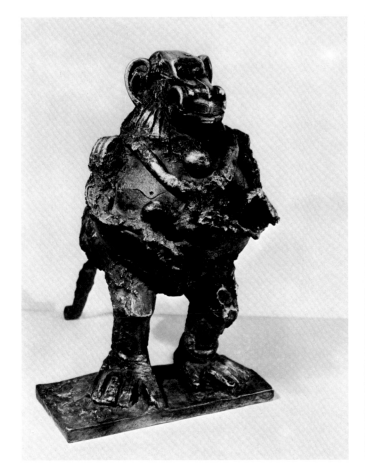

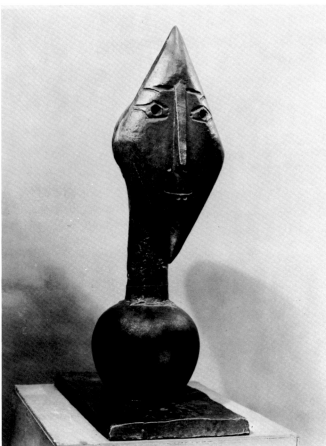

BABOON AND YOUNG. *Vallauris, 1951. Bronze, after found objects, 21 x 13¼ x 20¾ inches. (C&N, p. 244)*

HEAD OF A WOMAN. *Vallauris, 1951. Bronze, 19⅞ x 8⅝ x 14½ inches. (C&N, p. 244)*

makes them symbols of sin in Western Christian imagery—indeed, they provide part of the anatomy of the Devil. This same trait is a virtue in Picasso's pagan view; his goats are usually symbols of Arcadian fertility and joy (as in the pictures of the Antibes period of 1946, for example, where goats caper with nymphs and fauns). But the choice of the *She-Goat* as a subject is also testimony to Picasso's lifelong love of animals. A few years after the casting of this work, he kept a pet goat which had free run of the house and grounds at La Californie.

Baboon and Young is exceptional for the ease with which the baboon's head is recognized as having been cast from two toy motor cars set bottom to bottom; the found objects in the remainer of the work—the steel automobile spring which formed the backbone and tail, for

example—are more fully subsumed by the reality of the baboon. The use of the toy cars here is more than just a witty plastic transformation demonstrating Picasso's ability to envision two such objects as a baboon's head. Their very choice is not without emotional and inferential meanings. On the broadest level the toy cars belong to the world of make-believe and play—which has direct analogies to the process of making an assemblage sculpture. More specifically, they are the toys of Picasso's children Claude and Paloma, whom the artist had more than once affectionately imaged playing with them (p. 244:174). Thus, as objects, the toy cars were associated in Picasso's mind with his feelings about his children, a theme expressed, in turn, in this sculpture as an image of parental tenderness.[1]

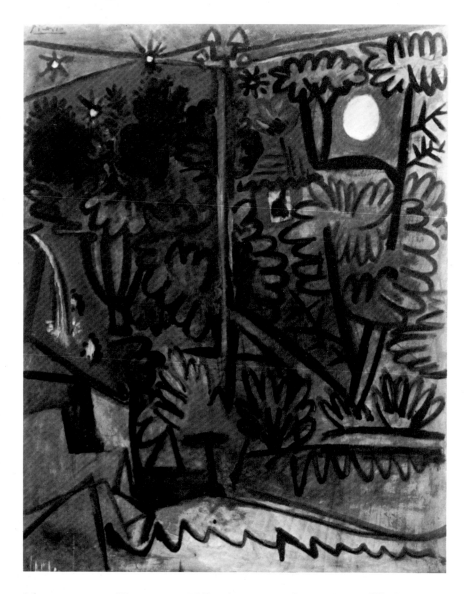

MOONLIGHT AT VALLAURIS. *Vallauris, 1951. Oil on plywood, 54 x 41¼ inches. (C&N, p. 244)*

In 1948 Picasso settled in Vallauris where a year earlier he had begun to work in ceramics with the assistance of the master potter Georges Ramié. Until his departure for Cannes in 1955, he was much occupied with the making and decorating of a large variety of vases, plates (see p. 178) and ceramic sculptures. His accomplishments in this field singlehandedly revitalized the town's chief industry, which had begun to atrophy in the years following World War I, and which was in full decline by 1948.

This view of the outskirts of the town, one of his rare nocturnes, is largely a draftsmanly picture. The artist laid in a terra-cotta ground up to the horizon line, and a blue one above it. The forms of the trees, electrical stanchion and house are contoured for the most part in black. (A few patches of bright green illuminate the foreground, and blackish green fills in an occasional reserved area of the background.) The objects thus take on a disembodied, transparent appearance in the light of the green and white moon.

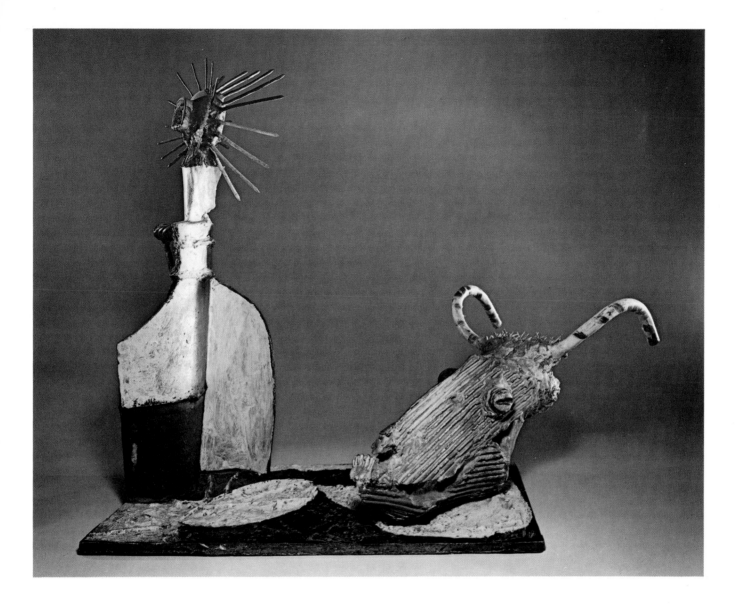

GOAT, SKULL AND BOTTLE. *1951–52. Painted bronze, 31 x 37⅜ x 21½ inches. (C&N, p. 244)*

This sculpture relates to a number of Picasso's paintings of the late thirties, forties and early fifties in which a candle is juxtaposed to a severed head or skull of an animal. Here the candle and the splayed "transparent" contours of the bottle from which it projects were cast from scrap metal, with nails and spikes representing its rays of light. The goat's skull was formed largely by bent corrugated board with nails of different sizes representing the teeth and the residual fur between the horns. The horns themselves were made from the handlebars of a child's bicycle and the eyes were made with the heads of giant bolts.

The animal, which in *She-Goat* had been a symbol of life and fertility, is here converted into a memento mori. The "Spanish" coloring of earth tones, grays and blacks—each of the three bronze casts was painted somewhat differently—reinforces the funereal aspect of the whole.

177

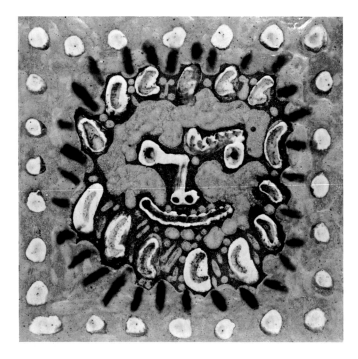

HEAD OF A FAUN. *1956. Painting on tile, 8 x 8 inches.* (*C&N, p. 244*)

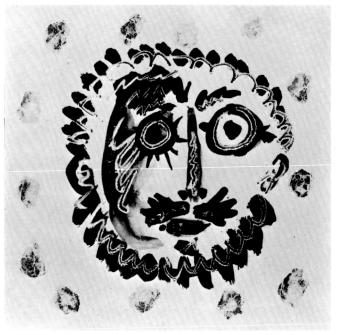

BEARDED FAUN. *1956. Painting on tile, 8 x 8 inches.* (*C&N, p. 244*)

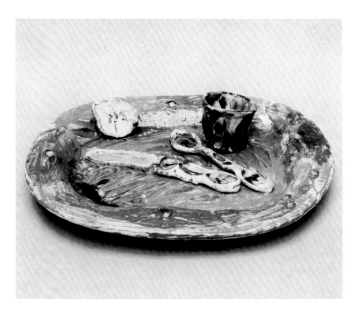

PLATE WITH STILL LIFE. *1954. Modeled polychrome glazed ceramic, 14¾ x 12½ inches.* (*C&N, p. 245*)

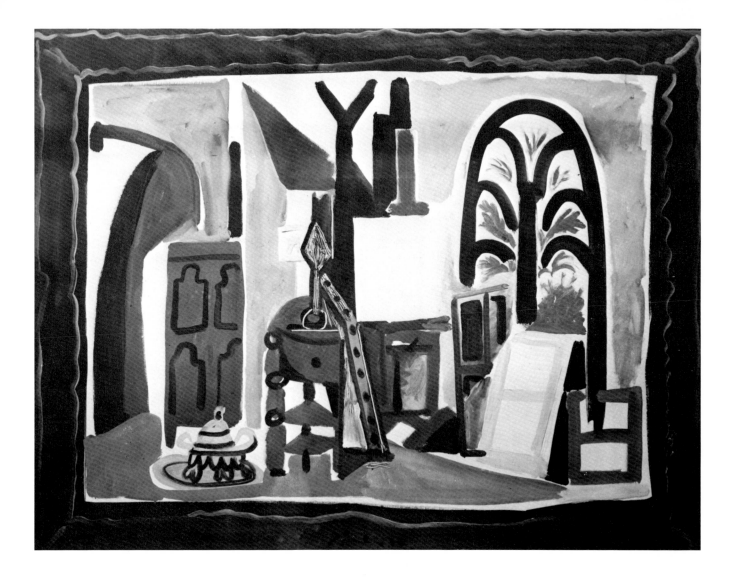

Studio in a Painted Frame. *April 1956. Oil on canvas, 35 x 45⅝ inches. (C&N, p. 245)*

Studio in a Painted Frame is, I believe, the finest of Picasso's series of recent [1956] paintings of the interior of his villa at Cannes. In it the artist has transformed the fantastic, though functioning, disorder of his studio into a beautifully controlled design suggesting at first glance his decorative late Cubist style. Yet, once one has seen the room itself, the objects in the picture are easily recognizable: the tall, heavy-mullioned window with the palm tree beyond, the squat brass stove from North Africa, his bronze bust of a woman with the diamond-shaped face (p. 175), one canvas on the easel ready for work and others scattered about on the floor, leaning every which way.

Four colors—tan, black, brown and the unpainted white of the canvas itself—make an austere harmony, singularly Spanish. When I mentioned this to Picasso he laughed, glanced down at the picture and said, half in self-mockery, "Velázquez." In the same spirit he has painted an "old-master" frame around the margins of the canvas and put his signature below, like a museum label. *(Reprinted by permission of Alfred H. Barr, Jr.)*[1]

WOMAN BY A WINDOW. *Cannes, June 1956. Oil on canvas, 63¾ x 51¼ inches. (C&N, p. 245)*

Woman by a Window is a salient work in the continuing farrago of images, based directly and indirectly on Jacqueline Roque, which Picasso began in 1954. A woman who "has the gift of becoming painting to an unimaginable degree,"[1] she continues to be his central subject. *Woman by a Window* was executed about two months after *Studio in a Painted Frame,* and its scene is likewise set in one of the rooms that Picasso used as an atelier in his villa, "La Californie," at Cannes. The beautiful, large-eyed Jacqueline, whom the artist was to marry two years later, sits in a rocking chair before a French window. To her right we see a fragment of a stretcher, apparently on an easel, and farther to the right, a balcony with its railing. A palm tree is silhouetted against the lawn.

The remarkably assured drawing of the head captures the serene classicism of Jacqueline's face, which seems to circulate around an all-seeing frontal eye. Her left hand, its contours among those scratched into the pigment, falls easily over the arabesque of the bentwood rocker whose shape—especially in this context of relaxed contemplation in a Riviera ambience—calls to mind Matisse.[2] The grisaille of Jacqueline's head and breasts informs her serene detachment with a sculptural coolness. The browns warm the tonality of the space around her, which is given freshness and luminosity by the transparent, thinly brushed green of the landscape.

Woman by a Window represents a fusion of the motif of a woman in a rocking chair, explored in a painting executed in the last week of March 1956 (p. 245:176), with that of the empty studio, four versions of which were completed between March 30 and April 2 (the date of the Museum's *Studio in a Painted Frame,* p. 179). The very next day (April 3) Picasso painted Jacqueline in a rocking chair (p. 245:177) sitting before a picture of the atelier that resembles the right side of *Studio in a Painted Frame,* with which it has in common Picasso's bust of the woman with a diamond-shaped face (p. 175), the canvas on the easel and the French window with its view of the palm tree in the garden. The latter motif appears in roughly the same position in *Woman by a Window,* though it is no longer part of a picture-within-a-picture.

After the paintings mentioned above, Picasso made a number of variations on the theme of Jacqueline looking at a canvas, of which a group of notebook drawings (p.

245:178–180) made on June 7—just four days before the completion of *Woman by a Window*—are particularly pertinent. Common to all these is the large frontal eye that is so striking in the painting. They also explain the curious brown and black triangle that projects toward Jacqueline from the right side of the stretcher that sits on the easel in *Woman by a Window.* This turns out to be a vestige of a motif clearly stated in the drawings, where the picture on the easel seems to project out to Jacqueline's eye (p. 245:179)—perhaps a graphic symbol for a kind of direct projection into the mind's eye (p. 245:180). Although this inventive element was not incorporated as such into *Woman by a Window,* it tends to explain not only the brown and black triangle, but also the other lines in the space between Jacqueline and the picture on the easel, and above all, the triangular form of her profile eye, which may be said to be as focused on that picture as the other is upon the man who is painting her.

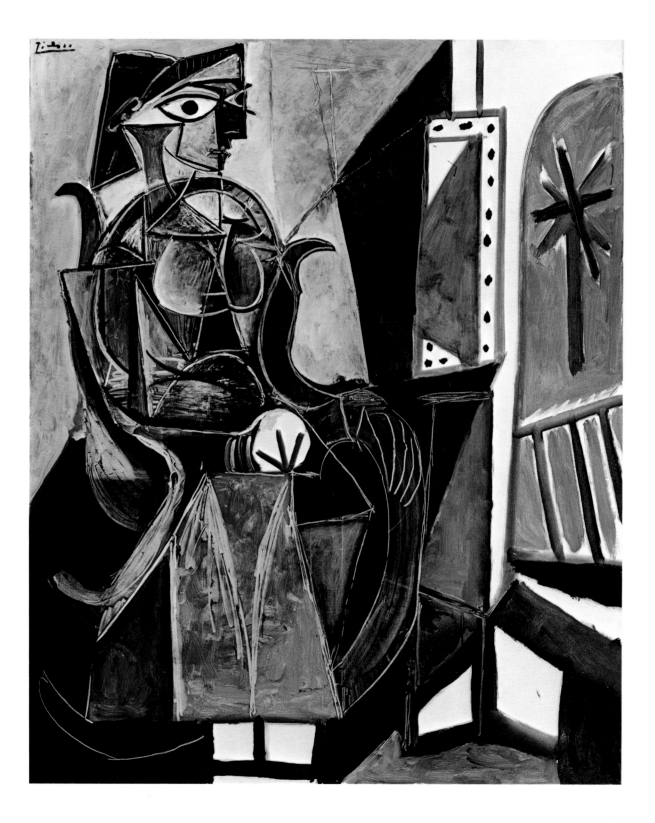

WOMAN IN AN ARMCHAIR. *Mougins, 1961–62. Oil on canvas, 63⅞ x 51⅛ inches. (C&N, p. 246)*

This picture shows Jacqueline seated on a red velvet chair playing with her pet Afghan, Kaboul, in the garden of Notre-Dame-de-Vie, the villa at Mougins into which she and Picasso moved in June 1961. Despite the informal motif and setting, *Woman in an Armchair* has the air of a seventeenth-century court portrait—a formal study of the consort of *le roi des peintres*. The antique chair, the manner in which Kaboul stands at attention, the pose of Jacqueline's body—her arms disposed at right angles paralleling the frame—and the focus of her glance at the painter-viewer rather than at the dog all reinforce this effect. In order to suggest a frontal position for Jacqueline's face—so that she might seem to look outward more than toward Kaboul—Picasso has used a cunning variant of the interior profile: Jacqueline's lips and chin are portrayed as if they were part of a profile facing the dog, while her nose belongs to a silhouette facing in the opposite direction. The result is a facial image whose profiles cancel out, as it were, into frontality.

Large in size and highly worked over its entire surface, *Woman in an Armchair* is a special work, a major set piece that Picasso distinguished from the rest of his production. No known Picasso of the last fifteen years is more *travaillé*; few approach its degree of elaboration. Picasso indulges his love of paint in this picture with sensuous abandon; in the bravura of its execution he pits himself against the great Spanish court painters Velásquez and Goya.

There is a great variety from point to point in the brushwork of *Woman in an Armchair*, but the common denominator of the notation is painterliness. The shaggy coat of Kaboul, for example, is realized in long streaks of gray seasoned with green, blue and brown, while the scumbling of the predominantly dark-green area around his snout serves as their foil. It is, however, in the long tresses of Jacqueline, where the extended curvilinear strokes form an intricate maze of blue, green and red highlights within the mass of black, that the stylistic richness of the conception most beautifully crystalizes. The patterning of the hair—capped by the accent of the brilliant yellow ribbon—is, above all, a color microcosm of a picture in which Picasso has used a larger number of saturated colors than is his habit, and brought it off with a superb decorative effect.

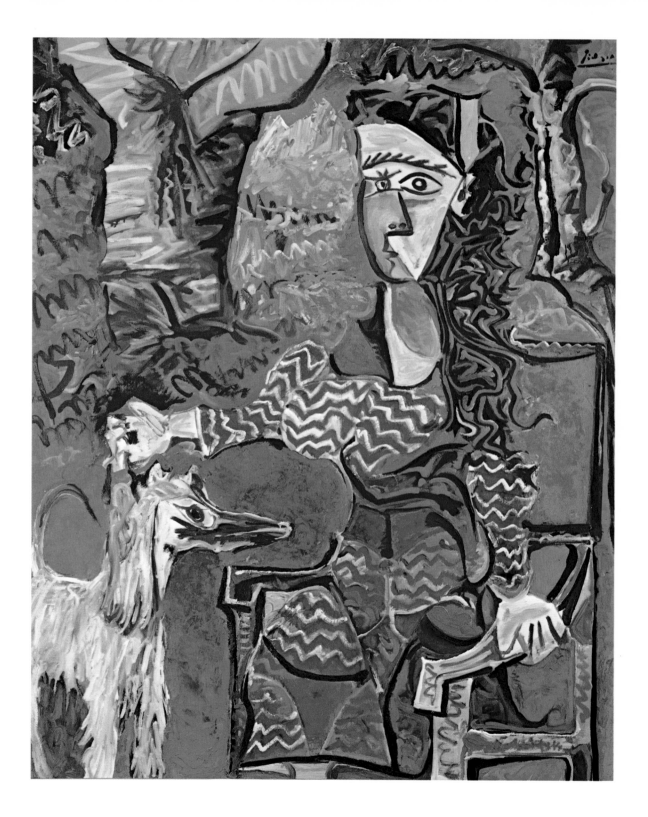

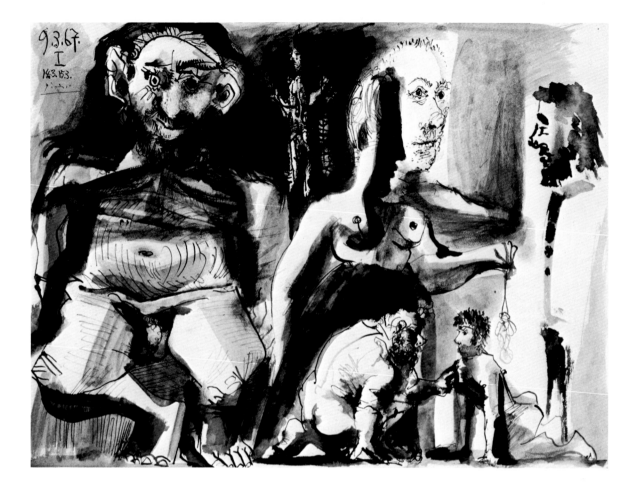

FIGURES. *Mougins, March, 1967. Wash, brush, pen and ink, 19½ x 25½ inches (sight). (C&N, p. 246)*

Picasso, always a prolific draftsman, has used drawing in many ways—in the development of styles such as Cubism, in the perpetuation of modes (such as neoclassicism) he no longer emphasized in painting, and in the elaboration of themes that have engrossed him. Such an elaboration of themes is apparent in the thousands of drawings created between 1966 and 1968, where many subjects long familiar in the artist's work—man with sheep, bathers, dancers, grandees—are recapitulated, often in surprising social and historical combinations. Many of these works are erotic; most are humorous. The richness of their invention is often astonishing, as is the occasional eschewal of technical elegance.[1]

This sheet of studies, which seems to be a private alle-gory, comes from that period. Here, figures are depicted in various scales and in several spatial realms. The dark eyes and rounded nose of the stubble-headed figure at the center resemble features of the aging Picasso himself. A woman's silhouette and body are united with his own. She dangles a puppetlike form. At her left, a corpulent dwarf (or dissolute Bacchus), antithesis of the godlike males of earlier works, is drawn in grotesque detail. He seems to advance mindlessly ahead. At the right, a simply clad young man, a type seen in Picasso's youthful work, observes the scene. Two couples are also shown. At the top, a pair whose relationship is equivocal is enveloped in a mesh of dark lines. Kneeling at the bottom, a beast-like male reaches for a graceless partner. He seems to parody the beauty and revelry of similar encounters between the Minotaur, or artist, and model that Picasso etched more than thirty years before. *(Elaine L. Johnson)*

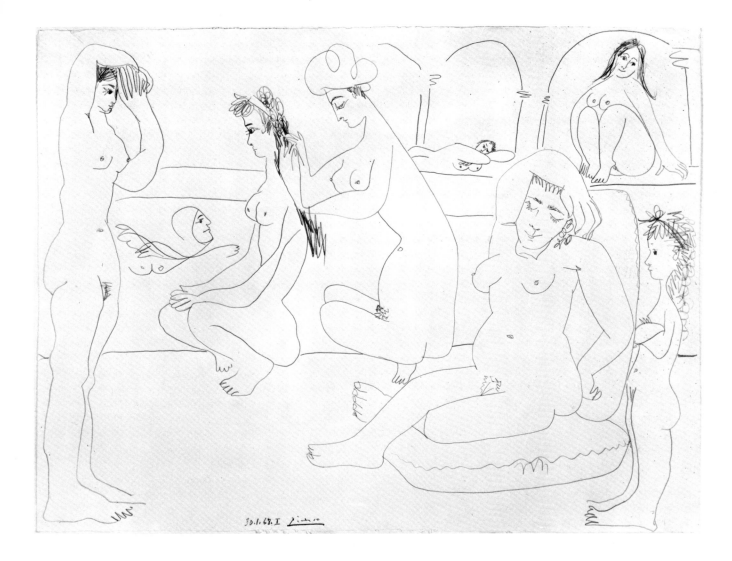

THE POOL. *Mougins, January 1968. Pencil, 22¹³⁄₁₆ x 30¹¹⁄₁₆ inches. (C&N, p. 246)*

Several drawings in the large group that Picasso created between 1966 and 1968 depicted women at leisure in a pool-side setting.[1] The deployment and attitudes of the figures had precedent in works such as Ingres' *Bain turc,* 1862 (p. 246:181), as well as in Picasso's own earlier compositions, such as *The Harem* of 1906, and the neoclassic and mannerist drawings and paintings of bathers of 1918.

Line had been Picasso's preferred means for depicting neoclassical subjects in his earlier drawings. Here, it has also become a tool of his humor. Idiosyncrasies of the flesh are carefully traced, and proportions are willfully caricatured. Two figures are at odds with the style and scale of the composition: the capped swimmer whose past motions are sketched, and the dreaming nude, top right, whose large size belies her implied distance. Two other figures stand pillarlike, framing the scene: a tall woman in an academic pose and a child observer.

The simple, unmodeled rendering of this drawing befits the uncomplicated, sun-flooded scene. Most of the contours are curvilinear and soft. Tension is provided by the long, taut line that describes the back of the central, turbanned figure, as well as by the horizontal indications of the pool's edge. *(Elaine L. Johnson)*

CATALOG AND NOTES

WORKS ARE LISTED in the order in which they appear in the book. A date is enclosed in parentheses when it does not appear on the work. Dimensions are given in feet and inches, height preceding width; a third dimension, depth, is given for some sculptures. For prints, references are given to the following standard catalogs:

G – Geiser, Bernhard, *Picasso: Peintre-Graveur*. 2 vols. published to date. Vol. 1 (1899–1931), Berne, Chez l'auteur, 1933; Vol. 2 (1933–1934), Berne, Kornfeld et Klipstein, 1968.

M – Mourlot, Fernand, *Picasso Lithographe*. 4 vols. published to date. Vol. 2 (1947–1949), Monte Carlo, André Sauret, 1950.

B – Bloch, Georges, *Pablo Picasso: Catalogue of the Printed Graphic Work*. 2 vols. published to date. Vol. 1 (1904–1967), Berne, Kornfeld et Klipstein, 1968.

1. *Self-Portrait: Yo Picasso*, 1901. Private collection, Los Angeles

SELF-PORTRAIT
Paris, (late spring or summer 1901)
Oil on cardboard mounted on wood, 20¼ x 12½ inches
Signed bottom right: "Picasso"; inscribed top left: "Yo"
Provenance: Private Collection, Nice; Paris art market
Promised gift of Mr. and Mrs. John Hay Whitney, New York
Ill. p. 25

1. There are two partial exceptions to this statement—both unfinished oils, dating from 1895 and c. 1896–97 respectively. Others possibly exist among the as yet unpublished works in Spain. The 1895 picture is a double portrait (Fig. 2) in which the principal sitter is in the right foreground. Behind him, turning toward the viewer, is an image of the fourteen-year-old Picasso. The other (Fig. 3), which shows the painter in a seventeenth- or eighteenth-century wig and costume, is not without interest for the iconography of *Suite 347* and related works, where the artist transposes himself and his father into court gentlemen.

2. Picasso, in conversation with the author, July 1971.
Although Jaime Sabartés (*Picasso: Documents iconographiques*, Geneva: Pierre Cailler, 1954, n.p., No. 63) identifies *Self-Portrait* as the first such image of 1901, it was certainly painted after *Self-Portrait: Yo Picasso* (Fig. 1), if the artist's recollection is correct. He may also have confirmed this order to Pierre Daix and Georges Boudaille (*Picasso: The Blue and Rose Periods*, Greenwich, Connecticut: New York Graphic Society, 1967, pp. 160–61), who argue convincingly that *Self-Portrait* is the later of the two; they publish a hitherto unknown pastel and charcoal sketch for *Self-Portrait: Yo Picasso*, on the verso of which is a figure that can be definitely connected with a painting, *At the Races*, probably identifiable as No. 32 in the catalog of the Vollard exhibition in June.

2. *Double Portrait*, 1895

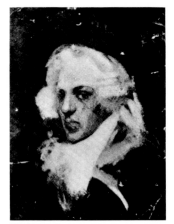

3. *Self-Portrait in Seventeenth- or Eighteenth-century Costume*, c. 1896–1897

4. *The Two Saltimbanques*, 1901. The Pushkin Museum, Moscow

5. *The Blind Man's Meal*, 1903. The Metropolitan Museum of Art, Gift of Mr. and Mrs. Ira Haupt, 1950

THREE CHILDREN
Paris, (1903–04)
Watercolor, 14½ x 10⅝ inches
Signed bottom left: "Picasso"
Verso: *Brooding Woman*
For provenance and donor, see below: *Brooding Woman*
Acquisition number: 4.56b
Ill. p. 26

BROODING WOMAN
Paris, (1904)
Watercolor, 10⅝ x 14½ inches
Signed on recto: "Picasso"
Recto: *Three Children*
Provenance: André Level, Paris; Leperrier, Paris;
 Max Pellequer, Paris; George Eumorphopoulos, London;
 Justin K. Thannhauser, New York
Gift of Mr. and Mrs. Werner E. Josten, 1956
Acq. no. 4.56a
Ill. p. 27

SALOME
(1905)
Drypoint, 15⅞ x 13¾ inches
G.17b/b
Lillie P. Bliss Collection, 1934
Acq. no. 89.34
Ill. p. 28

THE FRUGAL REPAST
(1904)
Etching, 18³⁄₁₆ x 14¹³⁄₁₆ inches
G.21b/11b
Gift of Abby Aldrich Rockefeller, 1940
Acq. no. 503.40
Ill. p. 29

1. Zervos, Christian, *Pablo Picasso*, 23 vols. published to date (Paris: Editions "Cahiers d'Art," 1932–1971), I, 78.

2. Zervos, I, 100.

3. Zervos, I, 96.

4. Zervos, I, 129.

5. Kahnweiler, Daniel-Henry, with Francis Crémieux, *My Galleries and Painters*. The Documents of 20th Century Art (New York: Viking, 1971), p. 37. "One day I was in my shop when a young man came in whom I found remarkable. He had raven-black hair, he was short, squat, badly dressed, with dirty, worn-out shoes, but his eyes were magnificent."

6. Geiser, Bernhard, *Picasso: Peintre-Graveur* (Berne: Chez l'auteur, 1933), preface.

7. Daix and Boudaille, *Picasso*, p. 254.

8. Zervos, I, 113.

MEDITATION (also known as *Contemplation*)
Paris, (late 1904)
Watercolor and pen, 13⅝ x 10⅛ inches
Signed lower right: "Picasso"
Provenance: Raoul Pellequer, Paris; Jules Furthman,
 New York; Vladimir Horowitz, New York
Collection of Mrs. Bertram Smith, New York
Ill. p. 31

1. Steinberg, Leo, "Sleep Watchers," *Life*, Vol. LXV, 26, December 27, 1968 (special double issue on Picasso)—a deeply sensitive study of this theme throughout Picasso's work.

2. Although Jean Sutherland Boggs (*Picasso and Man*, catalog of an exhibition at the Art Gallery of Toronto and the Montreal Museum of Fine Arts, January–March 1964, p. 10) had stated that the female figure "was, of course, his first mistress, Fernande Olivier," this identification is not found in Steinberg, "Sleep Watchers," Daix and Boudaille, *Picasso*, or elsewhere to my knowledge. In fact, Daix and Boudaille specifically identify (p. 257) the two pencil heads of Fernande in the somewhat later sketch for *The Actor* as "probably" the first images of Fernande in Picasso's work. Nevertheless Boggs' intuition did not contradict what relatively few intimate biographical facts are known of that period, and Picasso has recently confirmed to this author that the sleeping figure was, indeed, Fernande.

TWO ACROBATS WITH A DOG
Paris, (early) 1905
Gouache on cardboard, 41½ x 29½ inches
Signed and dated lower right: "Picasso / 1905"
Provenance: Galerie Thannhauser, Paris; Wright Ludington,
 Santa Barbara, California
Promised gift of Mr. and Mrs. William A. M. Burden,
 New York
Ill. p. 32

1. See Peter H. von Blanckenhagen: "Rilke und 'La Famille des Saltimbanques' von Picasso," *Das Kuntswerk* (Baden-Baden), v. 4, 1951, pp. 43–54. Theodore Reff ("Harlequins, Saltimbanques, Clowns, and Fools," *Artforum*, New York, x, 2, October 1971, pp. 30–43), sorts out the various typological sources for Picasso's casual mélange of attributes in his entertainers of the Rose Period. He also provides an invaluable survey of the pertinent late nineteenth-century art and literature Picasso may have seen and read.

2. For example, *Two Acrobats* in the Hermitage, Leningrad. I am indebted here to Meyer Schapiro in whose lectures at Columbia University the various implications of *saltimbanques* and entertainers in the early iconography of Picasso were discussed at length, especially in regard to the literary tradition spanning Baudelaire's prose poem *Le Vieux Saltimbanque* and Edmond de Goncourt's *Les Frères Zemganno*. Although I attended the Schapiro lectures only in the late 1940s, this Picasso material had formed part of his course when it was first elaborated some fifteen years earlier.

6. *Sleeping Nude*, 1904. Jacques Helft, Paris

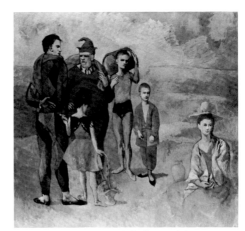

7. *Family of Saltimbanques*, 1905. National Gallery of Art, Washington, D.C.

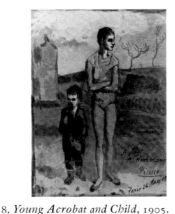

8. *Young Acrobat and Child*, 1905. Justin K. Thannhauser Foundation, The Solomon R. Guggenheim Museum, New York

9. *Boy with a Dog*, 1905. The Hermitage, Leningrad

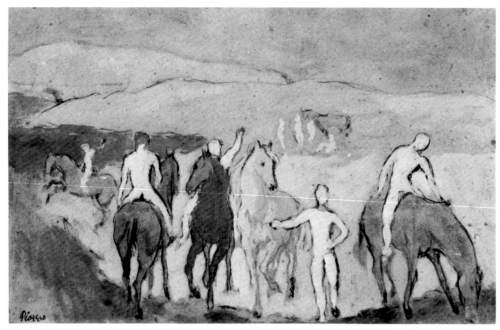

10. *Study for* The Watering Place, 1906. The Dial Collection, Worcester Art Museum

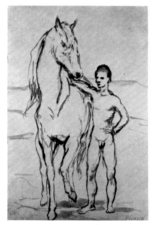

11. *Study for Boy Leading a Horse*, 1905. The Baltimore Museum of Art

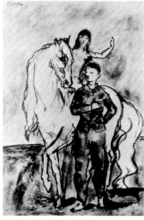

12. *Girl on Horseback, and Boy*, 1905–06

Picasso identified himself most directly with Harlequin in *At the Lapin Agile*, 1905 (Zervos, I, 120), in which he himself wears Harlequin's motley. For background on the Harlequin theme, see A. Blunt and P. Pool, *Picasso: The Formative Years* (Greenwich, Connecticut: New York Graphic Society, 1962), pp. 21–22.

3. Zervos, I, 134.

FAMILY WITH A CROW
Paris, (1904–05)
Crayon, pen and ink, 12⅞ x 9½ inches
Signed lower right: "Picasso"
Provenance: Alfred Flechtheim, Berlin; Private Collection, Basel; Heinz Berggruen, Paris; The Donor, Grosse Pointe Farms, Michigan
The John S. Newberry Collection, 1960
Acq. no. 384.60
Ill. p. 33

13. *Boy with a Pipe*, 1905. Mr. and Mrs. John Hay Whitney, New York

BOY LEADING A HORSE
Paris, (1905–06)
Oil on canvas, 86½ x 51¼ inches
Signed lower right: "Picasso"
Provenance: Ambroise Vollard, Paris; Gertrude and Leo Stein, Paris; Thannhauser Gallery, Lucerne
Gift of William S. Paley (the donor retaining a life interest), 1964
Acq. no. 575.64
Ill. p. 35

1. The various sketches which came to be summarized in the study for *The Watering Place* extend from the last months of 1905 to early summer 1906. One cannot be sure where *Boy Leading a Horse* fits into this order. Alfred H. Barr, Jr. (*Picasso: Fifty Years of His Art*, New York: The Museum of Modern Art, 1946, p. 42) accepted Zervos' dating of 1905 (Zervos, I, 118). I have adopted that of Daix and Boudaille (*Picasso*, p. 286).

14. Cézanne, *Bather*, c. 1885. The Museum of Modern Art, New York

2. *Boy Leading a Horse* has particular affinities with Cézanne's *Bather*, c. 1885 (Fig. 14); while this picture was probably not in the Salon d'Automne of 1904 and certainly not in that of 1905, it was in Vollard's possession in 1901 when Picasso exhibited with him, and the artist very probably saw it at that time.

3. Meyer Schapiro, lectures at Columbia University.

4. Blunt and Pool, *Picasso*, pp. 26–27.

5. "Rosewater Hellenism" is a term employed in the literary criticism in the late nineteenth century; Meyer Schapiro was the first to apply it to the painting of Puvis.

15. *Peasants*, 1906

16. *Peasants and Oxen*, 1906. Barnes Foundation, Merion, Pennsylvania

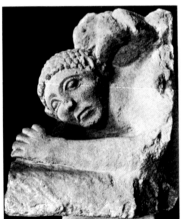

17. *Negro Attacked by a Lion*, stone bas-relief from Osuna. Museo Arqueológico Nacional, Madrid

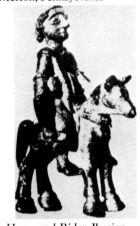

18. *Horse and Rider*, Iberian bronze from Despeñaperros. Museo Arqueológico Nacional, Madrid

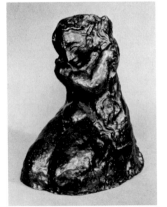

19. *Woman Combing Her Hair*, 1905–06

20. Study for *Woman Combing Her Hair*, 1906. Mr. and Mrs. George E. Seligmann, New York

THE FLOWER GIRL
Gosol, (summer); or Paris, (fall 1906)
Pen and ink, 24⅞ x 19 inches
Signed lower left: "Picasso"
Provenance: The Donor, Greenwich, Connecticut
Gift of Mrs. Stanley B. Resor, 1950
Acq. no. 99.50
Ill. p. 36

1. Daix and Boudaille, *Picasso*, p. 308, xv. 58, state that *The Flower Girl* was executed in Gosol or Paris, summer 1906.

2. Barr, *Fifty Years*, p. 256. Daix and Boudaille, *Picasso*, p. 308, xv. 57, believe that the sketch was indeed drawn from life.

3. See Barr, *Fifty Years*, p. 256, for information concerning publications on El Greco that came to Picasso's attention during 1906, as well as for a detailed discussion and reproductions of the compositional sources in El Greco and Cézanne for *Peasants and Oxen*.

WOMAN COMBING HER HAIR
Paris, (late summer or fall 1906)
Oil on canvas, 49⅝ x 35¾ inches
Signed lower left: "Picasso"
Provenance: John Quinn, New York; Mrs. Edward A. Jordan, New York; Marie Harriman Gallery, New York
Extended loan of the Florene May Schoenborn and Samuel A. Marx Collection
Ill. p. 37

1. The classic discussion of this influence in Picasso's work in 1906–07, which was first noted by Zervos following a conversation with Picasso, is James Johnson Sweeney's "Picasso and Iberian Sculpture," *The Art Bulletin* (New York), XXIII, September 1941, pp. 191–198. Sweeney notes the importance of the installation of the Osuna sculptures in the Louvre in the spring of 1906. Observing the differences between the *Woman Combing Her Hair* and Picasso's earlier sculpture of the motif, he attributes them in part to the intervention of Iberian sculpture, especially of the type exemplified by the votive bronze illustrated here.

2. This in no way contradicts the influence of Iberian sculpture. Picasso's assimilation of other art has always been generalized, so he would have considered the stylizations of Archaic Greek sculpture interchangeable with the stiff and simplified versions of Classical Greek art that issued at a later date from the provincial ateliers of Iberia after the Archaic had given way to the Classical and early Hellenistic styles in Greece itself.

TWO NUDES
Paris, (fall 1906)
Charcoal, 24⅜ x 18½ inches
Signed lower right: "Picasso"
Provenance: Jacques Sarlie, New York;
 Marlborough-Gerson Gallery, Inc., New York
Extended loan of the Joan and Lester Avnet Collection
Ill. p. 38

TWO NUDES
Paris, (late fall 1906)
Oil on canvas, 59⅝ x 36⅝ inches
Signed lower left: "Picasso"
Provenance: Paul Rosenberg, Paris; Rosenberg and Helft,
 London; John Quinn, New York; Keith Warner, Vermont;
 E. and A. Silberman Galleries, New York; The Donor,
 Pittsburgh
Gift of G. David Thompson in honor of Alfred H. Barr, Jr.,
 1959
Acq. no. 621.59
Ill. p. 39

1. Golding, John, *Cubism: A History and an Analysis 1907–
1914,* 2d ed. (London: Faber and Faber, 1968), pp. 52–53.
Golding's book is recommended as the most thorough and
scholarly account of the period 1907–14.

LES DEMOISELLES D'AVIGNON
Paris, (1907)
Oil on canvas, 8 feet by 7 feet 8 inches
Provenance: Jacques Doucet, Paris; Jacques Seligmann &
 Co., New York
Acquired through the Lillie P. Bliss Bequest, 1939
Acq. no. 333.39
Ill. p. 41

[The only text of scholarly importance to have appeared on
Les Demoiselles d'Avignon since the publication of Barr's
Picasso: Fifty Years of His Art is an article by John Golding
of the Courtauld Institute, London, in the *Burlington Maga-
zine* (London), C, 145, May 1958, pp. 155–63, which deals
most convincingly with the problems of style and chronology
that are raised by this painting. This material was subse-
quently incorporated with slight changes and additions into
the second edition of Golding's *Cubism* and is probably more
accessible to the student there.
 The book—or rather booklet—by Günther Bandmann,
Pablo Picasso: Les Demoiselles d'Avignon (Stuttgart: Philipp
Reclam jun., 1965) contains a few interesting observations on
the moralizing character of the first sketch for the painting,
but is otherwise a superficial résumé of the discussions of the
picture as they stood before the publication of Golding's arti-
cle, of which Bandmann seems unaware.
 Pierre Daix ("Il n'y a pas 'd'art nègre' dans 'Les Demoi-
selles d'Avignon'." *Gazette des Beaux-Arts* (Paris), series 6,
vol. 76, October 1970, pp. 247–70) has returned to the dis-

21. *Study for Woman Combing Her Hair,* 1906. City Art Museum
of St. Louis

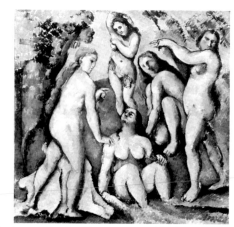

22. Cézanne, *Five Bathers,* 1885–87. Kunstmuseum, Basel

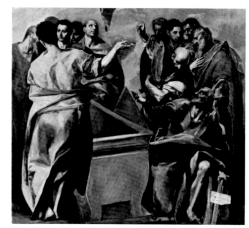

23. El Greco, *Assumption of the Virgin* (lower half), 1577.
The Art Institute of Chicago

24. *Study for Les Demoiselles d'Avignon*, 1907

25. *Study for Les Demoiselles d'Avignon*, 1907

26. *Study for Les Demoiselles d'Avignon*, 1907. Philadelphia Museum of Art

cussion of whether there is any influence of Negro art in *Les Demoiselles*. His argument for the negative is not convincing — at least to this author — in part because he does not adequately confront the facts and reasoning pointing to the contrary conclusion put forth by Golding and others. In regard to the chronological questions raised by this dispute, the student will find "A Note on the Discovery of African Sculpture" in Edward Fry's *Cubism* (London: Thames and Hudson, 1966, pp. 47–48) especially valuable for review. W.S.R.]

1. Besides these composition studies for *Les Demoiselles d'Avignon* reproduced on page 41, Zervos illustrates fourteen more (II, part 2, 629, 632–644). These do not include dozens of figure studies. [Since the publication of Barr's text, later supplemental volumes in the Zervos catalogue have included at least 14 drawings which relate closely to *Les Demoiselles* as well as others that may have some connection with it. (See Zervos, VI, 980 and 981, and XXII, 461; also VI, 977–979, 982–987, 990, 992)]

2. Several of Cézanne's paintings anticipate *Les Demoiselles d'Avignon* either in composition or in single figures. Compare nos. 94, 261, 265, 273, 276, 543, 547, 726 in Venturi, Lionello, *Cézanne, son art, son oeuvre*, II, Paul Rosenberg, Editeur (Paris, 1936).

3. The lower half of El Greco's *Assumption of the Virgin* is reproduced (p. 195:23) to illustrate his "compact figure composition and angular highlights."

4. Other studies for the figure at the left, pulling back the curtain, occur not only in the composition studies and in the *Two Nudes* (p. 39) but also in works reproduced in Zervos (I, 165, 166, 173).

5. This mask from the Itumba region of the French Congo may be compared with the upper right-hand face of *Les Demoiselles d'Avignon*.

6. Picasso's statement about his interest in Iberian sculpture and his discovery of African Negro art is reported by Zervos (II, part I, p. 10) as follows:

"On a toujours prétendu, et Mr. Alfred Barr Jr. vient de le répéter dans le Catalogue de la magnifique exposition d'oeuvres de Picasso qu'il a organisée à New York, sous le titre *Quarante ans de son art*, que les figures des *Demoiselles d'Avignon* dérivent directement de l'art de la Côte d'Ivoire ou du Congo Français. La source est inexacte. Picasso a puisé ses inspirations dans les sculptures ibériques de la collection du Louvre. En ce temps, dans le milieu de Picasso, on faisait un grand cas de ces sculptures, et l'on se souvient peut-être encore du vol d'une de ces pièces commis au Louvre, affaire à laquelle Apollinaire fut à tort mêlé.

"Picasso qui, dès cette époque n'admettait pas que l'on pût se passer, sans niaiserie du meilleur que nous offre l'art de l'antiquité, avait renouvelé, dans une vision personnelle, les aspirations profondes et perdurables de la sculpture ibérique. Dans les éléments essentiels de cet art il trouvait l'appui né-

cessaire pour transgresser les prohibitions académiques, dépasser les mesures établis, remettre toute légalité esthétique en question. Ces temps derniers Picasso me confiait que jamais la critique ne s'est donné la peine d'examiner son tableau d'une façon attentive. Frappée des ressemblances très nettes qui existent entre les *Demoiselles d'Avignon* et les sculptures ibériques, notamment du point de vue de la construction générale des têtes, de la forme des oreilles, du dessin des yeux, elle n'aurait pas donné dans l'erreur de faire dériver ce tableau de la statuaire africaine. L'artiste m'a formellement certifié qu'à l'époque où il peignit les *Demoiselles d'Avignon*, il ignorait l'art de l'Afrique noire. C'est quelque temps plus tard qu'il en eut la révélation. Un jour en sortant du Musée de Sculpture Comparée qui occupait alors l'aile gauche du Palais du Trocadéro, il eut la curiosité de pousser la porte en face, qui donnait accès aux salles de l'ancien Musée d'Ethnographie. Aujourd'hui encore, à plus de trente-trois ans de distance et en dépit des événements actuels qui le tourmentent profondément, Picasso parle avec une profonde émotion du choc qu'il reçut ce jour là, à la vue des sculptures africaines."

7. At the request of the writer, Paul Rosenberg asked Picasso whether the two right-hand figures had not been completed some time after the rest of *Les Demoiselles d'Avignon*. Picasso said, yes they had (July 1945). Later when asked whether he had painted the two figures before or after the summer of 1907, Picasso was noncommittal (questionnaire, October 1945).

8. J. J. Sweeney ("Picasso and Iberian Sculpture," p. 197) first proposed the case of the Gertrude Stein portrait as a precedent for Picasso's possibly having finished the two negroid heads considerably later and after his discovery of African Negro art.

9. Ardengo Soffici (*Ricordi di vita artistica e letteraria*, 2d ed., Vallecchi, Editore, Florence, 1942, p. 370) writes of seeing *Les Demoiselles d'Avignon* in Picasso's studio on the rue Schoelcher where the artist lived between 1913 and 1915.
 Early books on modern art very rarely if ever reproduce the picture. Reproductions are common only after 1925, and it was apparently not until 1938 that a monograph on Picasso included a reproduction (Stein, Gertrude, *Picasso*, Paris: Librairie Floury, 1938, p. 65). The earliest reproduction known to the writer was published in *The Architectural Record*, XXVII, May 1910, in an article called "The Wild Men of Paris" by Gelett Burgess.
 The painting seems to have been publicly exhibited for the first time in 1937 at the Petit Palais during the Paris World's Fair. That was after the death of the collector Jacques Doucet who years before had had it set like a mural painting into the wall of the stairwell of his house.

10. An analytical comparison of *Les Demoiselles d'Avignon* with Matisse's *Joie de Vivre* would be rewarding. Both were completed in the year 1907, the Picasso probably later than the Matisse. Both are very large compositions of human fig-ures in more or less abstract settings, the Picasso a draped interior, the Matisse a tree-bordered meadow. In both, color is freely used with a broad change of tone from left to right. The Picasso is compact, rigid, angular and austere, even frightening in effect: the Matisse open, spacious, composed in flowing arabesques, gay in spirit. The Picasso was the beginning of cubism; the Matisse was the culmination of fauvism. The Picasso lived a "private life" for thirty years; the Matisse made a sensation at the Salon des Indépendants in 1907 and has been famous ever since. Both canvases were epoch-making.

11. For earlier compositions of nudes which point toward *Les Demoiselles d'Avignon* see Zervos (I, 147, 160, 165). As already noted Zervos illustrates altogether 14 composition studies besides the three reproduced on page 196.

12. According to Zervos, Picasso recalls that André Salmon gave *Les Demoiselles d'Avignon* its title (Zervos, II, 1, p. 10). Kahnweiler, in a letter of 1940, writes that the title was given the picture shortly after the war of 1914–18, possibly by Louis Aragon who was at the time advising the collector Jacques Doucet to whom Picasso sold the painting.
 In his *Der Weg zum Kubismus* (Munich: Delphin Verlag, 1920), Kahnweiler calls the painting simply "a large painting with women, fruit and curtains," but gives it no title, an omission which confirms his opinion that the name is post-World War I. Fernande Olivier writing of the period 1904–14 does not mention the picture by name in her memoirs first published in 1931 (*Picasso et ses Amis*, Paris: Librarie Stock, 1933. The text is abridged from the author's articles in *Mercure de France* 227:549–61; 228:558–88; 229:352–68, May 1–July 15, 1931). The painting was reproduced for the first time with its present title in *La Révolution Surréaliste* (Paris), 4, July 15, 1925. André Breton, the editor of this magazine, says that it was he who, around 1921, persuaded Doucet to buy the picture, but he cannot recall who invented the title.

13. Barr, Alfred H., Jr., *Picasso: Fifty Years of His Art* (New York: The Museum of Modern Art, 1946), pp. 54–57.

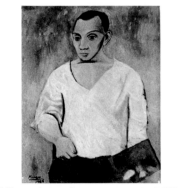

27. *Self-Portrait*, 1906
Philadelphia Museum of Art

28. Wooden Mask. Itumba.
The Museum of Modern Art, New York

29. *Head of a Man.* Iberian. Museo Arqueológico Nacional, Madrid

30. Reliquary Figure. Bakota, Gabon. Museum of Primitive Art, New York

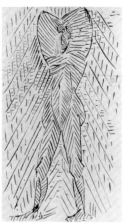

31. Drawing, 1907

HEAD
Paris, (late 1906)
Watercolor, 8⅞ x 6⅞ inches
Signed lower left: "Picasso"
Provenance: The Donor, Grosse Pointe Farms, Michigan
John S. Newberry Collection, 1960
Acq. no. 383.60
Ill. p. 42

HEAD OF A MAN
Paris, (spring 1907)
Watercolor, 23¾ x 18½ inches
Signed lower left: "Picasso"
Provenance: Pierre Loeb, Paris; Justin K. Thannhauser, New York
A. Conger Goodyear Fund, 1952
Acq. no. 14.52
Ill. p. 43

1. Despite its distortions and asymmetries the watercolor *Head of a Man* dates from early spring 1907, prior to any possible influence of African sculpture and before the elimination from *Les Demoiselles* of the male figure which was described by Picasso (Barr, *Fifty Years*, p. 57) as entering from the left bearing a skull as a memento mori in the earliest conceit for the composition. Golding (*Cubism*, plates 96a, 96b) juxtaposes it with a three-quarter view of one of the two Iberian heads (Fig. 29) that came into Picasso's possession in March 1907, and stresses the exaggerated, scroll-like ears common to both works. These heads, more primitive in character than the Osuna sculptures that were put on exhibition with considerable fanfare by the Louvre that spring, had in fact been stolen from the little-known Salle des Antiquités Ibériques of the Louvre by a Belgian adventurer named Géry-Pieret, whom Apollinaire had hired as a secretary. At the suggestion of Apollinaire, who was unaware of their provenance, the heads were offered to Picasso, and he bought them for a modest sum. In the fall of 1911, in the dénouement of a grotesque comedy of errors, the works were returned to the Louvre and later found their way back to Spain, where they are now in the Museo Arqueológico Nacional in Madrid. As Golding's comparison is convincing, it provides the date March 1907 as *terminus post quem* for the watercolor.

VASE OF FLOWERS
Paris, (fall 1907)
Oil on canvas, 36¼ x 28¾ inches
Signed lower left: "Picasso"
Provenance: Purchased from the artist in 1910 by Wilhelm
 Uhde, Berlin and Paris; Paul Edward Flechtheim, Paris;
 Mrs. Yvonne Zervos, Paris; Pierre Loeb, Paris; Mrs. Meric
 Callery, New York; Galerie Pierre, Paris
Gift of Mr. and Mrs. Ralph F. Colin (the latter retaining a
 life interest), 1962
Acq. no. 311.62
Ill. p. 45

1. In Vol. II, part I, of his catalogue raisonné of Picasso's work Zervos states that *Les Demoiselles* was completed at the end of spring 1907. He dates *Vase of Flowers* summer 1907, thus indicating, no doubt correctly, that it was painted after the larger work. It is most likely, however, that the repainting of the right-hand figures of *Les Demoiselles* was completed in late summer or early autumn; I have adjusted the date of *Vase of Flowers* accordingly.

2. This motif was identified by Picasso in conversation with the author.

3. For the best account of Picasso's much-argued relation to African art, see Robert Goldwater, *Primitivism in Modern Art*, rev. ed. (New York: Random House, 1967), Ch. V.

4. While such striated patterning is frequently compared to the surface ornamentation of African sculpture, Roland Penrose (*Picasso: His Life and Work*, London: Victor Gollancz, 1958, p. 132) has suggested the additional possibility of a relationship to fronds of a palm. Possibly he had in mind such a drawing as Fig. 32. Fig. 33, one of the few Picassos that (in its central head) seems to be a direct copy of a primitive mask, is dated by Zervos 1906 or 1907. (Were 1906 correct, it would indicate an interest in primitive art on Picasso's part long before his "revelation" at the Ethnographic Museum of the Trocadero described by Zervos in Vol. II, part I.) Our chief concern in this drawing, however, is with the ancillary figures whose heads seem, Klee-like, to be composed of the contours and veining of leaves. In Fig. 32, Picasso uses markings resembling palm fronds to articulate the back of a seated nude and then extends them in Fig. 34 to shade the entire figure.

BATHERS IN A FOREST
1908
Watercolor and pencil on paper over canvas,
 18¾ x 23⅛ inches
Signed lower right: "Picasso 1908"
Provenance: Rosenberg Gallery, New York;
 Mrs. Eleanor Rixson Cannon, New York
Hillman Periodicals Fund, 1957
Acq. no. 28.57
Ill. p. 46

32. Drawing (red ink), 1907

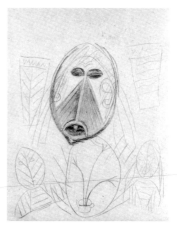

33. Drawing, 1906–07

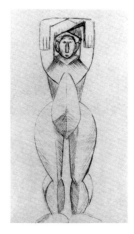

34. Drawing (ink), 1907

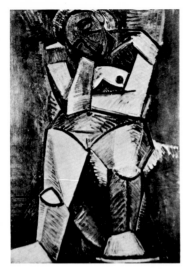

35. *Seated Woman*, 1908. The Hermitage, Leningrad

36. *Pears and Apples*, 1908

REPOSE
Paris, (spring or early summer 1908)
Oil on canvas, 32 x 25¾ inches
Signed upper right: "Picasso"
Provenance: A. Lefebvre, Paris; Galerie Beyeler, Basle
Acquired by exchange through the Katherine S. Dreier
 Bequest, and the Hillman Periodicals, Philip Johnson,
 Miss Janice Loeb, and Mr. and Mrs. Norbert
 Schimmel Funds, 1970
Acq. no. 575.70
Ill. p. 47

FRUIT AND GLASS
Paris, (summer 1908)
Tempera on wood panel, 10⅝ x 8⅜ inches
Provenance: Gertrude and Leo Stein, Paris
Promised gift of Mr. and Mrs. John Hay Whitney,
 New York
Ill. p. 49

1. Theodore Reff ("Cézanne and Poussin," *Journal of the Warburg and Courtauld Institutes*, London, XXIII, January 1960, pp. 150–169) observed that in the context of the letter in question "Cézanne was not reducing the visual world to a few ideal forms . . . but merely illustrating a method of achieving solidity in the representation of an object. . . ."

Cézanne's formulation, a kind of art-school catechism for elementary studies in perspective, may have been inspired by a desire on Cézanne's part to have Bernard—who oppressed the old painter with his constant theorizing—return, in effect, to simple art-school practices before going on to more complex procedures. However, given Cézanne's impatience with and ridicule of Bernard, as expressed in letters to his son Paul, Jr., it seems more likely that Cézanne, who evidently felt obliged to carry on with Bernard the kind of theoretical discussions he abhorred, simply fobbed him off with a homespun "theory."

LANDSCAPE
La Rue des Bois, (fall 1908)
Oil on canvas, 39⅝ x 32 inches
Provenance: Gertrude and Leo Stein, Paris
Promised gift of Mr. and Mrs. David Rockefeller, New York
Ill. p. 50

1. Zervos (II, part I, 83) assigns *Landscape* to Picasso's return to Paris from La Rue des Bois, presumably because of its less saturated greens and the absence of leaves on the trees. Yet there are landscapes with equally bare branches that he locates at La Rue des Bois. Moreover, we do not know how long into autumn Picasso stayed there. As it was not his practice while in Paris to go to the countryside to paint, this picture—if, indeed, it was painted in Paris—would have been based on a recollection or a sketch of La Rue des Bois. Maurice Jardot, however, assigned it to La Rue des Bois in his catalog of the retrospective at the Musée des Arts Décoratifs (*Picasso,*

Peintures 1900–1955, Paris: Musée des Arts Décoratifs, 1955), and Picasso has since confirmed the accuracy of that attribution in conversation with this author.

BUST OF A MAN

Paris, (fall 1908)
Oil on canvas, 36¼ x 28⅞ inches
Signed upper left: "Picasso"
Provenance: Galerie Kahnweiler, Paris; M. Roche, Paris; Galerie Pierre, Paris; Galerie Vavin-Raspail, Paris; Walter P. Chrysler, Jr., New York and Warrentown, Virginia
Extended loan of the Florene May Schoenborn and Samuel A. Marx Collection
Ill. p. 53

Zervos' date of fall 1908 for *Bust of a Man* (II, part 1, 76) seems plausible. Whether it was indeed painted after Picasso's return from La Rue des Bois or, as Kahnweiler believes (see Barr, *Fifty Years*, p. 63), during the summer prior to his departure is impossible to prove on the basis of external evidence, and Picasso's fluctuations of style in 1908 make close dating on purely internal grounds somewhat perilous.

1. Golding (*Cubism*, p. 55) observes that Salmon, in his *Jeune Peinture Française*, speaks of Picasso's having temporarily abandoned *Les Demoiselles*, painted another series of pictures, and taken it up again after returning from a holiday. This holiday Golding logically locates in the summer of 1907, which would reinforce the assumption that the two right-hand figures of the painting date from late summer or early fall.

It is not impossible that the many small studies related to the last stages of *Les Demoiselles* and the *Nude with Drapery*, studies executed by Picasso in oil, tempera, gouache, and watercolor on paper from a single block (12¼ x 9½ inches) in the summer of 1907, date precisely from the holiday of which Salmon speaks. Had the holiday been long, it would certainly have been noted elsewhere in the Picasso literature. For a week or two outside Paris, the painter would not have bothered with canvases and stretchers but might well have brought along a block of paper and some colors.

2. Goldwater, *Primitivism in Modern Art*, 2d ed., p. 154.

SHEET OF STUDIES

(Late 1908)
Brush, pen and ink, 12⅝ x 19½ inches
Signed lower right: "Picasso"
Provenance: Pierre Loeb, Paris; Albert Loeb and Krugier, New York
A. Conger Goodyear Fund, 1968
Acq. no. 22.68
Ill. p. 54

FRUIT DISH

Paris, (early spring 1909)
Oil on canvas, 29¼ x 24 inches
Signed upper right: "Picasso"
Provenance: H. S. Southaw, Esq. C.M.G.; Bignou Gallery, Paris; E. and A. Silberman Galleries, New York
Acquired through the Lillie P. Bliss Bequest, 1944
Acq. no. 263.44
Ill. p. 55

1. Zervos (II, part 1, 121) dated this picture winter 1908, which Kahnweiler amended to spring 1909. Golding considers it "probably of early spring." Since the crayon drawing (Fig. 37) is dated 1908 and probably postdates the *Sheet of Studies*, it is not impossible that the painting, albeit a variant view of the motif, dates from the mid-winter months.

2. Golding, *Cubism*, p. 72.

3. In conversation with the author, July 1971.

37. Study for *Fruit Dish*, 1908

38. *Vase, Gourd and Fruit on a Table*, 1909. Mr. and Mrs. John Hay Whitney, New York

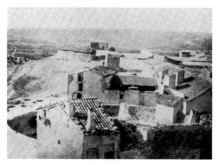

39. Photograph of Horta de San Juan by Picasso, 1909

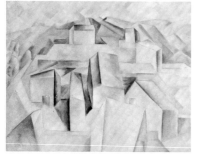

40. *Houses on the Hill, Horta*, 1909. Nelson A. Rockefeller, New York

41. *Study for The Reservoir, Horta*, 1909

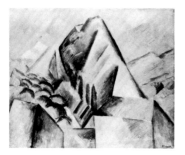

42. *Landscape, Horta*, 1909

THE RESERVOIR, HORTA
Horta de San Juan, (summer 1909)
Oil on canvas, 23¾ x 19¾ inches
Provenance: Gertrude and Leo Stein, Paris
Promised gift of Mr. and Mrs. David Rockefeller, New York
Ill. p. 57

1. Compare Braque's *Houses and Trees,* 1908 (Fig. 43) with the photograph of the motif (Fig. 44). This is one of a group of pictures painted at l'Estaque during the summer of 1908 and offered to the Salon d'Automne. When some were rejected, Braque withdrew the entire entry and showed the pictures soon afterward at Kahnweiler's gallery. Matisse is said to have commented on the "little cubes" in these paintings. But the name Cubism probably owes its existence to a review of the Kahnweiler show by Louis Vauxcelles, in which he described how Braque "reduces everything, sites and figures and houses to geometric complexes, to cubes." (*Gil Blas,* November 14, 1908).

2. What is always referred to as the "reservoir" at Horta was, in fact, a very large trough or *abreuvoir.* The townspeople did not draw water from it. Picasso recalls asking how they could even let their animals drink its rancid waters.

HEAD
(Spring 1909)
Gouache, 24 x 18 inches
Signed upper left: "Picasso"
Gift of Mrs. Saidie A. May, 1930
Acq. no. 12.30
Ill. p. 59

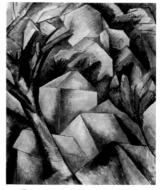

43. Braque, *Houses and Trees,* 1908. Kunstmuseum, Bern

44. Photograph by D.-H. Kahnweiler of the motif of Fig. 43

WOMAN WITH PEARS
Horta de San Juan, (summer 1909)
Oil on canvas, 36¼ x 28⅞ inches
Signed reverse: "Picasso"
Provenance: Alfred Flechtheim, Berlin; Alex Reid & Lefêvre
 Ltd., London; Pierre Matisse Gallery, New York; Douglas
 Cooper, Argilliers, France; Walter P. Chrysler, Jr.,
 New York and Warrentown, Virginia
Extended loan of the Florene May Schoenborn and
 Samuel A. Marx Collection
Ill. p. 60

TWO HEADS
Horta de San Juan, (summer 1909)
Oil on canvas, 13¾ x 13¼ inches
Signed lower left: "Picasso"
Provenance: Galerie Käte Perls, Paris; Walter P. Chrysler, Jr.,
 New York and Warrentown, Virginia; Dr. Albert W. Bluem,
 Short Hills, New Jersey; Peter W. Lange, Esmont, Virginia
A. Conger Goodyear Fund, 1964
Acq. no. 197.64
Ill. p. 58

45. *Apple*, 1910

This painting was originally the right section of a larger study
of three heads. According to Daniel-Henry Kahnweiler, it
was divided by André Level of the Galerie Percier. As repro-
duced in 1942 by Zervos (II, part 1, 162) the two sections
appear cut but mounted together (both sides were then in the
Walter P. Chrysler, Jr., collection). The Zervos reproduction
shows the left side of the picture signed, but the signature at
the lower left of the right section does not appear.

WOMAN'S HEAD
Paris, (fall 1909)
Bronze, 16¼ inches high
Incised at back of left shoulder: "Picasso"
Provenance: Weyhe Gallery, New York
Purchase, 1940
Acq. no. 1632.40
Ill. p. 61

There are two authorized editions of this bronze. The first,
unmarked and probably few in number, was cast by Vollard
sometime shortly after Picasso executed the piece. The sec-
ond, marked from one to nine, was cast—with Picasso's per-
mission—in 1960 from the original plaster in the collection of
H. Ulmann, Paris, by Berggruen, Editeur. The Museum's cast
is from the original Vollard edition.

1. Goldwater, Robert, *What Is Modern Sculpture?* (New
York: The Museum of Modern Art, 1969), p. 42.

2. The exceptions are a terra-cotta *Head* probably made not
long after *Woman's Head* and a plaster *Apple* (Fig. 45), made
early in 1910 but never cast. The apple in *Casket, Cup and
Apple* (p. 64) probably relates to this sculpture.

46. *Documents contre nature*, 1971

47. Diagrammatic sketch of *Still Life with Liqueur Bottle*

48. No. 81: *Suite 347*, 1968

STILL LIFE WITH LIQUEUR BOTTLE
Horta de San Juan, (late summer 1909)
Oil on canvas, 32⅛ x 25¾ inches
Signed lower left: "Picasso"
Provenance: Wildenstein Gallery, New York; Perls Galleries, New York; Walter P. Chrysler, Jr., New York and Warrentown, Virginia
Mrs. Simon Guggenheim Fund, 1951
Acq. no. 147.51
Ill. p. 63

1. Zervos (II, part 1, 173) placed this picture in Horta, and Picasso has subsequently confirmed that the picture was executed at the end of his stay there, though it might have received finishing touches shortly afterward in Paris.

2. When this picture was in the Walter P. Chrysler Collection, it was titled *Still Life with Siphon*. During its first years at The Museum of Modern Art it was called *Still Life with Tube of Paint* until a Spanish visitor pointed out that what had been taken for a tube of paint was actually a bottle of Anis del Mono (which brand name had figured in the title given it earlier by Zervos, II, part 1, 173).

3. Picasso had some years ago drawn a very summary sketch of the layout of the picture (Fig. 47) indicating the ceramic cock (which until now was not known to be a *botijo*). The title he has given Fig. 46 is a play on the term *d'après nature*.

CASKET, CUP AND APPLE
(Late 1909)
Ink wash, 9½ x 12⅜ inches
Signed on reverse: "Picasso"
Provenance: The Donor, New York
Gift of Justin K. Thannhauser, 1949
Acq. no. 691.49
Ill. p. 64

WOMAN IN A CHAIR
Paris, (late 1909)
Oil on canvas, 28¾ x 23⅝ inches
Signed upper right: "Picasso"
Provenance: Mlle Pertuisot, Paris; Paul Rosenberg & Co., New York
Gift of Mr. and Mrs. Alex L. Hillman, 1953
Acq. no. 23.53
Ill. p. 65

GIRL WITH A MANDOLIN
Paris, (early) 1910
Oil on canvas, 39½ x 29 inches
Signed and dated lower right:
 "Picasso/10" and on reverse: "Picasso"
Provenance: Daniel-Henry Kahnweiler, Paris; René Gaffé,
 Cagnes-sur-Mer; Roland Penrose, London
Promised gift of Nelson A. Rockefeller, New York
Ill. p. 67

1. Penrose, *Picasso*, p. 156. Penrose's interesting account of
the execution of this picture suggests that Fanny Tellier posed
clothed, which Picasso has told the author was not the case.

2. When this picture was in the collection of Roland Penrose
it was often reproduced with the caption-title *Girl with a
Mandolin (Portrait of Fanny Tellier)*. Jardot, *Picasso*, no. 22,
accepts this as a portrait, though he notes that Kahnweiler has
questioned his view.

3. Robert Rosenblum (*Cubism and Twentieth-Century Art*,
New York: Harry N. Abrams, 1960, p. 40) referred to *Girl
with a Mandolin* as "a Corot-like studio portrait." At his in-
stigation, my search has turned up *La Femme à la Toque*
(Fig. 50), which is disposed in a manner not unrelated to the
Picasso. It was exhibited in the Salon d'Automne (October 1–
November 8, 1909), which Picasso almost certainly saw. John
Richardson (*Georges Braque*, London: Penguin Books, 1959,
p. 11) had stated: "Indeed, I think that the Cubists' *penchant*
for figures with musical instruments can be traced to the im-
portant pioneer exhibition of Corot's figure paintings organ-
ized in Paris in 1909. It is at any rate significant that Braque
should still recall these works with enthusiasm."

4. Rosenblum, *Cubism*, p. 64.

STILL LIFE: LE TORERO
Céret, (summer 1911)
Oil on canvas, 18¼ x 15⅛ inches
Signed on reverse: "Picasso/Céret"
 (no longer visible as canvas has been lined)
Provenance: Paul Eluard, Paris; Rene Gaffé, Cagnes-sur-Mer;
 Roland Penrose, London
Promised gift of Nelson A. Rockefeller, New York
Ill. p. 68

"MA JOLIE" (WOMAN WITH A ZITHER OR GUITAR)
Paris, (winter 1911–12)
Oil on canvas, 39⅜ x 25¾ inches
Signed on reverse: "Picasso"
Provenance: Daniel-Henry Kahnweiler, Paris;
 Paul Guillaume, Paris; Marcel Fleischmann, Zurich
Acquired through the Lillie P. Bliss Bequest, 1945
Acq. no. 176.45
Ill. p. 69

1. This type of brushwork originated in Signac's basket-weave
variation on Seurat's *points*. But unlike Picasso, the Neo-

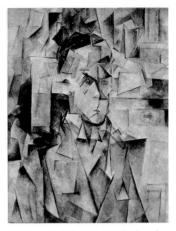

49. *Portrait of Wilhelm Uhde*, 1910. Joseph Pulitzer, Jr., St. Louis

50. Corot, *Femme à la Toque*, c. 1850–55

Impressionists had used it in the form of a consistent, molecular screen. Matisse, too, frequently used such neo-impressionist brushwork with varying degrees of consistency until about 1905.

The choice of rectangular strokes that echo the framing edge and almost resemble a kind of brickwork is consistent with the architectural nature of Cubist pictures. The texture of the strokes varies with the solidity of the planes they articulate. Compare, for example, those in the center of *"Ma Jolie"* with those in its upper corners.

2. With the exception of *Guernica* and perhaps a few other pictures, Picasso has never titled his works. Kahnweiler (*The Rise of Cubism*, New York: Wittenborn, Schultz, 1949, p. 13. Translated from the German *Der Weg zum Kubismus*) stresses the importance of providing Cubist pictures with descriptive titles so as to "facilitate" the viewer's "assimilation" of the image. This was, in any case, his common practice. Zervos accepted the tradition, cataloguing the picture the Museum has called *"Ma Jolie"* as *Woman with a Guitar* (II, part 1, 244). An early inscription on the stretcher—though not in Picasso's handwriting—identifies the picture as *Woman with a Zither*. Picasso told the author he is no longer sure what instrument was intended; he thinks it was a guitar.

3. Braque described the letters as "forms which could not be distorted because, being themselves flat, the letters were not in space, and thus by contrast their presence in the picture made it possible to distinguish between objects situated in space and those that were not." "La Peinture et nous, Propos de l'artiste, recueillis par Dora Vallier," *Cahiers d'Art* (Paris), XXIX, 1, October 1954, p. 16.

4. Greenberg, Clement, "The Pasted-Paper Revolution," *Art News* (New York), LVII, 46, September 1958, reprinted as "Collage" in *Art and Culture* (Boston: Beacon Press, 1961), p. 73. This brilliant formal analysis is devoted to the crucial transitional period of 1912–14.

5. Statement by Picasso, 1923, as reprinted in Barr, *Fifty Years*, pp. 270–71.

6. The refrain of *Dernière Chanson* begins "O Manon, ma jolie, mon coeur te dit bonjour." Jardot, *Picasso*, no. 28, identifies it as a well-known song of 1911 composed by Fragson and based upon a motif from a dance by Herman Frink.

7. Letter to Kahnweiler dated June 12, 1912, cited in Jardot, *Picasso*, no. 30. In some paintings of 1912 Picasso went beyond the allusion involved in the inscription "Ma Jolie," writing *j'aime Eva* on the surface.

8. See Robert Rosenblum, "Picasso and the Typography of Cubism," in *Picasso / An Evaluation: 1900 to the Present* (London: Paul Elek, 1972).

9. Picasso told the author that this picture was painted from the imagination and that while it was in no way a portrait, he had Eva "in mind" when he painted it.

STUDY FOR A CONSTRUCTION
(1912)
Pen and ink, 6¾ x 4⅞ inches
Signed lower left: "Picasso"
Provenance: Pierre Loeb, Paris
Purchase, 1943
Acq. no. 754.43
Ill. p. 71

CUBIST STUDY
(1912)
Brush and ink, 7¼ x 5¼ inches
Signed lower left: "Picasso"
Provenance: The Donor, Paris
Gift of Pierre Loeb, 1943
Acq. no. 753.43
Ill. p. 71

THE ARCHITECT'S TABLE
Paris (spring 1912)
Oil on canvas, oval, 28⅝ x 23½ inches
Signed on reverse: "Picasso"
Provenance: Gertrude Stein, Paris
Promised gift of Mr. and Mrs. William S. Paley, New York
Ill. p. 73

1. This picture is identified in Zervos (II, 321) as *La Bouteille de Marc (Ma Jolie)*. Margaret Potter (catalog of the exhibition *Four Americans in Paris*, New York: The Museum of Modern Art, 1970, p. 171) points out that in a letter to Gertrude Stein, Picasso called it simply *"votre nature morte (ma Jolie)"* while Kahnweiler's letter to Miss Stein regarding the sale of the painting referred to it as *The Architect's Table*.

2. Margaret Potter has drawn to my attention the passage in Gertrude Stein's *Autobiography of Alice B. Toklas* (New York: Harcourt, Brace, 1933, p. 136) that mentions a visit of the Misses Stein and Toklas to Picasso's studio on the rue Ravignan early in 1912. As the painter was not at home, Miss Stein left her calling card, and a few days later discovered that Picasso had worked a reference to it into *The Architect's Table*, then in progress. Her subsequent purchase of this picture was the first Picasso acquisition she made independently of her brother.

3. The image of pictorial reality as perfume—which though it can be sensed is insubstantial and cannot be located in space—seems particularly appropriate to some of the spectral forms of the pictures from the winter of 1911–12. Picasso would not have used such an image for the more tactile Cubism of 1908–10.

4. In conversation with John Richardson in 1952.

GUITAR
Paris, (early 1912)
Sheet metal and wire, 30½ x 13⅞ x 7⅝ inches
Provenance: Until 1971, this sculpture was owned
 by the artist.
Gift of the artist, 1971
Acq. no. 94.71
Ill. p. 75

1. There is no firm external evidence for the dating of *Guitar*, which Zervos (II, part 2, 773) and Penrose (*The Sculpture of Picasso*, New York: The Museum of Modern Art, 1967, p. 58) place in 1912. The *terminus ante quem* for its cardboard maquette is summer 1913, since it figures in a photograph (Fig. 51) of the studio on the boulevard Raspail that Picasso occupied for about a year, ending with his return from Céret where he vacationed during the summer of 1913. Sometime in the course of 1913, Picasso added a new bottom element to the maquette so as to incorporate it better into a *Still Life* of cut paper (Fig. 52); the whole ensemble was pinned for some months to the wall of his studio, where Kahnweiler had it photographed. That additional bottom element still exists, along with the other (disassembled) parts of the original cardboard maquette, though the ancillary paper forms which were added to make up the *Still Life* of 1913 have been lost.

Picasso has told the author that, while he cannot remember the year in which *Guitar* was executed, he recalls that this first of his construction-sculptures antedated his first collage, *Still Life with Chair Caning* (Fig. 53), "by many months." The date of that collage is itself the subject of some controversy. In 1945, Picasso indicated to Alfred Barr that it may date from 1911 (*Fifty Years*, p. 79). As a result of what Douglas Cooper described as a three-way discussion between himself, Picasso, and Kahnweiler ("The Making of Cubism," a symposium at the Metropolitan Museum of Art, New York, April 17–19, 1971), he proposed in 1959 (*Picasso*, an exhibition catalog, Marseille: Musée Cantini, May 11–July 31, 1959, no. 19) the date of spring 1912 (later refined to May 1912) for the collage—a date in keeping with the painted parts of the image. As this first collage, in which oilcloth was glued to the surface, antedated both Braque's and Picasso's first *papiers collés*, the date of November 9, 1912, given for it by David Duncan (*Picasso's Picassos*, New York: Harper and Brothers, 1961, p. 207) and repeated elsewhere cannot be correct. Picasso had already begun to make *papiers collés* in late September 1912, taking his lead from Braque, who made the first *papier collé* (p. 209:55) early in that month during Picasso's short absence from Sorgues, where the two had been vacationing together.

Cooper's dating for *Still Life with Chair Caning* is entirely logical; accepting it means dating *Guitar* near the beginning of 1912 or late in 1911—assuming that Picasso's recollection of the order of the two works is correct. On that score, it should be noted that the order of pivotal works is far easier for an artist to remember years afterward than is their particular dating.

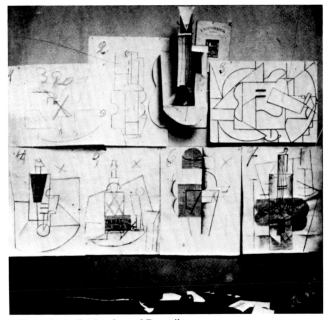

51. Picasso's studio, boulevard Raspail, 1912–13

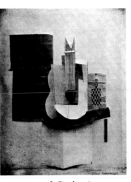

52. *Still Life* (containing the cardboard maquette of *Guitar*), 1913

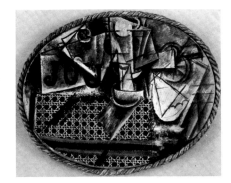

53. *Still Life with Chair Caning*, May 1912.

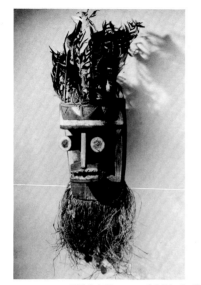

54. Wobé Ceremonial Mask. Sassandra, Ivory Coast. Musée de l'Homme, Paris

2. Douglas Cooper (*The Cubist Epoch*, London: Phaidon Press, 1970, p. 58) states that in the summer of 1912 Braque made paper and cardboard models (since lost) of objects, and that Picasso "followed his example." These 1912 models were "primarily investigations of form and volume, objects existing in paintings transposed for study in three dimensions" (p. 234). Cooper thus sees them as utilitarian objects which "became important forerunners of *papiers collés*." Braque may indeed have thought of them that way—which would explain why he failed to preserve them or translate them into more durable materials. That Picasso, on the other hand, thought of them as a new form of sculpture is evident from the way he treated them—and from what he subsequently developed out of them. (Cooper, in minimizing these works, would seem unaware of their immense impact on twentieth-century sculpture.)

As to whether Cooper is right in his contention that Picasso followed Braque in this matter, one can only choose between his and Picasso's version of events. Picasso had all along shown himself a more sculpturesque painter than Braque and would later confirm himself as a great sculptor, whereas Braque was a very timid and mediocre one. If, indeed, Braque made his cardboard models earlier, it was Picasso who saw their possibilities as sculpture.

3. In "Negro Art and Cubism" (*Horizon*, London, XVIII, 108, 1948, p. 418), Kahnweiler stated that such masks were "the decisive discovery *which allowed* painting *to create* invented signs, freed sculpture from the mass, and led it to transparency." In a later interview (*Galleries*, p. 63) he took a more conservative position, saying: "It would be wrong to suppose that the Cubists were led to these solutions (openwork sculpture) by Negro art, but in it they found a confirmation of certain possibilities. . . ."

4. See note 1, above. Picasso told the author that the mode of planar sculptural relief in a single material he initiated with *Guitar* "had nothing to do with collage." By 1913, however, construction and collage were in a reciprocal relationship.

VIOLIN AND GRAPES
Sorgues, (summer or early fall 1912)
Oil on canvas, 20 x 24 inches
Signed on reverse: "Picasso" and inscribed: "Céret/Sorgues"
Provenance: Daniel-Henry Kahnweiler, Paris; Alfred
 Flechtheim, Berlin; E. and A. Silberman Galleries, Inc.,
 New York; The Donor, New York
Mrs. David M. Levey Bequest, 1960
Acq. no. 32.60
Ill. p. 77

1. Schapiro, lectures at Columbia University.

MAN WITH A HAT
Paris, (December 1912)
Charcoal, ink, pasted paper, 24½ x 18⅝ inches
Provenance: Galerie Kahnweiler, Paris; Tristan Tzara, Paris
Purchase, 1937
Acq. no. 274.37
Ill. p. 78

1. The photograph of the boulevard Raspail studio wall
(p. 207:51) is especially interesting in this regard. While the
papiers collés of the bottom row are already in the state in
which Picasso finally left them (except for some refining and
darkening of the drawing), *Violin* (Fig. 56), second from the
left in the upper row (and marked number 2 by the artist),
has not yet received its collage elements. Sometime after the
photograph was taken, Picasso added to it panels of newsprint
and simulated wood-graining. Notice that the lines covered
by the upper panel in that operation have been redrawn on
top of the newsprint in their same positions, as have the
violin's decorative sound holes on the panel below. Picasso
also added a newsprint panel at the right, which is not indi-
cated in the drawing; the absence of such a plane—necessary
to the balance of the composition—might not have impressed
Picasso so long as the drawing was partly covered over by the
cardboard maquette for *Guitar*.

2. Observed by Sidney Janis, donor of *Head*; see *Three
Generations of Twentieth-century Art: The Sidney and Har-
riet Janis Collection of the Museum of Modern Art* (New
York: The Museum of Modern Art), forthcoming.

3. Murray, J. Charlat, "Picasso's Use of Newspaper Clippings
in his Early Collages," master's essay, Department of Fine
Arts and Archeology, Columbia University (New York),
1967, p. 21 (microfilm in the files of the Library of The
Museum of Modern Art).

4. The date of December 3, 1912, is not found on any news-
print Picasso actually used for this *papier collé*. It was prof-
fered in a memorandum of January 18, 1954, by Margaret
Miller, then Associate Curator of Museum Collections. Rob-
ert Rosenblum has confirmed that the newsprint does indeed
come from *Le Journal* of that date, and has provided the titles
of the articles and their pagination.

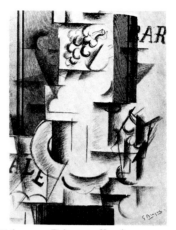

55. Georges Braque, *The Fruit Dish*, 1912. Private collection,
France

56. *Violin*, 1912–13

57. *Chair*, 1961.

HEAD
(Spring 1913)
Collage, pen and ink, pencil and watercolor, 17 x 11⅜ inches
Provenance: Daniel-Henry Kahnweiler, Paris;
 Cahiers d'Art, Paris; Theodore Schempp, Paris;
 The Donors, New York
The Sidney and Harriet Janis Collection (fractional
 gift), 1967
Acq. no. 640.67
Ill. p. 80

1. Lionel Prejger, "Picasso découpe le fer," *L'Oeil* (Lausanne), LXXXII, October 1961, p. 29.

2. In conversation with the author, July 1971.

3. The identification of the coronation text and the redating of a number of collages of this period, including *Head*—dated winter 1912–13 by Zervos (II, part 2, 403)—are to be found in Rosenblum's remarkable "Picasso and the Coronation of Alexander III: A Note on the Dating of Some *Papiers Collés*," *The Burlington Magazine* (London), CXIII, 823, October 1971, pp. 604–607, along with interesting speculations as to extra-plastic reasons why the artist might have used this particular thirty-year-old newspaper.

GLASS, GUITAR AND BOTTLE
(Spring 1913)
Oil, pasted paper, gesso and pencil on canvas,
 25¾ x 21⅛ inches
Provenance: Daniel-Henry Kahnweiler, Paris;
 Pierre Loeb, Paris; Marie Harriman, New York;
 The Donors, New York
The Sidney and Harriet Janis Collection (fractional
 gift), 1967
Acq. no. 641.67
Ill. p. 81

1. Picasso described the use of *pochoir* in this picture to the author.

2. Murray, "Picasso's Use of Newspaper Clippings." Murray also reads the MA and OR in the upper right as references to "Ma Jolie" and the "Section d'Or."

3. Suggested by Robert Rosenblum in conversation with the author.

4. The exact duration of Picasso's stay at his previous studio at 242 boulevard Raspail is not known. He installed himself at 5 bis rue Schoelcher after his return from Céret where he spent the summer of 1913, but this studio was probably rented in the previous spring prior to his departure for Céret.
 The puns and double entendres posited in my interpretation of this picture are consistent with Picasso's love of *jeux de mots* in communications with his friends (see fn. 1 under *Still Life: "Job,"* p. 215).

GUITAR
Paris, (spring 1913)
Charcoal, wax crayon, ink and pasted paper,
 26⅛ x 19½ inches
Signed lower left: "Picasso"
Provenance: Daniel-Henry Kahnweiler, Paris;
 Mme Lise Deharme, Paris; Sidney Janis Gallery, New York
Promised gift of Nelson A. Rockefeller, New York
Ill. p. 83

1. For the most fascinating, balanced and convincing account of this aspect of Picasso's iconography see Rosenblum, "Picasso and the Typography of Cubism." Murray ("Picasso's Use of Newspaper Clippings") gives a variety of penetrating interpretations along with what seem to this author a number of instances of overreading, largely related to Murray's mistaken assumption of "Picasso's total self-consciousness" (p. 9). For direct confirmation of Picasso's love of punning, see fn. 1 under *Still Life: "Job,"* p. 215.

2. Blesh, Rudi, and Janis, Harriet, *Collage: Personalities, Concepts, Techniques* (New York and Philadelphia: Chilton, 1961), pp. 23–24.

3. *Ibid*, p. 24.

4. Picasso enjoyed "sitting" stringed instruments in chairs, like personages; it was a favorite position for the sheet-metal *Guitar* (p. 75), which because of its large size took on an especially anthropomorphic appearance.

5. Picasso evidently began this *papier collé* as a horizontal composition; the erased forms of the tassels are visible in the upper right, and the way they hang indicates that the right side was originally the bottom of the composition. The change from horizontal to vertical may also explain the fact that the neck of the guitar is shown twice, both above and below its body.

MAN WITH A GUITAR
Céret, (summer) 1913
Oil and encaustic on canvas, 51¼ x 35 inches
Signed on reverse: "Picasso" and inscribed: "Céret 1913"
Provenance: Gertrude Stein, Paris
Promised gift of André Meyer, New York
Ill. p. 85

1. The "double image" as it was later to be exploited by illusionist Surrealists such as Dali was basically an optical trick. The artist had to discover a group of forms that could realistically represent two distinct objects at the same time (objects that were theoretically related on a psychological or poetic level). Picasso's fantasies in the pictures of 1913–14 were more of the order that would later be explored by the "abstract" Surrealists. His forms remain purposefully ambiguous, suggesting more than one object but literally describing none.

2. Braque ("La Peinture et nous," p. 17) observed that "the problem of color was brought into focus with the *papiers collés*."

 By emphasizing a flatness that obviated the graduated modeling in space characteristic of Analytic Cubism (a flatness which was then carried over into painting) collage pointed to the use of pure color. It should be kept in mind, however, that Matisse and other painters had been handling color that way—though within a different kind of compositional matrix—for some years.

CARD PLAYER
Paris, (winter 1913–14)
Oil on canvas, 42½ x 35¼ inches
Provenance: Léonce Rosenberg, Paris; Paul Guillaume, Paris;
 Dr. G. F. Reber, Lausanne; Francis B. Cooke, London
Acquired through the Lillie P. Bliss Bequest, 1945
Acq. no. 177.45
Ill. p. 87

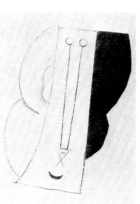

58. *Student with a Newspaper*, 1913–14 59. *Head*, 1913

60. *Man with a Guitar*, 1914

61. *The Glass*, 1914. Philadelphia Museum of Art

STUDENT WITH A PIPE
Paris, (winter 1913–14)
Oil, charcoal, pasted paper and sand on canvas,
 28¾ x 23⅛ inches
Provenance: Gertrude Stein, Paris
Promised gift of Nelson A. Rockefeller, New York
Ill. p. 89

1. Kahnweiler, *The Rise of Cubism*, pp. 15–16.

2. Boeck (Boeck, Wilhelm, and Sabartés, Jaime, *Picasso*, New York and Amsterdam: Harry N. Abrams, Inc., 1955, p. 169) reads the lower half of the X as a sign for a mustache, but reference to the *Student with a Newspaper*, where Picasso has added a mustache, makes it clear that this form characterizes the ridge above the upper lip.

WOMAN WITH A MANDOLIN
Paris, (spring 1914)
Oil, sand and charcoal on canvas, 45½ x 18¾ inches
Provenance: Gertrude Stein, Paris
Promised gift of Mr. and Mrs. David Rockefeller, New York
Ill. p. 90

1. Gertrude Stein, *The Autobiography of Alice B. Toklas*, p. 195.

2. Transcript of a conversation on Picasso between Daniel-Henry Kahnweiler and Hélène Parmelin, *Oeuvres des musées de Leningrad et de Moscou et de quelques collections parisiennes* (Paris: Editions Cercle d'Art, 1955) p. 20. Picasso cast doubt on Kahnweiler's explanation in conversation with this author, saying that a Russian musical group was concertizing in Paris and the lettering in question was visible all around the city on their posters.

PIPE, GLASS, BOTTLE OF RUM
Paris, March 1914
Pasted paper, pencil, gesso on cardboard, 15¾ x 20¾ inches
Signed lower right: "Picasso 3/1914"
Provenance: Daniel-Henry Kahnweiler, Paris;
 Mrs. Julianna Force, New York; The Donors, New York
Gift of Mr. and Mrs. Daniel Saidenberg, 1956
Acq. no. 287.56
Ill. p. 92

MAN IN A MELON HAT
1914
Pencil, 13 x 10 inches
Signed lower left: "Picasso/14"
Provenance: Valentine Dudensing, New York;
 Walter P. Chrysler, New York and Warrentown, Virginia;
 Kleeman Galleries, New York; The Donor, Grosse Pointe
 Farms, Michigan
The John S. Newberry Collection, 1960
Acq. no. 385.60
Ill. p. 93

1. See especially Zervos, II, part 2, 507, 858; VI, 1189–1191,
1194–1201, 1204–1216, 1218, 1223, 1227–1229, 1232, 1233,
1243.

62. Figure, 1914

GREEN STILL LIFE
Avignon, (summer) 1914
Oil on canvas, 23½ x 31¼ inches
Signed lower right: "Picasso/1914"
Provenance: Paul Rosenberg, Paris; Dikran Kahn Kelekian,
 New York; The Donor, New York
Lillie P. Bliss Collection, 1934
Acq. no. 92.34
Ill. p. 94

1. Barr, *Fifty Years*, pp. 90–91.

GLASS OF ABSINTH
Paris, (1914)
Painted bronze with silver sugar strainer, 8½ x 6½ inches
At bottom: raised letter "P" in bronze
This piece is one of six bronzes cast from the original wax.
 Five are painted differently, while the sixth is covered
 with sand; all incorporate a real sugar strainer.
Provenance: Daniel-Henry Kahnweiler, Paris;
 Fine Arts Associates, New York
Gift of Mrs. Bertram Smith, 1956
Acq. no. 292.56
Ill. p. 95

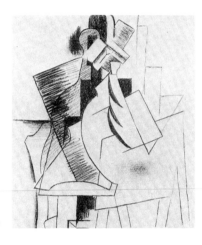

63. Figure, 1914

1. Kahnweiler, Daniel-Henry, *Les Sculptures de Picasso*
(Paris: Les Editions du Chêne, 1948), n.p.

2. Penrose, *Picasso*, p. 179.

3. In preparing a glass of absinth, a cube of sugar is placed on
a strainer of this type and held over the glass. Iced water is
then poured over the cube of sugar to dissolve it.

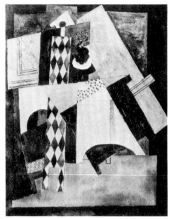

64. Harlequin next to Buffet with Compotier, 1915

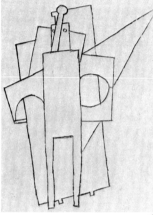

65. Dancing Couple, pencil, 1915–16

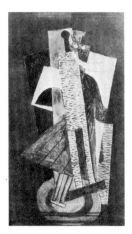

66. Dancing Couple, watercolor, 1915–16

GLASS, NEWSPAPER AND BOTTLE
Paris, (fall 1914)
Oil and sand on canvas, 14¼ x 24⅛ inches
Signed lower left: "Picasso"
Provenance: Léonce Rosenberg, Paris; Valentine Dudensing,
 New York; The Donors, New York
The Sidney and Harriet Janis Collection
 (fractional gift), 1967
Acq. no. 643.67
Ill. p. 96

1. Lippard, Lucy R. *The School of Paris: Paintings from the
Florene May Schoenborn and Samuel A. Marx Collection*
(New York: The Museum of Modern Art, 1965), p. 22.

GUITAR OVER FIREPLACE
Paris, 1915
Oil, sand and paper on canvas, 51¼ x 38¼ inches
Signed upper left corner: "Picasso/15"
Provenance: Galerie Pierre, Paris
Extended loan of the Florene May Schoenborn and
 Samuel A. Marx Collection
Ill. p. 97

HARLEQUIN
Paris, (late) 1915
Oil on canvas, 72¼ x 41⅜ inches
Signed lower right: "Picasso/1915"
Provenance: Léonce Rosenberg, Paris; Alphonse Kann, Paris;
 Paul Rosenberg, New York
Acquired through the Lillie P. Bliss Bequest, 1950
Acq. no. 76.50
Ill. p. 99

1. Stein archives, Collection of American Literature, Beinecke
Rare Book and Manuscript Library, Yale University. The
identification of the Museum's picture with the *Harlequin*
mentioned in the letter was made by Alfred Barr in 1950.

2. Boggs, *Picasso and Man*, p. 78.

3. Unlike most of the other works illustrated here, *Pianist*
(Fig. 67) does not relate directly to *Harlequin*; but the par-
ticular character of its two-part head and the general config-
uration of its protagonist suggest that painting's ambience.
Pianist is also the only image even distantly related to *Harle-
quin* in which the hand of the figure holds a rectangular plane.
 Harlequin Playing a Guitar (Fig. 68) is also not immedi-
ately related to the Museum's painting, but its combination of
a round and angular head above a diamond-patterned costume
place it within *Harlequin*'s orbit. The likelihood that Picasso
planned at any time to make the unfinished rectangle into a
guitar is not considerable. But neither is it totally obviated by
the lack of guitarlike indentations in the rectangle. Apart
from the fact that Picasso could have chosen to add them
later, he did, on occasion, envision strictly rectangular guitars
(e.g., Zervos, II, part 2, 955 of a little over a year later).

4. There are at least ten drawings and watercolors that relate directly to *Harlequin,* though it is possible that most of them postdate the painting. This was Zervos' opinion. Because one of them (Zervos II, part 2, 557) is inscribed to André Level and dated 1916, Zervos presumably also dated numbers 556, 558 (Fig. 66) and 559 in that year. But Picasso dated his gifts when he inscribed them. Thus, the Level picture could have been executed late in 1915—either before or at the time of the painting of *Harlequin*—and dated a few months later when Picasso gave it away. In any case, it is probable that some of the related drawings and watercolors antedate the oil.

The *Bottle of Anis del Mono* (Fig. 69) has obvious affinities with *Harlequin.* The prismatic cut-glass bottle characteristic of Anis del Mono, so beautifully expressed in a relief manner in *Still Life with Liqueur Bottle,* 1909 (p. 63), is here stylized in Synthetic rather than Analytic Cubist terms, producing a flat diamond-shaped pattern analogous to the traditional motley of Harlequin. Picasso has tilted the bottle, which seemingly has legs, in a manner comparable to the Harlequin in the Museum's painting, and has stylized the round hole in the rectangular neck of the bottle so as to recall the latter's head.

67. *Pianist,* 1916

STILL LIFE: "JOB"
Paris, 1916
Oil and sand on canvas, 17 x 13¾ inches
Signed upper left: "Picasso/ 16"
Provenance: Rolf de Maré, Stockholm; Carroll Carstairs
 Gallery, New York
Promised gift of Nelson A. Rockefeller, New York
Ill. p. 101

1. Speaking of this practice years later, Françoise Gilot observed: "One never referred directly to an event or a situation; one spoke of it only by allusion to something else. Pablo and Sabartés wrote to each other almost every day to impart information of no value and even less interest, but to impart it in the most artfully recondite fashion imaginable. It would have taken an outsider days, weeks, to fathom one of their arcane notes. It might be something relating to Monsieur Pellequer, who handled Picasso's business affairs. Pablo would write (since Monsieur Pellequer had a country house in Touraine) of the man in the tower *(tour)* of the château having suffered a wound in the groin *(aine)* and so on and on, playing on words, splitting them up, recombining them into unlikely and suspicious-looking neologisms, like the pirates' torn map that must be pieced together to show the location of the treasure.... He worked so hard at being hermetic that sometimes even Sabartés didn't understand and they would have to exchange several more letters to untangle the mystery." (Gilot, Françoise and Lake, Carlton, *Life with Picasso* (New York: McGraw-Hill, 1964), p. 177.

2. Murray, "Picasso's Use of Newspaper Clippings," pp. 26–27.

3. *Ibid.* Observed by Murray on the basis of a photograph of Jacob in Jean Oberlé's *La Vie d'artiste* (Paris: Editions de Noël, 1956), plate 12.

68. *Harlequin Playing a Guitar,* 1915–16

69. *Bottle of Anis del Mono,* 1915

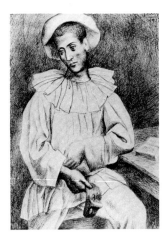

70. *Pierrot au Loup*, 1918

71. *Pierrot and Harlequin*, 1918

PIERROT
Paris, 1918
Oil on canvas, 36½ x 28¾ inches
Signed lower left: "Picasso/18"
Provenance: Bourgeois Gallery, New York; The Donor,
 New York
Sam A. Lewisohn Bequest, 1952
Acq. no. 12.52
Ill. p. 102

1. "If the subjects I have wanted to express have suggested different ways of expression I have never hesitated to adopt them." Statement by Picasso to Marius de Zayas, cited in Barr, *Fifty Years*, p. 271.

PIERROT
1918
Silverpoint, 14³⁄₁₆ x 10¹⁄₁₆ inches
Signed lower left: "Picasso/18"
Provenance: Alexander Iolas Gallery, New York
Extended loan of the Joan and Lester Avnet Collection, 1970
Ill. p. 103

GUITAR
Paris, (early 1919)
Oil, charcoal and pinned paper on canvas, 85 x 31 inches
Signed lower right: "Picasso" (signature added in 1938)
Provenance: Pierre Loeb, Paris; The Donor, Old Westbury,
 Long Island, New York
Gift of A. Conger Goodyear, 1955
Acq. no. 384.55
Ill. p. 105

1. I am indebted to Robert Rosenblum who offered this observation in support of my contention that the large diamond is to be read symbolically as a Harlequin.

2. *Guitar* has a number of affinities—the most important being the trompe-l'oeil nail—with a painting of the same motif made by Picasso in 1918 at the studio in Montrouge (Zervos, III, 140). While it is possible that the Museum's picture was executed there and that the strip of newspaper was therefore an afterthought, it is more likely that *Guitar* was executed early in 1919 after Picasso had moved to the rue de la Boétie.

SEATED WOMAN
Biarritz (1918)
Gouache, 5½ x 4½ inches
Signed lower right: "Picasso"
Provenance: Downtown Gallery, New York; The Donor,
 New York
Gift of Abby Aldrich Rockefeller, 1935
Acq. no. 127.35
Ill. p. 106

1. See Zervos, III, 166–178, 183, 203–206, 208–210, 212, 213, which are related to this composition.

RICCIOTTO CANUDO
Montrouge, 1918
Pencil, 14 x 10⅜ inches
Signed and inscribed lower right:
 "A mon cher canudo/Le poète/Picasso/Montrouge 1918"
Provenance: Ricciotto Canudo, Paris; Galerie Louise Leiris,
 Paris; Buchholz Gallery, New York
Acquired through the Lillie P. Bliss Bequest, 1951
Acq. no. 18.51
Ill. p. 107

TWO DANCERS
London, summer 1919
Pencil, 12¼ x 9½ inches
Signed lower left: "Picasso/Londres 19"
Provenance: Sergei Diaghilev, Paris; Léonide Massine, Paris;
 E. V. Thaw, New York
The John S. Newberry Collection, 1963
Acq. no. 178.63
Ill. p. 108

SLEEPING PEASANTS
Paris 1919
Tempera, 12¼ x 19¼ inches
Signed lower right: "Picasso/19"
Provenance: John Quinn, New York; Paul Rosenberg, Paris;
 Baron Shigetaro Fukushima, Paris; Mme Belin, Paris
Abby Aldrich Rockefeller Fund, 1951
Acq. no. 148.51
Ill. p. 109

1. Observed by Barr, *Fifty Years*, p. 106; also by Boggs,
Picasso and Man, p. 82.

NESSUS AND DEJANIRA
Juan-les-Pins, September 12, 1920
Pencil, 8¼ x 10¼ inches
Signed upper left: "12-9-20/Picasso"
Provenance: Galerie Louise Leiris, Paris;
 Curt Valentin Gallery, New York
Acquired through the Lillie P. Bliss Bequest, 1952
Acq. no. 184.52
Ill. p. 110

1. Penrose, *Picasso*, p. 144.

72. *Study for Sleeping Peasants*, 1919

73. *Maternité*, 1919

74. *Nessus and Dejanira*, watercolor, 1920

75. *Nessus and Dejanira* (first version), 1920

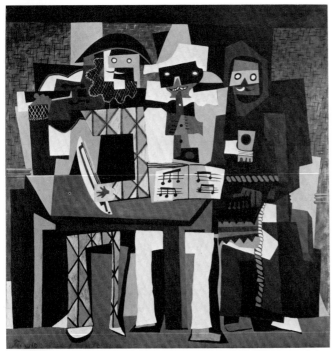

76. *Three Musicians*, 1921. Philadelphia Museum of Art

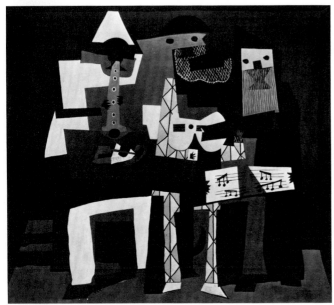

77. *Three Musicians*, 1921. The Museum of Modern Art, New York

THE RAPE
1920
Tempera on wood, 9⅜ x 12⅞ inches
Signed lower left: "Picasso/1920"
Provenance: Wildenstein & Company, Inc., New York;
 The Donor, New York
The Philip L. Goodwin Collection, 1958
Acq. no. 106.58
Ill. p. 111

THREE MUSICIANS
Fontainebleau, (summer) 1921
Oil on canvas, 6 feet 7 inches x 7 feet 3¾ inches
Signed lower right: "Picasso, Fontainebleau 1921"
Provenance: Purchased from the artist in 1921 by
 Paul Rosenberg and owned by him until its acquisition
 by the Museum
Mrs. Simon Guggenheim Fund, 1949
Acq. no. 55.49
Ill. p. 113

1. Henri Hayden's *Three Musicians* of 1919–20 (Fig. 78) has often been identified as a possible source for Picasso's versions of the subject and, indeed, insofar as it portrays—on a large canvas and in Synthetic Cubist style—three carnival-type musicians distributed evenly across the field of the composition, it certainly anticipates the later works. But the fabric of the Picasso pictures is very different and seems more related to Picasso's own work of 1920 and earlier than to Hayden's picture (itself unquestionably painted under the influence of the post-1914 Picasso).

2. The identity of these objects was confirmed by Picasso in conversation with the author.

3. The version of *Three Musicians* in the Philadelphia Museum (Fig. 76) shows the monk playing a kind of keyed harmonium or accordion. The music he holds in The Museum of Modern Art version has been put before the recorder-playing Pierrot, who has been shifted to the center of the composition. Harlequin, now playing a violin, closes the composition on the left.

The Philadelphia version is more subdivided into small shapes, and the middle of the value scale is much more in evidence. While generally more ornamental, it lacks the dramatic contrasts of light and dark, large and small, and what is finally the mysterious poetry of The Museum of Modern Art version.

4. Stravinsky's choice of Pergolesi also reflects his neo-classical interests in those years, the counterpart in Picasso being such pictures as *Three Women at the Spring* (p. 115).

78. Henri Hayden, *Three Musicians*, 1919–20. Musée National d'Art Moderne, Paris

79. *Pierrot and Harlequin*, 1920

81. *Monk*, 1921

80. *Pierrot and Harlequin*, 1920

82. *Dog and Cock*, 1921

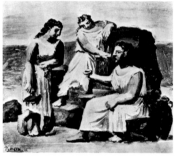

83. *Three Women at the Spring*, 1921

84. *Three Women at the Spring*, 1921

85. *Study for Three Women at the Spring*, 1921

86. *Study for Three Women at the Spring*, 1921

87. "Nymph of Fontainebleau," 1860. Cartoon by Couder, painted by Alaux, based on an engraving of the original composition (c. 1532–41) by Rosso. Château of Fontainebleau.

THREE WOMEN AT THE SPRING
Fontainebleau, (summer) 1921
Oil on canvas, 6 feet 8¼ inches x 7 feet 3¾ inches
Signed lower right: "Picasso/21"
Provenance: John Quinn, New York; Mrs. Meric Callery, New York; Carlo Frua de Angeli, Milan; J. B. Neumann, New York; The Donors, New York
Gift of Mr. and Mrs. Allan D. Emil, 1952
Acq. no. 332.52
Ill. p. 115

1. The gray and terra-cotta tones of this picture have frequently suggested building materials to its interpreters. Schapiro (lectures at Columbia University) spoke of stone and brick; Barr (Barr, Alfred H., Jr., *Masters of Modern Art*, New York: The Museum of Modern Art, 1954, p. 80) wrote of poured concrete.

2. This suggestion was first made by Jardot (*Picasso*, no. 54) and seconded by Boggs (*Picasso and Man*, p. 90). Jardot's text was read by Picasso who took no exception to the assertion.

LA SOURCE
Fontainebleau, July 8, 1921
Pencil, 19 x 25¼ inches
Signed lower left: "Picasso/8-7-21"
Provenance: Paul Rosenberg, New York; The Donor, Grosse Pointe Farms, Michigan
The John S. Newberry Collection, 1960
Acq. no. 386.60
Ill. p. 116

1. See Zervos, IV, 302–304 for two other drawings and a painting related to this theme and also executed during 1921.

2. The possible source of this image in the art of Fontainebleau was suggested to the writer by William Rubin.

88. Dog from the Fountain of Diana, Barthélmy Prieur, 1603. Incorporated into the present fountain in 1684 by the Kellers.

NUDE SEATED ON A ROCK
(1921)
Oil on wood, 6¼ x 4⅜ inches
Provenance: Purchased from the artist in 1934 by The Donor
Promised gift of James Thrall Soby,
 New Canaan, Connecticut
Ill. p. 117

THE SIGH
Paris, 1923
Oil and charcoal on canvas, 23¾ x 19¾ inches
Signed lower right: "Picasso/23"
Provenance: M. Knoedler & Co., Inc., New York
Promised gift of James Thrall Soby,
 New Canaan, Connecticut
Ill. p. 118

1. Soby, James Thrall, in *The James Thrall Soby Collection*,
New York: The Museum of Modern Art, 1961, p. 63.

STILL LIFE WITH A CAKE
May 16, 1924
Oil on canvas, 38½ x 51½ inches
Signed lower right: "Picasso/24"; dated: 16 mai
 (acc. Zervos, v, 185)
Provenance: Alphonse Kann, London
Acquired through the Lillie P. Bliss Bequest, 1942
Acq. no. 190.42
Ill. p. 119

STUDIO WITH PLASTER HEAD
Juan-les-Pins, (summer) 1925
Oil on canvas, 38⅝ x 51⅝ inches
Signed on lower right: "Picasso 25" and dated on the
 stretcher: "Juan-les-Pins/1925"
Provenance: Dr. G. F. Reber, Lausanne;
 James Johnson Sweeney, Houston
Purchase, 1964
Acq. no. 116.64
Ill. p. 121 and on cover

1. Picasso told the author that the toy theater in this picture
is an absolutely accurate representation of the one he had
made for Paul except for the omission of a human figure
originally placed at stage right.

2. Robert Rosenblum, in conversation with the author, has
drawn attention to an exceptional early Cubist painting of late
1908 (Fig. 90) in which the shading within the oval head
unquestionably anticipates the kind of interior profile which
Picasso was to isolate subsequently in the "double head."

3. The double head in Fig. 91 is claimed as an exception in
Robert Melville's "The Evolution of the Double Head in the
Art of Picasso," *Horizon* (London), VI, 35, November 1942,
p. 343, but it shows the convention in still a rather unformed
state.

89. Set for the ballet *Pulcinella*, 1920

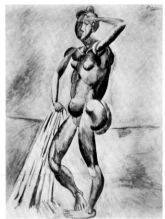

90. *Bather*, 1908

91. *Head of a Woman*, 1924

92. *Still Life with Ram's Head*, 1925

93. de Chirico, *The Philosopher's Promenade*, 1914

94. de Chirico, *Self-Portrait*, 1913

95. de Chirico, *The Span of Black Ladders*, 1914. Mr. and Mrs. James Alsdorf, Chicago

96. de Chirico, *The Scholar's Playthings*, 1917

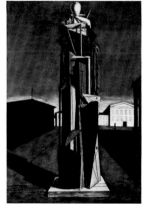

97. de Chirico, *The Great Metaphysician*, 1917. The Museum of Modern Art, New York

4. This motif occurs in two other oil paintings of 1925 (Zervos, v, 375, 444); however, it is most fully developed in *Studio with Plaster Head*.

5. Schapiro, lectures at Columbia University.

6. Picasso was unquestionably familiar with de Chirico's painting in the years prior to World War I when the Italian painter was being championed by Picasso's friend Guillaume Apollinaire. But none of the forms of Picasso's neoclassicism of 1915–24 reflects any special awareness of the Italian painter's art. In the two years prior to the painting of *Still Life with Plaster Head*, however, Picasso had been quite friendly with André Breton and was no doubt aware that the poet considered de Chirico (Surrealism's "fixed sentinel") along with Picasso himself ("Surrealism . . . has but to pass where Picasso has already passed, and where he will pass in the future") as the two artists most instrumental in the development of his movement. Indeed, in the First International Surrealist Exhibition held at the Galerie Pierre in November 1925, de Chirico and Picasso were (with Klee) the only non-Surrealists represented. This was, significantly, the first time Picasso had ever consented to participate in a group show.

7. In such pictures as *The Great Metaphysician*, 1917 (Fig. 97), de Chirico used a carpenter's square in conjunction with other forms resembling the tools of a designer or engineer (as well as suggestions of painting stretchers) to form scaffoldings that were inspired in part by the abstract structures of high Analytic Cubism. *The Great Metaphysician* is especially interesting in regard to *Studio with Plaster Head* in its juxtaposition of the carpenter's square with the white bust of what reads as a classical statue.

FOUR DANCERS
Monte Carlo, (spring) 1925
Pen and ink, 13 ⅞ x 10 inches
Signed lower right: "Picasso/ 25"
Provenance: Dikran Kahn Kelekian, New York;
 The Donor, New York
Gift of Abby Aldrich Rockefeller, 1935
Acq. no. 128.35
Ill. p. 123

1. See Douglas Cooper, *Picasso: Theatre* (New York: Abrams, 1968) for a discussion of the role of the theater in Picasso's life and work, a list of theatrical productions in which he has collaborated, and numerous illustrations of costumes, decor, and other compositions related to his theatrical experience.

SEATED WOMAN
December 1926
Oil on canvas, 8¾ x 5 inches
Signed upper left: "Picasso"; dated on the stretcher:
 "Decembra [*sic*] 26"
Provenance: Acquired from the artist in 1932
 by The Donors, New York

The Sidney and Harriet Janis Collection (fractional
 gift), 1967
Acq. no. 643.67
Ill. p. 124

SEATED WOMAN
Paris, 1927
Oil on wood, 51⅛ x 38¼ inches
Signed lower right: "Picasso/27"
Provenance: Mary Hoyt Wiborg, New York; Valentine
 Gallery, New York; The Donor, New Canaan, Connecticut
Fractional gift of James Thrall Soby, 1961
Acq. no. 516.61
Ill. p. 125

1. Hamilton, George Heard, *Painting and Sculpture in
Europe 1880 to 1940* (Baltimore: Penguin Books, 1967),
p. 305.

PAGE O FROM LE CHEF-D'OEUVRE INCONNU BY
 HONORÉ DE BALZAC
Wood engraving by Aubert after a drawing by Picasso
 (1926); published Paris: Ambroise Vollard, 1931;
 13 x 10 inches (page size)
The Louis E. Stern Collection, 1964
Acq. no. 967.64
Ill. p. 126

PAINTER WITH MODEL KNITTING FROM LE CHEF-D'OEUVRE
 INCONNU BY HONORÉ DE BALZAC
Paris (1927); published Paris: Ambroise Vollard, 1931
Etching, 7⁹⁄₁₆ x 10⅞ inches
G.126
The Louis E. Stern Collection, 1964
Acq. no. 967.64
Ill. p. 127

1. Barr, Alfred H., Jr., *Picasso: Fifty Years of His Art* (New
York: The Museum of Modern Art, 1946), p. 145.

THE STUDIO
Paris, 1927–28
Oil on canvas, 59 x 91 inches
Signed lower right: "Picasso/28"; inscribed on
 stretcher: "1927–28"
Provenance: Valentine Gallery, New York; The Donor,
 New York and Warrentown, Virginia
Gift of Walter P. Chrysler, Jr., 1935
Acq. no. 213.35
Ill. p. 129

1. Richardson, John, "Picasso's Ateliers and other recent
works," *The Burlington Magazine* (London), XCIX, 651, June
1957, pp. 183–84.

2. Rosenblum, *Cubism*, pp. 289–290.

98. *L'Atelier de la Modiste*, 1926. Musée National d'Art
Moderne, Paris

99. Infrared photo of left section of *The Studio*, 1927–28

100. *Project for a Monument*, 1928

101. *Head*, 1928.

102. *Sketch for Head*, 1928

103. *Woman*, 1928

104. *Woman's Head and Portrait*, 1929

3. The analogy between eyes and mouth, though not their displacement, was well advanced in 1908 in such pictures as *Bust of a Man* (p. 53), where the inspiration in that respect was almost certainly African art.

4. Picasso had originally considered giving the artist a rectangular palette (clearly visible in the infrared photograph, Fig. 99) but subsequently painted it out.

PAINTER AND MODEL
Paris, 1928
Oil on canvas, 51⅛ x 64¼ inches
Signed lower left: "Picasso/28"
Provenance: Paul Rosenberg, Paris; The Donors, New York
The Sidney and Harriet Janis Collection (fractional
 gift), 1967
Acq. no. 644.67
Ill. p. 131

1. Barr, *Fifty Years*, p. 157.

2. For an extensive discussion of such displacements, see Robert Rosenblum, "Picasso and the Anatomy of Eroticism," in T. Bowie and C. Christenson, eds., *Studies in Erotic Art* (New York: Basic Books, 1970).

3. Golding, John, "Picasso and Surrealism," *Picasso/An Evaluation: 1900 to the Present* (London: Paul Elek, 1972).

4. Observed by Lucy Lippard in the forthcoming catalog of The Sidney and Harriet Janis Collection (New York: The Museum of Modern Art, 1972).

5. Penrose (*Picasso*, p. 235) considers the classical silhouette against which the angry woman's head is seen to be a self-portrait.

BATHER AND CABIN
Dinard, (August 9, 1928) (acc. Zervos, VII, 211)
Oil on canvas, 8½ x 6¼ inches
Signed lower left: "Picasso 28"
Provenance: Valentine Gallery, New York; Oliver B. James,
 New York
Hillman Periodicals Fund, 1955
Acq. no. 342.55
Ill. p. 132

1. For the origin and development of Surrealist biomorphism see the author's *Dada and Surrealist Art* (New York: Harry N. Abrams, Inc., 1968), pp. 18–22 and *passim*.

2. Vallentin, Antonina, *Pablo Picasso* (Paris: Club des Editeurs, Hommes et Faits de L'Histoire, 1957), p. 85.

SEATED BATHER
(Early 1930)
Oil on canvas, 64¼ x 51 inches
Signed lower right: "Picasso"
Provenance: Mrs. Meric Callery, New York
Mrs. Simon Guggenheim Fund, 1950
Acq. no. 82.50
Ill. p. 133

WOMAN BY THE SEA
(April 7), 1929 (acc. Zervos, VII, 252)
Oil on canvas, 51⅛ x 38⅛ inches
Signed lower left: "Picasso/29"
Provenance: Aline Barnsdall, Santa Barbara, California
Extended loan of the Florene May Schoenborn and
 Samuel A. Marx Collection
Ill. p. 134

1. Golding, "Picasso and Surrealism."

105. Drawing from a sketchbook, 1927

PITCHER AND BOWL OF FRUIT
(February 22), 1931 (acc. Zervos, VII, 322)
Oil on canvas, 51½ x 64 inches
Signed lower left: "Picasso/xxxi"
Provenance: Paul Rosenberg, Paris;
 Henry P. McIlhenny, Philadelphia
Promised gift of Nelson A. Rockefeller, New York
Ill. p. 135

1. See below, p. 139, note 1 under *Girl before a Mirror.*

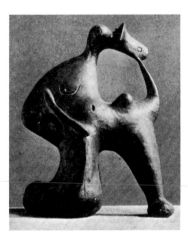

106. *Bather*, 1928

THE SERENADE
Paris, October 22, 1932
Brush, pen and ink, 10¼ x 13⅛ inches
Signed lower right: "Picasso/Paris 22 octobre xxxii"
Provenance: Daniel-Henry Kahnweiler, Paris; Curt Valentin,
 New York; Perls Galleries, New York;
 The Donor, New York
Gift of Miss Eve Clendenin, 1961
Acq. no. 315.61
Ill. p. 136

1. See Zervos, VIII, 33–36, 38, 39, 41, 42, 44, 45, 46, 48 for
compositions that are closely related.

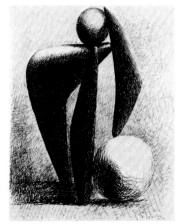

107. Page from a sketchbook, 1928

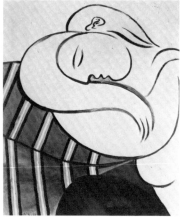

108. *Woman with Blond Hair*, 1931

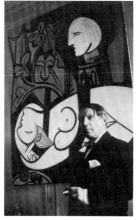

109. Photograph of Picasso by Cecil Beaton, 1931

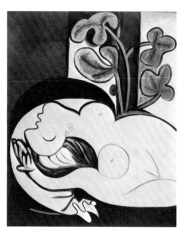

110. *Nude on a Black Couch*, 1932

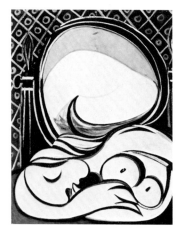

111. *The Mirror*, 1932

THE ARTIST AND HIS MODEL
Cannes, July 23, 1933
Gouache, pen and ink, 15⅞ x 20 inches
Signed lower right: "Picasso/Cannes 23 juillet XXXIII"
Extended loan of Mr. and Mrs. Arthur Wiesenberger
Ill. p. 137

1. Boeck and Sabartés, *Picasso*, pp. 314ff.

GIRL BEFORE A MIRROR
(March 14), 1932 (acc. Zervos, VII, 379)
Oil on canvas, 64 x 51¼ inches
Signed upper left: "Picasso XXXII"
Provenance: Paul Rosenberg, Paris; Valentine Dudensing, New York
Gift of Mrs. Simon Guggenheim, 1938
Acq. no. 2.38
Ill. p. 139

1. Although 1932 is the year traditionally given for the beginning of Picasso's liaison with Marie-Thérèse Walter, there are a few pictures dated 1931 by Zervos (Fig. 108) that were almost certainly inspired by her. Brassaï (*Conversations*, p. 28) speaks of Picasso's first image of Marie-Thérèse having been painted in December 1931, but there is good reason to think that these images go back to autumn of that year at the very least. There is a photograph of Picasso (see Rosenblum, "Picasso and the Anatomy of Eroticism," p. 347, fn. 23.) made by Cecil Beaton in 1931 in which the artist stands before a painting (Fig. 109) not catalogued by Zervos, in which the reclining nude is obviously of the series of images of Marie-Thérèse that continued in 1932 with *Nude on a Black Couch* (Fig. 110) and *The Mirror* (Fig. 111). The painting includes a representation of a sculptured bust that is quite clearly a portrait of Marie-Thérèse and no doubt represented one of the earliest of the series of her heads Picasso was to model in the studios he had made out of the stables of the seventeenth-century Château de Boisgeloup, near Gisors, which he had purchased in 1930 or early in 1931.

It seems probable that the first images of Marie-Thérèse date from the summer of 1931. Indeed, the remarkable change in mood in Picasso's painting as early as February and March 1931—as reflected in *Pitcher and Bowl of Fruit* (p. 135; dated February 22) and *Still Life on a Table* (Fig. 112; dated March 11)—suggests that his first contacts with her date from the beginning of the year. In view of the extraordinarily anthropomorphic character of *Still Life on a Table*, and its anticipations of *Girl before a Mirror* (see text, p. 140), it is perhaps not too far-fetched to consider this picture a metaphoric tribute to the seventeen-year-old girl who had just entered Picasso's life.

2. Schapiro, Meyer, cited in "A *Life* Round Table on Modern Art," *Life* (New York), XXV, 15, October 11, 1948, p. 59.

3. *Ibid.*

4. *Ibid.*

5. Rosenblum, "Picasso and the Anatomy of Eroticism," p. 349.

6. *Ibid.*

7. Sypher, Wylie, *From Rococo to Cubism* (New York: Random House, 1960), p. 280.

8. Gottlieb, Carla, "Picasso's *Girl Before a Mirror*," *Journal of Aesthetics and Art Criticism*, XXIV, 4, Summer 1966, pp. 509–18. Gottlieb asserts (p. 510) that "Picasso must have known *The Living-and-Dead Lady*, which was one of Gómez' prize possessions. In his autobiography published in Madrid as appendix to *La Sagrada Cripta de Pombo* in 1923, the poet dedicated two pages to it, illustrating it with a print. The main text of the same volume contains a photograph of Picasso, taken at the banquet which was given by Ramón in his honor at the Sacred Crypt of the Pombo (the meeting place for Gómez and his followers) in 1917, when Picasso stopped over in Madrid enroute from Rome to Paris. It is most probable that a copy of the book featuring his photograph would have reached Picasso."

9. Rosenblum, "Picasso and the Anatomy of Eroticism," p. 349.

10. Marion Bernadik uses the X-ray image in relation to the figure and reflection in an essay written in January 1945 for a class of Meyer Schapiro's at The New School, New York (copy in the Library of The Museum of Modern Art). She paraphrases Schapiro in referring to the Girl's body as "simultaneously clothed, nude and X-rayed," a passage cited in Barr, *Fifty Years*, p. 176.

11. Gottlieb, "Picasso's *Girl Before a Mirror*," p. 510, observes: "It has not been noted so far that the artist has introduced into his picture a clue which tells the beholder what the young beauty is discovering when studying her image. This clue is the form of the looking-glass—a figure-length, free-standing plate fitted with an adjustable inclination. Although known since the time of Louis XVI, this type came into popular use only during the nineteenth century—to disappear shortly afterwards in the twentieth. Such a mirror is called *psyché* in France and Austria, *psiche* in Italy, and *psiquis* in Spain. The English translation of this Greek word is "soul." Its meaning is commonly known since the words *psychology, psychoanalysis, psychosis*, etc. derive from this root. Scholars are furthermore familiar with it from the story of *Eros and Psyche*, where the soul is personified as a young and lovely girl who searches for divine love. As regards the transference of the name *psyche* to a mirror, it is founded upon the popular belief that the plate does not reflect the outward likeness of the person who is consulting it but his/her soul."

12. *Girl before a Mirror* is dated March 14, 1932. *Nude on a Black Couch* is dated March 9, 1932, and *The Mirror* is dated March 12, 1932.

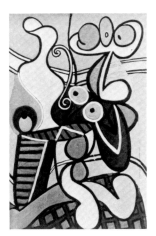

112. *Still Life on a Table*, 1931

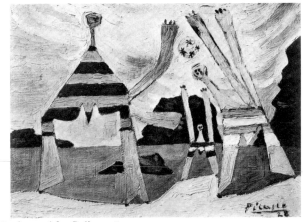

113. *Bathers with a Ball*, 1928

114. *The Living and Dead Lady.* Formerly Collection Ramón Gómez de la Serna

227

115. *Two Girls Reading,* March 29, 1934

116. Picasso's studio at Boisgeloup, early 1930s

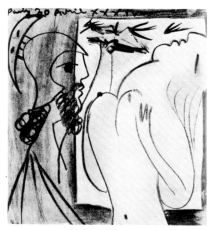

117. *Nude and Warrior,* April 30, 1934

TWO FIGURES ON THE BEACH
Cannes, July 28, 1933
Pen and ink, 15¾ x 20 inches
Signed lower right: "Picasso/ Cannes 28 juillet XXXIII"
Provenance: Galerie Robert, Amsterdam;
 Galerie Simon, Paris
Purchase, 1939
Acq. no. 655.39
Ill. p. 141

1. Cited in Leymarie, Jean, *Picasso Drawings* (Geneva: Skira, 1967), p. 58.

MODEL AND SURREALIST FIGURE
(May 4, 1933)
Etching, 10⁹⁄₁₆ x 7⅝ inches
G.346IIc.
Purchase, 1949
Acq. no. 221.49
Ill. p. 143

1. Bolliger, Hans, *Picasso for Vollard* (New York: Harry N. Abrams, 1956), p. x. Although one hundred plates were finished in 1937, the tirage was not completed until 1939, shortly before Vollard's death in an auto accident July 22. The prints were not made available until 1949. William S. Lieberman (*The Sculptor's Studio: Etchings by Picasso,* New York: The Museum of Modern Art, 1952) was the first to mention that the plates were "acquired" by Vollard, not commissioned, as Bolliger insists, because of the "success" of the Balzac and Ovid books. Neither of these books was, in fact, a financial success, and it is more probable that Vollard accepted a set number of plates in trade for several paintings Picasso acquired from him.

GIRL READING
Spring 1934
Oil on canvas, 64 x 51½ inches
Signed upper right: "Picasso/ XXXIV"
Provenance: Peter Watson, London
Promised gift of the Florene May Schoenborn and
 Samuel A. Marx Collection
Ill. p. 144

1. In addition to Fig. 115, of March 29, Picasso executed Zervos, VIII, 191, 192 and 194 on March 27, 28 and 30 respectively. Zervos, VIII, 193, although not dated, almost surely comes from the same period. From early in April—to judge by the relation of its surreal biomorphism and its setting to a *Still Life* dated April 7—comes still another version of the motif of two girls reading, which Zervos (VIII, 197) has mistakenly identified as a still life.

MYRRHINA AND KINESIAS FROM LYSISTRATA BY ARISTOPHANES
New York, The Limited Editions Club, 1934
Etching, 8⅝ x 6 inches
The Louis E. Stern Collection, 1964
Acq. no. 970.64
Ill. p. 145

INTERIOR WITH A GIRL DRAWING
Paris, February 12, 1935
Oil on canvas, 51⅛ inches x 6 feet 4⅝ inches
Inscribed on stretcher: "Paris 12 février xxxv"
Provenance: Mrs. Meric Callery, New York
Promised gift of Nelson A. Rockefeller, New York
Ill. p. 147

1. Of the three sketchbook drawings of February 5, 1935, Fig. 118 and one other, Zervos, VIII, 250, show the girl before a mirror that reflects her image. In Zervos, VIII, 252, she confronts an easel with a picture painted on it. The easel had appeared on the right side of the other two sketches but in those cases supported only a blank canvas.

2. Brassaï, *Conversations avec Picasso* (Paris: Gallimard, 1964), p. 268.

3. Painting over an entire picture, as opposed to making a new version on a separate canvas, is a relatively unusual procedure for Picasso after the Blue Period. It may well be that the painter called in Zervos between February 5 and 12 precisely because he knew he was going to paint over Fig. 122. This still leaves the conundrum of the date—February 17—which appears on the drawing for that first version (Fig. 121), and no explanation for that drawing's remarkable labyrinthine web of color identification lines. This author's surmise is that it actually preceded the making of Fig. 122—except for the color indications—and that only after having overpainted that picture did Picasso add the color notations from memory, possibly as a form of record, as well as the date of February 17.

The reader should keep in mind that in referring to the "first version" in the last paragraph of the text, the author has in mind the first painting executed on the very canvas which is now the Rockefeller picture (Fig. 122). That picture, in turn, may well have been preceded by a wholly different version now in the Musée National d'Art Moderne, Paris (Fig. 125), on which Picasso apparently did not inscribe a particular date. In the Paris picture, the girl drawing seems more awake, more outwardly oriented, and the picture reflected in the mirror is more clearly a still life.

118. *Girl Drawing*, February 5, 1935

119. *Girl Drawing*, 1935

120. *Girl Drawing*, 1935

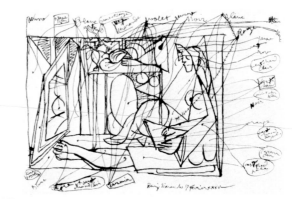

121. *Girl Drawing*, February 17, 1935

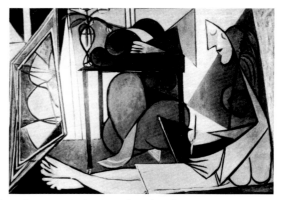

122. *Girl Drawing*, 1935 (subsequently painted over)

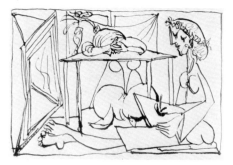

123. *Girl Drawing*, 1935

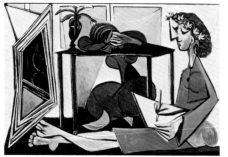

124. *Girl Drawing*, February 17, 1935

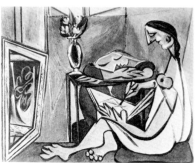

125. *Girl Drawing*, 1935. Musée National d'Art Moderne, Paris

137. *Still Life with Black Bull's Head*, November 19, 1938

MINOTAUROMACHY
(1935)
Etching and scraper, 19½ x 27⁷⁄₁₆ inches
B.288
Purchase, 1947
Acq. no. 20.47
Ill. p. 149

1. Barr, Alfred H., Jr., *Picasso: Fifty Years of His Art* (New York: The Museum of Modern Art, 1946), pp. 192–193.

FAUN AND SLEEPING WOMAN
(June 12, 1936)
Etching and aquatint, 12⁷⁄₁₆ x 16⁷⁄₁₆ inches
B.230
Purchase, 1949
Acq. no. 267.49
Ill. p. 150

1. Bolliger, *Picasso for Vollard*, p. xiv.

DREAM AND LIE OF FRANCO II
(January 8–9, 1937, and June 7, 1937)
Etching and aquatint, 12³⁄₈ x 16⁹⁄₁₆ inches
B.298
Gift of Mrs. Stanley Resor, 1958
Acq. no. 424.58.2
Ill. p. 151

1. J. J. Sweeney has suggested that the figure of Franco might have been inspired by Jarry's famous character, Ubu. When asked about this possibility Picasso replied—with Jarry's vocabulary—that he had been *"inspiré par l'étron"* (questionnaire, October 1945).

2. The interpretation of the etching owes much to the careful analysis of W. S. Lieberman.

3. Barr, Alfred H., Jr., *Picasso: Fifty Years of His Art* (New York: The Museum of Modern Art, 1946), pp. 195, 196.

STILL LIFE WITH RED BULL'S HEAD
Paris, November 26, 1938
Oil on canvas, 38⅛ x 51 inches
Signed at lower left center: "Picasso"; dated lower right: "26.11.38"
Provenance: Galerie Louise Leiris, Paris
Promised gift of Mr. and Mrs. William A. M. Burden, New York
Ill. p. 153

1. Exactly one week earlier (November 19, 1938), Picasso completed *Still Life with Black Bull's Head* (Fig. 137) where, despite the presence below the animal of what appears to be a socle, the bull's head—powerful and self-assured, as in *Guernica*—seems to materialize from out of the walls of the room.

126. *The Mistletoe Seller*, 1903 127. *Young Girl with Basket of Flowers*, 1905. Mr. and Mrs. David Rockefeller, New York

131. *Woman with Dead Child on a Ladder*, 1937 132. *Bullfight*, 1933

128. *Curtain for Parade*, 1917. Musée National d'Art Moderne, Paris

133. *Running Minotaur*, 1928 134. *Minotaur* (with dagger), 1933

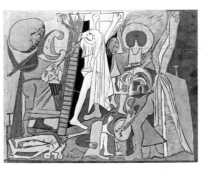

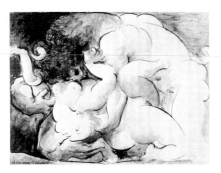

129. *Crucifixion*, 1930

135. *Minotaur*, 1933

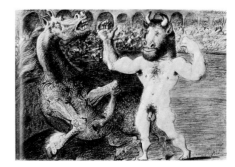

130. *The Balcony*, 1933

136. *Minotaur*, 1935

THE NECKLACE
September 8, 1938
Pen and ink, 26¾ x 17⅝ inches
Signed lower right: "Picasso" and dated lower left: "8.9.38"
Provenance: Louis Carré, Paris; Perls Galleries, New York;
 Henry A. Petter, New York
Acquired through the Lillie P. Bliss Bequest, 1949
Acq. no. 11.49
Ill. p. 154

1. Barr, *Fifty Years*, p. 219.

2. Leymarie, *Picasso Drawings*, p. 16.

RECLINING NUDE
Mougins, September 10, 1938
Pen, ink and gouache, 17 x 26¼ inches
Signed lower left: "10.9.38. Picasso"
Provenance: Berggruen et Cie., Paris
Extended loan of the Joan and Lester Avnet Collection
Ill. p. 155

NIGHT FISHING AT ANTIBES
Antibes, (August 1939)
Oil on canvas, 6 feet 9 inches x 11 feet 4 inches
Provenance: Christian Zervos, Paris;
 Carlo Frua de Angeli, Milan
Mrs. Simon Guggenheim Fund, 1952
Acq. no. 13.52
Ill. p. 157

1. Zervos, IX, 316 (in catalog listing) identifies this wrongly as Man Ray's apartment.

2. The account in this paragraph owes some details to Boeck and Sabartés (*Picasso*, p. 262) but is largely indebted to Penrose (*Picasso*, pp. 289–90).

3. Dora Maar in conversation with Sidney and Harriet Janis identified herself and Jacqueline Lamba as the ladies on the jetty. This identification is recorded in their book (*Picasso: The Recent Years 1939–1946*, New York: Doubleday and Co., 1946, text facing plate 5).
 The licking of the ice-cream cone by a darting tongue is not a new motif, having appeared a year before *Night Fishing* in a group of pictures of a man aggressively attacking that sweet. The taurine features of the male head and the pointed shape of the ice cream in Fig. 138 (and to some extent in Zervos, IX, 204 and 205) are unexpected, given the inherently pleasurable nature of the motif. Much more than in the case of Dora Maar in *Night Fishing*, this picture lends itself to an interpretation of licking a cone as involving potentially aggressive sexual activity (see notes 9 and 10 below).

4. Jacqueline Lamba was married to André Breton at the time.

5. This form has often been wrongly identified as the moon. That it must be read as the acetylene lamp used by the fishermen seems to this author necessary to the logic of the imagery; in any event, that interpretation is confirmed by Penrose (*Picasso*, pp. 289–90, and in a letter of September 28, 1971, to this author), who was in Antibes and was seeing Picasso at the time *Night Fishing* was painted. His reading of its imagery seems to this writer by far the most sensible of those proposed.

6. I owe this detail of my reading to Albert Boime's "Picasso's 'Night Fishing at Antibes': One More Try," *Journal of Aesthetics and Art Criticism* (New York), XXIX, 2, Winter 1970, p. 224.

7. The terminology used by Meyer Schapiro in his lectures at Columbia University (see also *Life*, "Roundtable," p. 59). In his discussion of the "internal image" of the body, Schapiro referred frequently to Paul Schilder's *Image and Appearance of the Human Body* (London: George Routledge and Sons Ltd., Psyche Monographs No. 4, 1935. New York: International Universities Press, 1951). Lawrence Steefel, Jr.'s "Body Imagery in Picasso's 'Night Fishing at Antibes,' " *Art Journal* (New York), XXV, 4, Summer 1966, p. 356, is an excellent and detailed analysis of the picture in terms of Schilder's theories. Here, for example, is Steefel's analysis of the form of the right hand of the fisherman with the spear:
 "Look at the hand on the gunwale. Its largeness is not only a function of its nearness to us and of Picasso's inherent love of exaggeration, but as an extension of the shaft-like arm, it gives us an image of the sensitivity of the fingers (or knuckles) balancing and sensing, predicting and reacting, enlarged in consciousness to a logical correspondence to their major role within the action as a whole. Moreover, the heavy mass of the body will flow into the hand (which is also cramped) forming a complex yet immediate sense of simultaneous numbness and sensitivity. [Schilder, pp. 91–92] Merely placing one's arm on a desk and pressing down and then pulling the body away slightly will produce analagous [*sic*] sensations for anyone. As in the face, so remarkably inverted, of the other fisherman bending over the gunwale, we have here an empirical translation of the feelings of body mass disrupting the normal body-image played into an expressive invention of form. These effects are combined with the odd sensation of the body as an "external" object to be discovered, an awareness which inversion of posture naturally evokes for the consciousness inhabiting that body. [Schilder, pp. 91–97]"

8. Levitine, George, "The Filiation of Picasso's 'Night Fishing at Antibes,' " *Journal of Aesthetics and Art Criticism* (New York), XXII, 2, Winter 1963, pp. 171–175.

9. Steefel, "Body Imagery," p. 358.

10. Boime "Picasso's 'Night Fishing at Antibes,' " p. 223. The problem with Boime's psychosexual interpretation of *Night Fishing* is not so much that his observations are wrong (although even those that ring most true were probably not as consciously intended as Boime supposes) as that he has placed his sometimes ingenious sexual associations at the very center of meaning in the work. Free association to spearing a

fish might indeed lead some minds to thoughts of aggressive sexual penetration, just as associations to licking an ice-cream cone might lead them to "a well known [sexual] variation" (Rothschild, see note 11 below). But such conjuries remain associations. Picasso is a most direct painter and is not loathe to present sexual drama in an uninhibited, undisguised fashion when that is his message. It is entirely contrary to the spirit of the way he paints to dismiss the given of his imagery by treating it only as a mask for another system of meanings, however much that system might contribute legitimate overtones to the manifest content. For Boime, fishing, strolling, observing, eating ice cream, etc., virtually cease to have any meanings in themselves. Thus, "the dominant theme of *Night Fishing* is sexual attraction and response . . . communicated through the *fishing metaphor*" (italics mine).

Although some flirtation is implied in Picasso's confrontation of pairs of men and women—and Boime develops the point with some interesting linguistic associations—it seems to this writer an exaggeration to consider the picture fundamentally a battle of the sexes in which the men and women become "predators trying to ensnare each other." The face of the fisherman on the left, distorted for expressive reasons that follow from his action, is, for Boime, "animalistic and repulsive," his eyes "malevolent." Boime forces this reading on that sailor so that he can serve Boime's embracing symbolic structure by representing the "metaphorical id" of the other fisherman, his "angelic" counterpart; Dora Maar becomes, by the same token, the id of Jacqueline Lamba. Picasso's contact with the Surrealists and his having read Freud are rung in by Boime—in a curious example of circular reasoning—as "documentary evidence in support of such an interpretation." But such "facts" fail to make the motivations attributed to Picasso in Boime's essay seem any less alien to the instinctual and unprogrammatic manner in which the artist has always elaborated his imagery.

11. Rothschild, Lincoln, "Letter to the Editor," *Journal of Aesthetics and Art Criticism* (New York), XIII, 2, Winter 1964, p. 273. This interpretation, which is devoid of those reservations invoked by Boime, is a classic of its kind. The figure of Dora Maar, misread as having "underwear showing through her skirt" becomes that of "the complete harlot." Rothschild's reading of the bicycle's motion is more in the spirit of Duchamp than Picasso. For him, *Night Fishing* finally becomes "perhaps Picasso's plea for light on the subject to dispel ancient, inhibiting confusions about sex . . . a courageous but also provocative attack on a deep social problem. . . ."

12. Jaffe, Hans L. C., *Pablo Picasso* (New York: Harry N. Abrams, Inc., 1964), p. 136.

13. Arnheim, Rudolph, "Picasso's 'Night Fishing at Antibes,'" *Journal of Aesthetics and Art Criticism* (New York), XXII, 2, Winter 1963, p. 167. "It seems legitimate to remember here," writes Arnheim, "that the painting was done in August 1939, when the imminence of World War II darkened the horizon.

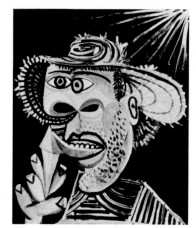

138. *Man Eating an Ice Cream Cone*, 1938

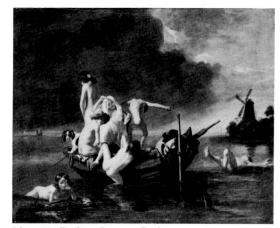

139. Nicolas Maes(?), *Bathers*. Louvre, Paris

In this ominous light, the murder of fishes, portrayed in our painting, acquires a particular meaning." Here again, the problem seems to this author one of overreading. It is impossible to say whether the dark colors of *Night Fishing* (perfectly explicable naturalistically) or any of the distortions (rationalizable in expressive terms) reflect political preoccupations on Picasso's part. (If present, they would have, in any case, related more to the then recent fall of Barcelona than to World War II, which had not yet begun.) Arnheim's sentimental interpretation of the central motif of *Night Fishing* as a kind of Massacre of the Innocents is all the more regrettable as it is tacked on to an otherwise sensitive account of the picture's structure.

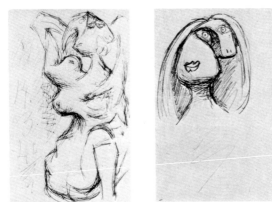

140. Page from a sketchbook,
March 14, 1940

141. *Woman's Head*, 1940

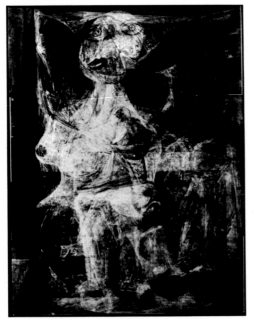

142. Radiograph of *Woman Dressing Her Hair*. (Made at the
Conservation Center of New York University)

143. Page from a sketchbook,
June 3, 1940

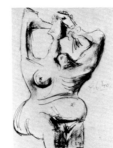

144. Page from a sketchbook,
June 4, 1940

WOMAN DRESSING HER HAIR
Royan, (2nd–3rd week, June 1940)
Oil on canvas, 51¼ x 38¼ inches
Signed upper right: "Picasso";
 inscribed on stretcher: "5–3.1940"
Provenance: Owned by the artist until summer, 1957
Promised gift of Mrs. Bertram Smith, New York
Ill. p. 159

1. Penrose, *Picasso*, p. 296.

2. In an essay, "The Women of Algiers and Picasso at Large," to be published in his forthcoming book, *Other Criteria* (New York: Oxford University Press, 1972), Leo Steinberg argues that simultaneity of aspects as a structural mode is unrelated to Cubist goals, even though the loosened facets of Cubism suggested some of the means. However, in the artist's later work the "weave of aspects" becomes "the efficient principle of a new consolidation."

3. Although the stretcher is inscribed March 5, 1940 (incorrectly cited in certain publications as March 6), Jardot (*Picasso: Peintures*, no. 95) was undoubtedly right in surmising that this painting was executed in June. Since the earliest drawing to approximate the pose of the whole figure dates from March 14 (Fig. 140; see last paragraph of text, p. 158), Picasso evidently began a related picture on this canvas at that time, and later painted over it. This is confirmed by a recent radiograph (Fig. 142), which gives some idea of the earlier picture. It shows that the head then took approximately the form we see in Fig. 141, undated but executed after March 2 (to judge by its place in a notebook begun January 10, 1940; see Zervos, x, 202–297).

 It is highly unlikely that the execution of *Woman Dressing Her Hair* antedates the closely related sketches of early June (Figs. 143–148). As Jardot is again probably correct in suggesting that Fig. 149, dated June 19, was executed *after* the painting (related sketches of that date deal with comparable pictures-within-pictures), we may surmise that *Woman Dressing Her Hair* was executed some time during the second and third week of June 1940.

4. John Berger (*The Success and Failure of Picasso*, Baltimore: Penguin Books, 1965, p. 151), in a glaring example of the intentional fallacy, assumes that the political situation is the subject of *Woman Dressing Her Hair* and pronounces it a failure because "a woman's body by itself cannot be made to express all the horrors of fascism." But even in *Guernica* and *The Charnel House*, Picasso transcended immediate circumstantial motifs to create more generalized, more universal images, and based these, moreover, primarily on the human body, which remains for him capable of communicating the fullest range of content.

5. Penrose, *Picasso*, p. 296.

6. The date(s) of these four sketches (Fig. 141, and Zervos, x, 284–286) is not known. The sketchbook containing them

was begun January 10, 1940. They occur a few pages after a drawing dated March 2 and are immediately followed by others dated May 26.

145. Page from a sketchbook, June 4, 1940

146. Page from a sketchbook, June 5, 1940

147. Page from a sketchbook, June 7, 1940

148. Page from a sketchbook, June 8, 1940

149. Page from a sketchbook, June 19, 1940

150. *Portrait of Dora Maar,* June 16, 1940

MARTIN FABIANI
Paris, July 17, 1943
Pencil, 20 x 13 inches
Dated lower right: "17 juillet 43"
Provenance: Martin Fabiani, Paris; The Donor, New York
Gift of Sam Salz, 1954
Acq. no. 249.54
Ill. p. 160

THE STRIPED BODICE
September 20, 1943
Oil on canvas, 39⅜ x 32⅛ inches
Signed upper right: "Picasso"; inscribed on stretcher:
 "20 septembre 43"
Provenance: Durand-Ruel Gallery, New York
Promised gift of Nelson A. Rockefeller, New York
Ill. p. 161

HEAD OF A WOMAN
July 16, 1941
Pen and ink on brown-gray paper, 10⅝ x 8¼ inches
Signed lower right: "16 juillet 41/Picasso"
Provenance: Pierre Loeb, Paris
Purchase, 1945
Acq. no. 9.45
Ill. p. 162

FEMALE HEAD
May 1940
Pencil, 8⅞ x 7⅜ inches
Signed upper left: "mai 40/Picasso"
Provenance: The Donor, New York
Gift of Justin K. Thannhauser, 1948
Acq. no. 7.48
Ill. p. 162

1. Barr, *Fifty Years*, p. 227.

2. Penrose, *Picasso*, pp. 278, 296, 330. A number of writers describe the animal head as "horse-faced."

WOMAN WASHING HER FEET
Paris, July 10, 1944
Wash, brush and ink, 20 x 13¼ inches
Signed upper left: "10 juillet/44/VII/Picasso"
Provenance: Galerie Louise Leiris, Paris
Purchase, 1953
Acq. no. 186.53
Ill. p. 163

1. See Zervos, XIII, 290, 291, 316–319, 325, for reproductions of the other drawings. This entire group of drawings relates to a figure in the painting of 1944, *Reclining Nude and Woman Washing Her Feet*, Zervos, XIII, 273.

HEAD OF A BOY
Paris, August 13–15, 1944
Brush and ink wash, 19¾ x 11¼ inches
Signed lower right: "Picasso/13–15 août 44 Paris"; and on
 reverse upper left: "13 août 44" and "15 août 44"
Extended loan of the Florene May Schoenborn and
 Samuel A. Marx Collection
Ill. p. 164

1. See Penrose, Roland, *The Sculpture of Picasso* (New York: The Museum of Modern Art, 1967), pp. 106, 107, for photographs of this sculpture.

PAUL VERLAINE
Paris, June 5, 1945
Wash, pen and ink, 11⅝ x 8¼ inches
Signed, on reverse: "Pour/Paul Eluard/Picasso/le mardi 6
 juin 1945"; dated, front, upper right: "5.6.45"
Provenance: Paul Eluard, Paris; M. Knoedler & Cie., Paris
Extended loan of the Joan and Lester Avnet Collection
Ill. p. 165

1. Penrose, *Picasso*, p. 135.

THE CHARNEL HOUSE
1944–45
Oil on canvas, 78⅜ x 98½ inches
Signed lower left: "Picasso/45"
Provenance: Walter P. Chrysler, Jr., New York and
 Warrentown, Virginia
Mrs. Sam A. Lewisohn Bequest (by exchange) and
 Purchase, 1971
Acq. no. 93.71
Ill. p. 167

1. See the discussion of *Woman Dressing Her Hair*, p. 158.

2. Whitney, Peter D., "Picasso Is Safe," *San Francisco Chronicle*, September 3, 1944. Cited in Barr, *Fifty Years*, p. 223.

3. Following Picasso's entry into the Communist party at the end of World War II, images bearing directly on collective social and political issues multiplied, e.g. *Massacre in Korea*, *War and Peace*. (He also contributed a poster and numerous drawings to the International Peace Movement.) Such images remain, however, numerically infinitesimal in his immense output.

4. As in *Guernica* where Picasso eschewed such details as contemporary weapons, which might have attached the image directly to the time and place of the Fascists' bombing, or even more generally to modern war (Schapiro, lectures at Columbia University), so he ensured the universality of *The Charnel House* by avoiding those references which would link it specifically with the concentration camps.

5. For a discussion of these interlocking iconographic layers in *Guernica*, see the author's *Dada and Surrealist Art*, pp. 290–309. A case is made there for a direct parentage of the

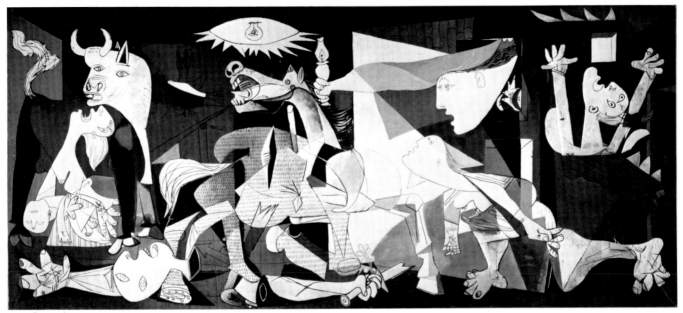

151. *Guernica,* 1937

152. *Guernica:* first progressive photograph (detail of left half),
by Dora Maar

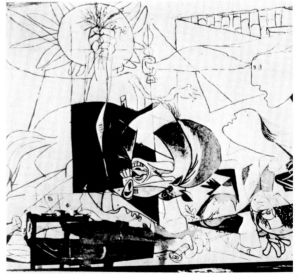

153. *Guernica:* second progressive photograph (detail of center),
by Dora Maar

154. *Study for Man with a Lamb*, 1942

155. *Bound Lamb*, 1943

156. *The Sacrifice*, 1938

configuration of the horse in certain of Picasso's Grünewald paraphrases of 1932, especially one in which the head of Christ resembles a snouted animal, its mouth open and tongue emerging.

6. In addition to such well-known examples as *First Steps* of 1943 (Zervos, XIII, 36) the reader is referred especially to the following pictures: Zervos, XI, 78, 79, 200; XII, 70–85, 157, 160; XIII, 74, 94, 95, 98, 207; XIV, 39, 89, 90.

7. Robert Rosenblum has pointed out an affinity in regard to the juxtaposition of dead bodies and still-life objects between *The Charnel House* and Goya's "Ravages of War" from *The Disasters of War*. The latter image (Fig. 161), certainly familiar to Picasso, contains six dead figures in a wrecked house in which a chair plays a role somewhat analogous to the still life in *The Charnel House*.

8. The date Picasso ceased work on *The Charnel House* is not known. The work could not possibly have been halted before July 1945, when Brassaï reports his painting it (see text, p. 169). It was first publicly exhibited in February 1946 in *Arts et Résistance*, a show sponsored by organizations of *maquis* and partisans at the Musée National d'Art Moderne in Paris. According to Sidney Janis, who was seeing Picasso at that time, the picture was not in its present state. Assuming Janis is correct, the final light blue-gray additions (see text, p. 169) were made well over a year after the work was begun, and possibly even later. When the picture was exhibited—in its present state—in the large Picasso retrospective at the Palazzo Nazionale of Milan in 1953, the catalog entry indicated that those final changes were made as late as 1948. The picture was purchased in 1954 by Walter P. Chrysler, Jr., from whom the Museum acquired it.

9. In the Zervos catalog this cock may be discerned in different form in both the first and second progressive photographs (XIV, 72, 73) where the gravure process gives maximal definition. However, the cock is barely visible in our smaller reference photographs (Figs. 165, 166) printed in offset.

10. Brassaï, *Conversations*, p. 224 (entry for Tuesday, July 10, 1945). These connotations of the French verbs *achever*, *exécuter* and *terminer* have been observed by Picasso in other contexts to make essentially the same point.

11. "It seems to me," writes Clement Greenberg ("Picasso Since 1945," *Artforum* Los Angeles, V, 2, October 1966, p. 29), "that in *Charnel House* Picasso also makes a specific correction of the color of the earlier picture [*Guernica*] by introducing a pale grey-blue amid the blacks and greys and whites. This works, along with the use of priming instead of applied white, to give the later painting more ease of space, more air."

12. *Ibid*, p. 28.

157. *Study for Head of a Lamb*, 1943

158. *Study for Guernica*, 1937

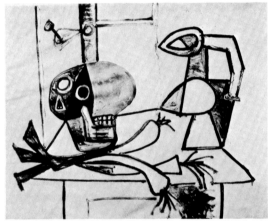

159. *Pitcher, Candle and Casserole*, 1945. Musée National d'Art
Moderne, Paris

160. *Skull, Leeks and Pitcher*, 1945

161. Goya: *Ravages of War*, c. 1810–1815. The Metropolitan
Museum of Art, Dick Fund, 1932

162. *Cock*, 1944

163. *The Charnel House*: detail, first progressive photograph, February 1945

165. *The Charnel House*: first progressive photograph, February 1945

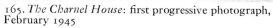

164. *The Charnel House*: detail, second progressive photograph, April 1945

166. *The Charnel House*: second progressive photograph, April 1945

167. *The Charnel House*: third progressive photograph,
May 1945

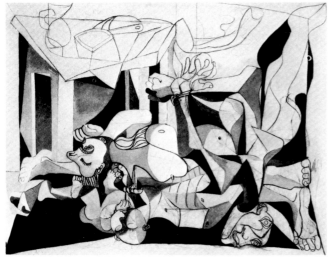

168. *The Charnel House*: fourth progressive photograph, undated

169. *The Charnel House* (final state). The Museum of Modern
Art, New York

170. Lucas Cranach the Elder, *David and Bathsheba*, 1526. Preussischer Kulturbesitz, Staatliche Museum, Berlin

DAVID AND BATHSHEBA
Paris, March 30, 1947
Lithograph, 25⅝ x 19¼ inches
M.109I/X
Louise R. Smith Fund, 1956
Acq. no. 776.56
Ill. p. 170

DAVID AND BATHSHEBA
Paris, March 30, 1947
Lithograph, 25⅞ x 19¼ inches
M.109II/X
Acquired through the Lillie P. Bliss Bequest, 1947
Acq. no. 254.47
Ill. p. 170

DAVID AND BATHSHEBA
Paris, March 30, 1947
Lithograph, 25½ x 19¼ inches
M.109IV/X
Acquired through the Lillie P. Bliss Bequest, 1947
Acq. no. 255.47
Ill. p. 171

DAVID AND BATHSHEBA
May 29, 1949
Lithograph, 25¹¹⁄₁₆ x 18¹⁵⁄₁₆ inches
M.109 bis I/I
Curt Valentin Bequest, 1955
Acq. no. 363.55
Ill. p. 171

1. Cited in Barr, *Fifty Years*, p. 272. See also Picasso's statement to Brassaï (p. 169) made shortly before his deep involvement with lithography.

2. Daniel-Henry Kahnweiler, introduction to *Cranach and Picasso* (Nürnberg: Albrecht Dürer Gesellschaft, 1968, n.p.): "The plates after *David and Bathsheba* were from a small reproduction of this painting in a Berlin catalog that I brought to him."

3. Barr, *Fifty Years*, p. 273.

4. Unpublished etchings based on Delacroix's *Women of Algiers* and a linoleum cut after Manet's *Luncheon on the Grass* are the only clear-cut exceptions.

5. Preussischer Kulturbesitz, Staatliche Museum, Berlin.

6. Staatliche Kunstsammlungen, Weimar. Picasso's lithograph is titled *Young Girl Inspired by Cranach* (Mourlot, 176).

7. Germanisches National Museum, Munich. In May 1949 Picasso made three lithographs of the subject (Mourlot, 182–184) and an etching and aquatint (Bloch, 1835).

8. Kunsthistorisches Museum, Vienna. Picasso's print is titled *Bust of a Woman after Cranach the Younger* (Bloch, 859).

MIRROR AND CHERRIES
June 23, 1947
Oil on canvas, 23⅞ x 19⅝ inches
Signed lower left: "Picasso"; dated on stretcher "23 juin 47"
Provenance: Kootz Gallery, New York
Promised gift of Mr. and Mrs. William A. M. Burden,
 New York
Ill. p. 172

PREGNANT WOMAN
Vallauris, (1950)
Bronze; first version; cast number two of an edition of six,
 41¼ inches high
Provenance: Galerie Louise Leiris, Paris
Gift of Mrs. Bertram Smith, 1956
Acq. no. 271.56
Ill. p. 173.

1. Gilot and Lake, *Life with Picasso*, p. 295.

SHE-GOAT
Vallauris, (1950, cast 1952)
Bronze; after found objects; 46⅜ x 56⅜ x 27¾ inches
According to Daniel-Henry Kahnweiler, this is one of
 two casts of this version.
Provenance: Galerie Louise Leiris, Paris
Mrs. Simon Guggenheim Fund, 1959
Acq. no. 611.59
Ill. p. 174

171. *Pregnant Woman*, second version, cast 1959

172. Plaster model for *She-Goat*, 1950

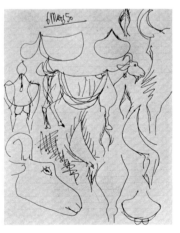
173. *Study for She-Goat*, 1950

BABOON AND YOUNG
Vallauris, 1951
Bronze; after found objects; cast number five of an edition
 of six, 21 x 13¼ x 20¾ inches
Dated on base: "1951"
Provenance: Galerie Louise Leiris, Paris
Mrs. Simon Guggenheim Fund, 1956
Acq. no. 196.56
Ill. p. 175

1. Picasso, who has had a monkey among his many other pets,
associated primates with scenes of family intimacy as early as
the Rose Period (Fig. 175).

174. *Paloma Playing*, 1953

175. *The Acrobat's Family with a Monkey*, 1905. Konstmuseum,
Göteberg, Sweden

HEAD OF A WOMAN
Vallauris, (1951)
Bronze; cast number two of an edition of six,
 19⅞ x 8⅝ x 14½ inches
Provenance: Galerie Louise Leiris, Paris
Benjamin Scharps and David Scharps Fund, 1956
Acq. no. 273.56
Ill. p. 175

MOONLIGHT AT VALLAURIS
Vallauris, (1951)
Oil on plywood, 54 x 41¼ inches
Signed upper left: "Picasso"
Provenance: Galerie Louise Leiris, Paris;
 Justin K. Thannhauser, New York
Promised gift of Mrs. Werner E. Josten, New York
Ill. p. 176

GOAT, SKULL AND BOTTLE
(1951–52)
Painted bronze; one of three casts, unmarked, and
 each painted differently, 31 x 37⅝ x 21½ inches
Provenance: Galerie Louise Leiris, Paris
Mrs. Simon Guggenheim Fund, 1956
Acq. no. 272.56
Ill. p. 177

HEAD OF A FAUN
1956
Painting on tile, 8 x 8 inches
Signed on reverse: "Picasso/24.1/56 VI/6.2.56"
Provenance: Galerie Louise Leiris, Paris
Philip Johnson Fund, 1956
Acq. no. 275.56
Ill. p. 178

BEARDED FAUN
1956
Painting on tile, 8 x 8 inches
Signed on reverse: "Picasso/15.2.56/II"
Provenance: Galerie Louise Leiris, Paris
Philip Johnson Fund, 1956
Acq. no. 274.56
Ill. p. 178

PLATE WITH STILL LIFE
(1954)
Modeled polychrome glazed ceramic, 14¾ x 12½ inches
Signed reverse before glazing: "Picasso"
Provenance: Saidenberg Gallery, New York
Gift of R. Thornton Wilson, 1967
Acq. no. 2511.67
Ill. p. 178

STUDIO IN A PAINTED FRAME
April 2, 1956
Oil on canvas, 35 x 45⅝ inches
Signed lower center: "Picasso"; dated on reverse: "2.4.56/II"
Provenance: Galerie Louise Leiris, Paris
Gift of Mr. and Mrs. Werner E. Josten, 1957
Acq. no. 29.57
Ill. p. 179

1. As quoted in a Museum of Modern Art press release, "Museum of Modern Art Acquires Recent Painting by Picasso" (August 11, 1957).

WOMAN BY A WINDOW
Cannes, June 11, 1956
Oil on canvas, 63¾ x 51¼ inches
Signed upper left: "Picasso"; dated on reverse: "11.6.56"
Provenance: Galerie Louise Leiris, Paris
Mrs. Simon Guggenheim Fund, 1957
Acq. no. 30.57
Ill. p. 181

1. Parmelin, Hélène, *Picasso dit . . .* (Paris: Gonthier, 1966), p. 80.

2. Richardson ("Picasso's Ateliers," p. 190) is "reminded—if anything to Picasso's advantage—of Matisse's *Portrait of Yvonne Landsberg* (Museum of Fine Arts, Philadelphia) of 1914."

177. *Woman in the Studio,* 1956

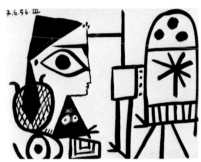

178. Notebook sketch, June 7, 1956

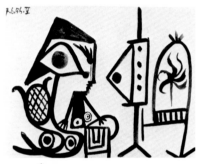

179. Notebook sketch, June 7, 1956

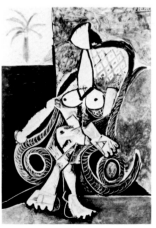

176. *Nude in a Rocking Chair,* 1956

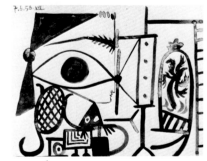

180. Notebook sketch, June 7, 1956

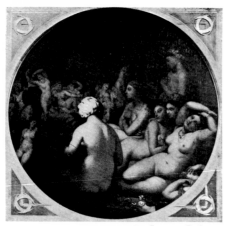

181. Ingres, *Bain turc*, 1862. Louvre, Paris

WOMAN IN AN ARMCHAIR
Mougins, 1961–62
Oil on canvas, 63⅞ x 51⅛ inches
Signed upper right: "Picasso"; dated on reverse:
 "N.D. de Vie/ 13 ... [illeg.] 12.61/1 14.15.16.17.18.19.
 20/ 21.22.23.24.25./ 26.27.28.29.30./ 1.1.62.2.3.4.5.6.10"
Provenance: Galerie Louise Leiris, Paris
Gift of David Rockefeller (the donor retaining a life
 interest), 1964
Acq. no. 329.64
Ill. p. 183

1. Richardson ("Picasso's Ateliers," p. 184) suggests a relationship between Picasso's increasing use of his studio as a subject in the late fifties and sixties and his consciousness of himself as *le roi des peintres*. The association of the studio with the court was probably one aspect of the motivation for the 1957 series after Velásquez' *Las Meninas*.

FIGURES
Mougins, March 9, March 14, March 15, 1967
Wash, brush, pen and ink, 19½ x 25½ inches (sight)
Signed upper left: "9.3.67/1/ 14.3.15.3/ Picasso"
Provenance: Galerie Louise Leiris, Paris
Extended loan of the Joan and Lester Avnet Collection
Ill. p. 184

1. For reproductions of other works in this series, see Feld, Charles, *Picasso: His Recent Drawings, 1966–1968*, preface by René Char (New York: Harry N. Abrams, Inc., 1969).

THE POOL
Mougins, January 30, 1968
Pencil, 22¹³⁄₁₆ x 30¹¹⁄₁₆ inches
Signed upper left: "9.3.67/1/ 14.3.15.3/ Picasso"
Provenance: Galerie Louise Leiris, Paris
Extended loan of the Joan and Lester Avnet Collection
Ill. p. 185

1. For other drawings directly related to this theme, see Feld, *Picasso: His Recent Drawings*, especially catalog nos. 344–353, 367, 369, 371.